Transformations in Cleveland Art, 1796–1946

This exhibition has been made possible by Hahn Loeser & Parks
with additional support from the Ohio Arts Council

Transformations in

Cleveland Art

1796–1946

Community and Diversity in Early Modern America

William H. Robinson and David Steinberg

with essays by Mark Cole, Henry Hawley,
Geraldine W. Kiefer, and Sabine Kretzschmar

The Cleveland Museum of Art Distributed by Ohio University Press

Published on the occasion of the exhibition *Transformations in Cleveland Art, 1746–1946: Community and Diversity in Early Modern America,* organized by the Cleveland Museum of Art.

Cover: Detail of Raphael Gleitsmann, *The White Dam,* 1939, private collection (fig. 103)

Editors: Barbara J. Bradley and Kathleen Mills

Designers: Thomas H. Barnard III and Laurence Channing

Production Manager: Charles Szabla

Printing: Great Lakes Lithograph, Cleveland

Library of Congress Cataloging-in-Publication Data

Robinson, William.
 Transformations in Cleveland art, 1796–1946 : community and diversity in early modern America / William Robinson and David Steinberg : with essays by Mark Cole . . . [et al.].
 p. cm.
 Exhibition was organized by the Cleveland Museum of Art.
 Includes bibliographical references.
 ISBN 0–940717–34–4 (cloth)
 ISBN 0–940717–33–6 (pbk.)
 1. Art, American—Ohio—Cleveland—Exhibitions. 2. Art, Modern—Ohio—Cleveland—Exhibitions. I. Steinberg, David, 1959– . II. Cleveland Museum of Art. III. Title.
N6535.C6R63 1996
709'.77132' 07477132—dc20 96–11969
 CIP

Contents

Foreword

THE CLEVELAND MUSEUM OF ART is proud to present *Transformations in Cleveland Art, 1796–1946,* the second of four major exhibitions organized to celebrate our city's bicentennial year. The Cleveland art project combines an exhibition and educational programs that will be presented during the 1996 bicentennial with this catalogue, a lasting legacy of the enterprise that will serve scholars and the public for years to come.

The history of art in Cleveland is a fascinating tale incorporating classic art historical issues such as the dialogue between international and local impulses, the impact of avant-garde styles, and the influence of social historical conditions. Looking at how these matters played out over a considerable period of time in this one complex urban center may produce insights that bear on other American cities as well. In this way *Transformations,* an interpretive study of the history of Cleveland's art, will contribute to the larger study of art making in the United States.

Since its founding in 1913, the Cleveland Museum of Art has maintained an active dialogue with the city's artists, often supporting their efforts through exhibitions, purchases, and scholarly studies. In 1915, a year before the building first opened to the public, Frederick Gottwald's *The Umbrian Valley, Italy* (see fig. 51) became the first work by a Cleveland artist to enter the permanent collection. Since then, the museum has acquired a significant corpus of Cleveland art, frequently augmented by gifts from civic-spirited citizens and organizations. The museum's curatorial staff has studied this art by presenting exhibitions and writing catalogues, including *Max Kalish and Alexander Warshawsky* (1946), *The Henry G. Keller Memorial Exhibition* (1950), *The William Sommer Memorial Exhibition* (1950), *The Carl Gaertner Memorial Exhibition* (1953), *Paul Travis: Africa, 1927–1928* (1982), and *Henry Keller: Paintings of a Traveler* (1994). Other aspects of the city's artistic heritage have been examined in the thematic exhibitions: *A Study in Regional Taste, The May Show, 1919–1975* (1977), *Progressive Visions: The Planning of Downtown Cleveland, 1903–1930* (1986), and *Cleveland Art Comes of Age: 1919–1940* (1989). The many annual May Shows and their successor exhibitions of regional artists' work are yet another important part of the museum's dynamic relationship with the artistic community.

Continuing and expanding on this tradition, *Transformations* is a pioneering effort to study the first century and a half of the visual arts in Cleveland. To realize this ambitious project, the curatorial team selected more than two hundred works in various media from public and private collections across the country. Perhaps the most difficult issue facing the curators was deciding how to define Cleveland art. They ultimately decided to be inclusive rather than exclusive, opting for the broadest possible sweep of association with the city's cultural life. Through their research the roster of names already familiar to the public was expanded to include exciting new discoveries. Rather than merely studying individual artists or objects in isolation, the curators have examined how artists interacted to form diverse communities of interest and how artists functioned in relation to the city's changing economic, social, and political structures. Anticipat-

ing that many Clevelanders will be surprised by at least some of these discoveries and conclusions, we hope this presentation will provide fresh insight and renewed appreciation for the city's artistic traditions.

Transformations in Cleveland Art, 1796–1946 is the collaborative achievement of William H. Robinson, the museum's assistant curator of modern art, and David Steinberg, assistant curator of paintings, to whom we owe thanks for more than two years of fruitful work. Henry Hawley, curator of Renaissance and later sculpture and decorative arts; Sabine Kretzschmar, curatorial assistant in prints and drawings; Mark Cole, research assistant; and Geraldine W. Kiefer, independent curator, were essential contributors to the endeavor. The catalogue, exhibition, and accompanying educational programs were made possible by a generous grant from the law firm of Hahn Loeser & Parks, whose corporate support truly benefits Cleveland's civic life in so many ways. Special thanks to Stephen J. Knerly, Richard Zellner, and all the partners for championing the show in celebration of the firm's milestone seventy-fifth anniversary year. We are also grateful for the continued support of the Ohio Arts Council.

Robert P. Bergman, Director
The Cleveland Museum of Art

LENDERS TO THE EXHIBITION

Miss Ruth E. Adomeit

Mr. and Mrs. Herbert Ascherman, Jr.

John P. Axelrod, courtesy Michael Rosenfeld Gallery, New York

Jean Barnett

Frederick C. Biehle

Nora A. Biehle

Stephen F. Biehle

Hugh J. and Ann Caywood Brown

Frank P. DiPrima

Dr. and Mrs. Michael Dreyfuss

Robert H. DuLaurance

Joyce Edson

Joseph M. Erdelac

Jamee and Marshall Field

Mrs. Leroy W. Flint

Mr. and Mrs. Edmund A. Hajim

William R. Joseph and Sarah J. Sager

The Harmon and Harriet Kelley Collection of African-American Art

William and Mary Kubat

Betty and Kenneth Lay

Patricia Lee-Smith, courtesy June Kelley Gallery, New York

Mr. and Mrs. William A. Monroe

Dr. Paul A. Nelson

Private collection, courtesy D. Wigmore Fine Art, Inc., New York

Private collection, courtesy Vixseboxse Art Galleries, Cleveland Heights, Ohio

Private collections

The Rose Family Collection

Mr. and Mrs. Samuel Rosenberg, courtesy Joan Washburn Gallery, New York

Jean Schenk

Carol and Michael Sherwin

Charles Sterling

Karen A. Tischer

Peter and Judy Wach

The Wasserman Family Collection

The Wilcox Estate

The Reba and Dave Williams Collection

Renee and Richard Zellner

Peter and Julie Jenks Zorach

Abby Aldrich Rockefeller Folk Art Center, Williamsburg, Virginia

Akron Art Museum

Burchfield-Penney Art Center, Buffalo State College, New York

Case Western Reserve University School of Law, Cleveland

City of Cleveland

Cleveland Artists Foundation

Cleveland Public Library

Cleveland State University

Cowan Pottery Museum, Rocky River Public Library, Ohio

Everson Museum of Art, Syracuse, New York

Fawick Art Gallery, Baldwin-Wallace College, Berea, Ohio

Fresno Metropolitan Museum, California

Hahn Loeser & Parks, Cleveland

Huntington National Bank, Cleveland

Karamu House, Cleveland

Kennedy Galleries, Inc., New York

Los Angeles County Museum of Art

National City Bank, Cleveland

National Museum of American Art, Smithsonian Institution, Washington, D.C.

Ohio Art Program

Ohio Historical Society, Columbus

Rachel Davis Fine Arts, Shaker Heights, Ohio

Southern Ohio Museum, Portsmouth, Ohio

Steve Turner Gallery, Los Angeles

The Union Club Company, Cleveland

United States Government

The Western Reserve Historical Society, Cleveland

Yannigan's Baseball Memories, Westlake, Ohio

Preface

ON A COLD WINTER DAY in 1909 an eight-year-old boy was hawking newspapers on the southwest corner of 105th and Euclid when a Peerless limousine pulled up to the curb. The rear window suddenly slid down and an old man silently handed a dime to the newsboy, who after fumbling through his pockets, realized he was out of change. When the man only glared back, the boy dashed into a nearby grocery and returned with the money. Before rolling the window up, the old man offered some advice: "If you want to be a success in business trust nobody, never give credit, and always keep change in your hand." As the limousine pulled away someone shouted: "Know who that man was?" So ended a chance encounter between two of Cleveland's most famous citizens, Bob Hope and John D. Rockefeller.[1]

History is filled with the unexpected convergence of what may have appeared at the time to be insignificant, random events. Although Cleveland's evolving artistic tradition is interwoven at every point with the city's history, almost nothing has been written about how economic, social, and political events affected the character of Cleveland art. Historians of Cleveland art have tended to focus on individual artists in isolation, rather than address such crucial issues as how artists responded to changing markets and patrons, patterns of immigration and ethnic diversity, or political and economic-class tensions.[2]

This catalogue explores the intersection between art and events during a period of extraordinary, sometimes disorienting change that transformed Cleveland from a canal village into a major industrial city. The authors reconstruct Cleveland's artistic life from its origins to the mid-twentieth century, when regional schools declined relative to the ascent of national and international art movements. Rather than a vague reflection of national trends, Cleveland art is studied within the context of the specific milieu in which it was created. The authors also examine how Cleveland artists interpreted themselves and their city, expressed the hopes and aspirations of their fellow citizens, and responded to rapid urbanization and industrialization. Particular attention is given to the various ways in which Cleveland artists confronted the challenges of the modern age while struggling to secure a niche in the economy of a city in the process of inventing itself. At the same time, the authors consider whether Cleveland art converges or diverges from national culture. This methodology has never before been applied to Cleveland art, and we believe it will challenge long-held assumptions about regional art production in America.

Transformations in Cleveland Art culminates years of effort to locate, document, research, and interpret the city's distinguished yet understudied and underappreciated artistic tradition. The curators of the exhibition tracked works of art through research in newspapers, exhibition catalogues, dealer records, and archives as well as through interviews with artists and their descendants. Although critical attention has historically focused on painting and sculpture, the curators expanded their research to include prints, photography, and decorative arts—areas of notable artistic production in Cleveland. Expanding the search brought illuminating discoveries about relationships between high and popular culture, sculptors

and craftsmen, painters and designers. This process unearthed significant works made by Cleveland artists or connected to the city's history, often in unexpected places. By uniting these and other works from disparate collections, the catalogue reconstructs personal historical relationships.

The curators concluded that the most appropriate way of discussing Cleveland's artistic tradition was through thematic essays, rather than separate entries for each work. This approach offered avenues for contextual interpretation that might be overlooked in more conventional readings of isolated objects. The essays are intended to provide diverse perspectives and a broad humanistic context for understanding Cleveland art. The selection of subjects and their organizational structure derive from analysis of events in Cleveland, rather than models of art history valid for other regions of the country.

Four catalogue essays survey general developments from 1796 to 1946, while three focus on more specific topics. David Steinberg's "The Forest City Rises: Symbol and Value in Cleveland's First Pictures" examines the artist-entrepreneurs who sought to interest the community in their skills and so adapted the genres of portraiture, landscape, and history painting to local purposes. Steinberg's second essay, "Fine Art in an Industrial Age," concerns the artists who established the city's first art clubs and academies, along with the relationship that developed between commercial and independent artistic production. The latter part of this essay studies the rising popularity of open-air painting and alternative perspectives during an age of tremendous industrial expansion. "Against the Grain: The Modernist Revolt," by William H. Robinson, presents Cleveland's modernist movement as a working-class reaction against entrenched social institutions and materialist values in a city dominated by the practical concerns of commerce and industry. This essay challenges conventional notions of how modernism was disseminated in this country as well as the degree to which midwestern artists continued to experiment with modernist styles during the 1920s and 1930s. "The American Scene Movement in Cleveland," also by Robinson, explores how Cleveland artists used local subjects to define a distinctive vision of civic identity, then turned to new pictorial strategies to confront pressing social and political issues during the Depression. Mark Cole's essay, "'I, Too, Am America': Karamu House and African-American Artists in Cleveland," concerns a notable group of Cleveland artists who functioned both as part of the city's integrated artistic community and as members of an artists' organization dedicated to promoting racial pride and solidarity. "Cleveland Craft Traditions," by Henry Hawley, studies the origins and evolution of local activity in this field, culminating in the city's emergence as a national leader in the decorative arts. Sabine Kretzschmar's "Art for Everyone: Cleveland Print Makers and the WPA" investigates how Cleveland printmakers of the 1930s turned to new techniques and subjects as a means of appealing to middle- and working-class audiences. In "From Entrepreneurial to Corporate and Community Identities: Cleveland Photography," Geraldine W. Kiefer explores relationships between the city's economic development and its evolving photographic tradition.

Fifty years have now passed since the close of the period under discussion, providing an appropriate historical distance from which scholars and historians may begin the process of evaluating the first 150 years of Cleveland art. We believe it is important to revisit the subject, rather than merely repeat the accepted opinions and the well-known views of the artists' contemporaries. Recent scholarship also offers opportunities to define issues more sharply and make comparisons with events elsewhere in America and abroad.

The authors have tried to avoid the boosterism and sanitizing that too often seep into studies of locally produced art. Our aim was to reconstruct the original context in which Cleveland art was created, rather than ignore controversies or interpret works to conform to popular opinion. Examining personal letters and diaries often disclosed clues to an artist's thoughts and intentions. Old newspapers and exhibition catalogues yielded equally revealing information about the meaning of the works.

Some members of the local community may be surprised to discover that their favorite artists do not appear in this catalogue. The curators insisted from the beginning that Cleveland art must be measured by the same standards of historical analysis and critical judgment as any other art. At the same time, practical considerations prevented the inclusion of every object worthy of merit. An important factor affecting the selection was a desire to avoid the encyclopedic method of merely choosing one or two works by every possible artist. Instead, each work was considered on its merits, while special consideration was afforded to works that epitomize major periods of regional art production. Our objective was not to write a definitive history of Cleveland art but to define issues and stimulate reconsideration of the subject.

This study focuses on artists active in the art life of Cleveland and the surrounding region, including some artists who relocated elsewhere but continued to exhibit or participate in the cultural life of northeast Ohio. With its concentration of art galleries, schools, and museums, Cleveland has historically exerted a sphere of influence that extends beyond the city proper into the surrounding region. Direct, interurban rail transportation with Akron, Berlin Heights, Sandusky, and other nearby population centers facilitated the development of a cohesive artistic community in northeast Ohio. Although there are no precise borders to this region, Cleveland's cultural influence has been most strongly felt in a sixty-mile arc around the city and fades as it collides with the cultural orbit of other major metropolitan centers.

Art historians know too well that the record of the past is incomplete and fragile. Over the years, public and private institutions in Cleveland have commissioned or purchased hundreds of works by local artists. Unfortunately, some of this art can no longer be located. Other works have suffered serious damage from being poorly stored or neglected. Entire collections have been known to vanish in garage sales after an artist's death. Embarrassing incidents have come to light of paintings by significant artists being discovered in the trash pile during office remodeling projects. By

identifying its historical and aesthetic importance, the curators hope to contribute to the appreciation and preservation of Cleveland's rich artistic legacy. Enhanced awareness of our common cultural heritage is one means of strengthening bonds and bringing the community together.

Nearly sixty years ago the Whitney Museum of American Art in New York organized an exhibition of Cleveland art. The catalogue stated in the introduction: "Cleveland has long been remarkable among American cities for the whole-hearted way in which it has supported and encouraged its native artists, and for the close relations between them and the Cleveland Museum of Art. The result of this intelligent attitude has been the growth of a local school of unusual vitality and variety."[3] We encourage the reader to use this catalogue as a means of measuring the validity of that statement.

NOTES

1. Arthur Marx, *The Secret Life of Bob Hope* (New York: Barricade Books, 1993), 22–23. Although Hope's birthday is often listed as 1903, Marx insists the actual date is 1901, in which case, Hope would have been eight years old in 1909.

2. The literature on Cleveland art is heavily weighted with monographic studies of individual artists. Broader studies of the subject are listed in the "Bibliographic Notes" at the end of this catalogue.

3. *Paintings and Prints by Cleveland Artists,* exh. cat. (Whitney Museum of American Art, 1937), unpaginated.

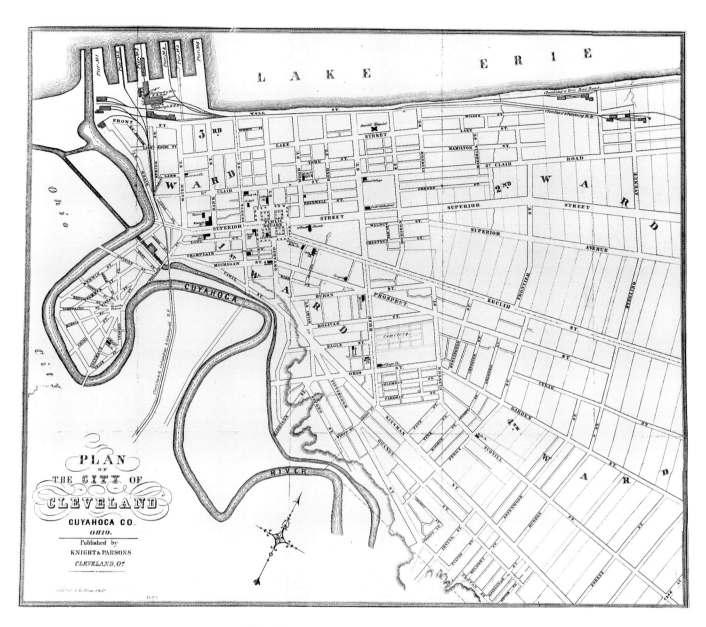

Plan of the city of Cleveland, 1853. The Western
Reserve Historical Society.

The Forest City Rises: Symbol and Value in Cleveland's First Pictures

WE HAVE A PAINTER in this city who can't be beat. He paints white oak pannels, &c. so curiously that they exceed in transparency the best crown glass. He painted a steamboat so faithfully that it blew up and took fire just as he was giving the finishing touch to the larboard smoke pipe. In a battle scene he delineated a cannon with such fidelity that it *went off* one night, taking the whole piece with it, and has not been heard of since.

—*Cleveland Herald,* 25 August 1847

AT ANOTHER TIME a slave was in the greatest danger of apprehension. At a supreme moment a plan was conceived, and Alonzo Pease [was] sent for. . . . Mr. Pease brought materials, and worked an hour upon the slave. At the end of that time the latter was a very respectable Caucasian, and had the satisfaction of knowing that all the paints could be washed off. In this disguise he left the house, entered a carriage, and was driven right through the crowd of slave-hunters in the most public way, without recognition.

—A. L. Shumway and C. DeW. Brower,
recounting events in Oberlin during the 1850s[1]

AS THESE ANECDOTES MAKE CLEAR, during the middle of the nineteenth century people in Cleveland and its environs held complementary conceptions of the painter's enterprise. The first extract presents painting as an art that creates one-to-one correlations between the world of experience and miniature worlds on panel. The apocryphal story of a painter depicting a cannon that goes off echoes such ancient boasts of the artist's power as the tale of the Chinese painter who, upon completing the eyes of a bird, was astonished to see his work fly away. Writing for a local newspaper, and referring to no painter in particular, a Clevelander hitched this sort of brag to civic pride: "We have a painter in this city who can't be beat." The second text presents artifice as painting's method and subterfuge as its end. Working on a human body, portraitist Alonzo Pease reportedly painted Caucasian features on an African slave. A remark about the temporary nature of this disguise relieved the unnamed black man, who had been afraid that he would go through the future alienated from his identity, trapped in interminable "whiteness." As his evasion of the slave hunters showed, painting can have a lasting effect upon the world despite the impermanence of its materials.

Characterizing the painter's art in terms of truth in one case and deception in another, these stories exemplify contemporary beliefs that painting

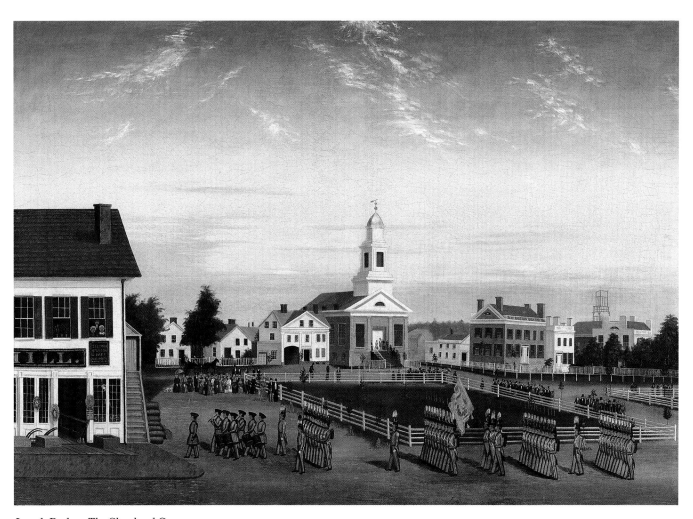

Joseph Parker, *The Cleveland Grays on Public Square*, 1839.

concerned more than the imitation or forgery of nature. Although the first townscapes, portraits, genre scenes, historical subjects, and landscapes created by men and women affiliated with Cleveland are naturalistic artifices on many counts, their engagement with goals other than representing how things look fulfills the expectations the anecdotes raise. Symbolizing the values of the people who made and viewed them, these paintings presented visions of the world that responded to and stimulated local emotional needs. As elements of contemporary social life, these paintings came into being through historical modes of production and then circulated within historical practices of display. As the town of Cleveland transformed itself into an industrial city, these symbols, values, needs, modes, and practices changed.

Even the spaces established by settlers had symbolic purposes. Public Square, never the geographic center of habitation, has been Cleveland's conceptual center from the time of the town's founding. Laid out by 1801 and partly cleared of trees before 1810, the square was first planted with saplings in 1827.[2] By about 1850, those trees had matured enough to allow the space to serve as a focal point for a publicity campaign identifying Cleveland as the "Forest City." Mid-century urban taste required the presence of trees so that citizens could claim a harmonious coexistence with nature. By contrast, a different fashion for place making had been current at the outset of the century during the important work of defining Cleveland as something other than an undifferentiated part of the wilderness. According to that early planning strategy, the image of man and his creations needed to be foremost.

The two oldest surviving paintings of the square, dominated by prominent public buildings, show that institutions were central to early ideas of what Cleveland was. In the first of these canvases (fig. 1), Joseph Parker shows the northwest corner, featuring the original First Presbyterian Church (built 1831–33). In a slightly later painting (fig. 2), Sebastian Heine presents the southwest quadrant, with the Second Court House (built 1828). By locating a church and a courthouse on their central axes, these compositions elevate specific buildings to the status of emblems representing Church and State.

In the more ambitious of these townscapes, First Presbyterian Church presides over a parade of the Cleveland Grays, the first uniformed militia west of the Alleghenies. The combination represents Cleveland as a community that inspires and sustains highly visible private initiatives undertaken with the public welfare in mind. Most of the town's citizens appear as either discretely massed spectators or lockstep marchers. The view is from a hotel called the Cleveland House, which was located on the south side of Superior Street to the west side of the square (see the Cleveland city plan, p. 5).[3] The vantage point, directly opposite the three figures visible through the second story window at left, suggests that we are part of a similar audience watching the festivities. Viewers and viewed alike thus participate in a celebration of collective identity.

Charles Giddings, merchant, shipowner, and director of the Commercial Bank of Lake Erie, commissioned this canvas in 1839 from a traveling theatrical producer, actor, and scenery painter named Joseph Parker.[4] Patron and painter bestowed the canvas on the Grays at the conclusion of a day of marching and convivial feasting that celebrated another gift from Giddings to the militia: a banner painted by Jarvis Hanks.[5] As the Grays sat in Parker's theater, "the curtain rose and such cheering was never heard before. Before them was presented the whole scene of the day ingeniously and truthfully transferred to canvas by Parker," who then sang his

Figure 1. Joseph Parker, *The Cleveland Grays on Public Square,* 1839, oil on canvas, 47 x 65 in. (119.4 x 165.1 cm). The Western Reserve Historical Society.

Figure 2. Sebastian Heine, *Cleveland Courthouse on Public Square,* ca. 1845, oil on canvas, 17½ x 25 in. (44.5 x 63.5 cm). The Western Reserve Historical Society.

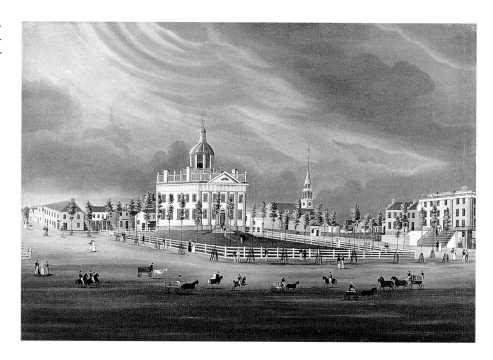

"Presentation of the Flag" set to the music of the Marseilles.[6] While the painting's content illustrates a civic occasion, its orchestrated reception actually constituted such an event.

Although a communal aesthetic circulated within and around Parker's painting of the Grays, the canvas made pointed reference to at least one town resident. Between the central axis of the painting and its right edge, the six-year-old house of patron Giddings rises prominently in a three-quarter view. Like his giving a flag and a townscape to the local militia, his buying and developing real estate on the perimeter of Public Square positioned him as a leading citizen within the local prestige order. That his house was subordinate to the church shows that Giddings knew his place within the community both literally and figuratively. Such a qualified yet unambiguous claim to a public profile was the only way to pursue high rank in a town where citizens typically affirmed their reliance upon one another by collective symbolic actions.

Easel painting was only one of many kinds of painting done in the pre-Civil War town. Neither Parker nor Heine thought of himself as what we might today call an artist. The former indulged in scenery painting as it was demanded by his theatrical work, while the latter advertised as a "sign and ornamental painter." In 1845 Heine informed the public of his partnership with Louis Chevalier by announcing that they were available for painting "Signs, Portraits, Miniatures, Transparencies, Drawings, Designs, Flags, Banners, Sceneries, Landscapes, Fire Boards, Imitation of Wood & Marble, &c."[7]

Both varied formats and great variety in the training of people who made pictures in Cleveland during the first three-quarters of the nineteenth century help explain the virtually uninterrupted stylistic diversity of local production through the period. Perhaps the most disparate images were the gift drawings made by members of the Shaker Community at North Union, the sole known example being James Mott's *The Throne of God* (fig. 3).[8] By signing his name "Instrument James M. Mott," the draftsman articulated his self-image as the recipient of a spiritual gift that he translated into visible form. Using concentric circles and radiating lines, Mott mapped a cosmos centered on "The Throne of God, and the center of

Figure 3. James Mott, *The Throne of God,* 1844, blue, black, and brown ink on fabric, 19½ x 23 in. (49.5 x 58.4 cm). Ohio Historical Society.

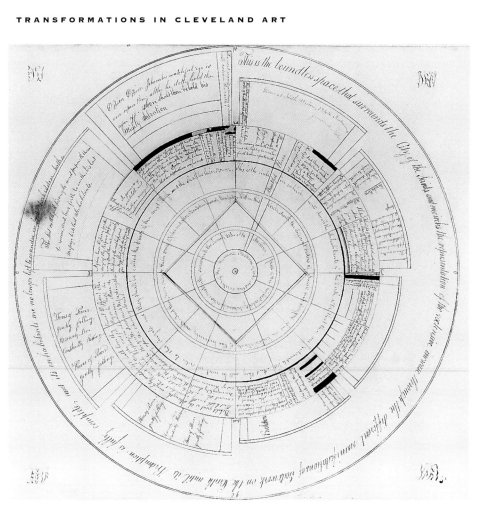

the Heavens." He wrote the names of the cardinal directions on the perimeter of the second outermost circle, a shape that defines one limit of "The boundless space that surround the City of the Saints."

In terms of commercial painting, Cleveland developed proto-urban qualities during the 1840s and 1850s. By contrast with the hunt-and-gather approach to commissions that characterized the practices of itinerant painters who moved through smaller villages and towns, artists who came to Cleveland found that the city supported a slash-and-burn strategy within the local economy. They came, stayed for a few years or so, and then, either exhausting themselves of local patronage or tiring of pursuing it, continued on their way.[9]

DIVERSE AXES OF CONTINUITY: HANKS AND SMITH

AMONG THE PAINTERS who positioned themselves in the life of the community, Jarvis Hanks and Allen Smith, Jr., were the most successful. First active in town in 1825 and again from 1835 until his death in 1853, Hanks spent more time in Cleveland than anywhere else during a peripatetic career. Overlapping with Hanks beginning in 1842 (although no record of contact between them exists) and expending most of his energies locally until 1883, Smith worked briefly in Detroit and New York City before settling in the West. While these men constitute two axes of continuity in the local art scene, they cannot be said to have changed the largely fragmentary character of its painting production; their pictorial styles and public images could hardly have been more different.

In 1825 Hanks advertised his availability to produce a great range of painting types, although the first item on his list offers a crucial link with the idea and practice of easel painting as a fine art: "Portraits, Gilt &

Smelted Signs, Landscape, Tavern Signs, Common Signs, Military Colours for regiments and independent companies, Masonic Transparencies, Carpets, Aprons, &c. &c."[10] While he painted a number of portraits in Cleveland, especially after 1835, Hanks still produced works in other formats, his highly praised flag for the Grays visible in Parker's painting being one prominent example.[11] In January 1838 he boldly advertised his exclusive devotion to portraiture, but by March he had capitulated to the limits of the marketplace, announcing that "he will not, however, refuse to execute Banners, Flags, or other works of a pictorial character."[12]

One way that Hanks cultivated portrait commissions involved an exhibition room installation that linked his art with the history of the town, a public relations gambit documented by a newspaper account:

> On entering his Rooms, our eye was arrested by the life-like portrait [fig. 4] of an old pioneer of the city, familiarly known as UNCLE ABRAM. The delineation of features and colorings are so perfect, as to leave no one for a moment at a loss as to the original. He sits before you, evidently wrapped in the contemplation of soon requiring for himself the last, sad offices he has for years performed for his fellow men.—There is still however, a glow of health on the furrowed cheek, that, while it speaks of ripe old age, solemnly hints to the young gazer—'You *may* need my services, before I require thine.'[13]

The canvas shows Abraham Hickox at the age of seventy-two. Born in 1765 in Waterbury, Connecticut, Hickox worked as a blacksmith and held the municipal office of sexton after migrating to Cleveland in 1809. Because the stencil formerly visible on the back of the canvas dates the painting to 1837 (two years before the newspaper notice), it is clear that the portrait was not a private painting done at the sitter's request. In addition, it hung in the exhibition room above a conspicuously contrasting full-length portrait of a lady. Hanks did both works at his own expense so that he might have on hand pieces to demonstrate his talent and help him secure commissions, choosing for one the portrait of a man popularly associated with

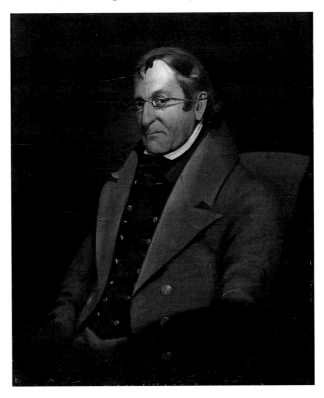

Figure 4. Jarvis Hanks, *Abraham Hickox,* 1837, oil on canvas, 28¾ x 24 in. (73 x 61 cm). The Western Reserve Historical Society.

the settling of Cleveland. By preserving a founder's likeness and exhibiting it without charge, Hanks demonstrated his public-mindedness and fostered patronage at the same time.

Hickox administered last rites in his capacity as sexton. The reporter's account alludes to this fact in its invocation of the death of both sitter and viewer. A conventional part of contemporary thinking about the genre of portraiture, the iconography of death also figures in the reporter's concluding recommendation that readers have their portraits painted:

> In a few sittings, a second self may be obtained, pleasing to look upon in the after life and note the changes of time, and worth more than gold to such as cherish a remembrance, when the canvass alone reflects the looks of kindness and love treasured of the departed in the living heart of hearts.

Here the words "after life" refer specifically to the duration following the occasion of portrait painting when viewers could compare aging sitter and immutable effigy, but they also introduce a consideration of the relationship between portraiture and the period following the sitter's death. While communal beliefs about salvation affirmed the existence of a heavenly afterlife, portraits cultivated an earthly afterlife for the sitter in collective as well as private memory. By including in the lower area of the painting a shadow cast by an unknown object from outside the frame, Hanks characterized portraiture as a genre that summons to viewers' minds ideas about presence and inevitable absence.

Unsigned and undated, one of the most remarkable paintings in the history of Ohio art was probably created by Hanks on an excursion to the southern part of the state between September 1840 and February 1841.[14] With six figures—three depicting people who were alive and three those who had passed away—*Death Scene, The Stone Family* (fig. 5) brought together on a single canvas a family separated by death.[15] Elizabeth Cook Spencer Stone sits at the center of the composition; her husband, Augustus Israel Stone, appears at the upper right. The pair married in May 1836 and settled in Marietta, where Stone was a merchant. In April 1840, Mrs. Stone gave birth to twins. The twenty-five-year-old mother died a little more than two months later, the infant Elizabeth Spencer lived slightly more than four months, and the infant Augustus Israel survived his sister by only a month.[16] Faced with the loss of his wife and two newborns, Stone commissioned the painting, which includes at lower left a portrait of Selden Spencer Stone, his only surviving child, and at upper left Mrs. Stone's mother, Prudence Cook Spencer. Just before his first visit to Cleveland, Hanks had painted Stone's mother in Marietta (1825, private collection).[17] Fifteen years later, the longstanding acquaintance between Hanks and Stone seems to have led to the creation of a unique family portrait.

Best understood as the product of a painter's artifice, the canvas does not transcribe how things looked during any given instant in 1840 so much as represent ideas that the patron held dear about his departed wife and children. Given the Second Great Awakening's widely influential emphasis on human agency, the prescriptions about "Preparation for Death" offered in 1834 by William Sprague, a Presbyterian minister from Albany, New York, can help articulate the ideals that Hanks tried to put before the Congregationalist Stone in Marietta. Sprague counseled that good Christians should meditate "on the amazing scenes which must open upon the spirit the moment death has done its work, and on the riches of that grace which secures to the believer a complete victory in his conflict and a triumphant

entry into heaven."[18] What Sprague asserted with words, the painter endowed with the status of fact through pictorial rhetoric.

Some of the persuasive aspects of the painting derive from the idea that Mrs. Stone's actions express her beliefs. So thoroughly has she released herself from earthly attachments, for example, that she clasps her hands piously rather than support the babes spilled precariously on her lap.[19] Her upward gaze also signifies a mind fixed on divinity. Hanks made his awareness of this convention explicit in a reminiscence about how his own mother looked when he departed for service in the War of 1812:

> Her eyes were overflowed with tears, and raised to Heaven. I can never forget her expression at that moment—it was one of deep sorrow mingled with patient submission. She seemed to say, though spoke not,—"Thy will be done, O Lord—Unto thy protection, God of hope and mercy, I resign my boy!"[20]

With her gentle smile, however, Mrs. Stone conveys confidence about her eternal fate rather than resignation about the timing of its commencement. She seems at peace, secure in her acceptance of Christ and receipt of grace. Hanks emphasized her raised face by setting it amid two compositional diagonals running toward the upper right, one aligning the heads of Mrs. Spencer, Mrs. Stone, and Mr. Stone, and the other connecting the top of Selden's head to Mrs. Stone's highlighted shoulder to Mr. Stone's hands. These vectors have their counterpoints in the chair crest, chest of drawers, and baseboard that gird the composition with vertical and horizontal elements.

Yet in a calculated ambiguity attributable to the artist's pictorial skills, the viewer cannot tell whether Mrs. Stone is a living person who controls the movement of her hands and face, or if these are traces of prior movements in a now-inert body.[21] The decision to clothe her in a burial gown appears to place her squarely among the deceased.[22] But by painting pink highlights on her otherwise pallid skin and by endowing her with a sentient eye, Hanks intentionally obscured whether Mrs. Stone is going through the mysterious transition from this world to the next or has already arrived on the other side. The rendering of her head as a dynamically foreshortened, bone-solid armature of sockets and ridges contributes to this confusion of a clear distinction between life and death and, in turn, to the painting's capacity to proclaim death's defeat.

Because the same theology that enabled adults to assist in their own salvation through free will also fostered anxieties about human beings who died unpracticed in exercising responsibility for themselves,[23] the representation of the Stone twins, who had been baptized, posed a special problem in creating the proper pictorial meaning. The painter's solution was to show the deaths of mother and twins as more or less simultaneous, even though all three died at different times over a span of three months. This imaginative scenario enabled him to link his characterization of the twins with that of their mother, a person whose capacity to enjoy the rewards of eternal life was less open to question.

In these ways Hanks provided the surviving Stones with reassuring claims about their recently departed kin, as well as with a model for the proper way to approach their own lives and deaths. In terms of precedents within the history of art, *Death Scene* combines two types of figural arrangements: the portrait of a dying woman in a moment of spiritual illumination (fig. 6), and the group portrait of a mother who died in childbirth in the company of surviving family members. Although relevant easel paint-

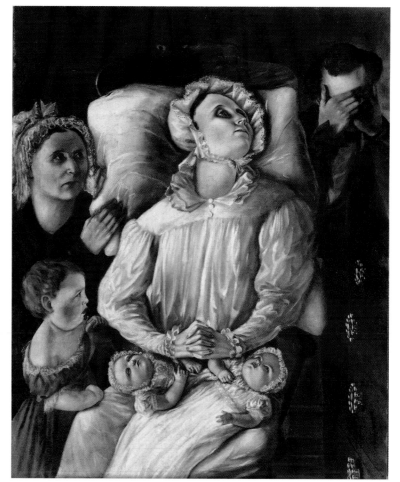

Figure 5. Attributed to Jarvis Hanks, *Death Scene, The Stone Family,* ca. 1840, oil on canvas, 43 x 35¾ in. (109.2 x 90.8 cm). Ohio Historical Society.

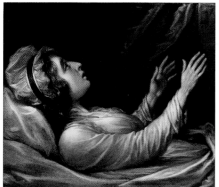

Figure 6. John Trumbull, *Sarah Trumbull (Sarah Hope Harvey) on Her Deathbed,* 1824, oil on canvas, 19⅝ x 24 in. (49.8 x 61.2 cm). Yale University Art Gallery, gift of Joseph Lanman Richards. [not in exhibition]

Figure 7. Allen Smith, Jr., *William Gordon,* 1848, oil on canvas, 33¾ x 26¾ in. (85.7 x 67.9 cm). The Western Reserve Historical Society. [not in exhibition]

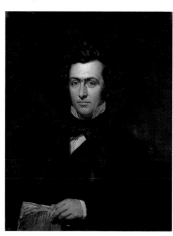

ings exist, both types are most common in English tomb brasses and sculpture groups, formats to which Hanks had no access.[24] On the whole, the rarity of prototypes indicates that the painter arrived at his conception with relative independence from a specific visual source, suggesting that the emotional necessities of new religious beliefs served as the mother of pictorial invention.

In 1842, three years after the article on the portraits in Hanks's studio, the *Herald* ran a paragraph about paintings by Allen Smith, Jr., on exhibition for visitors to his studio: "Our jolly, good-looking collector of Customs figures on canvass large as life and quite as natural, and a popular auctioneer is to be seen in *striking* likeness in everything except *knocking down.*"[25] Rather than promoting himself through a nostalgia-tinged portrait of an early settler, the recently arrived Smith exhibited pictures of progress-oriented men whose work fostered the town's circulation of goods. Placing economic exchange at the center of his public self-definition, Smith overtly bid for the patronage of other successful participants in the town's commercial life and accurately calculated the potential marketplace for portraiture. In 1848, for example, he painted portraits of William Gordon (fig.7), a phenomenally successful wholesale grocer, and his wife during the year that Gordon first served on Cleveland's city council.[26] Smith's portrait of Lucy Bidwell (fig. 8), painted about 1850 when the sitter was thirty-nine years old, demonstrates that an unmarried female business proprietor in Cleveland could also become wealthy enough to commission her own likeness.[27] For two decades following 1837, Bidwell sold fancy goods and millinery from a series of shops, usually on Public Square. Wearing a unique quilted housecoat, she fashions herself as stylishly as the clients whom she served. The diaper pattern dominating the portrait's opulent frame repeats

the quilting design to create a carefully coordinated ensemble based on values similar to those that made Bidwell so accomplished in her field.

In contrast to many who painted for the community, Smith placed easel painting at the center of his practice from the time he first arrived.[28] While his mainstay was portraiture, he also produced genre scenes, a type of painting that he first practiced when training at the National Academy of Design in New York City in the early 1830s. Over the next two decades, Smith painted at least fifteen works of this kind.[29] Several featured children, but the sole surviving example demonstrates his commitment to exploring adult issues. Painted the same year as his portraits of the Gordons, *The Young Mechanic* (fig. 9) explicitly raises questions about the nature of class structure and social opportunity in Cleveland.

The painting depicts two boys of similar age and intelligence but whose rank could not be more different. The wealthy boy, identified by his new suit and straw hat, holds a miniature boat—perhaps a toy or a model for a full-size boat—while the skilled manual worker (or "mechanic" as they were called at the time) sits barefoot among wood shavings. The dilapidated room suggests the mechanic's relative poverty, yet in order to get anything built, the wealthy boy must pay a visit. Another sign of the laboring boy's power is his neglect or refusal to rise in respect. As if allegorical figures of capital and labor, the two eye each other across the foreshortened worktable.

At right angle to this standoff is the direct relation that the composition fosters between mechanic and viewer. The working boy's face promotes empathic engagement with his situation. The table projecting to the right defines a point of view on the left side of the painting, literally and perhaps figuratively "on the mechanic's side." As if the shadow cast into the picture

Figure 8. Allen Smith, Jr., *Lucy Bidwell,* ca. 1850, oil on canvas, 35¼ x 28¼ in. (89.5 x 71.8 cm). The Western Reserve Historical Society.

Figure 9. Allen Smith, Jr., *The Young Mechanic,* 1848, oil on canvas, 40¹⁵⁄₁₆ x 32³⁄₁₆ in. (102.2 x 81.7 cm). Los Angeles County Museum of Art, gift of the American Art Council and Mr. and Mrs. J. Douglas Pardee.

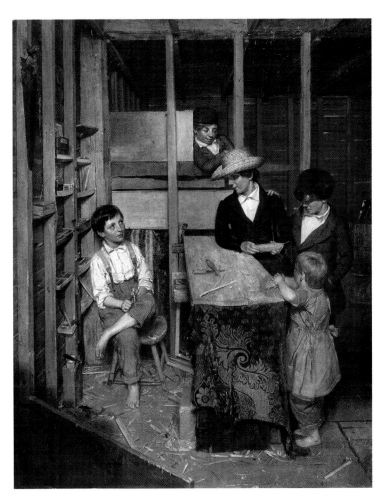

from outside the lower left corner were the viewer's own, entering into pictorial space would only require passing through the low gate.

The painting indirectly registers Smith's concern about the kind of dependent relationship that existed between himself and wealthy men. As a seeker of portrait commissions, he had to rely upon the vagaries of potential sitters seeking out his studio. The dynamics of mutuality structuring his genre scene turns a similar spatial liability into a symbolic asset. In addition, the painting's attention to the materiality of things suggests that Smith recognized and claimed a kinship between the mechanic's work and his own. Pieces of wood rendered in depth as well as parallel to the picture plane cram the composition, each revealing its grain and offering evidence of its construction process. A length of frayed ingrain rug (a common household textile) has been adapted from its normal use as a floor covering to decorate the table's end. The absence of well-established institutions and social practices in Cleveland promoting the idea of the fine arts as an elevated endeavor establishes a context for interpreting woodworking as a metaphor for the craft of easel painting. Appropriately, comments on Smith's painting when it appeared at New York City's American Art-Union drew attention to how it was painted: "The 'Young Mechanic' is a most careful and truthful interior of a carpenter's shop, with figures." "Every part is executed with the most commendable observation of nature."[30]

Providing a national constituency of lottery subscribers with a steel engraving each year as well as with an annual chance to win a painting between 1839 and 1852, the American Art-Union served as a vehicle for accommodating middle-class desires about art ownership to democratic ideals of social organization. Given his painting's egalitarian identification of the origin of personal tensions in class-based social divisions, Smith carefully matched his subject matter with his exhibition venue and perhaps created his canvas with that forum in mind.

Keyed to concerns widespread throughout the United States at the time, *The Young Mechanic* nonetheless originated in local circumstances that New York viewers could not have recognized. As the *Elyria Republican* complained in 1837: "For our part, we have no hope of Cuyahoga county . . . she has a central aristocracy composed of capitalists, rag barons [paper mill owners], and speculators, that contaminates the whole political atmosphere."[31] Obviously biased by a spirit of competition, this regional perspective still provides some insight into the characteristic links between Cleveland's financial and political orders. In a development parallel to the disgust registered by the newspaper of a rival region, efforts to raise the lot of skilled manual workers resulted in the organization of a mechanics' lyceum in the early 1840s to offer lectures and foster group solidarity. Painted in a city whose economic base was shifting from shipping and manual skills to manufacturing and banking, Smith's picture of a static face-off suggests how some people worried that social mobility might become a thing of the past because of an institutionalized gap between classes. Rather than proposing any solution to this dilemma, however, the painting only sets it forth in memorable visual terms.

In addition to selling a canvas to the Art-Union in 1848, Smith painted a suite of six portraits of the founding teachers of the recently established medical department of Western Reserve College.[32] Whether the department took the initiative to commission these portraits as a means of celebrating the distinguished faculty it had collected or the painter prompted the enterprise, this exceptional early instance of institutional largesse in Cleveland offered Smith an alternative to dependence upon individual purchasers. While Hanks also identified a source of income in this new re-

source within the city, he conceived of it in terms of traditional transactions between painter and patron. "Medical students who are about to leave the city to commence practice would do well to see Hanks and Howlett, sign painters."[33]

Like other portrait painters practicing in the 1840s, Hanks and Smith had to compete with the great promises to improve the speed and accuracy of making likenesses that accompanied the advent of photography in 1839. A newspaper notice from just two years later indicates how quickly entrepreneurs aligned the new technology with expectations traditionally linked to painted portraits. "All bachelors, at least, should visit Mr. G[arlick], and thus not entirely deprive posterity of a little image of their noble selves."[34] Photographic products such as daguerreotypes and ambrotypes required special equipment, technological expertise, and conceptual skills, which led to the rapid professionalization of photographers and to the occasional promotion of their reputations in lofty terms.

With the dissemination of the hybrid technique known as "photograph painting" around the middle of the 1850s, a niche opened for painters to participate in all the excitement. One notice from 1855 refers to "a life size photograph, colored by Smith" as "a perfection of portraiture."[35] One decade later, on the occasion of the storefront exhibition of a portrait of lawyer Franklin Backus (probably fig. 10),[36] a newspaper writer considered the process still sufficiently unknown to warrant description:

> This portrait is from the studio of North and Schwerdt, of this city, and is properly a colored photograph, although it seems a painting. The face is first thrown upon canvass by a camera, and the contour is thus obtained with distinctness, when the brush follows with the lifelike coloring.[37]

Figure 10. Attributed to Allen Smith, Jr., and William North, *Franklin Backus,* ca. 1865, oil on canvas, 64 x 54½ in. (162 x 138 cm). Case Western Reserve University School of Law.

While not explained in the article, people often treated canvases with chemicals so photographic negatives could be printed on them, enabling painters to work from fixed designs in well-lit rooms.[38] Just who painted the unsigned portrait of Backus is not resolved by the article's mention of photographer William North and painter Christian Schwerdt's studio. The stylistic similarity between this photograph painting and autograph works by Smith such as his portrait of Lucy Bidwell suggests that painters sometimes worked anonymously in studios run by photographers.[39] During North's long tenure in Cleveland from 1851 into the late 1870s, he worked with several painters, including Alonzo Pease, the painter of the disguised slave in Oberlin.[40]

Figure 11. Archibald Willard, *Minnie Willard,* ca. 1860, oil on canvas, 38³⁄₁₆ x 26⅛ in. (97 x 66.4 cm). The Cleveland Museum of Art, gift of John R. Wherry in memory of John Willard Wherry.

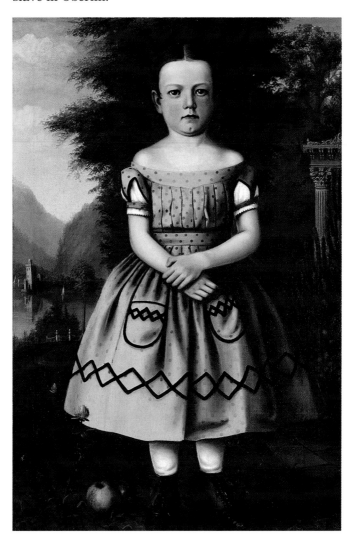

Figure 12. Alonzo Pease, *Lydia Pease,* ca. 1860, 36¾ x 29¼ in. (93.3 x 74 cm). Oberlin College Archives. [not in exhibition]

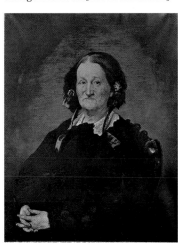

Photography probably figured into the practices of regional portrait painters in several different ways. Judging by the strong areas of well-drawn and crisply defined shadows in Archibald Willard's portrait of his niece Minnie Willard (fig. 11), he most likely based that painting directly on a photograph. Perhaps a photograph also served Pease as a model for a portrait of his mother, Lydia (fig. 12). The trace of a grid that has become visible through the canvas's delicately painted, now-translucent flesh tones reveals that the artist employed the traditional device of squaring for transfer. Conventionally used to ensure that complex designs initially worked out in small studies would be accurately copied onto large surfaces, this method could have helped Pease recreate the proportions of the face.

ART AND RANK: SITTERS, AMATEURS, AND PROFESSIONALS

Figure 13. Julius Gollmann, *An Evening at the Ark,* 1859, oil on canvas, 38 x 54 in. (96.5 x 137.2 cm). The Western Reserve Historical Society.

IN AN EXAMPLE OF CONTINUITY within painting practice, the German emigré Julius Gollmann drew separate pencil studies of fourteen sitters as the basis for perhaps the most ambitious group portrait ever made in Cleveland, *An Evening at the Ark* (fig. 13).[41] Using oil paint to copy these studies to a large canvas, Gollmann composed his figures in a room whose visual drama comes from three interior light sources: a gas lamp, a fireplace, and a burning piece of wood used to light a cigar. The painting represents a group of amateur naturalists organized in the mid-1830s under the aegis of William Case. They met in a building jokingly dubbed "The Ark" that Case owned on Public Square. Early on, the Arkites opened their collection of natural history specimens to public view, but after the found-

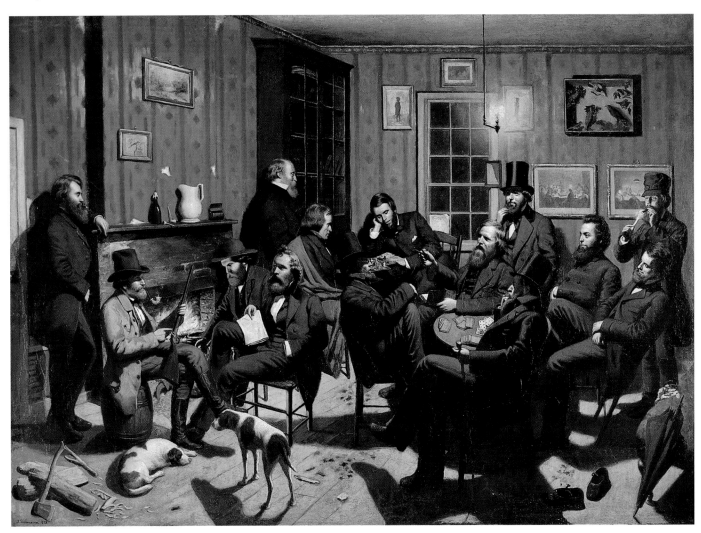

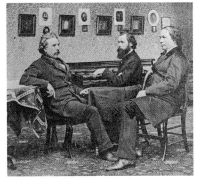

Figure 14. William Gordon, William Case, and Allen Smith, Jr., ca. 1859. The Cleveland Museum of Art Archives. [not in exhibition]

ing of the Cleveland Academy of Natural Sciences in 1845, the group's mission drifted toward providing members with a recreation forum.[42] Case exercised nearly boundless civic zeal in other arenas during subsequent years, serving two terms as mayor in 1850–52. In the late 1850s, he posed with businessman William Gordon and painter Allen Smith, Jr., in a photograph (fig. 14) that emblematically represented his centrality to the best of what Cleveland had to offer in the realms of commerce (Gordon at left) and the fine arts (Smith at right).[43] Around the same time, having commissioned Gollmann to commemorate the Arkites, Case acquired a pictorial vehicle for advancing that group's prestige.[44]

The men depicted in *An Evening at the Ark* boldly proclaim possession of social stations that in no way depend upon adherence to the genteel arts of deportment and housekeeping.[45] The poses tend toward rudeness (fig-

ures slouch or sit with knees raised above their waists, one tilts a chair back on two legs) and the room and its appointments grimy and messy (the wallpaper above the mantle is peeling off, wood scraps litter the floor, a spring protrudes through the worn couch at right). Propriety in such matters might be important to upwardly mobile men of lesser standing, but not to the Arkites. Rather, their bohemian self-presentations signal their identities as already-improved, profoundly refined people who can afford to appear in moments of leisure. Conspicuously exempted from the room's disarray, however, are the Arkites' immaculate suits. Free of creases, stains, and wear, these extensions of the figures' bodies connote a Christian model of cleanliness in order to suggest the sitters' status as their society's elect.

Through this artifice, the painting absorbs and unifies the dichotomous tensions that structured and animated *The Young Mechanic.* By demonstrating its sitters' capacity to invert and control conventional attributes of social class, the painting declares their social power. Looking out of the picture space with paper in hand, Case appears as the group's architect. Explicitly presented as doing nothing, he implicitly conveys his visionary role among a collective of leaders in society, business, and military service.

The mid-century link between art and social status articulated itself in many ways in Cleveland. From the mid-1830s until the late 1850s, a steady trickle of opportunities existed for men and women to become lady and gentleman amateur artists. Most art lessons centered on technique. While Mr. and Mrs. Honfleur offered only drawing lessons, Hanks, Miss Crosby, Alfred Boisseau, Miss Noble, Josiah Humphrey, and Miss Fox taught both drawing and painting.[46] Occasional opportunities to learn about watercolor, monochrome painting, and mezzotint, as well as perspective drawing, also existed.[47] Other lessons centered on such approaches to subject matter as flower painting, drawing from nature, and landscape drawing.[48] On the wall above the fireplace in *An Evening at the Ark* hangs a watercolor of a bird, possibly a replica of the Kentucky warbler that Case had painted and included in an exhibition of Arkite renderings of natural history specimens.[49] In contrast to, for example, the pay-per-view show that Thomas Stevenson held of his pupils' work in a rented space in the Commercial Buildings in 1842, the Arkites' capacity to hold an exhibition in their own quarters announced their firm position atop Cleveland's social hierarchy.[50]

In 1860 a question raised in the press over access to the activities of a new organization called the Cleveland Sketch Club brought to the fore art's frequent, yet often unarticulated exclusivity. The club met in members' homes or, in the case of club president and sculptor William Walcutt, in an artist's studio. To each meeting, every participant would bring a sketch based upon a predetermined topic.[51] Yet just after word of the club reached the public ear, the Cleveland *Daily Review* published a complaint that the club "wears somewhat of a conservative air to outsiders. Many a friend of art, or adept at the pencil, would like to lend a hand if there were a room in common for the club, instead of putting each member to the inconvenience of a *conversation* at home." Responding as if club representatives, the editors of the *Leader* parried with the declaration that members preferred private homes so that "meetings may wear more of a social air and be more truly a *conversazione.* It is not intended for a public exhibition, and 'friends of Art,' or 'adepts at the pencil,' must furnish an original sketch as a warrant of their fitness for membership."[52] Eventually, unofficial city sponsorship of a different group in 1876 would go some way toward opening access to a social organization devoted to creating works of art.

With regard to the economics of viewing, many and varied relations existed between patrons, painters, and audiences in Cleveland at mid-century. Reprising the theme of altruistic public display that the Ark initiated with its natural history museum and watercolor exhibition, *An Evening at the Ark* appeared at the newsdealers Hawks and Brothers in 1859. In this instance, however, public betterment did not come about only from seeing the exhibition, for the showing raised money to benefit an unspecified "Home for the Sick and Friendless."[53] This accomplishment of good works through an exercise in noblesse oblige on Case's part offers a defining complement to the world of the painting in which hardly a single figure lifts a finger.

Other portraits appeared in shop windows free of charge, appealing to viewers for whom the sitter was at least as important as the photographer or painter. Such a hierarchy of values underlies the previously mentioned problem with attributing the photograph painting of Franklin Backus. By contrast, the sitter's reputation as a lawyer would have determined his picture's popular reception in 1865. Perhaps his best-known argument resulted in the appointment of a new jury for the remaining defendants of the Ohio-Wellington Rescue trial after one of their number had been found guilty.[54] For viewers just before the conclusion of the Civil War, the sight in a frame maker's window of the portrait of a man firmly associated with the cause of abolition presented an icon of social ideals around which to rally.[55] Arms held behind his body lending him a slight forward arch, face looking resolutely into the distance, the figure of Backus could also have embodied the idea of perseverance that further progress would require.

Perhaps more than any other private individual in Cleveland during the nineteenth century, banker Truman Handy paid for portraits to keep himself in the minds of his contemporaries. Commissioned over a lifetime that lasted from 1807 to 1898, his likenesses by Hanks (1838, Western Reserve Historical Society), Caroline Ransom (1893, Western Reserve Historical Society), and F. W. Simmons (1896, Western Reserve Historical Society) span the nineteenth-century history of local portraiture. Handy also represented himself in 1860 as a benefactor of the recently founded Young Men's Christian Association, giving that institution a now-lost, life-size portrait of himself by one E. D. Howard.[56]

Using the old public relations ploy of painting a portrait at one's own expense, Pease and Ransom exhibited their likenesses of former Ohio congressman Joshua Giddings in, respectively, an Oberlin store during 1859 (fig. 15) and a Cleveland studio during 1861 (fig. 16).[57] Giddings had served in Congress until his health failed in 1858 but remained active in state affairs. Pease and Ransom, by promoting themselves in terms of this vet-

Figure 15. Alonzo Pease, *Joshua Giddings,* 1859, oil on canvas, 53 x 40 in. (134.6 x 101.6 cm). The Western Reserve Historical Society. [not in exhibition]

Figure 16. Caroline Ransom, *Joshua Giddings,* ca. 1859, oil on canvas, 39½ x 31½ in. (100.3 x 80 cm). U.S. Capitol, courtesy Architect of the Capitol. [not in exhibition]

Figure 17. Caroline Ransom, *Charles Whittlesey,* 1876, oil on canvas, 29½ x 24½ in. (74.9 x 62.2 cm). The Western Reserve Historical Society.

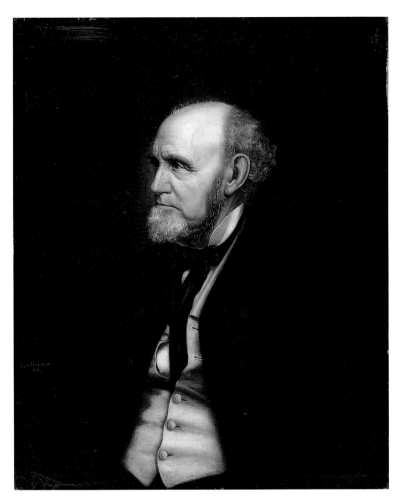

eran politician, linked themselves with antislavery reform and with the region's political identity. Ransom also had social aspirations, and in 1866 her studio was the site of an evening's entertainment of solos and duets that ladies and gentlemen attended "by invitation."[58] Through her acquaintance in the mid-1860s with Civil War officer and future president James A. Garfield, Ransom managed to forge a link between her career and national politics. In 1866 the portrait of Giddings she had shown in Cleveland became the first work of art by a woman acquired by the federal government, purchased for $1,000 from an appropriation to the Joint Committee on the Library for decorating the Capitol in Washington, D.C. Even though Ransom moved to Washington in the mid-1870s, she returned to Cleveland every year, producing a portrait of geologist Charles Whittlesey on one such trip (fig. 17).

PAINTING AS A MASS MEDIUM

IN TERMS OF THE RELATIONS between paintings and audiences, the practice of paying to see enormous canvases taken on national tours by artists and other entrepreneurs offers the most telling mid-century development in local viewing experiences. Beginning in 1840, a large painting made its way to Cleveland about once a year. Rembrandt Peale's *Court of Death* (1820, Detroit Institute of Arts), for example, arrived in 1847 while on a tour that began in New Haven and went to Hartford, Boston, Troy, Auburn, Geneva, Rochester, Buffalo, and then crossed Lake Erie to Detroit before arriving in Cleveland. Subsequently, the painting went to Pittsburgh, Cincinnati, Louisville, St. Louis, Mobile, and New Orleans.[59] While there were few local easel painters at any point during the 1840s, 1850s, and 1860s, there were nonetheless many paintings to see.

This trend dovetailed with the practice of spending hours at the exhibition of panoramas—canvases hundreds of feet long that work crews gradually scrolled from spool to spool across rented theater stages. Some of these paintings represented current events such as the Mexican War (1848) or passage to California for the gold rush (1849).[60] Because of the many homesick potential customers created by the Irish potato famine immigration starting in the late 1840s, numerous panoramas—including one in 1866 called the *Hibernicon*—featured Ireland.[61] Entrepreneurs showed relatively recent fires and wars that lent themselves to special polemical or pictorial interest: the conflagration of Moscow (1812), the wars for liberty in Italy and Hungary (1848), the bombardment of Sebastopol (1854–55), the Crimean War, (1853–56), the burning of Chicago (1871).[62] While the people who ventured to such showings could experience the local pleasures of seeing a "seven-mile mirror" of the Great Lakes or a panorama of Cleveland, they could also enjoy exotic travel panoramas featuring Niagara Falls, the Hudson River, New York City, the European continent, Italy, the Mediterranean shores, Jerusalem, and the Arctic.[63] Viewers could take an ocean voyage to Europe, travel on a whaler, or get a glance at the whole world.[64] Panoramas devoted to national and sacred literature presented scenes from the Bible, *Paradise Lost, Uncle Tom's Cabin,* and *Pilgrim's Progress.*[65] Some panoramas commemorated modern men: the murder of Joseph Smith, the funeral of Napoleon, Pilgrims and Revolutionary Fathers, and the life of Lincoln.[66] There was even a panorama on oil regions shown in 1865, the year John D. Rockefeller stopped working for commission merchants to devote his full attention to oil.[67] One wonders about the influence that such a vast representation of seemingly limitless resources might have had upon the ambitions of this shrewd and enterprising twenty-six-year-old.

The Civil War—subject of several panoramas, including one by sometime portraitist and future figurehead of Cleveland's artistic community Archibald Willard[68]—spurred a sense of historical self-consciousness in the city. As war loomed, people searched for precedents to help them to make sense of the identity-threatening crisis that endangered their country's existence. For this reason, around 1860 many men and women participated in the creation of public symbols representing themes from the War of 1812.[69] A resounding victory over its former mother country that defined the United States as a world power, the war offered citizens a confidence-bolstering image to contemplate in a time of despair. This was the moment when the city commissioned sculptor William Walcutt to create the Perry Monument representing Commodore Oliver Hazard Perry, the hero of the Battle of Lake Erie. Officials dedicated the statue at the center of Public Square on 10 September 1860 (see fig. 203), soon renaming the square Monumental Park in its honor. The next year, Ransom painted for a militia company called the Perry Light Infantry a banner that bore the hero's portrait.[70] A few years earlier, she had painted landscapes of Perry's Lookout, the site on Gibraltar Island from which Perry had watched British movements, and of Put-in-Bay on South Bass Island, the burial place of three American and three British officers following the Battle of Lake Erie.[71] In 1860 the event associated with the latter site prompted Louis Chevalier, former Cleveland partner of townscape painter Sebastian Heine and current resident of Erie, Pennsylvania, to create a history painting (fig. 18).

Chevalier appears to have been inspired in his choice of subject by a published address given by Dr. Usher Parsons, former surgeon of the American ship *Lawrence* and witness to the events at Put-in-Bay. After describing the hasty burial in the deep of the lake given to most of the forty-

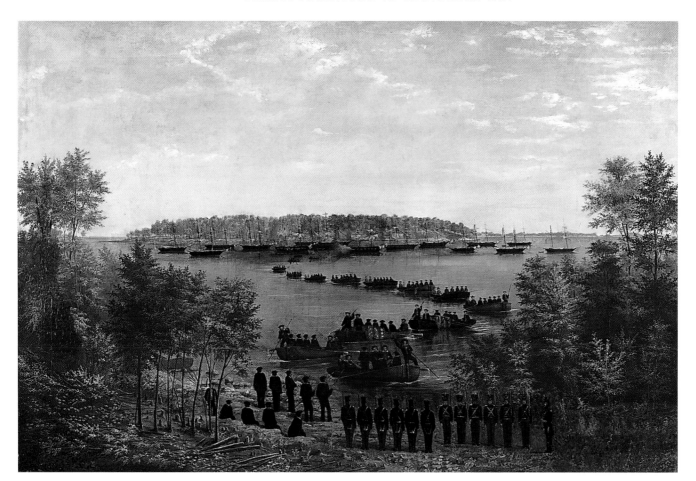

Figure 18. Louis Chevalier, *Burial of the Officers Slain at the Battle of Lake Erie, September 10, 1813,* 1860, oil on canvas, 35 x 53 in. (88.9 x 134.6 cm). The Western Reserve Historical Society.

one British and twenty-seven Americans killed at the Battle of Lake Erie, Parsons noted:

> On the following morning the two fleets sailed into this bay where the slain officers of both were buried in an appropriate and affecting manner. They consisted of three Americans . . . and three British officers. . . . Equal respect was paid to the slain of both nations, and the crews of both fleets united in the ceremony. The procession of boats, with two bands of music, the slow and regular motion of the oars striking in exact time with the notes of the solemn dirge, the mournful waving of flags and the sound of minute guns from the ships, presented a striking contrast to the scene presented two days before, when both the living and the dead, now forming in this solemn and fraternal train, were engaged in fierce and bloody strife, hurling at each other the thunderbolts of war.[72]

While Chevalier's imaginative sense of two-dimensional design generated the "solemn and fraternal train" that winds across the midground like a swath of funeral bunting, he strove for accuracy in his representation of the background ships, submitting by mail sketches to Parsons as well as to *Scorpion* sailing master Stephen Champlin, captor of the British ship *Queen Charlotte*.[73] With its minute images of the slain officers' flag-draped coffins in the third and fourth boats closest to the shore, Chevalier's canvas not only honored the dead but also reminded viewers of the sacrifices that war entailed. In this way, he contributed to his contemporaries' preparation for the work of mourning that, if there was war, would surely come into their collective and personal lives.[74]

CLEVELAND'S SPARSE LANDSCAPE PRODUCTION at mid-century during the heyday of the Hudson River school suggests how an appetite for making such pictures had not swept throughout the United States.[75] Visitors to the show window of Sargeant's frame shop could see Louis Rémy Mignot's *Sunset in the White Mountains* (1861, Fine Arts Museums of San Francisco), but that painting had been imported from New York City and had no local progeny.[76] The only known pastoral scene to have been produced in Cleveland (fig. 19) clarifies the atypicality of local interest in landscape painting, for Harvey Rice—its early owner and perhaps its patron—had an exceptional relationship to local lands.[77]

Rice began his lifelong career as a public servant representing Cuyahoga County in the state legislature. His appointment in 1831 as agent to sell 56,000 acres of Western Reserve land for the state school fund resulted in $150,000 going to subsidize instructing the region's young. In *The Sunny Bank (Kingsbury Run),* painted during Thomas Stevenson's second Cleveland period, the cattle grazing in the verdant ravine running between Warrensville Heights and the Cuyahoga River give the scene a utilitarian dimension. As direct recipients of the land's yield and as agricultural products themselves, they attest to nature's beneficence. Looking at this imagery, Rice may have considered Kingsbury Run's value in his capacity as a private citizen, for he owned land along it. But the painting would also have engaged him in his role as a promoter of the common good, because in his experience undeveloped land could initiate a causal sequence leading to abundant cash and then to improvements in public education. His painting thus represented Cleveland as a land of several varieties of plenty.

Unlike landscapes, paintings of local waterways were as numerous as townscapes. Sometime during George Clough's first stay in the city between 1862 and 1865, he used this kind of subject to pay tribute to Cleveland as a center of transportation and commerce (fig. 20).[78] In the lower right he pictured the Ohio canal from a vantage point on the eastern shore of the Cuyahoga at the base of what is now West 3rd Street; the building is a weighhouse erected in 1851.[79] A canal boat in the process of being weighed appears inside, while the horse that will draw it inland waits on the nearby bank. Counterposed to this right-to-left movement is the sequence of three paddle-wheel steamboats in different stages of completion on the far shore. In this way, Clough instilled his topographic view with rhythms primed to the progressive ideals that were making Cleveland into a city. Yet with the inexorable challenge of the railroads, canal use had gradually declined during the 1850s. While the canal side of the painting has but a single smokestack, the belching fumes across the river indicate both the concentration of factories on the city's west side and the status of manufacturing as the promise of future economic success.

Smith's ambitious view of Public Square (fig. 21) embraces the conceptual span defined by the paintings by Stevenson and Clough while registering the impact of entrepreneurship on local ideals of social participation in the thirty years since Joseph Parker's view of Public Square (see fig. 1). A comparison with Parker's painting may, in fact, have been intended. Smith made his canvas the same year that the newly founded Western Reserve Historical Society acquired Parker's painting. Both are similar in size, and both represent a vantage point from the second floor of the building occupying the southwest corner of the square (see the Cleveland city plan, p. 5).[80] While these points establish a basis for comparison, Smith challenged the conception of communal life championed by Parker with a program that promotes individualism.

Figure 19. Thomas Stevenson, *The Sunny Bank (Kingsbury Run),* ca. 1865, oil on canvas, 28½ x 35½ in. (72.4 x 90.2 cm). The Western Reserve Historical Society.

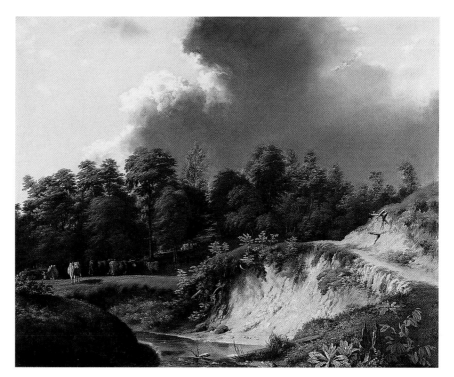

Whereas the town may be said to master the viewer in the early painting, the viewer masters the city in the later canvas. No architectural symbol dominates Smith's scene: the second First Presbyterian Church (begun in 1853) stood beyond its left edge and the Second Court House was razed sometime after 1858. Rather, the drama of the painting derives from its pictorial space: barreling swiftly into the middle distance, the vista of the street defining the square's south side cleaves the composition in two. The shadow created by the late afternoon sun behind the hotel sweeps from the bottom edge of the painting diagonally across the street and up a facade. Although the shadow is specifically the trace of a building, it simultaneously suggests the presence of a human body—albeit monumentalized—in front of the picture plane. In contrast to Parker, Smith depicted neither mirroring counterparts to his viewer nor a defining civic institution. The viewer's commanding gaze is a solitary one. The probability that Smith's picture is a photograph painting suggests profound links between the

Figure 20. George Clough, *Weighhouse on the Ohio Canal, Cleveland,* ca. 1863, oil on canvas, 19¾ x 29¼ in. (50.2 x 74.3 cm). The Western Reserve Historical Society.

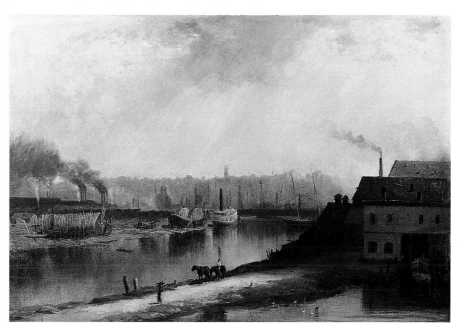

promulgation of individualistic ideologies and the then-novel proliferation of images made using camera lenses.

The historic shift from a communal to an individualistic aesthetic that determined these different ideal visions of the square has a precise correlate in the financial circumstances that brought the paintings into being. While Giddings commissioned Parker to paint his scene as a gift for a civic militia, Smith made his painting as an independent commercial venture for the marketplace. The year after he created it, the minutes of the Western Reserve Historical Society recorded: "It was hoped that some of our wealthy citizens would have procured and placed in the Society Rooms Mr. Smith's valuable painting of the Public Square as it appeared in 1869. Let us indulge the hope that at some future time it will find its way to our rooms."[81] Eventually, in the course of his successful law practice in Cleveland, former state supreme court judge Rufus Ranney acquired the painting.[82] Citizens like Ranney who acted in a public capacity could find on this canvas a pictorial complement to how they thought about their relationship to the city, inasmuch as its design cultivates the feeling of mastery that facilitates independent actions. This is not to say that the individualism given form in the 1869 view of the square was not compatible with the city's betterment. Rather, the change from the early to the later

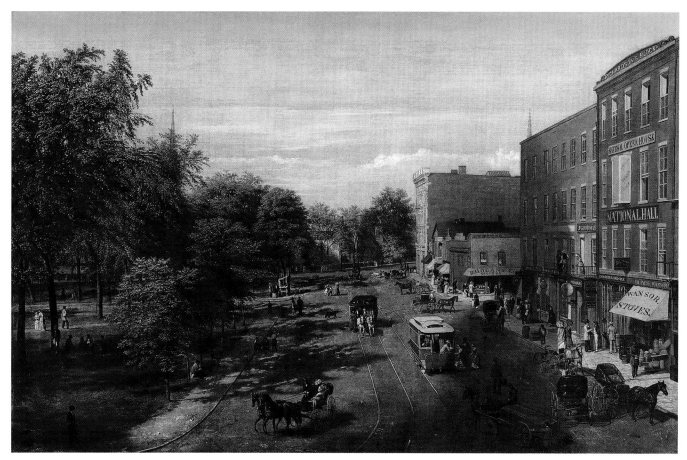

Figure 21. Allen Smith, Jr., *Cleveland Public Square,* 1869, oil on canvas, 40½ x 63½ in. (102.9 x 161.3 cm). The Western Reserve Historical Society.

views signifies the development of a belief that the common welfare depended upon solo rather than collective initiative.

Commercial life defined in individual terms percolates through the right side of the painting. In Cleveland as in other cities, people often referred to a block by the name of the property owner responsible for its development. Richardson's Block, denoted in letters filling a scrolled cornice at the block's center, announces the name of the individual responsible for that civic venture. The business activities of Wansor Stoves spill out far

onto the sidewalk. In some way, that private concern encroaches on public space, yet in terms of the daily experience of pedestrians, it only contributed to a sense of the thorough integration of private and public spheres. So fully did businesses dominate the square in the late 1850s that the new courthouse had to be sited elsewhere.

By choosing a view with trees on the left and buildings on the right, Smith created a composition that succeeds as a rebus for the "Forest City." With this verbal formulation as well as its imagery, the painting promoted the slogan coined to help shape a coherent image for the rapidly changing city. The concerted program of tree planting generally associated with William Case's terms as mayor (1850–52) necessarily included Cleveland's symbolic center. Many commercial enterprises—including the hotel whose view Smith depicts—adopted the phrase. A comparable imposition of an

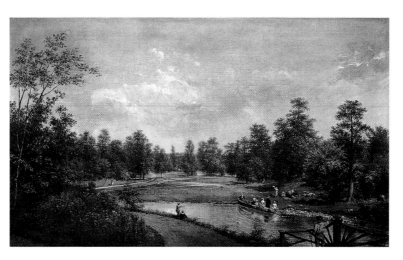

Figure 22. Allen Smith, Jr., *Picnic at Gordon Park,* ca. 1877, oil on canvas, 35 x 51 in. (88.9 x 129.5 cm). The Western Reserve Historical Society. [not in exhibition]

urban-pastoral ideal occurred in 1861, when the city council dubbed that space Monumental Park. Smith later abridged this official name when titling the canvas *The Park, in 1869.*

Around 1877 Smith gave form to his ambivalence about the varied fruits of economic prosperity that had come to structure city life in the three and a half decades since his arrival in Cleveland. *Picnic at Gordon Park* (fig. 22) depicts land that former patron and lifelong businessman William Gordon had begun to buy in 1865 and whose development led to it being called "one of the most exquisite private grounds in the country. It is a beautiful tract of land on the shore of the lake, where hundreds of men have been employed in beautifying it with walks, drives, grottoes and bowers."[83] Gordon opened the park to visitors every week, and Smith took advantage of one of those occasions to paint it at his own expense.[84]

Similar to *The Young Mechanic* (see fig. 9) in its concerns with the working class, *Picnic at Gordon Park* differs from that early work in its representation of the fruit of economic individualism rather than of troubled collectivism. Smith's spirited empathy with manual workers had prompted him to divide the first painting equally between a mutually acknowledging worker and a patron. Three decades later, however, he placed a laborer with shovel in hand in a compositionally marginal position. This low pictorial status does not seem entirely unwarranted, for he is not a specialized artisan-entrepreneur but rather one of the hundreds of unskilled wage earners who built the park. Standing in a place owned by and named for Gordon, the poor man has toiled on the rich man's turf and terms and now stands alienated from the products of his labor.

Yet, like other paintings produced in Cleveland on either side of the divide occasioned by the Civil War, *Picnic* strove to play an active role in con-

stituting the city's mental culture. While the social betters toward whom the laborer gazes predicate their enjoyment of leisure activities upon forgetting about all forms of labor, Smith stubbornly refused to render the worker and his work invisible. By incorporating that viewer, the painter not only asserted the crucial difference between Gordon Park and uncultivated nature, but also drew attention to how his depiction of the world is not neutral. Once again, he demonstrated the inextricable relationship between representation and having a point of view.

NOTES

1. *Oberliniana: A Jubilee Volume of Semi-historical Anecdotes Connected with the Past and Present of Oberlin College* (Cleveland: Home Publishing, 1883), 28–29. The late 1850s were active years for the Underground Railroad in Oberlin. Pease was in both Oberlin and Cleveland during 1858, the year of the Oberlin-Wellington Rescue.

2. Edmund H. Chapman, *Cleveland: Village to Metropolis: A Case Study of Problems of Urban Development in Nineteenth-Century America* (Cleveland: Western Reserve Historical Society and Press of Western Reserve University, 1964), 5, 10, 22.

3. The Cleveland House is visible to the right in Heine's painting.

4. D. W. Cross, "The Log Book. II. Cleveland Grays—The Presentation of the Flag." *Magazine of Western History* 8 (May 1888): 8. Cross was a Cleveland Gray in 1839, so his article is actually a reminiscence. Parker's first name is mentioned in the Western Reserve Historical Society (WRHS) annual report of 1869, reprinted in D. W. Manchester, "Western Reserve Historical Society, Cleveland, Ohio," *Magazine of Western History* 7 (February 1888): 382. Because of the similar conceptions evident in Parker's and Heine's paintings, the latter, undated canvas has often been assigned a date of 1839. A more reasonable proposal is about 1845, however, because that year Heine made his first appearance in the occasional, often annual, list of local residents called the city directory. It is unlikely that he made his canvas much later as the Cleveland House, visible at right, burned down in 1845.

5. "The design and execution of the Standard are worthy the reputation of Mr. J. F. Hanks as an Artist. On a ground of light azure appears on one side an encampment of the GREYS—on the opposite, the arms of the State of Ohio. It is richly decorated, and when borne through our streets yesterday, the frequent exclamations of 'splendid!' 'generous!' 'admirable!' passed deserved compliments on Artist, Donor, and the corps proudly marching beneath its waving folds" (*Daily Herald and Gazette* [23 May 1839],

2). One of the Grays present at this occasion, Colonel A. S. Sanford, donated the view of Public Square to the WRHS; the banner has not survived.

6. Cross, "Log Book," 8.

7. Elijah Peet, *Peet's General Business Directory of the Cities of Cleveland and Ohio, for the Years 1845–46* (Cleveland: Sanford and Hayward, Printers, 1845), unpaginated.

8. For Mott's drawing, see Edward Deming Andrews and Faith Andrews, *Visions of the Heavenly Sphere: A Study in Shaker Religious Art* (Charlottesville: University Press of Virginia, 1969), 114; Daniel W. Patterson, *Gift Drawing and Gift Song: A Study of Two Forms of Shaker Inspiration* (Sabbathday Lake, Maine: United Society of Shakers, 1983), 95. For gift drawings, see Sally M. Promey, *Spiritual Spectacles: Vision and Image in Mid-Nineteenth-Century Shakerism* (Bloomington and Indianapolis: Indiana University Press, 1993).

9. By far the earliest portrait painter known to have practiced locally was Samuel Dearborn, who after working in Pittsburgh stayed from about 1807 to 1809, and then moved to Lexington, Kentucky. Alvah Bradish numbers among the many other painters who came and departed in short order, leaving barely a trace. Having practiced in Rochester, he worked in Cleveland in 1836 and again in 1840 before eventually settling in Detroit in 1852. For Bradish in 1836, see Eckstein Case to Frederic A. Whiting, 17 October 1919, Cleveland Museum of Art Archives; for 1840, see *Cleveland Herald* (8 June 1840), 3. Case Western Reserve University owns his *Leonard Case, Sr.* (1836).

10. *Cleveland Herald* (14 October 1825), 1.

11. During the same period, Hanks painted a banner for the City Guard commissioned by "the Ladies of Cleveland" (*Daily Herald and Gazette* [5 July 1839], 3).

12. *Daily Herald and Gazette* (13 January 1838), 2, and (2 March 1838), 2.

13. *Daily Herald and Gazette* (6 May 1839), 2.

14. *Cleveland Daily Herald* (4 September 1840), 2, advertised Hanks's availability for music lessons, while the *Daily Herald and Gazette* (19 February 1841), 2, announced that he "has returned from his southern visit." For evidence of similar trips before and after the winter of 1840–41, see *Daily Herald and Gazette* (17 April 1839), 2; *Morning Daily True Democrat* (5 May 1852), 3, refers to "his southern winter tour."

15. Phoebe Lloyd, "Posthumous Mourning Portraiture," in Martha V. Pike and Janice Gray Armstrong, *A Time to Mourn: Expressions of Grief in Nineteenth Century America,* exh. cat. (Museums at Stony Brook, 1980), 85, emphasizes that the canvas "is manifestly not a rendering of an actual event."

16. J. Gardner Bartlett, *Gregory Stone Genealogy: Ancestry and Descendants of Dea. Gregory Stone of Cambridge, Mass. 1320–1917* (Boston: privately printed, 1918), 422–23. See the entry for 2 July 1840 in Nancy Riley, compiler, *Harmar Congregational Church Marietta, Ohio 1840–1855* (Waterford, Ohio: privately printed, 1987), 9: "*Augustus Israel* and *Elizabeth Spencer*—infant children of Augustus I. and Elizabeth C. Stone—*were baptised* at the house of Mr. Stone—Mrs. Stone being very low, and not expecting to live." For references to Augustus Stone's activity in the Commercial and Exporting Company of Marietta, the temperance movement, and the Anti-Slavery Society, see Andrew R. L. Cayton and Paula R. Riggs, *City into Town: The City of Marietta, Ohio, 1788–1988* (Marietta: Marietta College Dawes Memorial Library, 1991), 112–13, 146, 150.

17. In "A Biographical Memoir of Jarvis Frary Hanks. written by himself," unpublished mss., 1831 (Buffalo and Erie County Historical Society), 59, Hanks recalled that around April 1825 he stayed a month in Marietta when "I painted . . . Mr. & Mrs. Sardine Stone of Point Harmer, and some others." Lloyd, "Posthumous Mourning Portraiture," 85, notes that Hanks painted seven Stone family portraits.

18. William Sprague, *Letters on Practical Subjects to a Daughter* (New York: D. Appleton, 1834), quoted in James J. Farrell, *Inventing the American Way of Death, 1830–1920* (Philadelphia: Temple University Press, 1980), 37.

19. My thanks to Virginia Krumholz for this observation. Lloyd, "Posthumous Mourning Portraiture," 85, notes how Hanks's device of situating the babes between their mother's legs manifests their filiation.

20. Hanks, "A Biographical Memoir," 5–6.

21. Philippe Ariès, *Images of Man and Death.* trans. Janet Lloyd (Cambridge, Mass., and London: Harvard University Press, 1985), 247, describes the canvas as showing "the *moment of death*" but also characterizes the mother as "already in the grip of rigor mortis."

22. For a daguerreotype from about 1846 showing a dead woman with a similar white burial gown, see Stanley B. Burns, *Sleeping Beauty: Memorial Photography in America* (Altadena, Calif.: Twelvetrees Press, 1990), pl. 21.

23. Farrell, *Inventing the American Way of Death,* 39, 232 n.70, considers this issue.

24. See, for example, John Trumbull, *Sarah Trumbull on Her Deathbed* (1824, Yale University Art Gallery); John Souch, *Sir Thomas Aston at the Deathbed of His Wife* (1635, City of Manchester Art Galleries). On the former, see Sarah Cohen, "*Sarah Trumbull on Her Deathbed*" in Helen A. Cooper, ed., *John Trumbull: The Hand and Spirit of a Painter,* exh. cat. (Yale University Art Gallery, 1982), 168–69; on the latter, see Judith W. Hurtig, "Death in Childbirth: Seventeenth-Century English Tombs and Their Place in Contemporary Thought," *Art Bulletin* 65 (December 1983): 610–15. A taxonomy of slightly earlier sculpture groups appears in Nicholas Penny, "English Church Monuments to Women Who Died in Childbed between 1780 and 1835," *Journal of the Warburg and Courtauld Institutes* 38 (1975): 314–32.

25. *Cleveland Daily Herald* (16 December 1842), 3.

26. Brief biographies of William Gordon appear in W. Scott Robison, *History of the City of Cleveland* (Cleveland: Robison and Crockett, 1887), 472–75; *Magazine of Western History* 5 (December 1886): 292–302.

27. See Joan J. Bidwell, *Bidwell Family History 1587–1982* (Baltimore: Gateway Press, 1983), 114. Bidwell was born in 1811 in Connecticut.

28. *Morning Daily True Democrat* (21 May 1852), 3, reports the exception of Smith designing a flag.

29. For a list of these paintings, see David Steinberg, "Mr. Smith Goes to Cleveland, and Other Stories," in *Cleveland as a Center of Regional American Art* (Cleveland: Cleveland Artists Foundation, 1994), 12–13 n. 11. The newly discovered *Sheep Washing in the Reserve* (1851, Berry-Hill Galleries, New York) should be added to Smith's oeuvre. Of these paintings, locations are known for only *The Young Mechanic* and *Sheep Washing.*

30. Reviews from *Evening Post* (New York) and *New-York Courier and Enquirer,* reprinted in *American Art-Union Bulletin* 1 (25 November 1848): 29, 36.

31. Reprinted in *Daily Herald and Gazette* (25 August 1837), 2.

32. Smith also sold paintings to the Art-Union in 1846 and 1849. The medical department of Western Reserve College, established in Cleveland in 1843, was formally organized the next year while the college itself was still in Hudson, Ohio. The portraits, which depict Horace Ackley, Jacob John Delamater, John Delamater, John Lang Cassells, Jared Kirtland, and Samuel St. John, are now at Case Western Reserve University. For biographical information, see Frederick Clayton Waite, *Western Reserve University Centennial History of the School of Medicine* (Cleveland: Press of Western Reserve University, 1946), 74–103.

33. *Daily True Democrat* (13 February 1849), 2.

34. *Cleveland Daily Herald* (9 September 1841), 3.

35. *Cleveland Morning Leader* (13 October 1855), 3. There are references to crayon daguerreotypes in 1852; see, for example, *Morning Daily True Democrat* (9 January 1852), 4.

36. The Case Western Reserve University School of Law portrait appears to have been a gift from Backus's widow, along with a donation of money, in 1907. This provenance coincides with that of the painting from North and Schwerdt's studio, which, in the absence of any information to the contrary, appears to have been commissioned by Backus himself.

37. *Cleveland Morning Leader* (15 March 1865), 4.

38. Mention of printing photographs on ivory, wood, linen, and silk appears in Marcus Aurelius Root, *The Camera and the Pencil, or the Heliographic Art* (1864; repr. Pawlet, Vt.: Helios, 1971), 304; J. Towler, *The Silver Sunbeam* (New York: Joseph H. Ladd, Publisher, 1864; repr. Hastings-on-Hudson, N.Y.: Morgan and Morgan, 1969), 150–52, describes the transfer of collodion positives to japanned leather, linen, and paper. Aaron Scharf, *Art and Photography* (London: Allen Lane the Penguin Press, 1968), 33–34, briefly considers these processes.

39. In 1865, the year of the *Backus* exhibition, Smith returned to Cleveland after about four years in Cincinnati. *Cleveland Morning Leader* (13 October 1855), 3, records an early collaboration between Smith and North on a photograph painting.

40. See *Cleveland Morning Leader* (21 January 1858), 3, and (27 February 1858), 1.

41. The drawings, owned by the WRHS and currently unlocated, are reproduced in Walter B. Hendrickson, *The Arkites and Other Pioneer Natural History Organizations of Cleveland* (Cleveland: Press of Western Reserve University, 1962), between 22 and 23.

42. For anecdotes conveying the flavor of the homosocial bonding that took place at the Ark, see D. W. Cross, "The Ark and Its Founders. William and Leonard Case," *Magazine of Western History* 10 (June 1889): 140–46 (the article was installment six of Cross's series "The Log Book"; Cross appears in *An Evening at the Ark* as the gentleman wearing glasses); Eckstein Case, *Notes on the Origins and History of the "Ark"* (Cleveland: Printed for the Rowfant Club, 1902), 37–40.

43. Although undated, the photograph cannot date much before 1859 judging from the appearance of the sitters. That year, both Gordon and Case were 41 years old and Smith was 49. Smith moved to Cincinnati around then. By the time he moved back in 1865, Case was dead. In 1859 Gordon was president of the Cleveland Iron Mining Company.

44. After Case's death in 1862, the painting was owned by his brother Leonard Case, Jr., and exhibited under the title *The Arkites—Portraits* in the *Catalogue of Paintings, Statuary, &c., in the Fine Art Department, of the Cleveland Sanitary Fair* (Cleveland: E. Cowles, 1863), no. 10.

45. For a consideration of national trends in these directions, see John Kasson, *Rudeness and Civility: Manners in Nineteenth-Century Urban America* (New York: Hill and Wang, 1990).

46. On the Honfleurs' lessons, see *Daily Cleveland Herald* (10 November 1836), 2. On Hanks, see *Daily Herald and Gazette* (13 January 1838), 2, and (2 March 1838), 2; *Cleveland Herald* (6 October 1845), 2; *Daily True Democrat* (1 January 1851), 3, (15 January 1851), 2, and (13 January 1852), 3. On Crosby, see *Daily True Democrat* (18 May 1848), 2. On Boisseau, see *Morning Daily True Democrat* (25 December 1852), 2, (5 January 1853), 2; *Forest City Democrat* (23 January 1854), 4. On Noble, see *Cleveland Morning Leader* (18 August 1855), 3. On Humphrey, see *Cleveland Morning Leader* (11 September 1855), 2, (1 October 1855), 3, (10 October 1856), 4, and (20 March 1857), 4. On Fox, see *Cleveland Leader* (2 September 1871), 4.

47. Watercolor lessons were advertised by Thomas Stevenson in *Cleveland Daily Herald* (3 November 1841), 2, (3 January 1842), 2, and (3 January 1843), 3. Lessons in monochrome painting by Miss H. P. Snell were advertised in *Cleveland Morning Leader* (28 September 1854), 3; mezzotint lessons by E. D. Cobb in *Cleveland Daily Herald* (29 August 1840), 2; and lessons in perspective drawing by Jehu Brainerd in *Daily True Democrat* (8 October 1849), 2.

48. Flower painting was advertised by E. D. Cobb in *Cleveland Daily Herald* (29 August 1840), 2; drawing from nature by Mrs. Child in *Cleveland Daily Herald* (17 September 1841), 2; landscape drawing by Mr. Wood in *Daily True Democrat* (23 June 1851), 2.

49. Former Arkite Hamilton Smith made this tentative identification in a letter to Peter Neff, 16 December 1894, quoted in Hendrickson, *The Arkites,* 4, 6. He also states that a catalogue accompanied this exhibition.

50. On Stevenson's show, see *Cleveland Daily Herald* (9 February 1842), 3, (22 February 1842), 2, (25 February 1842), 2, 3, and (10 March 1842), 3.

51. Information on the Sketch Club draws from *Cleveland Morning Leader* (10 March 1860), 3, (15 March 1860), 3, and (12 April 1860), 3. The club began with two meetings before 10 March 1860: one at the home of Mr. Smyth, where people brought sketches they had made on the topic "Life," and another gathering at the home of Miss Cleveland, where "Truth" was the subject. On 14 March, 14 people brought drawings of "Peace" or "Piece" to Miss S. A. Noble's home. On 11 April, Walcutt hosted the group. Sometime after 12 April, Miss Shuhr hosted the club at Walcutt's studio, where people saw one another's interpretations of "The Parting."

52. *Cleveland Leader* (15 March 1860), 3.

53. *Cleveland Morning Leader* (13 May 1859), 3, refers to the canvas as a "grand historical painting." Presumably the news-dealers charged admission or took donations. In 1859, Bays' Asylum, St. Mary's Orphan Asylum, Cleveland Orphan Asylum, Monas Relief Society, and Ladies Home Missionary Society were all active relief organizations in the city.

54. R. C. Parsons, "Franklin T. Backus," *Magazine of Western History* 3 (November 1885): 8–15.

55. *Cleveland Morning Leader* (15 March 1865), 4. The article specifies that the frame maker Sargeant exhibited this photograph painting in his show window.

56. *Cleveland Morning Leader* (12 March 1860), 3.

57. On Pease's canvas, see *Oberlin Students' Monthly* (June 1859): 319; (July 1859): 361. That same year, Pease also painted portraits of Oberlin trustee John Keep and Professor John Morgan on speculation. The college took up a collection to pay for the portraits following a lecture; see *Oberlin Students' Monthly* 1 (July 1859): 361; *Oberlin Students' Monthly* 1 (October 1859): 473. The next year, the Oberlin Musical Union bought Pease's portraits of Oberlin president Charles Grandison Finney, Professor James Harris Fairchild, Dr. James Dascomb, and former president Asa Mahan with commencement concert proceeds; see *Oberlin Students' Monthly* 3 (December 1860): 62–63. On Ransom's canvas, which she had offered for sale at New York's National Academy of Design in 1860, see *Cleveland Morning Leader* (24 January 1861), 1. Sculptor John Quincy Adams Ward, a Ohio native, made a now-unlocated bust of Giddings around 1858 while in Washington, D.C.; see Lewis I. Sharp, *John Quincy Adams Ward: Dean of American Sculpture* (Newark: University of Delaware Press, 1985), 144–45.

58. *Cleveland Leader* (28 September 1866), 4.

59. Ellen Hickey Grayson, "Art, Audiences, and the Aesthetics of Social Order in Antebellum America: Rembrandt Peale's *Court of Death*" (Ph.D. diss., George Washington University, 1995), 637–41.

60. On the Mexican War, see *Daily True Democrat* (1 May 1848), 2, and (7 March 1849), 2; *Morning Daily True Democrat* (10 September 1853), 2. On the gold rush, see *Daily True Democrat* (22 August 1850), 2, (6 May 1851), 2, (5 March 1852), 2, and (3 March 1859), 2.

61. See *Morning Daily True Democrat* (19 January 1853), 3; *Cleveland Morning Leader* (19 May 1858), 2, and (24 December 1860), 1; *Cleveland Leader* (26 April 1866), 3, (31 December 1870), 1, and (31 March 1873), 1.

62. For the fire in Moscow, see *Cleveland Daily Herald* (10 May 1843), 2, and (13 October 1854), 3. For the wars of liberty in Italy and Hungary, see *Morning Daily True Democrat* (21 December 1852), 3. On the bombardment of Sebastopol, see *Cleveland Morning Leader* (22 January 1856), 1. For the Crimean War, see *Cleveland Morning Leader* (13 January 1859), 3. For the Chicago fire, see *Cleveland Leader* (9 January 1872), 4.

63. On the Great Lakes panorama, see *Cleveland Morning Leader* (7 November 1854), 3. For Cleveland, see *Cleveland Morning Leader* (28 December 1854), 3. On Niagara Falls, see the *Morning Daily True Democrat* (30 April 1853), 2; *Cleveland Morning Leader* (15 March 1859), 3. On the Hudson River, see *Daily True Democrat* (24 July 1848), 2. For views of New York City, see *Daily True Democrat* (14 June 1853), 3; *Cleveland Morning Leader* (1 March 1858), 2. On the voyage to Europe, see *Cleveland Morning Leader* (10 August 1855), 3. Regarding Italy, see *Cleveland Morning Leader* (29 October 1859), 3. For the panoramas showing the Mediterranean, see *Daily True Democrat* (20 September 1850), 2. For the Holy Land, see *Cleveland Morning Leader* (5 December 1856), 1; *Cleveland Leader* (26 January 1867), 4. For the Arctic, see *Cleveland Morning Leader* (27 October 1858), 1.

64. Concerning Europe, see for example the *Cleveland Morning Leader* (20 April 1857), 3. For whaling voyages, see *Daily True Democrat* (23 December 1849), 2; *Cleveland Morning Leader* (22 December 1859), 2. Regarding a glance at the world, see *Morning Daily True Democrat* (23 December 1852), 2.

65. Regarding scenes based on the Bible, see *Daily True Democrat* (12 July 1849), 2; *Cleveland Morning Leader* (28 September 1860), 1. For *Paradise Lost,* see *Daily True Democrat* (26 November 1849), 2; *Cleveland Leader* (24 September 1864), 1, and (2 October 1865), 4. For the panorama of *Uncle Tom's Cabin,* see *Cleveland Morning Leader* (7 July 1860), 1. On *Pilgrim's Progress,* see *Cleveland Leader* (7 July 1860), 1.

66. On Joseph Smith's murder, see *Daily True Democrat* (13 July 1849), 2. For Napoleon's funeral, see *Daily True Democrat* (13 November 1850), 2. Regarding Pilgrims and Revolutionary War personages, see for example *Cleveland Morning Leader* (27 August 1857), 3. For Lincoln, see *Cleveland Leader* (1 December 1865), 4.

67. On oil regions, see *Cleveland Leader* (21 October 1865), 4.

68. On Willard's panorama of the Civil War, see *Cleveland Morning Leader* (12 March 1862), 2. Tours of other proprietors' canvases are noted in *Cleveland Morning Leader* (3 February 1863), 3, (14 April 1863), 3, and (9 June 1864), 4.

69. I would like to thank Carl Ubbelohde for sharing his thoughts on this topic.

70. *Cleveland Leader* (26 July 1861), 3.

71. Benson J. Lossing, *The Pictorial Field Book of the War of 1812* (New York: Harper and Brothers, 1868), 505, 518, 532 n. 1.

72. Usher Parsons, "Speech of Dr. Usher Parsons at Put-in-Bay Island . . .," in *An Account of the Organization & Proceedings of the Battle of Lake Erie Monument Association, and Celebration of the 45th Anniversary of the Battle of Lake Erie, at Put-in-Bay Island on September Tenth, 1858* (Sandusky, Ohio: Henry D. Cooke, 1858), unpaginated. Parsons apparently cribbed his account from that of another witness, Samuel R. Brown, *Views on Lake Erie* (Troy, Mich.: Francis Adancourt, 1814); see Lossing, *Pictorial Field Book,* 532 n. 2.

73. See Stephen Champlin to Chevalier, 15 February 1860, 27 August 1860, and 29 August 1860, William L. Clements Library of Americana, University of Michigan.

74. The painting, which served as a model for a lithograph of 1875 titled *Burial Scene, of the Officers Slain, at Perry's Victory on Lake Erie, Sept. 10th 1813,* appeared in the section of the 1878 loan exhibition devoted to Cleveland artists called "Home Art." See *Catalogue of the Loan Exhibition 1878,* rev. ed. (Cleveland: Leader Printing, 1878), room 7, no. 103.

75. For the Hudson River painters as "the first New York school," see Angela Miller, *The Empire of the Eye: Landscape Representation and American Cultural Politics, 1825–1875* (Ithaca and London: Cornell University Press, 1993).

76. *Leader* (2 April 1862), 3, reported the painting's display upon its recent purchase by Henry F. Clark, one of the newspaper's editors.

77. The painting was left to the WRHS by Rice's heir Walter.

78. J. Gray Sweeney considers *Weighhouse* (there identified as *Lockhouse*) in relation to a pictorial type that he calls the harbor view in *Great Lakes Marine Painting of the Nineteenth Century,* exh. cat. (Muskegon Museum of Art, 1983), 80–82. At some point the painting was acquired by Dr. D. H. Beckwith, who, in addition to owning a portrait of himself by Allen Smith, Jr., also had *Bull-Fight* by P. B. West, an animal painter who lived in the city between 1876 and 1880. Clough offered an unlocated *Cuyahoga River, Ohio* for sale as no.144 at the Brooklyn Art Association in December 1869.

79. *A Photo Album of Ohio's Canal Era, 1825–1913,* rev. ed. (Kent, Ohio: Kent State University Press, 1992), 59, reproduces a 1859 photograph of the other side of the weighhouse, taken from the same shore on which Clough stood, but slightly downriver. Alfred Boisseau's *View of Cleveland* (ca. 1853, WRHS) offers a more comprehensive view of the canal and river system, and includes the weighhouse slightly to the right of center.

80. The building itself had changed, however, for two years after fire destroyed the Cleveland House in 1845, another hotel, soon named the Forest City House, replaced it.

81. Record Group 60, box 1, vol. 1:121, WRHS Archives. The painting was eventually given by Charles Strong.

82. Smith still owned the painting, then called *The Park, in 1869,* at the time of the 1878 loan exhibition; see *Catalogue of the Loan Exhibition 1878,* room 7, no. 9. The painting did not appear in the first edition of the catalogue. Ranney's ownership is mentioned in *Cleveland Plain Dealer* (18 April 1943), Art Gravure sec.

83. Robison, *History of the City of Cleveland,* 475.

84. Smith owned the canvas when he exhibited it at the 1878 loan exhibition; see *Catalogue of the Loan Exhibition 1878,* room 7, no. 4.

Fine Art in an Industrial Age

IN THE MID-1870S, a critical mass of men in Cleveland came to pursue painting as a fine art. Not only did this new density accelerate the pace of interaction between artists, it also fostered clubs and schools devoted to teaching and exhibiting. Ironically, this intensified community interest in painting heightened awareness of the limits of local education and inspired many artists to travel abroad. Upon return, they often imported attitudes toward picture making that prompted their retreat to northeast Ohio's agricultural hinterlands for subject matter. As part of this constant motion between other cities and towns, painters threaded through Cleveland's visual art support systems, some run on a shoestring solely by artists and others that involved the local, cash-rich fortunes that arose with the Civil War manufacturing boom.

The Art Club, the first of the artist-based institutions, came into being in 1876 through the efforts of men who wanted to draw from the live model, a commitment that resulted in a modest current of figurative art in the city. A photograph of the club's life-drawing class from 1887 (fig. 23) shows a male domain down to its anonymous nude model, a janitor by trade.[1] Women who "stand confessed, like Mother Eve," but with narrow bandages concealing their eyes and perhaps their identities, posed for the club as well.[2] Gender codes also marked the spaces where easel painters brought their work to public notice:

> The studio of Mr. Simmons [fig. 24] is an ideal bachelor den of a studio. . . . Rugs and draperies decorate the room with apparent carelessness and there is not a feminine suggestion in it.[3]

Although it had an open membership, the club considered itself primarily a masculine sphere of action, a circumstance that fostered the organization of the Western Reserve School of Design for Women during 1882.[4] On the whole, these institutions were distinct both in the gender of their students and in the kinds of skills they encouraged—drawing the figure for club members and preparing for design careers for students at the school. A painting of 1879 by the Art Club's first principal instructor, Frank Tompkins, of "a fair young girl glancing over the contents of a portfolio in the corner of a studio" tenuously bridged these zones by defining females as consumers rather than makers of fine art.[5]

Predictably, far fewer women studied abroad than men. Anna Stuhr Weitz's trip to Paris in 1887 and Caroline Whittlesey's two years in Holland, Italy, and Paris beginning in 1893 were rare among their sex.[6] By contrast, De Scott Evans went to Paris in 1877, a trio of fellows left for Munich the next year, and other ambitious men went alone or in small

Figure 23. Life-drawing class of the Cleveland Art Club, Old City Hall, 1887. The Cleveland Museum of Art Archives. [not in exhibition]

Figure 24. Interior view in the studio of F. W. Simmons, 1897. From George C. Groll, *A Cleveland Scrapbook*. The Cleveland Museum of Art, Ingalls Library. [not in exhibition]

groups to these and other European cities over the coming decades. Some artists returned to Cleveland permanently, others occasionally, a few never.

During this period in Cleveland, the careers of almost everyone who aspired to making fine art intertwined with overtly commercial uses of paint and art in the city. The most influential exception was the Indiana native De Scott Evans, who studied in Cincinnati and served as professor of fine arts at Mount Union College, Ohio, before migrating to the Cleveland area in 1874 at the age of twenty-seven. The subjects of his early religious and literary paintings bespeak lofty ambitions: *Christ Establishing the Holy Sacrament, King Lear, Witch Sycorax,* and *Musidora.* One work, *Siren of the Wine Cup* (fig. 25), probably done while Evans was still in Cincinnati, uses an allegorical figure to prompt viewers to meditate on the pleasures and, ultimately, the perils of alcohol. He showed these and other paintings in the college art gallery, including among them his copy of a self-portrait by Rubens, a work that suggests some pretension to joining a lineage of artistic greatness.[7]

By contrast, the early production of Archibald Willard, who moved to Cleveland in 1873 at the age of thirty-three, suggests how the division between commercial and fine art can easily be blurred. Willard painted wagons and portraits in Wellington, Ohio, before the Civil War and a panorama in 1865 after his military service. He returned to work for the wagon makers and, at that time, also amused himself by making humorous, moralizing easel paintings that caught the imagination of Cleveland photographer and entrepreneur James F. Ryder. Convinced he could make a fortune selling mass-produced imagery, Ryder persuaded Willard to move to Cleveland to aid in realizing that dream. By December 1876, Evans and Willard helped found the Art Club.[8]

The presence of these men in the city precipitated the impulse to make fine arts from several young commercial artists.[9] Working with a house and sign painter for two years beginning in 1873 when he was twenty, Adam Lehr studied easel painting with Evans in 1874 and with Willard the next year. Lehr did his first noncommercial painting in 1876 but maintained partnerships with house and sign painters until late into the decade. He began exhibiting with the Art Club in 1877 and in 1880–81 studied at New York City's Art Students League, which had been founded in 1875. Perhaps he intended to follow in the footsteps of Tompkins, a former resident of New York State who, having completed two years' training at the league in 1877, promptly began teaching at the Art Club. Despite this

exposure to fine art ideals, Lehr periodically advertised his work as a painter or letterer of signs until the end of the century. In contrast to such concurrent pursuits of commercial and fine arts, Otto Bacher moved sequentially from one to the other. Painting signs and ship inscriptions in 1874 at the age of eighteen, he proudly listed himself in the 1875 city directory as "art student DeScott Evans," only to begin study soon thereafter with Willis Adams, an Antwerp-trained painter from Massachusetts.[10] Bacher chose a symbolic day, 4 July 1876, for his first dated etching, the result of amateur trials in an unfamiliar medium pursued alongside Sion Wenban, a photo retoucher working for Ryder.[11] Bacher's full commitment to art brought him to Munich in 1878 to study at the Royal Academy, and Adams and Wenban accompanied him on the trip.[12] Bacher's boon companion Frederick Gottwald, who had gilded ship figureheads and painted landscapes for passenger boat saloons, studied with Willard for five years beginning in 1875 when he was seventeen. In 1881 Gottwald moved to New York for a year at the Art Students League (possibly overlapping with Lehr) and then, following in Bacher's footsteps, went on to Munich for three years.

Young commercial artists who worked with neither Willard nor Evans made similar transitions. John Kavanagh, who seems to have begun professional life in 1872 at the age of fifteen working as a printer for photographer William North, enrolled for a year in the Antique class at New York's National Academy of Design in 1876.[13] Upon his return he listed himself as an artist in the city directory and created highly regarded crayon portraits. In 1882 he set off with Tompkins for two years in Munich that overlapped with Gottwald's stay.[14] In the mid-1880s, Max Bohm also set out upon an exclusive pursuit of painting as a fine art. When he designed commercial lithographs in 1884 at the age of sixteen, he had already spent a year drawing the figure at the Art Club (he is the student to the far left in fig. 23). In 1887 he set off for Paris with his aunt, the painter Anna Stuhr Weitz, to study with Boulanger at the Académie Julian.[15] While Bohm returned to his native city only occasionally during the balance of a career in art that flowered into the most widely celebrated of any Clevelander of his day, the local art community continued to exhibit and report on his paintings.[16] Of the young Art Club painters who later played major roles in the city's art life, F. W. Simmons appears to have been the only one without commercial ties. He came to Cleveland from northwest Pennsylvania around 1879 at the age of twenty to study with Tompkins. Simmons also studied in New York at the Art Students League before 1883, when he returned to his adopted city and taught in the local league founded the previous year.

How these ventures were financed is not completely understood. Self-funded trips like Bacher's, which immediately followed his exhibition and sale held just for that reason, appear to be exceptional. Alexander Gunn of the Worthington Iron Company spotted Lehr's talents as a sign painter and paid for his studies at the Art Students League. Theodate Pope, daughter of Cleveland iron magnate and art collector Alfred Atmore Pope, wrote about Kavanagh in her diary for 1886: "Poor fellow, he is I sincerely believe a true artist and all he needs is money to get to Paris with. . . . I said I would give up candy and soda water for a year . . . in order to send him."[17] The girl's father, who already owned a portrait of his mother by the painter (see fig. 36), ended up supporting a trip that allowed Kavanagh to stay in Paris for three years beginning in 1886.[18] Brigadier general and railroad tycoon John H. Devereux supported local artists in several ways. He subsidized Bacher's first exhibition at Brooks Military school and later paid

Figure 25. De Scott Evans, *Siren of the Wine Cup,* 1870, oil on canvas, 74 x 55 in. (188 x 140 cm). Private collection. [not in exhibition]

Willard "enough to buy a small farm" so that Devereux could donate to his hometown of Marblehead, Massachusetts, a large version of the painter's *The Spirit of '76*.[19]

As a crucible for artistic energies, the Art Club surpassed all expectations. From the outset, it had a quasi-official status in Cleveland because civic officials, persuaded by city clerk and amateur draftsman William Eckman, allowed the club to meet in the top story of a building newly occupied by City Hall in the beginning of 1876.[20] In brokering this deal, Eckman used his public vocation to support his private avocation. Having arrived in the city in 1853, he was working as a Western Union Telegraph Company operator in 1867 when he achieved a modest reputation for drawing burlesques of current events and humorous sketches—a talent exercised throughout the forthcoming decade (fig. 26).[21] At the Art Club's first meeting in December 1876, Eckman's fellow students of the human figure demonstrated their recognition of his efforts by granting him the honor of first pose (fig. 27).[22] A letter from *Cleveland Herald* editor Charles Fairbanks two years later shows how Eckman's enthusiasm for whimsical drawing was contagious (fig. 28).

In 1881, while maintaining many of the same personnel, the Art Club changed its character because of a reorganization effort spearheaded by new arrival Miner Kellogg, a cosmopolitan sixty-year-old American-born painter.[23] Under the name of the Cleveland Academy of Art and with a board of incorporation buttressed by such wealthy citizens as T. D. Crocker, John H. Devereux, William Gordon, John D. Rockefeller, and Jeptha H. Wade, the academy raised $4,000 for a collection of casts in 1882. That year a local imitation of New York's Art Students League organized to fill the now highly visible need for an informal life drawing class. Also in the course of 1882, perhaps inspired by the first issues of the *Art Student* from the School of the Museum of Fine Arts in Boston and *Palette Scrapings* from the Saint Louis School of Fine Arts, two issues of the *Art Club Courier*, the first art paper in Ohio, appeared.[24] The next year *The Sketch Book*, which had a run lasting just over a year, promoted local artists and sought to raise the level of knowledge about works of art.

Figure 26. William Eckman, *Seated Boy Reading*, 1876, graphite, 8⁵⁄₁₆ x 10⅞ in. (21.1 x 27.6 cm). The Western Reserve Historical Society.

Figure 27. Otto Bacher, *William Eckman,* 1876, graphite, 10 x 5³⁄₁₆ in. (25.4 x 13.2 cm). The Western Reserve Historical Society.

Figure 28. Charles Fairbanks, *A Less Agreeable Business Engagement,* 1878, ink and watercolor, 5³⁄₈ x 7 in. (13.6 x 17.8 cm). The Western Reserve Historical Society.

This imposing coalition of artists and industrialists soon ran out of steam. In 1885, when Gottwald helped found a reorganized Art Club upon his return from Munich, the only trace left by the academy was a debt of rent to the city. The Art Students League eventually merged with the new Art Club, and among the members were the children of a number of German émigrés from the revolution of 1848. This ethnic affiliation, symbolized by the long-lived Gottwald, later led people to call the group the "Old Bohemians." While the photocollage of artists published in 1902 for the fiftieth anniversary edition of the German-language newspaper *Waechter und Anzeiger* pictured fourteen Clevelanders of German descent, men such as Adams, Evans, Kavanagh, Simmons, Tompkins, Wenban, and Willard, among other Art Club members, did not share this heritage.[25]

"NATURAL SUBJECTS": BODIES, BRIC-A-BRAC, AND BIRDS

THE ART CLUB'S COMMITMENT to studying the figure had one unfortunate consequence, for around the beginning of 1875 it inspired Evans to play a joke at the expense of an African-American newsboy. According to Justice John P. Green, the suit brought by the boy's mother was "the most humorous episode that occurred in my office."

> [S]eeing a picturesque little colored "newsie", on the avenue, whose appearance attracted his notice, he [Evans] offered to compensate him, if he would come into the studio and, not "pose," but, submit to some decoration. The boy consented, and once in the studio, Mr. Evans painted his nose a bright vermilion hue, streaked his forehead and cheeks more or less, with the same, and sent him into an adjoining room, tenanted by a lady, lover of art, to deliver to her a note which, apropos, the artist had written and given to him.
>
> The note ran, somewhat, as follows: "Dear Miss:—knowing you to be fond of natural subjects, I send you, herewith, one on foot. He has a pedigree", etc, etc, etc.[26]

Court records indicate that the "newsie" was one Alexander Coram, who, instead of delivering the note, went home. His mother, America Coram, sought three hundred dollars "for personal injuries sustained by the plaintiff by the unlawful willful and malicious ill treatment deception & personal violence of the Defendant towards the plaintiff."[27]

Evans intended to make a witty link between diverse ideas about what constituted the "natural." In the realm of pictorial representation, this referred to drawing or painting from live models and to rendering landscape out of doors—both of these practices being distinct from the increasingly disparaged exercise of copying works of art. The Art Club's commitment to drawing the figure arose in this climate of opinion. Yet with a different meaning, the same word "natural" also pervaded the discourse of race theory. Stimulated by an idea current among some U.S. citizens of European descent that people of African and Native American origin were more primitive, closer to nature, and therefore more natural than themselves, Evans covered the black boy's face with markings suggestive of Indian war paint in order to invoke two racial types of the natural on a single body. His note to a studio neighbor added yet a third idea to the mix by alluding to the boy's desirability as an object of artistic study.[28]

Finding in favor of the plaintiff, the progressive jurors clearly saw Alexander Coram as a person rather than a body. Furthermore, having no ties to the artworld, they had no basis for finding Evans's joke funny even though they might grasp its content once explained. In a passionate dis-

play of sensitivity to the Corams' experience, they awarded one hundred dollars. Less than the three hundred requested, this considerable amount was nonetheless a substantial punishment for Evans.

Omitting this event from its brief biography of the artist, *The Sketch Book* instead concerned itself with the sources of the painter's mature style. "In the spring of 1877 Mr. Evans went to Paris, where he remained one year studying under Wm. Bougureau [sic], the famous French artist for whose works Mr. Evans entertained the liveliest admiration; here he acquired the taste for ornate interiors and bric-a-brac productions, in which he has since met with much success."[29] *Mother's Treasures* (fig. 29), one of two known surviving works by Evans from his trip to Paris,[30] combines the figural style of the Académie Julian's famous master with elaborate settings and materials derived from the example of Parisian favorite Alfred

Figure 29. De Scott Evans, *Mother's Treasures,* 1877–78, oil on canvas, 53½ x 72½ in. (136 x 162 cm). Private collection. [not in exhibition]

Stevens.[31] Using the theme of filial love that appears in a Bouguereau work such as *Charity* (1878, private collection), the painting strives toward, but does not satisfactorily replicate, the French artist's characteristically crisp contours and softly modeled volumes.[32] Yet it was the depiction of yard goods that attracted a Cleveland reviewer's eye during the *Loan Exhibition 1878,* a show of art larger than any previously held in Cleveland, shortly after Evans returned: "His silks, satins, and velvets, it seems, could not possibly be painted better."[33] The title of the canvas and the classicizing profile of its eldest figure suggest that the artist's conception derives from a story recounted by the Roman historian Valerius Maximus: When asked by a materialistic woman which of her treasures she valued most, the mother of the Gracchi indicated her children. Yet the values promoted in the anecdote and the painting are not identical, for the noble matron painted by Evans, surrounded by offspring as well as material splendor, need not choose between alternatives; she has it all. Owned by land developer T. D. Crocker, the painting offered visitors to his Tuscan villa on Euclid Avenue a reassuring image of the compatibility of familial and financial success.[34]

The bric-a-brac style that Evans imported to Cleveland was his most valuable contribution to the city's visual culture. After his return from Paris, he advertised himself as a portrait painter, while newspaper notices drew special attention to his success in children's portraits—a genre that enabled him to epitomize the values set forth on an elaborate and imaginative scale in *Mother's Treasures.* In the *Taxidermist* (fig. 30), a painting sent to New York to be shown at the National Academy of Design in 1881, Evans set elegantly attired young ladies of the upwardly mobile middle class into the decrepit workshop of a man who stuffs animals for a living.

Figure 30. De Scott Evans, *Taxidermist,*
1881, oil on canvas, 36⅛ x 24⅛ in. (91.8 x
61.3 cm). Charles Sterling Collection.

With her late canary in hand, one lady ponders the possibilities for that
departed loved one's permanent exhibition. Perhaps the small bell jar that
the taxidermist holds aloft will not do and the larger alternative by his
right arm would make a more fitting final resting place. While the wealthy
also visited a poor tradesman in *The Young Mechanic* (see fig. 9) by Allen
Smith, Jr., Evans coded his transaction in terms of light feminine senti-
ment rather than weighty masculine industry. The taxidermist aims to
please, and when he succeeds in that goal, the women will leave without
needing to return to his shop or to question the inequality of the social re-
lations there enacted.[35]

In the *Taxidermist* Evans limited his treatment of elaborate objects
to the materials and cuts of the ladies' dresses, but in most of his genre
scenes figures appear in settings as lavish as their clothing. With its care-

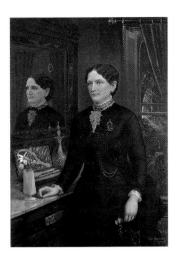

Figure 31. George Senyard, *Frances Caroline Whitbeck,* ca. 1887, oil on canvas, 49 x 35 in. (124.5 x 89 cm). The Western Reserve Historical Society. [not in exhibition]

fully rendered still-life elements, a painting like George Senyard's *Frances Caroline Whitbeck* (fig. 31) suggests how Evans's style served as a model for other painters in Cleveland.[36] Yet the squalor surrounding the taxidermist creates a jarring perspective from which to consider its better-dressed figures. Similarly, the concluding comment in the artist's biography in *The Sketch Book* shows how other members of Cleveland's artistic community also distanced themselves from the materialism they perceived in the society that enjoyed and bought his paintings.

> In the luxurious appointments of the modern parlor and drawing-room Mr. Evans finds his best inspirations and while many of his canvasses may be freighted with an over-abundance of accessory, the fault may with reason be found in the fashion of the day rather than in the artist.[37]

Not only did the content of certain paintings prompt distaste, but the rooms devoted to "Bric-a-brac" at the *Loan Exhibition 1878* and to "Curios" at the *Art Loan Exhibition of 1894* suggest that some contexts in which paintings appeared did not please everyone either. Given Adam Lehr's singular commitment to the social leveling theories of Henry George—so ardent that he chose "Adam Lehr: Single Taxer" as his epitaph—it is probable that he was one such fault-finder.[38]

Offered for sale and hung "on the line" in New York City, the *Taxidermist* apparently had national impact precisely because it left Cleveland.[39] On the return route to his native San Francisco after studying art in Munich, Henry Alexander began an extended stopover in New York in 1883. He created *The First Lesson (The Taxidermist)* (fig. 32) after he arrived home in 1885.[40] With his elderly protagonist attending to a small bird in a shop filled with strange and startling juxtapositions of corpses, Alexander seems to have taken his inspiration from Evans. Alexander, however, depicts a particular San Francisco taxidermist's shop and changes the narrative about exchange to one concerning the generational transmission of craft practices.

Around the same time, Evans created a modern variant of the *paragone,* recast in terms of painters and taxidermists (fig. 33).[41] Featuring a bird identical to the one in the left foreground of the *Taxidermist,* he integrated his presentation of how taxidermy enlivens the inert with a bravura display of two arts of deception specific to painters. One is the ability to imitate objects; Evans captures the not-quite-animate quality of a properly stuffed bird. The other is the rendering of pictorial space. The parrot casts a shadow upon an exquisitely scored and stained backdrop of fitted boards,

Figure 32. Henry Alexander, *The First Lesson (The Taxidermist),* 1885, oil on canvas, 25 x 34¼ in. (63.5 x 87 cm). The Fine Arts Museums of San Francisco, Mildred Anna Williams Collection. [not in exhibition]

Figure 33. De Scott Evans, *Homage to a Parrot,* ca. 1881, oil on canvas, 20 x 16 in. (50.8 x 40.6 cm). Fresno Metropolitan Museum.

and the glass shards in front of the illusionistic box partly obscure the objects behind them. To great effect, the head and lively eye of the bird appear as if seen directly; the viewer need not look through a glass but can see face to face. Playing with artists' proverbial ability to make "speaking likenesses," Evans included an inscribed card that, in effect, gives his painting the power of language. It is not a surrogate voice for the now-mute bird, however, but for its (fictional) French taxidermist or exhibitor, one Pierre Gastereau. Translated into English, the text reads:

> This parrot was found in South America and from there was taken to Paris where he learned to speak the French language for many years. At the age of 20 he died was stuffed with straw and now here he is.

Culminating in an assertion about the moment they are read, these sentences re-enact the dynamic between real absence and fictional presence otherwise in play throughout the canvas in pictorial terms.

Evans taught Lehr and Bacher, so it is not surprising that both young artists produced still lifes of animals before planar backdrops; Lehr continued to work in this format throughout his career.[42] While Evans's bird perches teasingly close to the realm of the living, Lehr's game (fig. 34) of-

Figure 34. Adam Lehr, *Hanging Game,* 1900, oil on composition board, 15¹⁵⁄₁₆ x 19⅞ in. (40.5 x 50.5 cm). Jean Barnett Collection.

fers no such ambiguity. The limp head, splayed feet, and jutting wings as well as the slashes of dark feathers across the illuminated breast connote just how broken and vulnerable a body this is. According to these examples of the genre of still-life painting, a mastery of the ability to render both the near-quick and the stone-dead served as defining aspects of the painter's art.

DIALOGUES WITH MUNICH AND PARIS

TOWARD THE END of the 1880s, New York art critic George Sheldon perceived a national trend among artists:

> The ease and speed with which the trip to Europe is now accomplished have done much for the improvement of American art. Many artists spend each summer abroad, and to no artist does a sea-voyage seem a great undertaking . . . our young Americans continue to avail themselves of the very great advantages of the École des Beaux-Arts, and have made an impression also in the art-schools of Munich."[43]

In the latter city, artists from Cleveland studied the human figure alongside their compatriots, many of whom followed the dictates of Professor Ludwig

Figure 35. John Kavanagh, *Portrait of an Old Man,* ca. 1884, charcoal on tan paper, 19⅜ x 15½ in. (49.2 x 39.4 cm). The Cleveland Museum of Art, gift of Mrs. A. J. Weatherhead.

Löfftz in devoting attention to one particular type of humanity.[44] As recalled by the German painter Lovis Corinth, who like Kavanagh and Gottwald also studied at the Royal Academy in the early 1880s, "'Ruins of mankind' we used to call them. We scrutinized their faces and tried to render the study in a grayish-green tone. We called such a work 'good in tone.'"[45] Kavanagh's haunting rendering of an elderly man's head (fig. 35) gains in expressive qualities from the golden tonality of his paper. Undated, he may have drawn it in Munich or upon his return home in 1884. He clearly created his oil portrait of the mother of Alfred Atmore Pope (fig. 36) locally and received praise for it during an exhibition at Ryder's Gallery.[46] Writing about the painting without knowing its sitter's identity, Kenyon Cox illustrates the effects of this kind of portrait on viewers.

> It is the head of an old Quaker lady in cap and spectacles, wearing a gray shawl over a black dress and a bit of lawn at her throat. The tone is silvery and pleasant and the handling direct and able, the pigment being laid on with some body, but with a flowing brush, in a manner that was evidently learned in Munich. As a mere piece of painting, it is attractive, but it is the presentation of character in it that holds one. The strong, sweet face, the shrewd, yet kindly eyes, the puckered lips with a

Figure 36. John Kavanagh, *Theodate Stackpole Pope,* 1885, oil on canvas, 22 x 17¾ in. (56 x 45.2 cm). Hill-Stead Museum. [not in exhibition]

Figure 37. Frederick Gottwald, *Old Card Players,* 1892, oil on canvas, 18 x 24 in. (45.7 x 61 cm). Private collection. [not in exhibition]

hint of humor in the corners—all the marks of a wholesome and delightful old age are given with such sympathy and felicity that one feels an equal interest in the sitter and the artist.[47]

Kavanagh also seems to have found pictorial prototypes congenial to his temperament in the unsentimental reports of contemporary social conditions painted by the German Max Liebermann, who was active in Munich in the late 1870s and early 1880s. Soon after Kavanagh returned to Cleveland, he began "a sketch of a street scene during the recent cold snap, showing a half frozen newsgirl and two Samaritans bending over her."[48]

Gottwald also drew and painted heads of elderly people, but more central to his practice after returning to Cleveland was creating modest narrative situations using these pictorial elements. His *Old Card Players* (fig. 37) shows the enduring impact of this instruction. The significance of such iconography for painters and viewers in the cities to which American painters returned after their studies at the Royal Academy has not received the attention it deserves. Yet in young cities like Cleveland pictures of the elderly may have provided reassuring images of venerability and continuity in the face of ceaseless change.[49]

Munich was also a popular destination for Cleveland's well-to-do in the 1880s. In the course of a conversation with a German art dealer, Bacher's former traveling companion Wenban noted that the man:

Inquired from what city in America I come;—Cleveland: Oh indeed, we have a great many customers from Cleveland; I told him I know it very well and was about to tell him I had sent lots of Clevelanders to him; but just then some of the Aristocracy drove up and he had to rush over to the front part to receive them.[50]

Working his hometown connections while abroad, Wenban sought to secure a position for himself in a foreign art market, but he made no headway in interesting a dealer in his work.

Painters from Cleveland continued to go to Paris long after Evans's brief sojourn. After coming back from Munich, Kavanagh first hoped to resume study in Germany but soon set his sights on the French capitol. One of the fruits of the three-year stay that began in 1886 was *Washerwomen* (fig. 38), a genre scene modeled on the example of Jules Breton, that hung at the Paris *Universal Exposition* of 1889 and, after Kavanagh's return home, in the Art Club exhibition of 1891.[51] His repeated acts of hauling out the can-

vas for other shows offer an early glimpse of his inability to forge a successful career locally.[52] F. W. Simmons also sought out Paris, making four trips there between the mid-1880s and 1900. He produced *A Daughter of Italy* (fig. 39) before his return in 1900 and received praise for it during a benefit exhibition for a maternity hospital in Cleveland.[53]

ART AND ENTREPRENEURSHIP

THROUGHOUT THESE DECADES of men traveling abroad in pursuit of skills worthy of great artists, Archibald Willard stayed in Cleveland, riding to some extent on the wave of income and reputation created around 1876, the year that he painted several versions of the most famous conception in the history of Cleveland art—*The Spirit of '76,* first called *Yankee Doodle.* Decades later, he recalled: "[T]he original canvas was the regulation chromo size, and then, as I became ambitious to be represented at the Centennial, a large painting was made and sent to Philadelphia."[54] If that describes the canvas now in Marblehead, Massachusetts, then the centennial painting was ten feet high and eight feet wide.[55] As large as life, the painting attested to the magnitude of its creator's ambitions. Willard came to make many replicas of this pictorial success, the last begun in 1912 (fig. 40) in response to a commission from Cleveland City Hall. Willard's reminiscences about the initial development of his design suggest that he came to

Figure 38. John Kavanagh, *Washerwomen,* 1889, oil on canvas, 47½ x 39⅝ in. (120.6 x 100.6 cm). The Union Club Company.

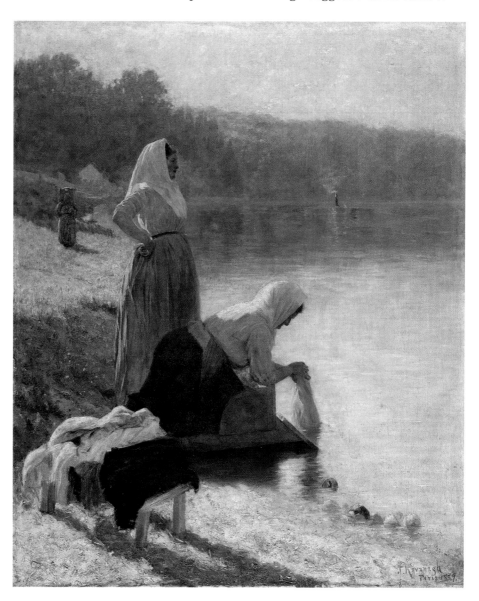

Figure 39. F. W. Simmons, *A Daughter of Italy,* ca. 1900, oil on canvas, 21½ x 18 in. (55 x 46 cm). The Western Reserve Historical Society.

believe in the inspired nature of his conception over the years that he continued to recall its origin. Just thinking about *The Spirit of '76* elevated his opinion of himself as an artist.[56] Yet such lofty beliefs make strange bedfellows with the commercial impulses that both motivated Willard to realize his ideas and fueled the processes by which people consumed the resulting imagery. From this perspective, the man who brought Willard to Cleveland, James F. Ryder, was a key player in the events of 1876.[57]

A year earlier, exercising a business savvy keenly attuned to discovering latent opportunities, Ryder recognized that there would be an enormous market for a chromolithograph with nationalistic content when the country celebrated the centennial of the Declaration of Independence. Even though festivities would be held from coast to coast, Ryder knew through his connections with the National Photographic Union that Philadelphia, the city where the document had been signed, was to host an exhibition that included a Photographers' Hall. In what turned out to be a pioneering effort to coordinate the rhythms of the marketplace with those of a national celebration, Ryder charged Willard with the task of devising an image that would sell. For the former Civil War soldier and painter, the War of 1812 offered a middle term between his own day and the War of Independence. His first image of three marching men drew upon his memories of drunken War of 1812 veterans drumming in a local militia parade.[58] As he had done with the paintings that initially brought him to Ryder's attention, Willard sought to create a work in a comic, burlesque mode. The various accounts of the process by which he developed an image befitting the seriousness of the historic events of 1776 and the forthcoming events of 1876 double as narratives on the matter of Willard becoming serious about art. As both photographs and chromolithographs, the resulting image circulated nationally in countless copies.

While *The Spirit of '76* came into being only because of Ryder's vision of the potential market for mass-produced imagery, the paintings with which Willard realized his conception have been scrutinized extensively as historians steeped in fine art ideas about originality have searched for an original version.[59] Having wrestled with this matter in some detail, the artist's

Figure 40. Archibald Willard, *The Spirit of '76,* 1912–13, oil on canvas, 120 x 98 in. (304.8 x 248.9 cm). City of Cleveland.

descendant and biographer Willard Gordon has trenchantly asked, "Which then was the 'original'? The original what? The original cartoon? The original sketch? The original design for a painting? The original canvas? The original Centennial painting? The original masterpiece?"[60] Similarly, a newly discovered document about the history of Willard's efforts to realize his conception shows the limited utility of efforts to link *The Spirit of '76* with assumptions about aesthetic autonomy and genius. Not only did he engage in an ongoing dialogue with Ryder about his different ideas but, as recounted by the daughter of Cleveland photographer J. M. Greene, the painter was not even wholly responsible for realizing his design.

> When Mr. Willard was painting "Yankee Doodle" as he called it, he came to Mr. Clough's studio and said "George, I am stuck and want your help. I am painting a picture which started out to be comic but I want to change it into a patriotic one and I can't get the real vim into it and I am about ready to give up the whole thing." Mr. Clough said "bring it here and I'll try to help you." Mr. Willard did so and Geo. Clough painted the spirit into the face of the old fifer in "The Spirit of 76."[61]

Such ruptures in the ideology of the masterpiece find their complement in the exhibition history of the painting, for it did not hang in Memorial Hall with most of the easel paintings in the exhibition but in the Art Annex. Judging from press notices, the painting was virtually ignored.[62]

The success of Willard's design lay partly in its capacity to symbolize the significance of an entire war for U.S. citizens in 1876. Just as his corps of

men could not be stopped on the battlefield, so too was their nation's advent a product of inexorable forces. These figures' allegorical identities partly derive from the distinct role that each plays in an ensemble representing the three ages of man. Painting each figure just before his right foot falls, and with the right feet of the two rightmost figures precisely overlapping the left feet of the two leftmost figures, Willard endowed this collection of types with an expressive unity of design.

Ambiguities in both Willard's original and revised titles indicate the close connection between his vision of the American past and the circumstances of his moment of creation, for "Yankee Doodle" named a song inextricably linked with nineteenth-century Independence Day celebrations, and the "'76" in *The Spirit of '76* refers as readily to 1876 as to 1776. Showing marching musicians, the painting alludes to the festive parades that played a central role in centennial celebrations nationwide. Willard's decision to cast only Caucasians in his musical military march-cum-parade resonates with the increasing segregation that characterized parades across the country after mid-century.[63] Furthermore, contemporary viewers gladly consumed imagery that interpreted their forebears in nation building as "on the move," for they sought to see this quality in themselves as they endeavored to stride confidently into their own collective future. Expressing these values in the language of economic individualism, Ryder used imagery strikingly similar to Willard's.

> In his march through life [a man] must keep his place in the procession. It is better that he step upon another man's heels than have his own stepped on. He must keep pace with the crowd of strugglers reaching for the front.[64]

The image of drummers in motion had a specific wage-earning connotation in the 1870s, for "drummers" were also men who drummed up business while traveling from place to place. Willard's *The Drummer's Best Yarn* (1885, private collection), a genre scene about storytelling among traveling salesmen, demonstrates the painter's explicit investment in a thematics of earning.[65] As a physical object, the centennial canvas dramatized the ideal of motion itself, for it traveled from city to city by train once the Philadelphia Exposition had closed.

For decades after the centennial, the prospect of having a repeat success occasionally lured Willard to attempt historical and allegorical subjects on patriotic themes. On the occasion of the Columbian quarter-centenary in 1892, for example, he designed (and Ryder published) a humorous image that declared the identity of baseball as a quintessential American game by attributing its invention to the original Americans (fig. 41). Willard rendered both spectators and players comic. The Italian explorer and his entourage spy demurely on the strange event at hand, and the Indians appear in a variety of grotesque attitudes. In this manner, the artist unintentionally estranged his viewers from their national pastime, a factor that probably contributed to the print's limited success. Nonetheless, Willard's conception may have had an impact upon local memory, for in 1915 the Cleveland baseball franchise was named the Indians.[66]

Bearing the modern title *The Young Tycoon* (fig. 42), one painting by the artist sublimated his financial preoccupations into humor. Depicting a shoeshine boy at the outset of his working life, Willard has that figure strike a surprisingly adult attitude, with jacket confidently grasped, thumb cocked, and gaze knowingly trained on some distant object. This incongruity lies at the heart of various ways that Willard's conception

Figure 41. Archibald Willard, *What Columbus Found,* 1892, lithograph, 20¾ x 28¾ in. (52.6 x 73 cm). Library of Congress, Washington, D.C. [not in exhibition]

Figure 42. Archibald Willard, *The Young Tycoon,* ca. 1890s, oil on canvas, 36¼ x 22 in. (92.1 x 55.9 cm). Private collection.

Figure 43. Otto Bacher, *Sketch Book: Man Wearing Top Hat,* 1877, graphite, 6½ x 4⅝ in. (16.5 x 11.7 cm). Jean Schenk Collection.

makes meaning. From one perspective, the imagery promises that financial success must greet the efforts of so determined a child. Yet it is unclear if he possesses more confidence than ability, and his low station sets up a barrier to him achieving any lofty goal. Nonetheless, we cannot be sure that we are not seeing a boy at the outset of a fabulous rise, an uncertainty that endows the implied narrative with a certain thrilling quality.

Another way to interpret the figure is that, while he possesses a boy's proportions, he is in some way already the grown man that he will become and already complacent about the wealth that will be his. To the extent that this conceit generated the painting's imagery, Willard may have been inspired by "How I Served My Apprenticeship," an autobiographical essay of 1896 by Andrew Carnegie. Recalling the hardships of his first job and the consolation of his being able to earn money for his family, he reminisced:

> But I was young and had my dreams, and something within always told me that this would not, could not, should not last—I should some day get into a better position. Besides this, I felt myself no longer a mere boy, but quite a little man, and this made me happy.[67]

Taking his imagery from this "rags to riches" story or from some other contribution to that cultural myth, Willard simultaneously brought the plight of the underprivileged working class into the realm of Cleveland's visual culture, rendered it risible, and invoked the outside chance of someone striking it rich.

THE IDEA OF THE COUNTRY

HAVING MET WILLARD by the end of 1876 during the first Art Club meetings, Bacher experimented with what could be learned from the elder artist, and so made occasional forays into the realm of caricature (fig. 43). More important to the long-term development of his art, however, was his experience of Cleveland as a financially driven urban center that he sought to avoid or resist, a circumstance revealed by the differences between his early and late representations of the rural community of Richfield, Ohio. After his trip to Munich in 1878, which he followed up with extended travels to Italy in the company of Frank Duveneck in Florence and James A. McNeill Whistler in Venice, in late 1882 Bacher returned to Cleveland and subsequently established a coed summer art colony at Richfield. Over the course of that season and of the following summer, he worked on *Ella's Hotel, Richfield, Ohio* (fig. 44), a canvas enriched by out-of-doors observation but probably worked-up in a studio. His success in capturing the effects of glare and bright light attest to his sensitivity to certain optical phenomena. Yet while the horse's gait indicates that the attached wagon is in motion, the starkly drawn spokes suggest that it is standing still.[68] Bacher signed and dated the painting just before leaving for Paris early in 1885.[69]

During the period in New York City following his return to the States in 1887, Bacher revisited Richfield in memory and on canvas. When he had first lived in Richfield, he depicted a leisurely paced economic life. Perhaps the working man transporting the large can on the midground wagon in *Ella's Hotel* casts a judgmental gaze at the slothful foreground porch occupants, but such morality would be a minority opinion. Once removed from the realities of the place, however, Bacher eventually structured a composition that showed his awareness of the processes by which small businesses in Richfield were being incorporated into larger networks (fig. 45). The

Figure 44. Otto Bacher, *Ella's Hotel, Richfield, Ohio,* 1883–85, oil on canvas, 31 x 42½ in. (78.7 x 107.9 cm). Private collection.

Figure 45. Otto Bacher, *Country Store, Richfield, Ohio,* 1892, oil on canvas, 27 x 34 in. (68.5 x 86.4 cm). Frank P. DiPrima Collection.

Figure 46. Archibald Willard, *Kingsbury Run,* ca. 1890s, oil on canvas, 30 x 24 in. (76.2 x 61 cm). Private collection.

men in the picture space of his genre scene, divided into two contingents by the steeply sloping floorboards, consider a deal. The cigar-smoking drummers to the left have propositioned the storekeeper at right. Of the drummers, one continues persuading blandly while the other studies their potential client's face under cover of lighting up. The man seated on the barrel is so absorbed in matters at hand that he forgets to hold his drinking glass upright. Curiously, in its capacity to invoke the dynamics of urban-rural interaction, the scene as presented may resemble no event in the history of Cleveland art so much as Ryder propositioning Willard to move from Wellington to Cleveland.

In the mid-1880s, Bacher had wanted Richfield to be an idyllic respite from Cleveland. Almost a decade later, picturing a collision between the irresistible force of modern business and more traditional ways of buying and selling, he finally expressed his anxiety about the urban center's impact upon a surrounding community. Paradox charges this entire sequence, for, after all, the painter himself had only been able to get to the town via the city.

During almost every year of the 1880s, and into the 1890s, the Art Club sponsored sketching expeditions to rural areas for large parties. The first such occasion occurred in 1877, when a steamer brought plein-air enthusiasts to the Black River. While the brass and string band might not have facilitated communion with nature, the announcement that "Willard will give a series of charcoal sketches for the edification of the passengers" meant that drawing lessons were available for those so inclined.[70] Willard himself pursued out-of-doors landscape painting as a pastime throughout his career (fig. 46). By contrast, R. Way Smith's professional life centered upon such productions. He was instructor of "landscape from nature" during the first season of the Western Reserve School of Design for Women in 1882–83 and made the sale of such paintings his principal means of support. In 1888 a reporter visiting his studio described a landscape painted in the open air, "with nature's model posing for him." Of another work, the same writer claimed that "the picture is one of the kind that tend to take a person's thoughts away from the cares of business and bid him list to nature's teachings."[71] Steeped in early and mid-nineteenth-century roman-

tic conventions about the redemptive power of nature, the article integrated its claims about landscape painting's capacity to affect their viewers with allusions to the poetry of William Cullen Bryant and John Keats. A late landscape by Smith (fig. 47), although benefiting from the knowledge and skill he had gained from his direct studies of nature, was clearly painted in the studio. Its simple but carefully composed story concerns sheep faced with the threat of brewing storm clouds. The poor creatures cluster, move away from their grazing, and turn toward a gate silhouetted against the sky. With its suggestion that some man-made shelter lies beyond, the gate creates a narrative structure that reiterates Smith's practice. While an artist must go out into nature to satisfy his aesthetic needs, that journey is always undertaken with reference to the realm of society from which he has come and to which he must inevitably return.

Occasionally, the passion for painting out of doors inspired the herding instincts in some artists. Under such circumstances, leaders arose who directed seasonal schools in rural communities. The group that Bacher taught at Richfield in the summer of 1883 became the local prototype for this kind of venture. In 1888, three years after Gottwald returned from Munich and was appointed principal instructor at the Western Reserve School of Design for Women, he established a summer colony at Zoar

Figure 47. R. Way Smith, *Sheep in Land-scape,* 1899, oil on canvas mounted to board, 25 x 29 in. (63.5 x 73.2 cm). National City Bank Collection.

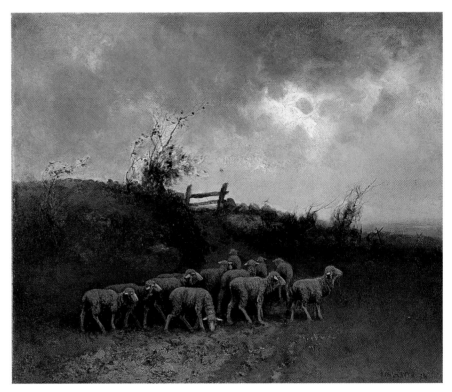

that was to become an annual affair.[72] In the early years of this century, after studying at Munich's Royal Academy and receiving an appointment as professor at the same school in which Gottwald taught (by then renamed the Cleveland School of Art), Henry Keller started a summer school in Berlin Heights.[73]

In his early engagement with commercial art, Keller followed the career pattern previously set by Cleveland fine arts painters during the 1870s and 1880s, but he neither frequented the Art Club nor made a clean break from commercial art during his twenties. Instead, beginning in 1887 at the age of eighteen, he took a year of the industrial design curriculum of the Western Reserve School of Design for Women. After fine arts training in Germany during 1890–91, he returned to Cleveland and began designing

Figure 48. George Adomeit, *Country Lane,* ca. 1900, oil on canvas, 20½ x 13⅞ in. (52 x 35.8 cm). The Cleveland Museum of Art, gift of Ruth E. Adomeit.

posters for Morgan Lithograph Company while pursuing art studies at a local night school and in Cincinnati and New York. Only beginning in 1899 at the age of thirty, when he began three years of art training in Düsseldorf and Munich, can he be said to have begun an exclusive pursuit of fine art.

The stylistic directions taken at Cleveland's art colonies were imminent in the principles laid out in *The Sketch Book* in 1883. As the periodical's name implies, the editor valued efforts to record in graphic form the direct observation of nature, and such productions need not be highly finished. To the contrary, a fully completed surface could connote that one had spent too much time making the representation and not enough attending to its source. Referring to the specific lithography technique used to produce *The Sketch Book,* an editorial noted that "finish is neither desired, nor in any great degree possible by the process employed; the character of the subject is all that is aimed at, and simplicity of method is a merit rather than the reverse."[74] Once launched upon the elusive goal of capturing "the character of the subject," artists sought appropriate prototypes that gave them the impression that, if properly emulated, they would achieve what they sought. Perhaps the signal events in this pursuit were the public displays of different paintings of haystacks by Claude Monet that took place in two consecutive years in the early 1890s. These showings came about through the largess of local collector Alfred Atmore Pope, who made these paintings available for viewing as soon as he acquired them. Bubbling with enthusiasm over the version set in winter, a reviewer of the Art Club's 1892 exhibition wrote:

> Certainly the subject is common place but the painting is wonderfully vivid and true to nature. Monet is constantly selecting themes that other artists never dream of depicting. Last year he selected the self-same subject, two haystacks, except that they were presented in the summer time. That picture aglow with warmth; the present one is cold, frosty, crunchy. For out of door effects the impressionist style is incomparably the best.[75]

Figure 49. Henry Keller, *Harvest Time,* ca. 1903, oil on canvas, 12⅛ x 12⅛ in. (30.8 x 30.8 cm). The Cleveland Museum of Art, anonymous gift in memory of Henry G. Keller.

Composed of bright, unmodulated colors laid down with broad brush-strokes, these paintings signaled a major advance in technique to contemporary advocates of the aesthetics of direct painting. Although not appreciated by all viewers, similar approaches to out-of-doors subjects by artists in Cleveland and from Cleveland can be seen for the next forty years.[76]

Working at Zoar under Gottwald's tutelage, George Adomeit created stark horizontal bands of light and dark to punctuate the viewer's movement into pictorial space (fig. 48). At Berlin Heights, Keller devised a metaphor for his own work in the fields, an image of men carefully stacking bales on a wagon (fig. 49). Abel Warshawsky, who studied with Gottwald in Cleveland between 1900 and 1905, moved to France, re-importing impressionism to its source (fig. 50). On his annual trips to Italy between 1907

Figure 50. Abel Warshawsky, *Washerwomen at Goyen,* 1917, oil on canvas, 25½ x 32 in. (64.8 x 81.3 cm). The Cleveland Museum of Art, gift of the Cleveland Art Association.

Figure 51. Frederick Gottwald, *The Umbrian Valley, Italy,* 1914, oil on canvas, 28⅞ x 24 in. (73.4 x 61 cm). The Cleveland Museum of Art, gift of Mrs. John Huntington.

and 1915 and on subsequent travels in that country in the 1920s, Gottwald brought an academic impressionism that emphasized structure, drawing, and conventional devices for creating pictorial recession (fig. 51). Made in pursuit of the elusive ideal of direct contact with nature, these paintings nonetheless employ mediations and artifices. Their high-key palettes suggest the effects of brilliant sunlight for indoor viewers. Flaunting raw

Figure 52. Henry Church, Jr., *Still Life,* ca. 1888, oil on paper mounted on cloth, 26 x 36 in. (66 x 91.4 cm). Private collection.

edges of the pieces of paint that cover their surfaces, these paintings declare direct traces of the individual moments of time that transpired during their creation. Over the course of the years during which such ploys became conventional wisdom, many contemporaries lost interest in this enterprise of capturing "the character of the subject."

THE COUNTRY AS VANTAGE POINT

THE HISTORY OF CLEVELAND ART around the turn of the century includes many representations of rural life and spaces from the perspective of people socialized into urban ways of thinking and trained in urban painting techniques. Yet a complementary rural point of view can be discerned in the paintings and sculptures of Chagrin Falls blacksmith Henry Church, Jr., who lived his entire life in this village about fifteen miles east of Cleveland. Church pursued the urban art of illusionistic oil painting, albeit in an amateur style of hard edges and unmodulated surfaces. His reputed train trip to the city (Chagrin Falls got its first railroad line in 1877) to receive advice on materials from Archibald Willard, whose fame as the creator of *The Spirit of '76* had penetrated to this nearby hinterland, makes explicit his link with art making as practiced by city folk.[77] Working on paper and composition board, Church used standard formats for still lifes (fig. 52) and honorific portraits. In one particularly expressive challenge to these standards, he fashioned himself as a man who conceived and made art independently of urban norms (fig. 53).[78]

While obviously an amusing animal painting featuring two monkeys fighting over a lone banana, *The Monkey Picture* also succeeds as a composition that intentionally violates the conventions of a decades-old type of still-life painting. This type features a table with an edge adjacent and par-

Figure 53. Henry Church, Jr., *The Monkey Picture,* ca. 1888, oil on paper mounted on cloth, 28 x 44 in. (71.1 x 111.8 cm). Abby Aldrich Rockefeller Folk Art Center.

allel to the picture plane. A vista into deep space to one side relieves an otherwise shallow central space dominated by abundant fruit.[79] Church's straightforward interpretation of this format in another painting clarifies that he understood his monkey painting—a work that is manifestly not a depiction of still life (that is, inert nature)—as a gleeful departure from such norms. In this sense, he conceived of his identity as a painter in terms analogous to the depicted monkeys who upset the ordinary order of things. The innovation at the level of content that inspired Church to introduce his monkeys has several similarly jarring counterparts in his pictorial challenges to typical presentations of space and scale. At left, the normally proportioned tail of one monkey extends an uncanny distance to encircle the head of a tiger-skin rug, apparently animated and upset by the turn of events. While that rug has the usual proportions for an object in the middle distance, the goblet that crashes onto it, although no larger than other objects on the table, seems gargantuan in its new situation.

Working with the dialectic between infraction and punishment, Church self-consciously included in his painting a policeman in pursuit. Running by the cage from which the animals have escaped, the uniformed officer appears bent on their return. A similar tension informs the comic self-portrait by Fairbanks (see fig. 28), for the witty publisher's fate is as yet uncertain. In both images, urban civil servants act to restrain. For Fairbanks, only being apprehended for a gravely serious crime (of which he may or may not be guilty) can excuse him from honoring the social nicety of accepting a dinner invitation in Cleveland. At issue in *The Monkey Picture* are the violations of wild beasts and an artist who breeches iconographic and formal decorum. Connecting his painting practice to the

Figure 54. Henry Church, Jr., *Self-Portrait,* ca. 1885, oil on wood, 29¾ x 23½ in. (75.6 x 59.7 cm). Collection of Mr. and Mrs. Samuel Rosenberg, courtesy Joan Washburn Gallery.

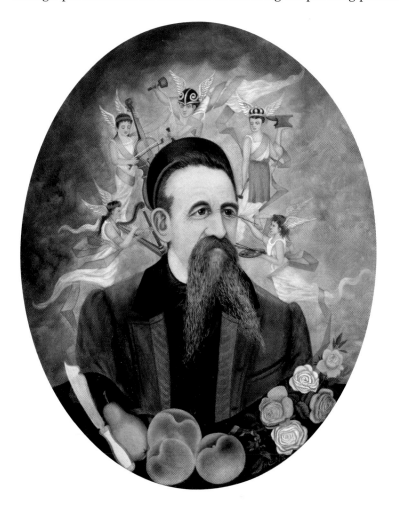

chain of associations linking monkeys with actions coded as "natural," the resident of Chagrin Falls asserted an artistic identity in opposition to the city and its laws about the proper places for animals and the proper behavior of picture makers.[80]

Relative to the state of the arts in Cleveland, Church's professional concerns were archaic for the late nineteenth century, a fact in which he took pride. In 1891 the sign outside his studio read "Portrait, Landscape, Banner and Sign Painting a Specialty. Gilding, Bronzing, Glass and Screens. Old Paintings Retouched." In the diverse formats mentioned, this advertisement recalls the activities of such Cleveland painters from the 1840s as Hanks and Heine. The sign's transcription comes from a city newspaper reporter who sought the painter out as a curiosity. He described Church as a man who thinks that "he who can paint a portrait should also be able to paint a sign and who then, in defiance of probable ridicule, openly states that he is ready to do either kind of work."[81] Engaging in a discussion in which both parties understood that in their day painters held up an exclusive pursuit of fine art as either a norm or a goal, Church subverted his interlocutor's expectations.

Another aspect of Church's posturing emerges in a consideration of his procedure for sculpting *The Rape of the Indian Tribes by the White Man* (finished 1885, South Chagrin Reservation, Cleveland Metroparks), an elaborate figural program carved in living rock on which he worked in secret for years. According to a later newspaper article, Church hoped that when people came across the completed work in the woods they would conclude about its authorship:

> It was the spirits! It was supernatural! Spirits actually guided his hands, so he believed, and he was but working under their inspiration. But to merely say so would not convince the world. He must therefore not let it be known that it was through his hands that they worked.[82]

This scheme, frustrated when residents discovered Church at work on the sculpture in 1885, draws upon ideas similar to the ones that had motivated James Mott in 1844, when that Shaker believed himself to be a vessel for divine creativity (see fig. 3). Yet once Church's project had been exposed, his prior efforts to create a "miraculous" work forged for him a paradoxical public character as someone who claimed to receive spiritual gifts and sought to create false impressions.

With its winged squadron holding instruments of artistic creation near symbolically relevant parts of his head, Church's *Self-Portrait* (fig. 54) explicitly advances the point about divine inspiration. A harp and cello play by his ear, a sculptor's chisel and hammer shape his cranium, and a paintbrush touches his eye. Larger and more elaborate than such oval portraits of famous men from his hand as *Lord Byron* (ca. 1880s, after Thomas Phillips's portrait of 1814, private collection) and *Rubens, Michael Angelo, and Raphael* (ca. 1880s, private collection), his portrait of himself, like *The Monkey Picture,* once again varies a standard format. That Church depicted himself attended by celestial creatures has no bearing on the possibility of such visits. Yet the act of composing and realizing such a didactic program is as much an act of creative public relations as it is of inspired creation. This pose was not without its effects upon his contemporaries. The aforementioned newspaperman called his article "A Genius Near Home," and on the occasion of Church's death, an admirer declared, "No one can look upon his handiwork, either in painting or carving, and not see a born genius."[83]

Figure 55. Henry Church, Jr., *Angel of Night,* ca. 1885, sandstone and glass taxidermy eyes, 48 x 18 x 18 in. (121.9 x 45.7 x 45.7 cm). Private collection.

Figure 56. Henry Church, Jr., ca. 1906, standing with his sculpture *The Young Lion and the Fatling Together* of 1887 (sandstone and glass taxidermy eyes, 54 x 72 x 26 in. [137 x 183 x 66 cm], private collection).

The abundant mental imagery to which Church gave form in paint and stone sometimes resulted in conjunctions of beasts. In *Angel of Night* (fig. 55) the two owls that are the angel's attributes are as fully realized as characters as the figure whose identity they define. *The Young Lion and the Fatling Together* (fig. 56) invokes the imagery of Isaiah 11:6–9: "The wolf also shall dwell with the lamb, and the leopard shall lie down with the kid; and the calf and the young lion and the fatling together; and a little child shall lead them." Made with the intention of ornamenting the Chagrin Falls village square,[84] the sculpture was to have provided local viewers with a vision for the future of their community, a scriptural ideal of earthly harmony achieved through the reconciliation of antagonistic forces.[85] Ironically, through acts of vandalism prior to 1937, the sculpture lost both its child and the forged chain by which he led the lion.[86]

Around the same time that Church sought to consolidate community identity with his public sculpture, Cleveland received its greatest wave of immigrants. The pictorial community also became even more cosmopolitan during the period immediately before World War I. Visiting his home city in 1909–10, Max Bohm exercised the skills that made him a European success. Demonstrating the strong sense of two-dimensional pattern making that James A. McNeill Whistler had pioneered, as well as a striking juxtaposition of tight modeling and broad brushstrokes, he painted an uncommissioned portrait of a Cleveland woman (fig. 57) who, a decade prior, had declined his marriage proposal because of her doubts about his ability to earn a living.[87] The portrait that the young William Zorach painted of his sister Mary (fig. 58) around the same time shows his famil-

Figure 57. Max Bohm, *Lucy,* 1909, oil on canvas, 49 x 50 in. (124.5 x 127 cm). Mr. and Mrs. Edmund A. Hajim Collection.

Figure 58. William Zorach, *My Sister Mary,* 1908, oil on canvas, 28½ x 18½ in. (72.3 x 47 cm). The Peter and Julie Jenks Zorach Collection.

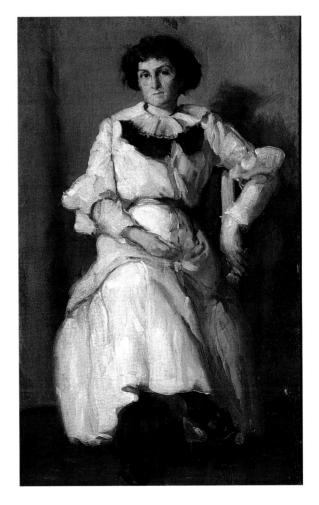

Figure 59. Grace Kelly, *For to Admire, For to See,* ca. 1910, watercolor, 17¼ x 22½ in. (43.8 x 57.2 cm). Mr. and Mrs. William A. Monroe Collection.

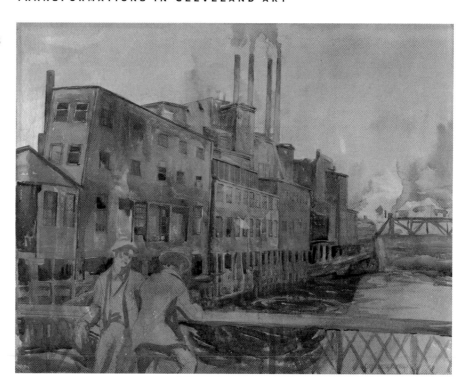

iarity with the palette and brushwork of Munich painting, learned in his case after two seasons at the National Academy of Design.

It was also during this time that painters turned to industrial subjects. Grace Kelly, the daughter of poor Irish immigrants, applied to the urban scene the freely brushed, translucent veils of watercolor that she had learned with Keller at Berlin Heights (fig. 59). While she depicted the factories of her own neighborhood from a pedestrian's point of view, August Biehle painted those same Flats (fig. 60) from the window of his office at the Sherwin-Williams Company, makers of paint and varnish, where he supported himself after his return from studying easel painting in Munich. His composition offers a view into the valley around the Cuyahoga, piling up buildings and spewing smokestacks high into the picture space. Around 1893, the company's advertising manager George Ford had conceived of a

Figure 60. August Biehle, *Fire Tug on the Cuyahoga River,* 1908, oil on board, 14½ x 14 in. (36.8 x 35.6 cm). Nora A. Biehle Collection.

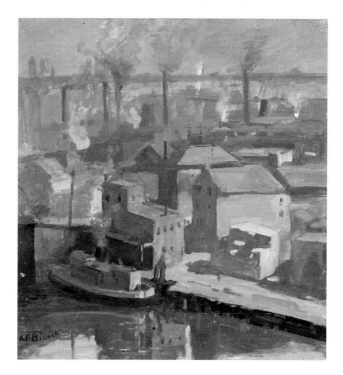

Figure 61. Sherwin-Williams logo, ca. 1904.

view from an even more distant vantage and drew a paint can pouring its contents over the planet. Designers soon adjusted his conception, tilting the globe on its side so that Cleveland became the point from which paint was to "cover the earth" (fig. 61).[88]

Shortly before his death in 1918, Archibald Willard choreographed a tableau vivant of his famous trio for a Flag Day pageant in Wade Park.[89] The coherent patriotic display of this Flag Day celebration contrasted dramatically with the assertion of ethnic identity that occurred during the Fourth of July parade the next month. Potentially divisive, these signs of difference within the community gave way to a full-scale riot during the May Day commemoration in 1919, when long-term residents of the city who associated newer immigrants with radical socialist politics expressed their disapproval through violence.[90] While many in the city sought to march forward with an economy dependent on the city's industrial success, the narrow racial background of the members of Willard's blueblood brigade meant that it was not a symbol around which all could rally.

NOTES

1. A typed sheet on the photograph's verso provides this identification.

2. "The Nude in Art," *Cleveland Plain Dealer* (5 April 1880), 1.

3. *Cleveland Plain Dealer* (24 January 1895), sec. 2, p. 5.

4. Nancy Coe Wixom, *Cleveland Institute of Art: The First Hundred Years 1882–1982* (Cleveland: Cleveland Institute of Art, 1983) offers the best history of this school, founded by Sarah Kimball as the Western Reserve School of Design for Women, first taught by Harriet Kester, directed by Georgie Norton beginning in 1891, and endowed by such figures as Mrs. Henry Bingham Payne and Mrs. Liberty Holden.

5. *Cleveland Plain Dealer* (20 February 1879), 4. This painting anticipates several works by De Scott Evans in Cleveland in the late 1880s that treat both women and paintings as aesthetic objects; see Nannette V. Maciejunes, *A New Variety, Try One: De Scott Evans or S. S. David,* exh. cat. (Columbus Museum of Art, 1985), figs. 10, 11.

6. See Charleen Akullian, "Max Bohm: Romantic American Visionary," *American Art Review* 6 (October–November 1994): 116; *Cleveland Plain Dealer* (24 January 1895), sec. 2, p. 5.

7. *Catalogue of the Officers and Students of Mount Union College, 1873–74* (Alliance, Ohio: Monitor Steam Printing House, 1873), 12. Some background information about Evans's appointment can be found in Newell Yost Osborne, *A Select School: The History of Mount Union College and an Account of a Unique Educational Experiment, Scio College* (Mount Union College, 1967), 486. Maciejunes, *A New Variety* offers the most comprehensive survey of

Evans's career to date. The untitled nude dated 1873 in that publication (Figure 9) must be the aforementioned *Musidora*.

8. *Cleveland Plain Dealer* (8 December 1876), 4; *The Voice* (10 December 1876), quoted in William W. Andrew, *Otto H. Bacher* (Madison, Wis.: Educational Industries, 1973), unpaginated. According to *The Voice* (26 November 1876), quoted in Andrew, *Otto H. Bacher,* Willis Adams and Bacher held a life class in their shared studio during the winter of 1875–76.

9. The information in this and the next paragraph is pieced together from several sources, the most important being a typescript, "Our Artists," Cleveland—Art and Artists, Clipping Files, Ingalls Library, Cleveland Museum of Art (CMA). From internal evidence, this text can be dated to between 1895 and 1897; possibly Willard was its author.

10. For Adams, see Roger Black, *Willis Seaver Adams / Retrospection,* exh. cat. (Hilson Gallery, Deerfield Academy, 1966).

11. Otto A. Weigmann, *Sion Longley Wenban 1848–1897* (Leipzig: Verlag von Klinkhardt and Biermann, 1913), 47–48, catalogues four etchings made in Ohio by Wenban before he began his long and eventually successful career in Germany.

12. The trio's German work drew much attention when sent back to Cleveland for the Art Club exhibition the following year. *Cleveland Plain Dealer* (15 December 1879), 1.

13. See undated newspaper clipping, ca. 1892, roll 1499, frame 22, Archives of American Art (AAA), Smithsonian Institution, Washington, D.C.

14. Tompkins remained longer than Kavanagh and was the man who informed Gottwald in 1885 that the position of chief instructor was open at the Western Reserve School of Design for Women. Gottwald returned to Cleveland immediately, but Tompkins, who had few ties to Ohio, eventually settled in Boston.

15. While there, he may have crossed paths with Kavanagh, who pursued the same course of study that year during his second European trip.

16. In 1892 twelve large canvases by Bohm, painted in among other places Brittany and Bavaria, appeared in an Art Club exhibition. In 1899 a one-man show of his works was held at his father's house on Detroit Street. See *Cleveland Plain Dealer* (3 October 1892), 8; *Waechter und Anzeiger* (9 August 1902), 121.

17. Diary, 4 August 1886, archives, Hill-Stead Museum (Farmington, Conn.). My thanks to Sandra L. Wheeler for bringing this passage to my attention.

18. Kenyon Cox, "The Collection of Mr. Alfred Atmore Pope," in *Noteworthy Paintings in American Private Collections,* ed. John LaFarge and August F. Jaccaci (New York: August F. Jaccaci Company, 1907), 1:294.

19. *Cleveland Plain Dealer* (13 March 1921), magazine sec., p. 8; Willard quoted in *Cleveland Plain Dealer* (17 April 1880), 4. The asking price for this version of *The Spirit of '76* had been $5,000, although the amount settled upon seems to have been somewhat less. At some point, Devereux also gave his portrait by Bacher to Marblehead; both paintings now hang there in Abbot Hall. Bacher's long friendship with the Devereux family is indicated by a painting of Venice that he inscribed as a gift to the general's daughter (1887, Adams Davidson Galleries, Washington, D.C.).

20. Mary Sayre Haverstock, "Art Life in Old City Hall," in *F. C. Gottwald and the Old Bohemians,* exh. cat. (Cleveland Artists Foundation, 1993), 43–46, offers the best account of the Art Club's relation to City Hall. The building, built in 1867 on the former site of William Case's Ark, stood on the Case Block adjacent to Case Hall. In 1882 the Western Reserve School of Design for Women, founded that year in a private home, also had quarters at City Hall.

21. *Leader* (9 August 1867), 4.

22. Bacher gave this drawing to the recently retired Eckman as a gift in 1885, praising its recipient extravagantly as "not only the first to pose and to help art in this city—but he has also been first in everything related to art in this city." See container 1, folder 11, William H. Eckman papers, Western Reserve Historical Society. Because Art Club histories have sometimes centered upon Willard, he has been identified as the subject of Bacher's drawing and remarks; see Haverstock, "Art Life in Old City Hall," 44. "Our Artists," Ingalls Library, CMA, clarifies that "the first pose was W. H. Eckman, familiarly and well known as 'Billy.' He was attired in a fetching costume, topped with the ridiculous short coat with a disproportionate cape that was worn in the Centennial year."

23. See Kellogg's clippings scrapbook from these years, roll 986, AAA.

24. The only known reference to the *Art Club Courier* appears in "Our Artists," Ingalls Library, CMA. William H. Gerdts, *Art across America: Two Centuries of Regional Painting 1710–1920* (New York: Abbeville Press, 1990), 2:215, suggests that the Boston and St. Louis periodicals inspired Cleveland's *The Sketch Book,* but the discovery of the existence of the *Courier* establishes that a local impulse to publish predated *The Sketch Book.*

25. This collage, reprinted in Samuel Orth, *History of Cleveland* (Chicago and Cleveland: S. J. Clarke Publishing, 1910), 1:between 458 and 459, features Otto Bacher, Max Bohm, Frederick Gottwald, George Groll, George Grossman, Herman Herkomer, John Herkomer, Adam Lehr, Louis Loeb, Arthur Schneider, O. V. Schubert, Dan Wehrschmidt, and Emil Wehrschmidt. As a prominent painter in England, Herman's nephew Sir Hubert von Herkomer recalled his impoverished childhood in Cleveland between 1851 and 1857 in *The Herkomers* (London: Macmillan Publishers, 1910), 21–30.

26. John P. Green, *Fact Stranger than Fiction: Seventy-Five Years of a Busy Life with Reminiscences of Many Great and Good Men and Women* (Cleveland: Riehl Printing, 1920), 168–69. My thanks to Mark Cole for bringing this passage to my attention, and to Martin Hauserman, Jacob Latham, and Judy Satina for invaluable help excavating the case.

27. Justice of the Peace Docket, Cleveland Township, 1875, 1; see also 502–4.

28. The use of such models is indicated by art criticism as well as painting titles, for example, the 21 February 1885 notice in the *Cleveland Plain Dealer* that Kavanagh "is working on a darkey's head in oil," a reference to the *Study of a Negro* (collection unknown) exhibited by Kavanagh at the National Academy of Design that year.

29. *The Sketch Book* 2 (February 1883): 20.

30. The other painting is pure Bouguereau—a copy of the 13-year-old *War (First Discord)* (1864, private collection) that Evans imitated down to its signature, which has led to speculation that he tried to pass it off as a genuine Bouguereau to Charles Olney, who purchased it for $1,200 in 1892 and later gave it along with his entire collection to Oberlin College. Although inscribed "W. Bouguereau 1864," the painting is attributed to Evans in an annotation to a list of Olney's collection by Oberlin botany professor Frederick O. Grover: "This was not painted by Bougereau [sic] but by his pupil—Evans of Cleveland while studying with Bougereau." My thanks to Marjorie Wieseman for transcribing this document. See also Wolfgang Stechow, *Catalogue of European and American Paintings and Sculpture in the Allen Memorial Art Museum Oberlin College* (Oberlin, Ohio: Oberlin College, 1967), 54–55.

31. See Nancy Troy, "From the Peanut Gallery: The Rediscovery of De Scott Evans," *Yale University Art Gallery Bulletin* 36 (Spring 1977): 42. On transatlantic tastes in this direction, see Rémy G. Saisselin, *The Bourgeois and the Bibelot* (New Brunswick, N.J.: Rutgers University Press, 1984).

32. For *Charity,* see the entry by Louise d'Argencourt in *William Bouguereau 1825–1905,* exh. cat. (Montreal Museum of Fine Arts, 1984), 204–6.

33. *Cleveland Leader,* miscited as September 1878 when quoted in Clara Erskine Clement and Laurence Hutton, *Artists of the Nineteenth Century and Their Works,* 4th ed. (Boston: Ticknor, 1884), 242. The review probably dates from October.

34. *Catalogue of the Loan Exhibition 1878,* rev. ed. (Cleveland: A. W. Fairbanks, 1878), room 7, no. 6, lists Crocker as the owner of *Mother's Treasures.* For biographies of Crocker, see obituaries in Cleveland newspapers following his death on 17 September 1899. Given Crocker's longstanding affiliation with Mount Union College, including a period as a trustee, he could have played some role in encouraging the initial move to Cleveland made by its professor of fine arts, Evans. The prompt appearance of *Mother's Treasures* in Crocker's collection suggests that it may have been painted with him in mind and that he may have played some role in supporting Evans's trip abroad. Evaluations of the artist's career at the time almost always mentioned this painting.

35. Only four years after this canvas was painted, Carl Akeley, the future organizer of the Akeley African Hall at the American Museum of Natural History in New York, got his first professional opportunity when called upon to preserve P. T. Barnum's famous Dumbo after a train killed that elephant. While Evans stresses taxidermy's contribution to making a feminine keepsake, Donna Haraway, "Teddy Bear Patriarchy: Taxidermy in the Garden of Eden, New York City, 1908–1936," *Social Text* 9 (Winter 1985): 20–64, offers a remarkable consideration of how taxidermy could also be enlisted in supporting a male-dominated, capitalist social order.

36. The sitter died in 1886 at the age of forty-eight. Both internal and external evidence suggest that the portrait is posthumous: The tree stump in the window vista offers a symbol of mortality, and Senyard first appears in the city directory in 1887.

37. *The Sketch Book* 2 (February 1883): 20.

38. Henry George (1839–1879) published *Progress and Poverty* in 1879.

39. The early provenance of this painting is not known. Its owner reports that it was found in a taxidermist's shop.

40. See the evocative entry by Sally Mills in Marc Simpson, Sally Mills, and Jennifer Saville, *The American Canvas: Paintings from the Collection of the Fine Arts Museums of San Francisco* (New York: Hudson Hills Press, 1989), 188.

41. The *paragone* denotes the Renaissance debate over the relative merits of painting and sculpture. *Homage to a Parrot* is one of a set of related still lifes whose authorship has posed problems to students of American art because most are signed "S. S. David" or some similar, probably pseudonymous variant. Given its kinship with *Taxidermist* (1881) and its use of French, which suggests a date close to Evans's Paris trip, *Homage* appears to be among the earliest of the group. This inquiry has been pursued by Maciejunes, *A New Variety;* Troy, "From the Peanut Gallery," 36–45; William H. Gerdts and Russell Burke, *American Still-Life Painting* (New York: Praeger, 1971), 167–68.

42. For Bacher, see *Still Life—Birds* (1876, Berry-Hill Galleries, New York) reproduced in *Otto Bacher 1856–1909,* exh. cat. (R. H. Love Galleries, Chicago, 1991), 15. For Lehr's early use of this format, see *The Sketch Book* 2 (February 1883): 23.

43. George William Sheldon, *Recent Ideals of American Art* (New York and London: D. Appleton, 1890), 4. My thanks to David Park Curry for bringing this passage to my attention.

44. Michael Quick, "Munich and American Realism," in *Munich and American Realism in the 19th Century,* exh. cat. (E. B. Crocker Art Gallery, 1978), offers a useful introduction to the art of Americans in Munich.

45. Corinth's autobiography of 1926 is quoted in Horst Uhr, "Lovis Corinth's Formation in the Academic Tradition: Evidence of the Kiel Sketchbook and Related Student Drawings," *Arts Magazine* 53 (September 1978): 94 n. 15.

46. See the review in the *Cleveland Plain Dealer* (14 October 1885), 5.

47. Cox, "The Collection of Mr. Alfred Atmore Pope," 1:294.

48. *Cleveland Plain Dealer* (14 February 1885), 1. The sketch may have led to the canvas *Poverty,* exhibited at the National Academy of Design later that year.

49. See the similar studies of heads produced by J. Ottis Adams and Samuel Richards, Indiana painters who also studied in Munich in the early 1880s, discussed in Martin F. Krause, Jr., *Realities and Impressions: Indiana Artists in Munich 1880–1890,* exh. cat. (Indianapolis Museum of Art, 1985). F. W. Simmons, who studied in Munich a decade after Kavanagh and Gottwald, offered a late rehearsal of this conventional practice when painting *Old Peasant* (1893, CMA).

50. Wenban to Geo Wenban, 20 December 1889, quoted in Weigmann, *Wenban,* 13.

51. A belated instance of a tie between Munich painting and Kavanagh's work may be his unlocated *Sisters,* apparently painted in Paris and shown in Cleveland in 1889 after his return. Judging from its description, "Three Sisters of Mercy are singing in the corner of a church. . . . The faces of the three are exquisite and full of expression" (*Cleveland Plain Dealer* [10 November 1889], 5), the painting had much in common with a canvas done in the Munich area during Kavanagh's residence, Wilhelm Leibl's *Three Women in Church* (1878–82, Kunsthalle, Hamburg).

52. See *Cleveland Plain Dealer* (29 September 1891), 8, (3 October 1892), 8. The painting appeared at the 1892 exhibition of the Boston Art Club as *Lavereuses.* The polite words of the 1894 art loan show reviewer invite disbelief: "It speaks well for the good qualities of Kavanagh's "Washerwomen on the Seine" that, though often exhibited, its familiarity does not make it tiresome" (*Cleveland Plain Dealer* [4 January 1894], 2). The painter's malaise while at home had even been noted after his first trip during a studio showing of work done in both Munich and Cleveland: "The pictures painted . . . in Munich show the result of this congenial art atmosphere, and those executed in Cleveland, although good, are tempered by the cold, forbidding surroundings that chill the artist's inspiration" (*Cleveland Plain Dealer* [9 July 1886], 8).

53. See *Cleveland Plain Dealer* (11 December 1900), 8. "The brilliant little Italian girl is one of the finest things among the number and is greatly liked."

54. Willard quoted in Spencer Adams [Gertrude Hunter], "Art," *Cleveland Town Topics* (2 November 1912), 13.

55. Willard F. Gordon, *"The Spirit of '76"* . . . *An American Portrait: America's Best Known Painting, Least Known Artist* (Aero Publishers, 1976), 25, notes that the Marblehead painting as it currently appears differs from representations of the centennial painting.

56. See A. M. Willard, "The Picture That Would Not Be Funny: The Story of the Most Popular Historical Painting in America," *The Housekeeper* 35 (July 1912): 5–6; and Adams, "Art." The City Hall commission may have been prompted by the first article, a nationally published description of the events leading to his conception of 1876. By the time of the interview with Willard published by Adams in November 1912, that final reprise of his centennial design was almost complete. Ryder had already codified the outlines of Willard's accounts some two decades prior; see James F. Ryder, "The Painter of 'Yankee Doodle,'" *New England Magazine* n.s. 13 (December 1895): 482–94.

57. Thomas H. Pauly, "In Search of 'The Spirit of '76,'" *American Quarterly* 28 (Fall 1976): 444–64, centers on the commercial context in which Willard's imagery arose and circulated.

58. Amos J. Loveday, Jr., "The Spirit of '76," in *Archibald M. Willard and "The Spirit of '76,"* exh. cat. (Ohio Historical Society, 1992), 9, reproduces the drawing that Willard made in 1895 in an effort to recreate the already-lost drawing of this subject.

59. Efforts to disentangle the different versions include Rip Pratt, "The Duplicate in Abbott Hall," *Yankee* 26 (September 1962): 52–57, 94–95; Gordon, *"The Spirit of '76"*; Loveday, "The Spirit of '76," 8–10. For a provocative challenge to the idea of the original, see Rosalind Krauss, "The Originality of the Avant-Garde: A Postmodernist Repetition," *October* 18 (Fall 1981): 47–66.

60. Gordon, *"The Spirit of '76,"* 38.

61. Caroline Greene Williams to Frederic Whiting, 15 October 1919, CMA Archives. "Father told me not to say anything about this as Willard was his friend, but now all the parties have passed away and I think you ought to know what an able man Geo. Clough was."

62. Pauly, "In Search of 'The Spirit of '76,'" 449–50.

63. See Mary Ryan, "The American Parade: Representations of the Nineteenth-Century Social Order," in *The New Cultural History,* ed. Lynn Hunt (Berkeley, Los Angeles, London: University of California Press, 1989), 131–53.

64. James F. Ryder, *Voigtländer and I: In Pursuit of Shadow Catching* (Cleveland: Cleveland Printing and Publishing, 1902), 236. Pauly quotes part of this passage in "In Search of 'The Spirit of '76,'" 460.

65. See the insightful discussion of the latter painting in Timothy B. Spears, *One Hundred Years on the Road: The Traveling Salesman in American Culture* (New Haven and London: Yale University Press, 1995), 113–17. While Spears discusses later titles such as *The Drummer's Latest Yarn* and *The Drummer's Last Yarn,* the *Cleveland Plain Dealer* called the painting *The Drummer's Best Yarn* ([31 January 1885], 4, and [7 February 1885], 1). Ryder reproduced it as a sepia postcard.

66. Historians generally credit the Penobscot Indian Louis Sockalexis, who played with the team during the 1897–99 seasons, with inspiring the Indians name. On his irrelevance to the 1915 *Cleveland Plain Dealer* contest for naming the team, see Philip Althouse, "The Sockalexis Myth," *Free Times* (8–14 November 1995), 3.

67. First published in *Youth's Companion* (23 April 1896), repr. in *The Gospel of Wealth and Other Timely Essays* (New York: Century, 1901), viii. On achieving a partial degree of financial independence from his family, Carnegie wrote: "I think this makes a man out of a boy sooner than almost anything else, and a real man, too, if there be any germ of true manhood in him" (ibid., vii). Infrared analysis of the shoeshine box at the lower right of Willard's painting reveals that it originally bore the initials "A C," a tantalizing clue for any effort to see the painting as an evocation of the young Andrew Carnegie.

68. Thomas Eakins's *The Fairman Rogers Four-In-Hand (A May Morning in the Park)* (1879–80, Philadelphia Museum of Art) offers a slightly earlier effort to depict the effects of spinning wheels.

69. The relationship between Bacher's painting and Simmons's apparently similar but unlocated *A Country Road* exhibited at just around the same time is unclear: "In the foreground is the wooden piazza of an old-fashioned country hotel with the dusky country conveyance, the occupant of which is engaged in conversation with the landlord, who is resting one foot upon the wheel" (*Cleveland Plain Dealer* [24 January 1885], 1).

70. *Cleveland Plain Dealer* (29 May 1877), 4. For an overview of the issues surrounding this sort of cultural practice, see Roderick Nash, "The Exporting and Importing of Nature: Nature-Appreciation as a Commodity 1850–1980," *Perspectives in American History* 12 (1979): 517–60.

71. *Cleveland Plain Dealer* (20 May 1888), 5.

72. See, for example, *Cleveland Plain Dealer* (24 June 1889), 3.

73. See Rotraud Sackerlotzky, *Henry Keller's Summer School in Berlin Heights,* exh. cat. (Cleveland Artists Foundation, 1991).

74. *The Sketch Book* 1 (July 1883): 5.

75. *Cleveland Plain Dealer* (3 October 1892), 8.

76. As noted in an exhibition review in the *Cleveland Plain Dealer* (7 January 1894), 7: "The impressionist school is poorly understood by people in general, and yet it is a strong, vigorous institution and a formidable rival to the realistic one. There are several fine examples on exhibition and, as may be imagined, are misunderstood to a great extent. They are not for casual glances, but for deep study." Quoted in Nancy Coe, "The History of the Collecting of European Paintings and Drawings in the City of Cleveland" (M.A. thesis, Oberlin College, 1955), 25.

77. See the information supplied by Church's daughter, Mrs. Jessie Sargent, in Sam Rosenberg, "Henry Church of Chagrin," in Sidney Janis, *They Taught Themselves: American Primitive Painters of the 20th Century* (New York: Dial, 1942), 103. Lynette I. Rhodes, *American Folk Art: From the Traditional to the Naive,* exh. cat. (Cleveland Museum of Art, 1978), 36 n. 37, notes that, among other volumes from the 1870s and 1880s, Church owned the August 1883 issue of *The Sketch Book*. Jane E. Babinsky and Miriam Church Stem, *The Life and Work of Henry Church, Jr.* (Chagrin Falls, Ohio: privately printed, 1987), unpaginated, notes that Willard lived near his exact contemporary Church when the former's father preached in South Russell in 1850.

78. The problem of dating Church's paintings deserves mention. While he had sketched in charcoal since entering his father's blacksmith shop in 1849 at the age of thirteen, the only firm date for his career as a painter may be that of his father's death in November 1878, when, "finally freed of the parental censorship, [he] took to painting, hunting, and sculpture in earnest" (Sargent quoted in Rosenberg, "Henry Church," 103). Church "painted until the end of his days" (Sargent quoted in Rosenberg, "Henry Church," 102). The dates "late 1870s" for *Still Life* (fig. 52) and "c. 1895–1900" for *The Monkey Picture* (fig. 53) suggested in Jean Lipman and Tom Armstrong, ed., *American Folk Painters of Three Centuries* (New York: Hudson Hills Press, 1980), 178–79, derive from the reasonable assumption that Church's conventional still life preceded his take-off on that format, yet there is no reason to believe that it took him two decades to reformulate the idea motivating the more conventional work. The nearly identical settings in these paintings and the striking "before" and "during" effect they create when viewed together suggests that Church conceived them as pendants, perhaps to be exhibited jointly in Church's Art Museum, his gallery built in Geauga Park around 1888. Rhodes, *American Folk Art,* 27, reproduces a photograph of this building. A photograph of Church working on a still life reproduced in Babinsky and Stem, *Life and Work of Henry Church,* shows a third version of this still-life format framed in the upper left corner. Because Church kept his sculpting secret until the discovery in 1885 of *Rape of the Indian Tribes,* his *Self-Portrait* (fig. 54), which includes a winged sculptor, would not have been done before that year.

79. For another example, see Wagguno, *Fruit and Baltimore Oriole* (1858, National Gallery of Art), reproduced in Deborah Chotner, *American Naive Paintings. The Collections of the National Gallery of Art Systematic Catalogue* (New York and Cambridge, U.K.: Cambridge University Press, 1992), 387.

80. In 1882, six years before Church's Art Museum in Geauga Park, Jeptha Wade donated to the city Wade Park, at first a home for deer to which other animals were gradually added. The first zoo building on the site was erected in 1889.

81. Stonehouse, "A Genius Near Home," *Cleveland Plain Dealer* (12 July 1891), 12.

82. Ibid. While it is clear that the histrionic writing style belongs to Stonehouse, this analysis is based upon an assumption that the sentiments expressed are Church's.

83. "Unique Character," *Chagrin Falls Exponent* (23 April 1908), 4.

84. Information from Sargent, quoted in Ray Turk, "Lifts Mystery Veil from Squaw Rock: Daughter of Smithy Who Made Carving Tells of His Work," *Cleveland News* (7 August 1932), magazine sec., p. 4. My thanks to Victor and Carol Studer for providing the citation data.

85. According to "Unique Character," "the sculptured lion and the lamb with the child to lead them . . . was the expression in stone of his high ideal of what the dawn of right, justice and peace would bring to the world." Because village trustees did not meet Church's proposal with enthusiasm, the sculpture stayed on his front lawn until shortly before his death.

86. A monumental stone frog, made by Church without a site in mind, nearly decorated Public Square in an installation partly conceived by Harvey Rice, who in 1857 had introduced the proposal for erecting the Perry Monument in that space. Around 1887, on a visit to Chagrin Falls, Rice and Jay Athey saw Church's sculpture, purchased it, and charged Church with the task of having it sent downtown by flat car. They probably intended the frog for the southwest quadrant of the square, landscaped at the time with a lagoon. Before it could be installed, however, the sculpture was either stolen or lost.

87. This information, from a typescript after a letter by Bohm's daughter, was provided by Alfred J. Walker Fine Art, Boston.

88. Ford first conceived a similar image for a cleaning-compound manufacturer in 1890. The company officially adopted the logo and slogan in 1905. See Kathleen McDermott and Davis Dyer, *America's Paint Company: A History of Sherwin-Williams* (Cambridge, Mass.: Winthrop, 1991), 27, 50.

89. *Cleveland Plain Dealer* (15 June 1918), 2.

90. On this sequence of events, see John Bodnar, "Public Memory in an American City: Commemoration in Cleveland," in *Commemorations: The Politics of National Identity,* ed. John R. Gillis (Princeton. N.J.: Princeton University Press, 1994), 74–89.

William Sommer, *Bach Chord*, 1923.

Against the Grain: The Modernist Revolt

WE ARE LEFT WONDERING WHAT, after all, really took place in the American provinces in these years before word of the great avant-garde movements of Europe penetrated to the inner sensibilities of the gifted and the aspiring.

—Hilton Kramer, 1970[1]

AROUND 1910 an active modernist movement emerged in Cleveland that remains unacknowledged in American art histories.[2] During the 1920s and 1930s, a period when the Midwest is typically presented as a bastion of regionalist realism, Cleveland artists continued to explore modernist styles. The persistence of this movement challenges the notion that American artists abandoned modernism after 1920 and that prior to the Second World War modernism failed to penetrate beyond a few East Coast cities or very deeply into the national psyche.[3]

The Cleveland modernist movement resists simple definition. Never homogeneous, it embraced a broad spectrum of individuals with varied aesthetic philosophies. Its founders included mid-career artists who had already produced a considerable body of work prior to joining this rebellion against the city's established institutions and cultural traditions. Some artists only lingered at the movement's periphery without ever fully embracing the ideas of the radicals. After the First World War, some of the movement's most celebrated painters reversed themselves and renounced modernism. Even during its heyday, the movement's scope was obscure because the artists belonged to an array of disparate organizations and never united into a single group with a common agenda or title. Despite such complexities, these artists were united—at least for a time—by a shared attraction to the intoxicating ideology of modernism.

The term *modernism* refers to a system of related assumptions and beliefs more than to a period in time.[4] It advocates a radical critique of both the past and the present, posits that prevailing artistic conventions have become exhausted, and crusades for deliberate, revolutionary change. From experimental science modernism borrows a passion for investigating the world through new methodologies. It embraces a spirit of relativism and skepticism, rejects nationalism and localism as parochial, and regards art as a tool for challenging entrenched ideas, social hierarchies, and belief systems. Born in the nineteenth century amid the tumult of political revolutions, modernism exalts individuality and freedom, especially from conventional standards of beauty, morality, and fidelity to nature.

Modernism proliferated in a climate of social, economic, and political upheaval. The invention of photography and the industrial revolution of

the nineteenth century brought cheap, mass-reproduced products into direct competition with the labor-intensive art object. By the century's end, many artists came to regard art as a means of resisting the corrupting power of commercialism and the debased standards of mass production. Confronted by a crisis of role and identity, artists used their metier to redefine the nature and function of art. They invented a myriad of movements or "isms," each articulating a vision of art's purpose in a world that seemed increasingly hostile to the artist's pursuit of free, creative inquiry. Their relentless pursuit of innovation set in motion a protracted cycle of artistic patricides—arguably the hallmark of the modernist era.

LOUIS RORIMER AND THE CLEVELAND "SECESSIONISTS"

LIKE ALFRED STIEGLITZ in New York, Louis Rorimer championed the growth of modernism in his native city. Born in Cleveland to a family of German immigrants, Rorimer attended the Manual School of Training and the Cleveland School (later Institute) of Art.[5] At about age sixteen, he went abroad to study applied arts in Munich and Paris. On returning to Cleveland in 1895, he opened his own studio for producing handmade furniture. Disturbed by the debased quality of mass-produced industrial products, Rorimer campaigned to raise aesthetic standards by stressing individuality and originality of design in finely crafted decorative arts (see fig. 178).[6] In 1898 he began teaching at the Cleveland School of Art. In 1909 he collaborated with Henry Keller in establishing the school's design department, with a curriculum that embraced the study of decorative ornament, color theory, and non-Western art. Among the many students who passed through Rorimer's classes were Horace Potter, Abel Warshawsky, Max Kalish, and Charles Burchfield.

In the fall of 1910 Rorimer's former pupil Abel Warshawsky returned to Cleveland after three years in France, where he had painted with pure, brilliant color inspired by the impressionists and post-impressionists. According to Warshawsky, Rorimer was enthusiastic about his new paintings but cautioned that "compared with the dark brown school of painting then prevalent . . . my canvases would appear like a pyrotechnical display."[7] Despite this warning, Warshawsky exhibited his recent paintings at the Rorimer-Brooks Studios. Although one Cleveland newspaper attributed Warshawsky's thickly painted surfaces to the "evil influence of [Paul] Cézanne," a group of artists—including Gustav Hugger, Hugo Robus, William Sommer, and William Zorach—were so impressed they persuaded Warshawsky to provide group classes in the evenings and on Sundays.[8]

In March 1911 Keller, Sommer, Warshawsky, and others sympathetic to experimental art organized themselves as the "secessionists" and held their first group exhibition at the Rorimer-Brooks Studios.[9] For several years the secessionists remained at the forefront of the Cleveland modernist movement. Their exhibitions, modeled after the Independents in New York and various secessionist groups in Europe, were conceived as an alternative to the annual juried exhibitions held at the Cleveland School of Art since 1906. Like the salons sponsored by various national art academies, the art school exhibitions were controlled by conservative juries. Rebelling against this system, the secessionists aspired to promote artistic freedom and individuality through exhibitions without juries or prizes. To sustain coherence and quality, however, they restricted entries to members and invited colleagues. Although the secessionists did not exhibit exclusively together, they felt a solidarity of purpose in opposing the city's established art clubs and institutions. An early skirmish occurred in April 1911 when the jurors for a citywide exhibition at the Rowfant Club rejected

Warshawsky's paintings, and only reversed themselves after one member, Henry Keller, threatened to resign in protest.[10]

HENRY KELLER AND THE BERLIN HEIGHTS ARTISTS

HENRY KELLER, whose work "is inevitably the starting point for any study of Cleveland painters," was born on a ship to a family of German immigrants bound for America.[11] He spent his early years in Cleveland designing circus posters for the Morgan Lithograph Company. In 1899 he went abroad to study at art academies in Düsseldorf and Munich, where he painted outdoor studies in brilliant, impressionist colors. In 1902, after receiving a silver medal at a Munich salon, he returned home to assume his forty-year teaching tenure at the Cleveland School of Art.

Around 1903 Keller began spending his summers painting on family-owned farmland in Berlin Heights, Ohio, a small town about forty miles west of Cleveland, accessible by train, and within walking distance of Lake Erie. To supplement his income he gave painting lessons in Berlin Heights, which by 1909 had become formalized into the Henry Keller Summer School. With Keller's encouragement, students and colleagues from Cleveland began flocking to this rural retreat by the lake. The Berlin Heights summer colony remained active until the early 1920s and attracted some of Cleveland's leading artists, including August Biehle, Clara Deike, William Eastman, Grace Kelly, and Frank Wilcox.

Around 1910 Keller's enthusiasm for impressionism, or art based on the direct transcription of observed reality, waned in favor of a growing preoccupation with theoretical design. This new interest was inspired partly by his study of the color theories of James Maxell, Ogden Rood, and Hermann von Helmholtz. From 1910 to 1913 Keller collaborated with physiologist John MacCleod of Western Reserve Medical School on a series of experiments, the results of which they published in an article that criticized academic painting for its dull, unimaginative color.[12] Conversely, Keller and MacCleod praised the inventive color of the post-impressionists and fauves as necessitated by psychological laws of compositional harmony.

Keller's reputation as Cleveland's leading modernist dates from 1913, when two of his paintings appeared in the Armory Show. Keller distributed posters throughout Cleveland advertising this enormous international exhibition, which opened in New York before traveling to Chicago and Boston, and which is often cited as the watershed event that introduced modernism to America. In late February, after spending a week at the exhibition in New York, he returned to Cleveland and, in five public lectures at the Potter Studios, surveyed the major movements in modern art. Covering topics from post-impressionism to futurism, Keller asserted that modernism began with the post-impressionist proclivity to distort form and color according the needs of compositional harmony and emotional expression. Interpreting modernism as a corrective response to the corrupting influence of naturalism, Keller urged artists to be "creators" rather than copyists. He regarded Cézanne as the pioneer of modern pictorial design, noting that Cézanne unified his compositions through abstract structural rhythms. He credited Cézanne with inventing the technique of surrounding forms with an intense blue outline as a means of creating sensations of three-dimensional volume without resorting to the dulling effect of shading with tones. Following the precedents he observed in the paintings of Cézanne and Henri Matisse (fig. 62), Keller surrounded the figures in *Wisdom and Destiny* (fig. 63) with intense blue outlines.

The contrast between Keller's *Disturbed* (fig. 64) and *Wisdom and Destiny* demonstrates the new direction his art took after 1910. He obviously

considered both works major statements because he sent *Disturbed* to the Carnegie Institute's prestigious annual exhibition of 1910 and *Wisdom and Destiny* to the Armory Show of 1913. The broken brushwork and high-key color of *Disturbed* create the effect of outdoor light and atmosphere, as if the scene had been painted directly from nature. *Wisdom and Destiny,* by contrast, is an allegorical theme based on a poem by the Belgian Symbolist Maurice Maeterlinck. The hooded figure is an allegory of Wisdom, the nude woman looking at a glass ball (probably symbolizing the sphere of life) represents Destiny, and the man on the left is Arcady, here depicted as a carefree shepherd, unburdened by wisdom and untroubled by thoughts of destiny. The figures are outlined in dark blue, while the juxtaposition of red and green in the robes is intended to heighten color intensity through the law of complementary contrasts..

Keller's new approach disturbed one Cleveland art critic enough to recommend that he abandon the "post-impressionism" of *Wisdom and Destiny* and return to the more pleasing "impressionist" style of *Disturbed*.[13] This criticism seems ironic in retrospect because the literary subject and naturalistic space of *Wisdom and Destiny* are not that far removed from Kenyon Cox's academic painting *Tradition* (fig. 65). In contrast to his large salon compositions, Keller took greater liberties with the small experimental studies he painted at Berlin Heights. He displayed a particular passion for the painting process in *Student at Work* (fig. 66) as evidenced by the intense color, energetic brushwork, and areas of exposed canvas.

Figure 62. Henri Matisse (French, 1869–1954). *Blue Nude,* 1907, oil on canvas, 36¼ x 55¼ in. (92.1 x 140.3 cm). The Baltimore Museum of Art; the Cone Collection formed by Dr. Claribel Cone and Miss Etta Cone of Baltimore, Maryland. [not in exhibition]

Figure 63. Henry Keller, *Wisdom and Destiny,* 1911, oil on canvas, 30⅛ x 40⅛ in. (76.5 x 102 cm). The Cleveland Museum of Art, gift of Mrs. Henry A. Everett for the Dorothy Burnham Everett Memorial Collection.

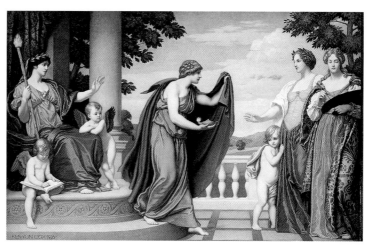

Figure 64. Henry Keller, *Disturbed,* 1908, oil on canvas, 36 x 36 in. (91.5 x 91.5 cm). The Cleveland Museum of Art, gift of the Korner & Wood Company. [not in exhibition]

Figure 65. Kenyon Cox, *Tradition,* 1916, oil on canvas, 41¾ x 65¼ in. (106 x 165.5 cm). The Cleveland Museum of Art, gift of J. D. Cox. [not in exhibition]

Figure 66. Henry Keller, *Student at Work,* ca. 1912, oil on canvas, 18 x 12 in. (45.7 x 30.5 cm). Fawick Art Gallery, Baldwin-Wallace College.

Figure 67. Clara Deike, *Sunflowers and Chickens,* 1912, gouache on canvas, 14½ x 19¾ in. (36.8 x 50.2 cm). Fawick Art Gallery, Baldwin-Wallace College.

Under Keller's leadership, other artists at Berlin Heights experimented with post-impressionist methods of compressing space and applying pure color unmodulated by shading. Clara Deike's gouache *Sunflowers and Chickens* (fig. 67) exhibits the essential features of the Berlin Heights style: forms are simplified into bold shapes with strong two-dimensional silhouettes; space is suggested by the optical interaction of pure color

Figure 68. Henry Keller, *Study in Abstraction,* ca. 1912, gouache, 12 x 10 in. (30.5 x 25.4 cm). Fawick Art Gallery, Baldwin-Wallace College.

rather than through tonal gradations; and shadows are rendered with intense violet or blue. This style, seen in paintings exhibited at various Cleveland galleries, became popular with progressive artists throughout the city, including Charles Burchfield.

Between 1911 and 1914 Keller painted a series of studies in various modernist styles. He experimented with the flat, decorative shapes of the nabis, the pure colors of the fauves, the geometric shapes of the cubists, and the sharply fragmented forms of the futurists. In 1913 he announced that art was entering a new era of abstraction and that painters were on the verge of discovering a new, metaphysical dimension in art.[14] His own research in this direction is seen in an experimental study that approaches total abstraction (fig. 68), with hints of burning trees and dark meteoric forms reminiscent of Wassily Kandinsky's apocalyptic landscapes.

WILLIAM SOMMER AND WILLIAM ZORACH

WILLIAM SOMMER AND WILLIAM ZORACH were the most radical members of the Cleveland modernist movement. Although Sommer was considerably older than Zorach, they shared remarkably similar ideas and experiences. Sommer was born in Detroit to poor German immigrants and dropped out of school at the age of fourteen to apprentice in commercial lithography. By 1890 he had saved enough money to afford a year of formal art study in Munich, but immediately afterward he returned to America and spent the next sixteen years working as a commercial lithographer in New York City. Zorach was born to poor Lithuanian immigrants and grew up in the Cleveland slums. He left school after eighth grade to work odd jobs, eventually apprenticing at a lithography shop.[15]

In 1907 Sommer moved to Cleveland to accept a position at Otis Lithography, where the eighteen-year-old Zorach was serving his apprenticeship. They quickly became friends and began painting together in their free time. "From him," Zorach wrote, "I learned the difference between a real artist and a commercial artist—and the idealism which is the basis of the true artist."[16] Zorach even honored his friend by painting his portrait (fig. 69) in the same dark, tonalist style that Sommer had learned in Munich.

Sommer and Zorach were profoundly impressed with the brilliantly colored paintings that Warshawsky exhibited at the Rorimer-Brooks Studios in the fall of 1910. That November, Zorach and fellow lithographer Elmer Brubeck accepted Warshawsky's advice and left for Paris to discover European modernism for themselves. Sommer would probably have joined them if he had not been supporting a family of five. During Zorach's absence, Sommer became involved in the founding of two art organizations: the previously mentioned secessionists and the Kokoon Klub.

The Kokoon Klub was established in August 1911 by Sommer and Carl Moellmann. Like many of the club's founding members, Sommer and Moellmann had moved to Cleveland to work in the city's booming lithography industry. Lacking any institutional affiliation, they formed this artists' organization and converted a tailor's shop into a working studio and gallery where they could paint and exhibit independently. The Kokoon Klub mounted its first group exhibition in November 1911. Insisting that the organization did not exist for commercial purposes, they initially displayed their paintings without titles or signatures. The members were divided, however, in their aesthetic philosophies. The moderates, led by Moellmann, admired the earthy, gritty realism of Robert Henri and hoped to model the club after the New York Kit-Kat Club. The radicals, led by Sommer, were more sympathetic to the European avant-garde. Apparently expressing the radical view, a Cleveland magazine reported that the word

Figure 69. William Zorach, *William Sommer,* 1907, oil on canvas, 18½ x 12½ in. (47 x 31.8 cm). Joseph M. Erdelac Collection. [not in exhibition]

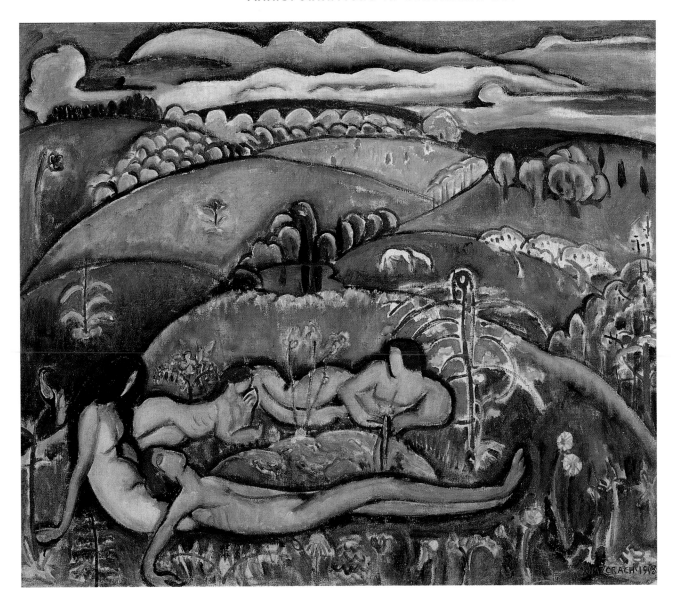

Figure 70. William Zorach, *Spring,* 1913
(recto of double-sided canvas), oil on canvas,
31¾ x 36¾ in. (80.6 x 93.4 cm). The Jamee
and Marshall Field Collection.

kokoon was chosen because it symbolized protecting the embryo of indi-
vidual genius so it might break free of the naturalist tradition.[17]

In late 1911 Zorach returned from Paris, where he had met Gertrude
Stein and encountered paintings by Picasso and Matisse. Once back in
Cleveland, Zorach resumed his job at the lithography shop and began ex-
perimenting with pure color. His new approach impressed his colleagues,
especially Sommer. "Bill immediately swung into the more abstract paint-
ing," Zorach recalled.[18] In February 1912, a year after the founding of the
secessionists, Zorach joined them in a group exhibition at the Taylor Gal-
lery. Among the participating artists were Brubeck, Keller, Sommer,
Warshawsky, Zorach, Gustav Hugger, and Caroline Osborn. The press re-
ported that visitors broke into discussions of Matisse when standing before
Zorach's "wondrous roses and other primary arrangements."[19] Two months
later the Taylor Gallery organized Zorach's first solo exhibition, and Zorach
participated in another secessionist exhibition at the Rowfant Club. When
the latter exhibition was poorly received, Keller complained publicly about
the lack of appreciation for "progressive" art in Cleveland.[20]

Although Zorach moved to New York in late 1912, he continued to ex-
hibit at the Kokoon Klub and other Cleveland venues. In 1914 he sent a
painting titled *Spring* to a group exhibition at the Taylor Gallery. This

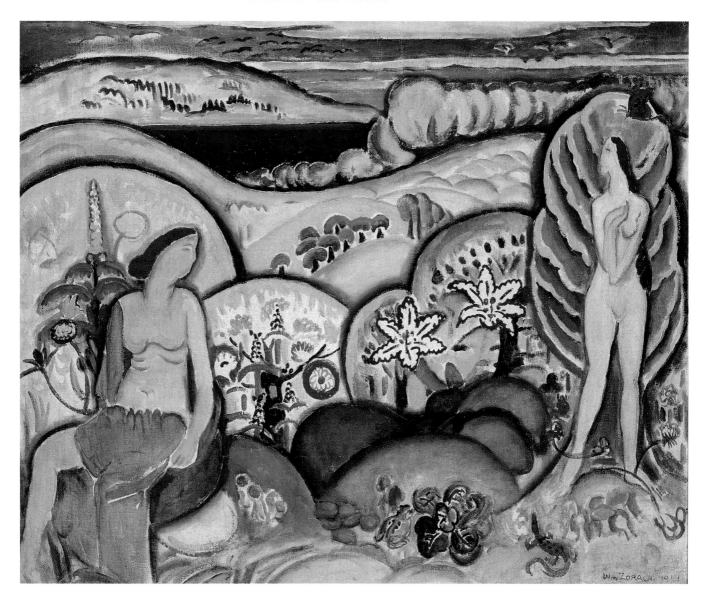

Figure 71. William Zorach, *Untitled* (Summer), 1914 (verso of double-sided canvas), oil on canvas, 31¾ x 36¾ in. (80.6 x 93.4 cm). The Jamee and Marshall Field Collection.

Figure 72. Wassily Kandinsky. *Cover for* Der Blaue Reiter *Almanac,* 1912, 11 x 8 in. (28 x 20.3 cm). Frederick C. Biehle Collection. [not in exhibition]

painting may have been Zorach's double-sided canvas displaying *Spring* on the front (fig. 70) and an untitled allegory on the back (fig. 71).[21] Both images are utopian visions of nudes in a landscape, with echoing colors and shapes that symbolize the integration of man and nature. Egg-like and flowering phallic shapes hint at nature's fecundity, while the sensuous colors amplify the overt eroticism of the nudes. These compositions were likely inspired in style and subject by Matisse's *La Joie de Vivre* (1905–6, Barnes Foundation, Philadelphia) although the landscape forms also suggest parallels with Marsden Hartley's symbolic paintings of 1912–14.[22]

August Biehle joined the Cleveland modernist movement in 1912, contributing to its gathering momentum. The son of a German-immigrant decorator, Biehle received his initial art training in Cleveland before going to Munich in 1903 and again in 1910 for two years of study. While living in Munich he became aware of the activities of Der Blaue Reiter (the Blue Rider), an avant-garde artists' organization founded in that city in late 1911 by Franz Marc and Wassily Kandinsky. Biehle returned to Cleveland in the summer of 1912 with a copy of *Der Blaue Reiter* (fig. 72), an illustrated book setting forth the group's philosophy (Kandinsky designed the horse and rider on the cover). In September 1912 the Rorimer-Brooks Studios exhibited a selection of paintings by Biehle, who said nature was only

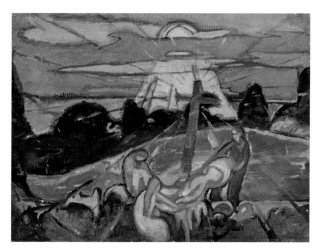

Figure 73. August Biehle, *The Deposition,* 1913, oil on board, 21¼ x 29½ in. (54 x 75 cm). Stephen F. Biehle Collection.

the starting point for these experiments in decorative design.[23] The contrast between Biehle's *Fire Tug on the Cuyahoga* (see fig. 60) and the *Deposition* (fig. 73) demonstrates that his Munich trip occasioned a radical transformation in his art. While the earlier painting was inspired by direct observation of nature, the latter is a visionary interpretation of a mystical subject, conveyed through imaginary color and form. Biehle's new approach resonated with the Cleveland modernists, who were fascinated by his copy of *Der Blaue Reiter.* As a result of this blossoming relationship, Biehle began an apprenticeship under Sommer at Otis Lithography and became active in the Kokoon Klub.

By 1913 Sommer was also experimenting with radical distortions of form and color. His principal sources of inspiration were paintings by Zorach and Biehle, reproductions in *Der Blaue Reiter,* and paintings by Matisse and Kandinsky he had seen in the Armory Show. While Sommer had used a tonalist palette prior to 1910, his painting *The Red Cottage* (fig. 74) explodes with intense, vibrant color. The electric violets and reds of the cottage are applied wildly, as if with deliberate disregard for the heavy outlines that are unable to contain them. The unpainted areas around the cottage illustrate why Sommer's paintings were sometimes criticized for lacking finish; however, he never concerned himself with such orthodox aes-

Figure 74. William Sommer, *The Red Cottage,* ca. 1914, oil on board, 19¾ x 26¼ in. (50.1 x 66.7 cm). Joseph M. Erdelac Collection.

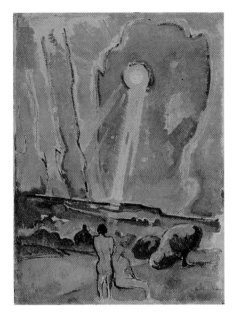

Figure 75. William Sommer, *Adam and Eve on the First Morn,* ca. 1915, oil on board, 32 x 24 in. (81.2 x 61 cm). Joseph M. Erdelac Collection. [not in exhibition]

Figure 76. William Sommer, *The Three Graces,* ca. 1916, watercolor, 12 x 16 in. (30.5 x 40.6 cm). Cleveland Artists Foundation.

Figure 77. William Sommer, *Psyche,* ca. 1916, oil on board, 21 x 12½ in. (53.3 x 31.8 cm). Joseph M. Erdelac Collection.

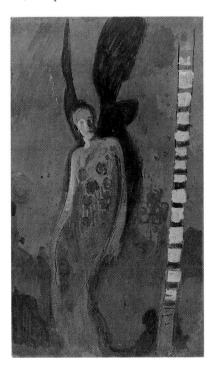

thetic criteria. Rather than control, he sought spontaneous, intuitive, emotional experience—revelatory bursts of charged, ecstatic energy. In 1916 he announced:

> Since I dropped the old way of painting and have become free from conventions, I have developed myself in an original way. We post-impressionists are beyond copying. . . . I believe art should be as spontaneous as the song of a bird. No one taught the bird to sing. I do not care a snap for academic proportions.[24]

Sommer's art was heavily influenced by his fascination with poetry and philosophy. His pursuit of transcendent spirituality derived partly from his admiration for Arthur Schopenhauer and German idealist philosophy.[25] Sommer's infatuation with the philosophy of Friedrich Nietzsche and the poetry of Ezra Pound validated his exaltation of power and energy over the conventionally beautiful or pleasing. Nietzsche, in particular, affirmed Sommer's conviction that art must at times appear ugly, brutal, even barbaric. Sommer's paintings *Adam and Eve on the First Morn* (fig. 75) and *Three Graces* (fig. 76) express his ambition of throwing off the shackles of civilization and returning to basic, primitive instincts. The women in the

Three Graces raise their arms in unison to create abstract rhythms that unite their naked bodies with the cosmos. Their ecstatic dance seems to affirm the Nietzschean "will to power" through unrestrained sexuality. In 1915 Raymond O'Neil, one of the few Cleveland art critics to support Sommer and the Kokoon Klub modernists, quoted "the wise" Nietzsche as having said: "To the existence of art, to the existence of any aesthetic activity, a preliminary psychological condition is indispensable, namely ecstasy." O'Neil specified that by ecstasy he meant intensified sensation, power, sexual excitement, desire, emotion, and above all: "ecstasy of the surcharged will."[26]

In later years Sommer was increasingly influenced by the Russian philosopher Petr Uspenskii, who asserted that reality exists at a mysterious, psychic level beyond the world of everyday thought or knowledge. Uspenskii inspired Sommer to concentrate on spiritual experience and the vital "life force" of objects. Believing that true reality exists not in the material world but in the mysterious realm of dreams and imagination, Sommer wrote in one of his notebooks:

> Art is no longer a sensation we take up with the eyes alone. Art is the creation of our spiritual, inward vision, nature just starts us off. Instead

Figure 78. William Sommer, *Horse Drawn Cart in Thunderstorm,* ca. 1918, oil on board, 20 x 25½ in. (51 x 64.8 cm). Joseph M. Erdelac Collection.

of working with the eyes we conceive with the unconscious and thus the [the artist's] complete changing of nature.[27]

The closed eyes of the winged muse in Sommer's painting *Psyche* (fig. 77), depicting the Greek personification of the soul, embodies this quest for inward-turning, visionary experience. To explore the subconscious, Sommer painted as spontaneously as possible, at times disregarding technical control or finish. He continued this striving for emotional intensity in *Horse Drawn Cart in Thunderstorm* (fig. 78), as well as his paintings of the early 1920s (see fig. 91).

CHARLES BURCHFIELD AND THE CLEVELAND SCHOOL OF ART

ALTHOUGH CHARLES BURCHFIELD WAS A PIVOTAL FIGURE in the Cleveland modernist movement, art critics and historians have presented him as a self-invented artist who forged his own path in the "wilderness" of the Midwest. This perception still persists even among national art critics, who are unaware of the early history of modernism in the "provinces." The myth of Burchfield's "virgin" birth originated in the late 1920s, when it served the ideological needs of American isolationists and cultural nationalists. In 1928 the artist Edward Hopper wrote:

> Burchfield has been said to be one hundred percent American. He is all that and more. . . . He seems to be the latest in the line of our painters who have been race-conscious. . . . He has spent most of his life away from the groups of ultra-sophisticates and tongue-in-the-cheek *cognoscenti* who are found in our great cities.[28]

In 1930 Alfred Barr, director of the Museum of Modern Art, validated this tendency to regard Burchfield as an American log-cabin genius: "It is impossible to discover any important external influence upon Burchfield's art. . . . He was almost completely ignorant of what had happened in Europe."[29] In 1935 the art critic Thomas Craven continued the trend of dismissing Burchfield's experiences in Cleveland:

Figure 79. Charles Burchfield, *Easter Dance Poster,* 1913, gouache on board, 28 x 22 in. (71 x 56 cm). Kennedy Galleries, Inc. [not in exhibition]

Figure 80. Charles Burchfield, *Untitled* (Clump of Purple Trees), 1915, watercolor, gouache, and graphite, 13½ x 19½ in. (34.3 x 49.5 cm). Burchfield-Penney Art Center, Buffalo State College, gift of Tony Sisti.

Burchfield frequented an art school in Cleveland, and managed to survive it. Had he been made of the usual plastic stuff, he would have submitted to the Franco-American system of preparing young students for a post-graduate course in Parisian fads. . . . [He] avoided New York and the contagion of cults.[30]

Attempts to perpetuate the myth of Burchfield's artistic "purity," as if he had been inoculated from the contagion of culture by his self-imposed isolation in the hinterlands of the Midwest, has been a consistent refrain of art historians who assert that Burchfield was unaffected by modern art. Burchfield's activities in Cleveland suggest otherwise.

Burchfield grew up in Salem, Ohio, a small town about sixty miles east of Cleveland. Although his high school teachers hoped he would become a Latin scholar, he enrolled in the Cleveland School of Art in 1912 with the intention of eventually entering the lucrative field of commercial illustration. Rather than a traditional beaux-arts academy, this institution had been founded in 1882 as a school of design for women. At the time Burchfield entered, Principal Georgie Leighton Norton still insisted that most students wanted a "practical" education and that the school existed to provide business and industry with designers, illustrators, and craftsmen—a mission of particular importance to Cleveland in light of the continuing influx of unemployed immigrants.[31] Norton derived this emphasis on social service and vocational training from her studies at Boston's Normal Art School, where any art aspiring to intellectual revolt or sensual pleasure was regarded with suspicion.

The rest of the staff at the Cleveland School of Art held conflicting opinions about the purpose of art training. "The faculty, at the time I entered

the school," Burchfield observed, "was composed of an oddly assorted group of individuals of conflicting aims and purposes."[32] Conservatives dominated the fine arts classes. Frederick Gottwald, a senior faculty member whose tenure dated to 1885, headed the Pictorial Art course. As such, he taught introductory drawing and all levels of oil painting, including the most advanced level—painting from life. Gottwald regarded "modern" art, meaning everything from post-impressionism to cubism, as either a deliberate fraud or debased lunacy. His opinions were shared by May Ames, the school's art history teacher, and Grace Kelly, an instructor of watercolor painting who later became the city's most influential art critic.[33]

Burchfield hated Gottwald's freshman drawing class and quickly gravitated toward the more progressive faculty in the design department.[34] Louis Rorimer headed the department, Henry Keller taught illustration, Frank Wilcox taught applied design, and William Eastman taught design theory.[35] Keller and Eastman encouraged Burchfield to study modern and non-Western art, including Japanese prints and Chinese scroll paintings, both of which could be seen at exhibitions in Cleveland.[36] Keller particularly impressed students with his theory that Cézanne's system of structuring his post-impressionist paintings was analogous to the Chinese method of arranging simplified, flattened shapes in a compressed space of tightly integrated, overlapping planes.

Burchfield's talent at design was recognized during his freshman year when he received several honorable mentions and a first place in school poster competitions. His *Easter Dance Poster* (fig. 79), completed during the spring of his freshman year, displays his facility at transforming natural objects into rhythmic patterns of flat stylized shapes, undoubtedly influenced by the design curriculum established by Rorimer and Keller. Reflecting on his first year at school, Burchfield wrote: "Design was my

Figure 81. William Sommer, *Viaduct at Sunset,* ca. 1914, watercolor and gouache over graphite, 11⅛ x 14⁵⁄₁₆ in. (28.3 x 36.4 cm). The Cleveland Museum of Art, gift of Dr. and Mrs. Theodor W. Braasch.

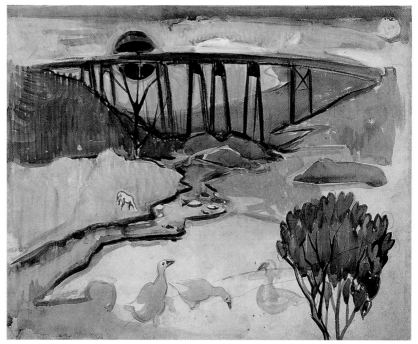

special field. It was the one thing in which I excelled and which was the solace for some of my disappointments in other classes. . . . Keller also said my feeling for design amounted 'almost to genius.' "[37]

In the fall of 1914 Burchfield began attending the exhibitions and soirees of the Kokoon Klub, where he encountered Keller's experimental paintings.[38] Burchfield certainly knew of the Klub's "Nuit Futuriste," held

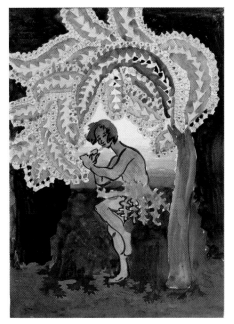

Figure 82. Charles Burchfield, *Landscape with Faun,* 1915, watercolor, 14 x 10 in. (35.6 x 25.4 cm). Courtesy Kennedy Galleries, Inc.

in the spring of 1915, at which Keller and others imitated the British vorticists and dubbed themselves the "blasts." In March of that year Burchfield noted in his journal that Keller "has volunteered to show me the post-impressionist method of using the blue outline."[39] Burchfield's watercolor *Untitled* (Clump of Purple Trees) (fig. 80), depicting Wade Park and the Amasa Stone Chapel on Euclid Avenue in the background, borrows its flattened forms and blue/violet shadows from the Berlin Heights style, also seen in Deike's *Sunflowers and Chickens* (see fig. 67).

Toward the end of March, after seeing the five Zorach paintings on permanent display at the Kokoon Klub, Burchfield decided to meet "Big Bill Sommer" and hopped the interurban trolley to Brandywine, about twenty miles south of Cleveland, where Sommer had recently established a studio in an abandoned schoolhouse.[40] Burchfield was accompanied on this trip by Eastman, Wilcox, and Walter Heller—all members of the Kokoon Klub and junior instructors at the Cleveland School of Art.

Burchfield discovered that for several years Sommer and Zorach had been painting imaginative subjects charged with emotional intensity and brilliant fauvist color. Sharing a common disdain for conventional art, they sought relief through noncommercial experiments with abstract color and imaginary subjects. They believed art should explore dreams and the subconscious and aspired to convey feelings of emotional intensity and spiritual vitality in their paintings. As Zorach wrote: "It is the inner spirit of things that I seek to express, the essential relations of forms and colors to universal things. Each form and color has a spiritual significance to me."[41] Echoes of Zorach's untitled allegory (see fig. 71) and Sommer's *Viaduct at Sunset* (fig. 81) appear in Burchfield's *Landscape with Faun* (fig. 82). The explosive color of Burchfield's painting *Summer* (fig. 83) also suggests inspiration from Zorach and Sommer.

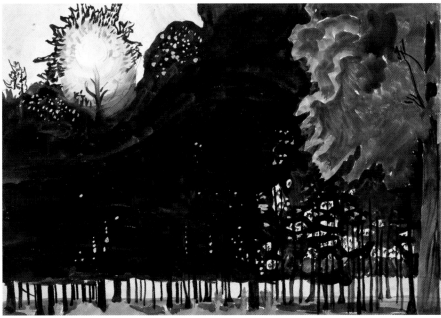

Figure 83. Charles Burchfield, *Summer,* ca. 1915, watercolor, 13⅞ x 9¾ in. (35.2 x 24.8 cm). Private collection.

Figure 84. Charles Burchfield, *Afternoon in the Grove,* 1916, watercolor and graphite, 14 x 20 in. (35.6 x 51 cm). Burchfield-Penney Art Center, Buffalo State College, gift of Tony Sisti.

Burchfield derived more than stylistic models from Sommer and Zorach, as he followed their striving to convey transcendent, spiritual experience through symbolic form and color. Comparing Burchfield's *Afternoon in the Grove* (fig. 84) with Sommer's *Viaduct at Sunset* offers one of many examples of how Burchfield emulated Sommer's motifs of radiant suns and moons. The rising tree branches and electric colors in Burchfield's watercolor *Summer,* which seem to symbolize a state of spiritual awakening, are also reminiscent of the tree behind the nude on the far right of Zorach's allegory. Burchfield's enduring attraction to watercolor, his preferred medium, may also be indebted to Sommer and Zorach, who both worked extensively in that medium because its demand for rapid execution facilitated the spontaneous exploration of subconscious, emotional states.

THE NIETZSCHEAN REVOLT

BURCHFIELD'S RECEPTIVITY to modernist painting was prepared by his earlier exposure to the philosophy of Friedrich Nietzsche. When Burchfield arrived at the Cleveland School of Art, Nietzsche's writings were the most hotly debated topic of discussion among the students. "Nietzsche at once commands our respect," Burchfield jotted in his journal in October 1914.[42] The following month Burchfield wrote of his desire to be free of Christian

Figure 85. Charles Burchfield, *Self-Portrait,* 1916, watercolor, graphite, and conté crayon, 19¹³⁄₁₆ x 13⅝ in. (50.3 x 34.6 cm). The Charles Rand Penney Collection of Works by Charles E. Burchfield, Burchfield-Penney Art Center, Buffalo State College.

dogma so he could "look at nature with an innocent eye." He continued, "My salvation is that I think neither of God or eternity. The present!"[43] In November 1914 Burchfield voted against Prohibition because he considered it "a blow at personal liberty," and for a straight Socialist ticket because "their principles mean the freedom of humanity from graft and greed."[44] Nietzsche's denunciation of middle-class "slave" mentality, and his exaltation of the artist as a superior being exempt from accepted codes of social behavior and cultural traditions, resonated with Burchfield and the Cleveland modernists. The intensity of their self-analysis, as well as their Nietzschean glorification of the artist as an oracle of revolutionary ideas, is keenly felt in their self-portraits (figs. 85, 86).

Although Burchfield later renounced his youthful attraction to Nietzsche, his decision to abandon commercial illustration during his student years must be considered in the context of the revolt against materialism that Nietzsche inspired among the Cleveland modernists. Most of the city's artists came from poor or lower middle-class families, and even after professional training they entertained little hope of supporting themselves through "creative" work. Although a few individuals survived by teaching or painting portraits, most artists were forced to support themselves as commercial lithographers, designers, illustrators, or decorators.

Figure 86. William Sommer, *Self-Portrait,* ca. 1917, watercolor, 12 x 9½ in. (30.5 x 24 cm). Joseph M. Erdelac Collection.

Many artists in this predicament became embittered against America's business culture. Sommer and Zorach detested the work they produced as commercial lithographers, prompting Sommer to throw down his lithographic crayons in disgust from time to time and disappear for days on drinking binges. "I remember how fed up he got working day and night at the shop," Zorach recalled, "how depressed he was and how desperate to get some painting done on Sundays—and holidays."[45] Another co-worker observed: "Bill hated to go back to his job. He reminded us constantly that he was being crucified at the lithographic plant."[46] Zorach experienced similar feelings after his return from Europe:

> America was so busy, so business-like. . . . I got my job back at the lithograph shop and worked day and night. I felt like a slave. . . . No depression I have ever suffered through was more desperate and overwhelming than my return to America.[47]

Although Warshawsky visited Cleveland frequently to see family and to exhibit, he lived mostly in France and confessed to a local newspaper: "For some reason or other I cannot work here. . . . The artist is considered with contempt because he has no money."[48]

Many Cleveland modernists shared Warshawsky's alienation from a society that seemed obsessed with the pursuit of material wealth. In March 1915 Burchfield wrote of a conversation with one of his instructors:

Figure 87. Charles Burchfield, *Church Bells Ringing, Rainy Winter Night,* 1917, watercolor, gouache, and graphite on two sheets of paper, 30¼ x 19¾ in. (77 x 50.2 cm). The Cleveland Museum of Art, gift of Mrs. Louise M. Dunn in memory of Henry G. Keller.

[Frank] Wilcox was talking today of the downfall of Oriental Art and civilization due to the advent of materialistic Capitalism. . . . Materialism it must seem is the cause of most [of] the world's ills . . . exploitation is one of the most horrible as it means the destruction of the great Hindu, Chinese, and Japanese arts and cultures. These nations, once full of the poetry of life, are fast becoming as grossly materialistic as Occidents.[49]

That summer Burchfield expressed his own anti-materialist attitudes while making sketches for a mural, about which he wrote: "The Indian myth 'Hiawatha' is to be the basis. In the great tragedy of the Indian race being exterminated by the European is to be symbolized the greater tragedy of nature being lost and destroyed by commercialism."[50]

Cleveland modernists sought release from this situation through art based on emotional, spiritual experience. It was in this milieu that Burchfield discovered that making art could be a creative investigation of the inner, spiritual life of the mind, rather than a mere trade or craft. "When I am going to school," Burchfield wrote in October 1913, "I am an artist."[51] He also discovered that drawing was not merely a technical skill, but a matter of conceiving original thoughts and ideas.[52] By 1914 these ideas had crystallized enough for Burchfield to consider altering the direction of his life. When Wilcox asked if he still intended to become an illustrator, Burchfield replied, "Not ultimately." "Oh," Wilcox said, "you want to be an artist. You're crazy too like some of the rest of us."[53]

Despite being described by Cleveland newspapers as a "genius," Burchfield found few buyers for his paintings.[54] After graduating from art school in the spring of 1916, he began working full-time as an account clerk in Salem. For the next five years he remained active in the Cleveland art community and participated in more than ten Cleveland exhibitions, including six solo shows. Yet, as a result of his poor financial prospects, he broke off his engagement with Alice Bailey, a fellow art student with whom he had fallen in love, and became depressed and suicidal.[55] In 1917, haunted by nightmares and fears of going mad, he filled nearly six notebooks with symbolic motifs for psychological states, including insanity, melancholy, morbidness, and fear. He labeled these notebooks "Conventions for Abstract Thought."

In December 1917 Burchfield painted one of his most memorable images, *Church Bells Ringing, Rainy Winter Night* (fig. 87). He later described its origins:

> It was an attempt to express a childhood emotion—a rainy winter night—the church bell is ringing and it terrifies me (the child)—the bell ringing motive reaches out and saturates the rainy sky—the roofs of the houses dripping with rain are influenced; the child attempts to be comforted by the thoughts of candle lights and Christmas trees, but the fear of the black, rainy night is overpowering.[56]

Comparing this painting with the church (fig. 88) reveals how Burchfield transformed the tower and its round windows into a hallucinatory form that suggests the approach of a predatory bird. He imaginatively exposed the interior of the lantern tower to reveal a swaying bell and then combined the shape of the bell with his symbolic motif for "fear" to create a "sound/emotion" that reverberates through the dark, rainy night.

Figure 88. First Baptist Church in Salem, Ohio, as it appeared in 1917. [not in exhibition]

THE PLAY HOUSE AND LAUKHUFF'S BOOKSTORE

Figure 89. William Lescaze, *Bookmark for Richard Laukhuff,* 1920–23. Special Collections, Case Western Reserve University. [not in exhibition]

Figure 90. William Lescaze, *Bookplate for Hart Crane,* 1920–23. Special Collections, Case Western Reserve University. [not in exhibition]

AROUND 1916 the focus of modernist activity in Cleveland shifted from the Kokoon Klub to the Play House and Laukhuff's Bookstore. Rather than a conventional theater, the Play House was founded in 1916 as a workshop for experimental art, music, poetry, and dance. Embracing the slogan "democracy in art," it welcomed immigrants and organized events celebrating the city's diverse cultures, such as nights of ethnic music and folk dances.[57] The organization selected the art and drama critic Raymond O'Neil to be its first director. O'Neil hoped to model the organization after Max Reinhardt's avant-garde theater and the Moscow Art Theater, which he had visited on trips to Germany and Russia.[58]

Sommer and Keller were among the guiding forces behind the Play House, which included poets and musicians but no professional actors. In 1918 Sommer designed the set, costumes, and program for a Play House performance of *Everyman.* A reviewer described Sommer's costumes as "symbolic rather than historical" and his curved set as a "cyclorama" illuminated by "ultra-modern lighting."[59] The Play House also sponsored art exhibitions, including solo and group exhibitions that brought together works by Burchfield, Deike, Keller, Osborn, Robus, Sommer, Warshawsky, and Zorach.

In 1916 Richard Laukhuff, a German-immigrant intellectual, created another hub of modernist activity when he opened a bookstore in the Taylor Arcade.[60] The bookstore carried European avant-garde magazines, including *Junge Kunst;* left-wing periodicals such as *The Masses;* and the New York "little" magazines, including *The Dial.* Laukhuff also stocked banned books by James Joyce and Ezra Pound, and he told anyone asking for conventional literature to try the department stores. As an advocate for experimental art, Laukhuff reserved space for displaying paintings in his bookstore. Nearly every artist associated with the city's modernist movement exhibited at Laukhuff's, including Burchfield, Deike, Keller, Sommer, and Zorach. When Burchfield departed for army boot camp in the summer of 1918, he left fifty watercolors with Laukhuff, who exhibited a selection of them on a rotating basis.[61] After Burchfield returned in 1919, Laukhuff mounted an exhibition of Burchfield's recent paintings, which the artist described as displaying "surrealistic" tendencies. Laukhuff was heavily criticized for this exhibition, and Burchfield had a change of heart and destroyed these bizarre and psychologically disturbing paintings, an act he later regretted.[62]

For decades Laukhuff's bookstore remained a center for the exchange of ideas among Cleveland artists and poets. Sommer spent his free hours there arguing with Laukhuff, often in German, about art, politics, and philosophy. Visiting writers—including Sherwood Anderson, Carl Sandburg, and Langston Hughes—also frequented Laukhuff's. In May 1919 Laukhuff gave Burchfield a copy of Sherwood Anderson's *Winesburg, Ohio,* the newly published novel that influenced Burchfield's decision to abandon visionary modernism for a more objective interpretation of the American scene.[63]

It was almost certainly at Laukhuff's that Sommer began his long friendship with Hart Crane, a nineteen-year-old aspiring Cleveland poet. After their meeting in 1919, Sommer and Crane began spending long hours together discussing art and philosophy. As the political and cultural climate in the city turned against modernism, Crane joined the circle of avant-garde artists, poets, and musicians who frequented Sommer's studio in Brandywine. William Lescaze, a Swiss architect trained in Paris, spent the early 1920s working as a draftsman in Cleveland and left remembrances of his association with this circle in his *Bookmark for Richard Laukhuff* (fig. 89) and his *Bookplate for Hart Crane* (fig. 90).[64] Another

member of the group, the writer Robert Bordner, recalled an evening spent with Sommer and Crane:

> Crane, Sommer, and I were walking on the dirt road under a starry early winter sky from Brandywine. . . .We had been listening to Bill's Bach records, and Bill was declaring he could SEE in color the various movements of the music. . . . Crane was fascinated and we got into whether poetry could be heard in colors too.[65]

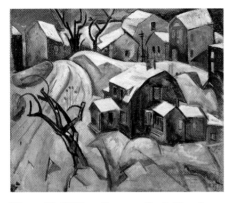

Figure 91. William Sommer, *Bach Chord,* 1923, oil on board, 20 x 23¾ in. (50.8 x 60.8 cm). Akron Art Museum, gift of Russell Munn in memory of Helen G. Munn.

Crane admitted to deriving certain creative principles from Sommer, such as the synesthesia implied by the title of the painter's *Bach Chord* (fig. 91). "I have lately run across an artist here whose work seems to carry the most astonishing marks of genius," Crane wrote to a friend. "I have taken it upon myself to send out some of his work for publication."[66] As a result, *The Dial* published some of Sommer's drawings and the poet William Carlos Williams purchased a watercolor. When Crane moved to New York in 1923, his relationship with Sommer grew strained because Sommer failed to respond to letters from New York magazines and galleries, and Crane felt unappreciated. Although wounded, their friendship endured and Crane always insisted on seeing Sommer on his return visits to Cleveland. Correspondence between Crane and Sommer reveals they shared feelings of despair and alienation from the mad, speculative frenzy of the 1920s, a world that did not seem to have any room for "poetry."[67] Sommer, who once abandoned his job and family but got only as far as Chicago before changing his mind, certainly understood some of the reasons for Crane's suicide in 1932.

REACTION: THE CLEVELAND SOCIETY OF ARTISTS

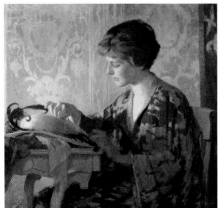

Figure 92. William Edmondson, *The Blue Feather,* 1917, oil on canvas, 27¾ x 29¾ in. (70.5 x 75.6 cm). The Cleveland Museum of Art, gift of Morris Glauber. [not in exhibition]

MODERNISM ENCOUNTERED A STIFF REBUFF in Cleveland. Grace Kelly, an artist and the art critic for the *Cleveland Plain Dealer* from 1926 to 1949, launched her writing career in 1911 with a free-lance article that denounced the impressionists as "freaks" interested only in fame, money, and "slapping on paint in unique ways with the deliberate intention of attracting attention."[68] In March 1913, on the heels of Keller's lectures defending the Armory Show, a group of Cleveland artists met at the Gage Gallery to form the Cleveland Society of Artists, which became the city's conservative rival to the Kokoon Klub.[69] The society's founders included George Adomeit, Ora Coltman, William Edmondson, and Frederick Gottwald.[70] Edmondson's *The Blue Feather* (fig. 92) is a restrained painting that conveys an idealized, sentimental view of work within accepted gender roles of the period. Through both subject and style, this painting embodies the society's goal of upholding traditional values and standards of craftsmanship. A magazine review of the society's 1920 exhibition noted:

> The annual showing of the work of the Cleveland Society of Artists is on at the Gage Gallery. . . . Good, sane, serious work is prevalent, unmarked for the most part by eccentricities in evidence at many showings. Conservatism has been the policy of this society in its progress toward better art.[71]

Conservatives looked to Kenyon Cox, an artist with strong Cleveland ties, for leadership in their fight against radical modernism. Born in Warren, Ohio, Cox painted with the Cleveland Sketch Club in the early 1880s. He later moved to New York, but continued to receive commissions from Cleveland firms and returned to the city to install his murals at the

Citizen's Saving and Trust in 1903 and the Federal Building in 1911.[72] His painting *Tradition* (see fig. 65) entered the collection of the Cleveland Museum of Art within a year of the institution's opening. In April 1913 a Cleveland magazine quoted Cox as denouncing the Armory Show modernists for ignoring the classical tradition, which he considered the source of all worthwhile art. Cox assailed the radicals for exalting in "savage" individuality and sensationalism.[73] In his view, modernism was the offspring of immigrants and bomb-throwing anarchists. Cox was particularly irate about his compatriots because he believed American art should express the nation's conservative instinct through commitment to proven laws, order, sobriety, refinement, good taste, and traditional values.

In June 1913, two months after the publication of Cox's comments, the Taylor Gallery in downtown Cleveland opened an exhibition of French cubist paintings that featured works by Albert Gleizes, Fernand Léger, and Jean Metzinger.[74] Invited to write the catalogue essay, Keller seized the opportunity to defend the cubists for their innovative methods of restructuring pictorial space. Keller interpreted cubism as "metaphysics in art," by which he meant art deriving from abstract mental construction, rather than the imitation of nature.[75] The Taylor Gallery exhibition attracted hundreds of visitors and tremendous controversy, reported by the *Cleveland Plain Dealer* in articles titled "Show of Weird Work of Cubist Artists" and "Onlookers Gasp at Cubist Art."[76] The newspaper even commented on the exhibition in its editorial section:

> Copies of the pictures have gone far and wide. . . . The pictures are so outlandish that they compel attention. Any freak may prove profitable if it is sufficiently monumental. . . . To the average mind cubism is sheer tomfoolery.[77]

In January 1914 the Taylor Gallery opened another modernist exhibition, this time devoted to American artists. Paintings by Brubeck, Hugger, Sommer, Warshawsky, and Zorach were combined with works by Marsden Hartley, Abraham Walkowitz, Max Weber, and other New York modernists.[78] The exhibition catalogue labeled these artists "post-impressionists," the catch-all term used in American art criticism of the period to describe the various tendencies that went beyond impressionist fidelity to nature by distorting form and color. As reflected in the *Leader*'s headline, "Biggest Laugh in Town This Week Not in Theater, But Art Gallery," Clevelanders greeted the American modernists at the Taylor Gallery with the same ridicule as the European cubists.[79] Gottwald joined the crowd by declaring in a companion article that the modernists were lunatics and their paintings "all rot!"[80]

The outbreak of World War I contributed to the gathering controversy, as the public increasingly perceived modernism as an anti-democratic, elitist movement transplanted from Europe. Nietzsche, the hero of the Cleveland modernists, was denounced for his theory of the "morality of the masters," which besides exalting the creative individual as a superior being, also justified war on the grounds that the strong are destined to destroy the weak. "No philosopher is more in the people's minds at the present than Friedrich Nietzsche," *Cleveland Town Topics* asserted in November 1914, "and the reason is that many regard his teachings as having largely to do with the great European war."[81]

As the conflict progressed, the Cleveland press increasingly attacked German culture as barbaric and permeated with an aggressive, war-like spirit. German was eliminated as a language of instruction in the public schools, some groups refused to play German music, and newspapers urged boycotts of German-American businesses. Cleveland modernists, many of whom were of German descent, were caught up in the xenophobic hysteria. In 1917 Louis Rorimer responded to growing anti-German and anti-Semitic sentiment by anglicizing the spelling of his name from Rorheimer to Rorimer.

The rise of radical leftist movements in central and eastern Europe toward the end of the war heightened anxieties about immigrants and other "hyphenated" Americans. *Cleveland Town Topics* blamed "foreigners" for the 1919 May Day riots on Public Square:

> Not an American face was visible in the parade. The refuse of Europe was in the lines. Hence there can be no possible excuse for any person or organization adopting any designation other than American (since the war abolished the hyphen), except a superior devotion to another country other than ours.[82]

It was even suggested that the German general staff was still secretly operating and taking revenge on America by cooperating with the Communists to fund labor strikes in Cleveland.

Like Kenyon Cox, many Americans linked the confusing myriad of modernist "isms" to the revolutionary politics of anarchism, socialism, and bolshevism. In the reactionary postwar era, Benjamin Karr, the art critic of the *Sunday News Leader,* viciously criticized Sommer, Zorach, and other Cleveland modernists. He wrote of Zorach's 1919 exhibition at the Play House: "Some visitors essayed to discover deep meaning and esoteric power in human figures which looked like arrangements of malformed sausages" and that Zorach had abused "all laws of coherent thinking" with his "ridiculous houses and absurd trees . . . [suggesting] too painfully the staggering of fancy drunk on its own nightmare dreams."[83] In a series of articles, Karr launched a broad attack against the "revolting" and "unwholesome" paintings of the modernists, described as "weird freaks" and "self-deluded seekers of sensational novelties." "It is not necessary," Karr concluded, "to take seriously what might well be called the 'lunatic fringe.' "[84]

In 1919 the Cleveland art critic Norma Stahl praised that year's May Show at the Cleveland Museum of Art for excluding all "freak" art, meaning radical modernism.[85] Art critics of the period repeatedly used the word "freak" as the antithesis of sane, wholesome, virile, and "normal." To conservatives, the modernists and their leaders—from Gertrude Stein to Greenwich Village bohemians—were social anarchists and advocates for every sort of radical cause, from political to sexual revolution, including free love and homosexuality. In this climate, the phrase "freak art" became another epithet for censuring modern painting, just as denouncing it as "savage" carried racial overtones, and "anarchistic" evoked frightening political connotations. This reaction against the modernist "freaks" of the "lunatic fringe" (the phrase made popular by President Theodore Roosevelt in his comments about the Armory Show) would frighten Americans of the postwar era into demanding a "return to normalcy."

POSTWAR MODERNISM

AFTER WORLD WAR I many Cleveland artists abandoned experimental modernism for a more conservative approach. Keller and Warshawsky relinquished their flirtation with fauvist color and returned to more faithful representations of nature. Burchfield destroyed his 1919 "surrealistic" paintings and began producing "realistic" paintings of local subjects, thereby becoming identified with the American scene and regionalist movements. Among his earliest works in the new manner were watercolors painted in 1921 on a sketching trip through eastern Ohio with Eastman and Keller.

Despite the changing cultural and political climate, some Cleveland artists persisted in their devotion to modernism. Sommer's powerful paintings *Landscape for Orpheus* (1922, Hirshhorn Museum and Sculpture Garden, Smithsonian Institution) and *Bach Chord* (see fig. 91) make no

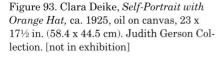

Figure 93. Clara Deike, *Self-Portrait with Orange Hat,* ca. 1925, oil on canvas, 23 x 17½ in. (58.4 x 44.5 cm). Judith Gerson Collection. [not in exhibition]

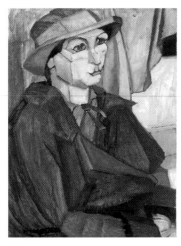

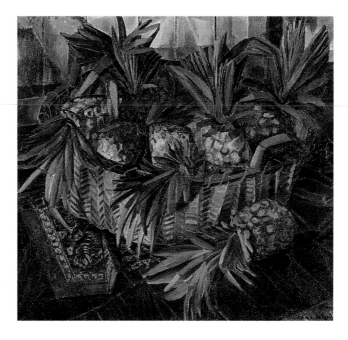

Figure 94. Clara Deike, *Pineapples,* 1931, oil on canvas, 29⅝ x 31¾ in. (75.2 x 80.6 cm). Hahn Loeser & Parks Collection.

Figure 95. William Eastman, *The Chalice Flower,* ca. 1920, oil on aluminum leaf on canvas, 31¼ x 27 in. (79.4 x 68.6 cm). Cleveland Public Library.

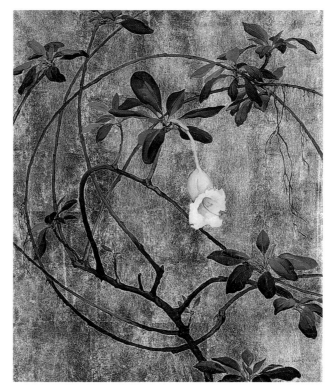

concession to popular taste. Deike combined her early experiments in fauvist color with a new preoccupation with cubist structure (figs. 93, 94). By juxtaposing warm against cool colors within a framework of faceted geometric planes, her compositions became increasingly volumetric and monumental. Eastman, an instructor of design at the Cleveland School of Art and Burchfield's former sketching companion, continued the experiments he had begun around 1915 with metal-leaf backgrounds (fig. 95). Biehle launched into new experiments with interlocking, cubist planes, as seen in his *Study for a Great Lakes Exposition Mural* (fig. 96) and *Farm Near Canal* (fig. 97).

During the interwar period, Biehle and Paul Travis, both active in the early Kokoon Klub, accommodated the conservative taste of the era by working simultaneously in modernist and realist styles (compare figs. 97

Figure 96. August Biehle, *Study for a Great Lakes Exposition Mural*, 1936, watercolor and graphite, 20 x 30 in. (50.8 x 76.2 cm). Joseph M. Erdelac Collection.

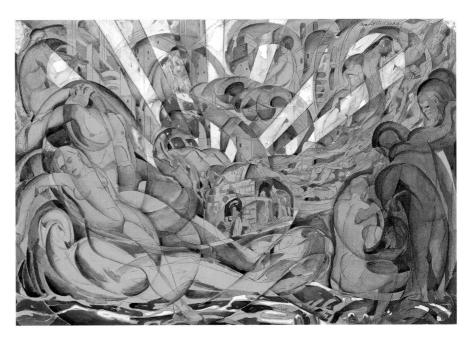

Figure 97. August Biehle, *Farm Near Canal*, 1935, oil on board, 31¾ x 38½ in. (78.8 x 97.8 cm). Frederick C. Biehle Collection.

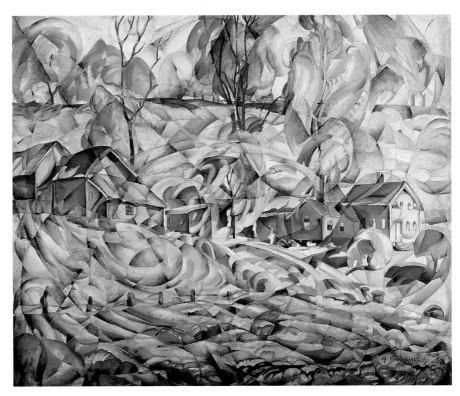

Figure 98. Paul Travis, *The Blue Plate,* 1940s, oil on fiberboard, 24½ x 30¼ in. (62.2 x 76.8 cm). The Wasserman Family Collection.

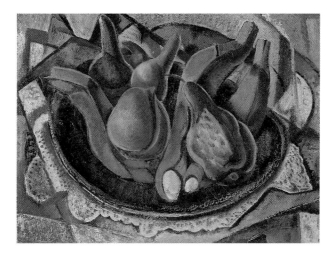

and 114, 98 and 138). Sommer responded to the vogue for American scene subjects by interpreting rural themes in the modernist language of geometric form and prismatic color (fig. 99). He also refined his watercolor style and filled shapes delicately outlined in pencil or ink with luminous color (fig. 100). Whimsical line—applied quickly and without reworking—became increasingly important as he exploited the facility he had devel-

Figure 99. William Sommer, *Yellow Cows,* 1941, watercolor and graphite, 19 x 23½ in. (48.3 x 59.7 cm). Joseph M. Erdelac Collection.

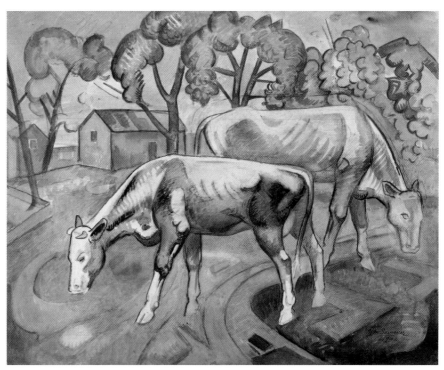

Figure 100. William Sommer, *Still Life with Palette,* ca. 1925, watercolor and graphite, 6⅞ x 10¼ in. (17.5 x 26.1 cm). Joseph M. Erdelac Collection.

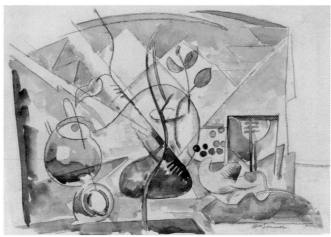

Figure 101. William Sommer, *Apples (for Hart Crane),* ca. 1930, watercolor, 8 x 10 in. (20.3 x 25.4 cm). Joseph M. Erdelac Collection.

oped at drawing after a life's work in lithography. His watercolor *Apples* (fig.101) is an homage to his twin heroes, Cézanne and Crane. This small, gem-like watercolor may have been a direct response to Crane's 1922 poem *Sunday Morning Apples,* which carries a dedication to Sommer. For an artist who loved hard cider, the apples may also refer to a source of creative inspiration. (Sommer's standard response to people who criticized his

Figure 102. William Grauer, *White Stallion,* ca. 1938, oil on canvas, 30 x 35 in. (76.2 x 89 cm). Hugh J. and Ann Caywood Brown Collection.

heavy drinking was: "Nothing creative ever came out of a bottle of Coca-Cola.")[86]

New talents also appeared in the 1920s and 1930s to contribute to Cleveland's modernist movement. In the early 1920s William Grauer arrived from Philadelphia, where he had studied at a school of industrial design. His painting *White Stallion* (fig. 102), with its interlocking cubist planes, illustrates how Cleveland artists accommodated modernist styles to the regionalist vogue for rural subjects. In 1930s Raphael Gleitsmann, who studied informally with Paul Travis and associated with students and faculty at the Cleveland School of Art, established himself in the region as an imaginative painter who fused modernist and American scene imagery. *The White Dam* (fig. 103), an entirely invented scene, combines industrial machines and bizarre distortions of scale to create a disturbingly surreal

Figure 103. Raphael Gleitsmann, *The White Dam,* 1939, oil on canvas, 38½ x 43½ in. (97.8 x 110.5 cm). Private collection.

vision of modern life. The hard-edged, precisionist drawing and emphasis on simplified, geometric shapes suggest the influence of Clarence Carter, who during 1937–38 headed the painting division in Cleveland of the Federal Art Project of the Works Progress Administration (see figs. 141, 153).[87]

Cleveland never developed a continuous sculptural tradition, but from time to time independent artists distinguished themselves as creators of three-dimensional objects.[88] Alexander Blazys, a Lithuanian immigrant, introduced modernist sculpture to Cleveland upon his arrival in 1925. His *Russian Dancer* and *Balalaika Player* (fig. 104) borrow their faceted geometric planes from cubism, but with a particular emphasis on rhythmic movement. During the same decade, R. Guy Cowan initiated a unique wedding of crafts and sculpture at the Cowan Pottery Studios. His *Adam and Eve* (fig. 105) blend an art deco style with sophisticated rhythms in ce-

Figure 104. Alexander Blazys, *Russian Dancer* and *Balalaika Player*, 1925, bronze, 10¼ x 11½ x 5 in. (26 x 29.2 x 12.7 cm) and 12¼ x 7¾ x 3⅝ in. (31.1 x 19.7 x 9.2 cm). The Cleveland Museum of Art, Hinman B. Hurlbut Collection.

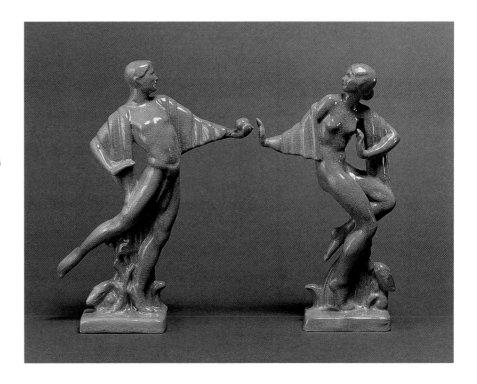

Figure 105. R. Guy Cowan, *Adam* and *Eve*, 1928, glazed ceramic, each 13¾ x 10½ x 3¼ in. (35 x 26.7 x 8.2 cm). The Cleveland Museum of Art, Educational Purchase Fund.

ramic sculptures that reverse traditional gender roles. Adam tempts Eve with the apple, rather than the biblical version, which blames Eve for mankind's fall from grace. Cowan brought numerous sculptors—including Blazys, Edris Eckhardt, and Waylande Gregory (see fig. 180)—to his pottery studios to collaborate with craftsmen in the production of ceramic sculptures. As these artists moved from wheel-thrown ceramics to sculptural modeling, Cleveland emerged as a national center for innovation in the decorative arts. Local artists were encouraged to experiment in this direction when the May Show was expanded in 1927 to include the category "ceramic sculpture."

Viktor Schreckengost, the finest ceramic sculptor associated with the Cowan Studios, was born to a family of potters in Sebring, Ohio. He came to Cleveland in 1924 to study at the Cleveland School of Art and for five

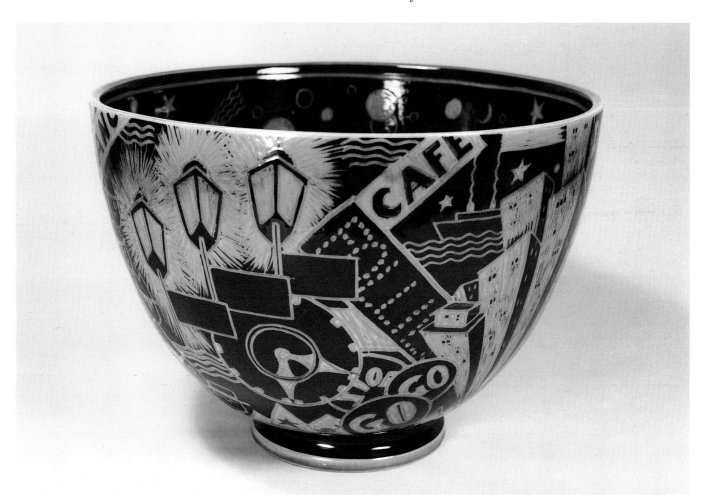

Figure 106. Viktor Schreckengost, *Jazz Bowl*, 1931, glazed ceramic, 11⅜ x 16⅜ in. (28.9 x 41.6 cm). Cowan Pottery Museum, Rocky River Public Library.

years supported himself by playing the saxophone and clarinet in jazz bands. In 1929 he went to Vienna to study ceramics and continued his passion for music by playing at night in the city's lively cabarets. After traveling through Germany, where fascist political parties denounced modern painting and jazz as the art of degenerate races, he returned to Cleveland in 1931. Back at home, he split time between teaching at the Cleveland School of Art and producing ceramics at Cowan Pottery, where he created his *Jazz Bowl* (fig. 106) using an innovative sgraffito technique of scratching through a lustrous black glaze to define the underlying forms later glazed in Egyptian blue. For this bowl, commissioned by Eleanor Roosevelt to celebrate her husband's re-election as governor of New York, Schreckengost selected an appropriately American subject. He recalled:

I thought back to a magical night when a friend and I went to see [Cab] Calloway at the Cotton Club. My friend had only just arrived in New York from Vienna and he just flipped; he fell in love with the city, the jazz, the Cotton Club—everything. As I remembered that night, I knew I had to get it all on the bowl.[89]

Schreckengost attempted to recreate the strange light that permeated the club district at night through the bowl's deep blue color. The sharp lines and cubist shapes explode with the lively energy and syncopated rhythms of the jazz Schreckengost first discovered in Cleveland nightclubs. "I've always loved jazz," he once remarked, "and I'd be happiest when I could get the feeling of that sound."[90] The *Jazz Bowl* was one of the last works produced at Cowan Pottery before the Great Depression forced the firm into bankruptcy.

Sol Bauer, who supported himself as a civil engineer, was one of the few Cleveland artists to carry forward modernist traditions in wood sculpture. Essentially self-taught, he received seven first prizes for sculpture in the May Shows at the Cleveland Museum of Art. His interest in modernism had been stimulated by his friendship with Sommer. They met during the early years of the Depression. "Things were particularly bad for Mr.

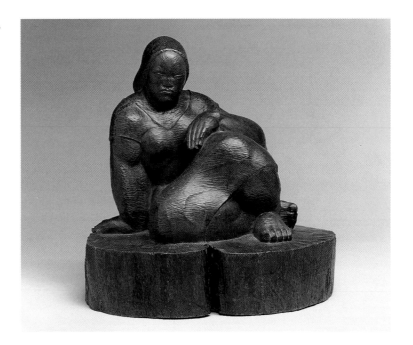

Figure 107. Sol Bauer, *Seated Woman,* 1941, wood, 13 x 13 x 11 in. (33 x 33 x 27.9 cm). The Cleveland Museum of Art, Dudley P. Allen Fund.

Sommer," Bauer recalled, "and I tried to make it a practice to visit him frequently, taking along such things as watercolor paper."[91] Sommer certainly told Bauer of his friend Zorach, who after leaving Cleveland had abandoned oil painting and achieved national acclaim as a sculptor. Bauer's sculpture *Seated Woman* (fig. 107) continues Sommer and Zorach's veneration of expressive, primitivist forms. The roughly gouged surface makes visible the struggle of the artist's hand in the creative act, while powerful sensations of volume and energy are conveyed through the upwardly spiraling masses.

DESPITE CRITICISM and the absence of material rewards, a number of Cleveland artists continued to pursue experimental modernism throughout the 1920s and 1930s. Often working alone and in the face of mounting hostility from American cultural nationalists, these artists remained committed to exploring experimental design and expressing cathartic emotions repressed by a predominantly conservative society suspicious of sensuality and unconventional ideas.

The Cleveland artists who persisted in their devotion to modernism did so at a price. Sommer's continuing struggle for recognition and economic survival is a case in point. In 1922 the *Sunday News Leader* greeted his first appearance in the May Show with the comment: "William Sommer shows two nightmare outbreaks of futurist paintings which may well inspire hope that the future of such art is far distant."[92] The following year this newspaper again criticized Sommer's works in the May Show for giving vent to his "impulse toward the fantastic and grotesque, in two or three of the most repulsive and useless pictures which the jury let go by."[93] Even more damaging than public criticism was Sommer's inability to attract patrons. From 1922 to 1946 he exhibited 162 works in 25 May Shows but sold only two oil paintings. He eventually found buyers for his ink drawings of nudes, which although slightly stylized, followed the traditional academic practice of sketching models from life in the studio. He did develop an audience for his watercolors of animals and children, but he must have been disappointed that the public so vastly preferred his pleasant, light-hearted works to his powerful oils and philosophical subjects.[94]

Like other Cleveland modernists, Sommer found himself increasingly isolated and embattled after 1920. The Kokoon Klub, which he had cofounded in the prewar era, became known for its annual masked ball (a popular social event), rather than as the champion of challenging, alternative art. Schreckengost said of the Klub in the 1920s:

> I never went to any of the parties because I couldn't afford it. Most of the people who went were not artists. There were a lot of agency people who would bring their clients to see what Left Bank life was like.[95]

Another artist recalled that Sommer "had no disciples at the club; nobody was interested in his art at all; this was sad, because he came in alone, fought his way alone, and went home alone."[96] But that is not the whole story. In the end, Sommer and a band of Cleveland artists triumphed against the reactionary pressures to abandon modernism by creatively fusing various styles and subjects, at times blending elements of cubism, fauvism, surrealism, and art deco. Their hybrid creations signaled a new and concluding phase to Cleveland modernism of the early twentieth century.

NOTES

1. Hilton Kramer, "Charles Burchfield, A U.S. Provincial," *New York Times* (24 January 1970), 27.

2. *Encyclopedia of World Art*, s.v. "Modernism" (New York: McGraw-Hill, 1965), 10:202–10. Notable studies of the subject include: Abraham A. Davidson, *Early American Modernist Painting: 1910–1935* (Harper and Row, 1981); William I. Homer, *Alfred Stieglitz and the American Avant-Garde* (Boston: New York Graphic Society, 1977); Peter Morrin et al., *The Advent of Modernism: Post-Impressionism and North American Art, 1900–1918,* exh. cat. (High Museum of Art, 1986).

3. In recent decades art historians have been working to dispel such notions by investigating the rise of modernism in Chicago, West Coast cities, and other areas outside the eastern seaboard. For example, see Sue Ann Prince, *The Old Guard and the Avant-Garde: Modernism in Chicago, 1910–1940* (Chicago: University of Chicago Press, 1990).

4. The literature on modernism is extensive. Various views of the subject are found in: Herbert Read, *The Philosophy of Modern Art* (London: Faber and Faber, 1952); Hilton Kramer, introduction to *The Age of the Avant-Garde* (New York: Farrar, Straus and Giroux, 1956); Clement Greenberg, *Art and Culture: Critical Essays* (Boston: Beacon Press, 1961); Robert Hughes, *The Shock of the New* (London: British Broadcasting Corporation, 1980); Suzi Gablik, *Has Modernism Failed?* (New York: Thames and Hudson, 1984); Rosalind E. Krauss, *The Originality of the Avant-Garde and Other Modernist Myths* (Cambridge, Mass.: MIT Press, 1985); Monique Chefdor et al., *Modernism: Challenges and Perspectives* (Chicago: University of Illinois Press, 1986); Donald Kuspit, *The Cult of the Avant-Garde Artist* (New York: Cambridge University Press, 1993).

5. Originally spelled "Rohrheimer," the family name became "Rorheimer" in 1906 and was anglicized in 1917. That spelling has been used consistently throughout this catalogue. See Henry Hawley, "Cleveland Craft Traditions," n. 15.

6. Rorimer created works in an eclectic range of styles, from the international arts and crafts movement of the 1890s to art deco in the 1920s. His activities are discussed in greater detail in "Cleveland Craft Traditions."

7. Abel G. Warshawsky, *The Memories of an American Impressionist*, ed. Ben L. Bassham (Kent, Ohio: Kent State University Press, 1980), 138.

8. Ibid., 139–40. Warshawsky does not mention Zorach as among the lithographers who approached him after this exhibition; however, in *Art Is My Life: An Autobiography of William Zorach* (Cleveland: World Publishing, 1967), 19, Zorach mentions seeing Warshawsky's paintings that fall.

9. *Cleveland Town Topics* (18 March 1911), 16. Among the other participants were Gustav Hugger, Carl Moellmann, Caroline Osborn, Hugo Robus, and Abel Warshawsky. Zorach did not participate because he was in Paris from late 1910 to late 1911.

10. Warshawsky, *Memories of an American Impressionist,* 138. The Rowfant Club, founded in 1892 and still active today, is an organization of book collectors that sponsored art exhibitions in the early years of this century.

11. *Thirty Paintings by Cleveland Artists,* exh. cat. (Los Angeles Art Museum, 1931), unpaginated.

12. Henry Keller and John MacCleod, "The Physiology of Color Vision in Modern Art," *Smithsonian Report* (1913): 723–39.

13. Unidentified newspaper clipping in the *Scrapbook of the Cleveland Institute of Art (CIA Scrapbook) 4* (1913), 112. In 1915 Keller was commissioned to paint a 70-foot mural of *Wisdom and Destiny* for City Hall, but when asked to cover the nudes, he withdrew from the project.

14. Spencer Adams [Gertrude Hunter], "Apropos of the Keller Exhibition at Korner & Wood Gallery," *Cleveland Town Topics* (19 April 1913), 15.

15. Zorach was not very precise in recording the company names and dates of his employment. Apparently he worked for both Morgan and Otis Lithography, but in exactly what order and when remains unclear. See Zorach, *Art Is My Life,* 12–18, 27–28.

16. Ibid., 13.

17. D. Undine Baker, "An Evening with the Klub," *Cleveland Town Topics* (27 March 1915), 15–16. The club's founding and early activities from 1911 to 1915 are chronicled in the weekly art columns of *Town Topics*.

18. William Zorach to Henry Francis, 1 June 1950, William Sommer Papers, Archives of American Art (AAA), Smithsonian Institution, Washington, D.C.

19. Spencer Adams, "Seccessionists [sic] Again," *Cleveland Town Topics* (2 March 1912), 9–10. Zorach is identified as William Finkelstein. Among the other artists in the exhibition were Brubeck, Hugger, Keller, Moellmann, Osborn, and Warshawsky.

20. Spencer Adams, "Rowfant Club Exhibition," *Cleveland Town Topics* (30 April 1912), 3.

21. Between 1912 and 1914, Zorach painted a number of allegories titled *Spring,* all depicting nudes in a landscape.

22. Marsden Hartley lived in Cleveland (1896–99), attended the Cleveland School of Art (1898–99), associated with Gertrude Stein's circle in Paris at the same time Zorach was there, and sent works to the 1914 exhibition of American post-impressionists at the Taylor Gallery in Cleveland.

23. Spencer Adams, "August Biehle," *Cleveland Town Topics* (28 September 1912), 10–11.

24. Sommer quoted in Spencer Adams, "He Joined the Post-Impressionist Ranks," *Cleveland Town Topics* (14 October 1916), 19.

25. Sommer's philosophical ideas are known through his letters and statements written in his notebooks, as well as the letters and testimonials of his colleagues. Many of these materials are preserved in the Sommer Papers, AAA.

26. O'Neil made the comment in his review of a Keller exhibition, but the observation applies equally to Sommer; see, Raymond O'Neil, "Keller Gives Best One Man Exhibition," *Cleveland Leader* (25 April 1915), IV–5.

27. Sommer Papers, AAA. Uspenskii's (sometimes spelled Ouspensky) most notable books are *Tertium Organum (A Key to the Enigmas of the World)* (1921) and *A New Model of the Universe* (1931).

28. Edward Hopper, "Charles Burchfield: American," *The Arts* 14 (July 1928): 10.

29. Alfred H. Barr, Jr., *Charles Burchfield: Early Watercolors, 1916–1918,* exh. cat. (Museum of Modern Art, 1930), 6.

30. Thomas Craven, "Our Art Becomes American," *Harper's Monthly Magazine* (September 1935): 433.

31. Norton expressed her views in newspaper interviews and school circulars that are preserved in *CIA Scrapbooks 3–5* (1909–15). A 1913 newspaper article claimed that 90% of the students at the Cleveland School of Art sought a "practical education," while only 10% hoped to become fine artists (*CIA Scrapbook 4*).

32. Charles Burchfield, undated handwritten essay about the Cleveland School of Art, Paul Travis Papers, 2, AAA.

33. Kelly and Ames denounced the modern artists as frauds primarily interested in gaining notoriety and money; see Grace Kelly, "Impressions of the Long-Haired Cult," *Cleveland Town Topics* (25 March 1911), 16, and Edith Sommer, "Miss Ames Discusses the Isms in Art," *Cleveland Town Topics* (6 April 1918), 25.

34. Charles Burchfield, "Autobiographical Notes: Life and Career," undated typed manuscript, 5, Whitney Museum of American Art Library, New York. Slight changes have been made in capitalization for stylistic consistency.

35. Keller joined the faculty as a part-time instructor of watercolor painting in 1903 and became the instructor of decorative illustration around 1909. William Brigham taught design theory during Burchfield's freshman year, 1912–13, and was succeeded in the fall of 1913 by Eastman.

36. Keller collected and exhibited Japanese prints at the Cleveland School of Art; the Hatch Galleries of Cleveland exhibited Chinese scroll paintings in 1914.

37. *Charles E. Burchfield Journal (CEB Journal),* 2 August 1913. Burchfield's journals are in the collection of the Burchfield-Penney Art Center at Buffalo State College. Selections have been published in J. Benjamin Townsend, *Charles Burchfield's Journals: The Poetry of Place* (Albany: State University of New York Press, 1993).

38. *CEB Journal,* 31 October 1914. Burchfield never became a member, but many of his closest friends were active in the club, including Eastman, Keller, Wilcox, and Charles Kaiser.

39. *CEB Journal,* 17 March 1915. The "Nuit Futuriste" is described in various newspapers and magazines (*CIA Scrapbook 4*).

40. *CEB Journal,* 18 and 20 March 1915. During the following two years Burchfield returned a number of times to Brandywine, although whether he met Sommer again is not known. Sommer did not keep a diary, but he did record Burchfield's Salem address in one of his sketchbooks of about 1915–18. (Sommer Papers, AAA).

41. Artist's statement in *The Forum Exhibition of Modern American Painters,* exh. cat. (Forum Gallery, 1916), 1.

42. *CEB Journal,* 13 October 1914.

43. *CEB Journal,* 22 October 1914.

44. *CEB Journal,* 3 November 1913.

45. Zorach to Henry Francis, 1 June 1950, Sommer Papers, AAA.

46. Philip Kaplan, "Look for the Miracle," undated typed manuscript, Sommer Papers, AAA.

47. Zorach, *Art Is My Life,* 27.

48. Raymond O'Neil, "Paris' Warshawsky to Exhibition Here," *CIA Scrapbook 4,* 112. Warshawsky also expressed admiration for Matisse and Kandinsky.

49. *CEB Journal,* 9 March 1915.

50. *CEB Journal,* 31 August 1915.

51. *CEB Journal,* 16 October 1913.

52. Burchfield essay, 6, Travis Papers, AAA.

53. *CEB Journal,* 18 October 1914.

54. Edith Sommer, "Cleveland Boy Styled a Great Genius," *Cleveland Town Topics* (1 December 1917), 3.

55. Townsend, *Charles Burchfield's Journals,* 72.

56. John I. H. Baur, *Charles Burchfield,* exh. cat. (Whitney Museum of American Art, 1956), no. 2.

57. "Art Ability Runs High at Little Theater," *Cleveland Town Topics* (4 May 1918), 10–12.

58. After O'Neil resigned as director in 1921 the Play House began to produce more conventional dramas and, ironically, is now the city's most established mainstream theater. The history of the Play House is recorded in June McCune Flory, *The Cleveland Play House* (Cleveland: Press of the Case Western Reserve University, 1965).

59. "Play House Group to Stage 'Everyman' Uniquely," *Cleveland Town Topics* (18 May 1918), 17. Sommer was also involved in planning a Play House production of the Yiddish play *The Dumb Messiah* about the tragedy and persecution of the Jews.

60. A personal recollection of the bookstore is found in Philip Kaplan, *The Making of a Collector, Laukhuff's of Cleveland* (Akron: Northern Ohio Bibliophilic Society, 1990).

61. Jessie Glasier, "Burchfield 'Impressions' Shown," *Cleveland Plain Dealer* (18 August 1918), Cleveland sec., 7.

62. Burchfield discussed these watercolors in a letter to John Baur, 5 April 1955, Whitney Museum Library.

63. Burchfield noted that Anderson's novel "produced a profound effect on me." See "Autobiographical Notes: The Years 1915–1919–1943," undated typed manuscript, 4, Whitney Museum Library.

64. Lescaze moved to New York City in 1923 and began a distinguished career in architecture.

65. John Unterecker, *Voyager* (New York: Farrar, Straus and Giroux, 1969), 203.

66. Crane to Gorham Munson, 10 April 1921, quoted in Unterecker, *Voyager,* 195. A letter dated 7 August 1950 from Samuel Loveman, a poet in Sommer's circle, to Henry Francis indicates that Sommer and Crane met in 1919 (Sommer Papers, AAA).

67. These letters are preserved in the Sommer Papers, AAA.

68. Grace Kelly, "Impressions of the Long-Haired Cult," *Cleveland Town Topics* (25 March 1911), 16.

69. These artists were addressed at the meeting by Frederic Whiting, at the time the director of the John Heron Art Institute in Indianapolis but later appointed the Cleveland Museum of Art's first director.

70. This group was alternatively called the Society of Cleveland Artists and the Society of Cleveland Painters. Among its other founding members were Herman Matzen, Wilbur Oakes, and Charles Shackleton. After 1918 many Kokoon Klub artists—including Keller and Biehle—moderated their views and joined the society, and this crossover confused many Clevelanders about the society's original character and purpose.

71. "Exhibition of Cleveland Artists," *Cleveland Town Topics* (13 November 1920), 33.

72. H. Wayne Morgan, *Kenyon Cox: 1856–1919, A Life in American Art* (Kent, Ohio: Kent State University Press, 1994): 72, 151, 163. The mural in the Federal Building is titled *Passing Commerce Pays Tribute to the Port of Cleveland.* The Citizen's mural was reinstalled in the auditorium of the Cleveland School of Art in the mid-1920s.

73. Spencer Adams, "The New Art," *Cleveland Town Topics* (26 April 1913), 20.

74. The origins of the exhibition are discussed in Aaron Sheon, "1913: Forgotten Cubist Exhibitions in America," *Arts Magazine* 57 (March 1983): 93–107. The Taylor Gallery was affiliated with the Taylor Department Store.

75. Keller's essay is reprinted in David A. Vermilion, "To Trap a Convincing Reality: The Life and Work of Henry G. Keller" (M.A. thesis, Kent State University, 1982), 80.

76. *Cleveland Plain Dealer* (17 June 1913), 7, and (1 July 1913), 17.

77. "Cubists in Cleveland," *Cleveland Plain Dealer* (1 July 1913), 14.

78. William Murrell Fisher, *Catalogue of Painting and Sculpture at the William Taylor Gallery,* exh. cat. (William Taylor Gallery, 1914), not illustrated. The foreword by S. J. Warshawsky and essay discuss modern art in general without specifically referring to the artists or works in the exhibition.

79. *Cleveland Leader* (11 January 1914), 8. Despite his article's headline, Raymond O'Neil, the paper's art and drama critic, was sympathetic to modernism and emerged from this controversy as a leading advocate of progressive art.

80. "'New Art? All Rot!' Gottwald Declares," *Cleveland Leader* (11 January 1914), 8.

81. "The Meaning of Nietzsche's Philosophy," *Cleveland Town Topics* (14 November 1914), 4a.

82. "Red Friday," *Cleveland Town Topics* (3 May 1919), 1.

83. "Art: Camp Pictures to Be Seen at the Playhouse: More 'Freak' Art," *Sunday News Leader* (9 February 1919), Dramatic sec., 6.

84. Karr criticized both European and American modernists in a series of articles published in the *News Leader* from February to August 1921, including "Art" (2 February 1920), "Cleveland Artists Exhibit Many Wholesome Pictures" (15 May 1921), and "Not Futurist Freaks" (17 August 1921). See *Scrapbook of the Cleveland Museum of Art 1* (1921).

85. Norma Stahl, "Cleveland's Art Invites Visitors," *Cleveland Town Topics* (3 May 1919), 28–31.

86. "Hart Crane's Friend Sommer," *Art News* 49 (November 1950): 37.

87. Although Gleitsmann did not work under Carter, he would certainly have known his paintings. Gleitsmann began to frequent the Cleveland School of Art in the early 1930s, and he had his second solo exhibition at Cleveland College (part of Western Reserve University) in 1940. *The White Dam* was the featured painting of that exhibition.

88. John Herkomer (1821–1913), a Bavarian woodcarver, may have been the city's first resident sculptor. From 1851 to 1883 he operated a Cleveland studio that produced hand-carved moldings and architectural sculpture, and in 1876 Herkomer helped found the Art Club. Herman Matzen (1861–1938), a German-trained artist, taught crafts at the city's Manual Training School prior to teaching at the Cleveland School of Art, 1887–1926. Cleveland's most distinguished sculptor of the early 20th century, Max Kalish, worked in a social-realist style and, as such, is discussed in the next essay.

89. Carmie Amata, "The Essence of an Era," *Plain Dealer Magazine* (14 August 1983), 14.

90. Ibid., 10, 14.

91. Bauer to Aldrich Underwood, 14 January 1946, Sommer Papers, AAA.

92. Benjamin Karr, "Work of Cleveland Artists, Craftsmen, Shown at Museum," *Sunday News Leader* (7 May 1922), 2.

93. Benjamin Karr, "Art Exhibit Proves to Be Real Success," *Sunday News Leader* (13 May 1923), 9.

94. That Sommer considered his oils his most important achievement is indicated by his submission of five oils—and only oils—to his first two shows (1922, 1923), for which he received no prizes and no sales. The following year he submitted only figure drawings of studio models, which sold. Among his philosophical subjects are *Landscape for Orpheus* of 1922 and *Fireworshippers* (unlocated), painted around 1918 for the wealthy Philadelphia collector Albert Barnes. Barnes returned this depiction of "primitive man discovering fire" with the excuse that his wife disliked it. The painting remained in Sommer's studio until at least 1946. Sketches for the composition and reminiscences of the affair with Barnes are preserved in the Sommer Papers, AAA.

95. Viktor Schreckengost, quoted by Helen Cullinan in "When Cleveland Artists Had a Ball," *Plain Dealer* (13 July 1966), H–6.

96. Philip Kaplan, quoted by Hunter Ingalls in "The Several Dimensions of William Sommer" (Ph.D. diss., Columbia University, 1963), 178.

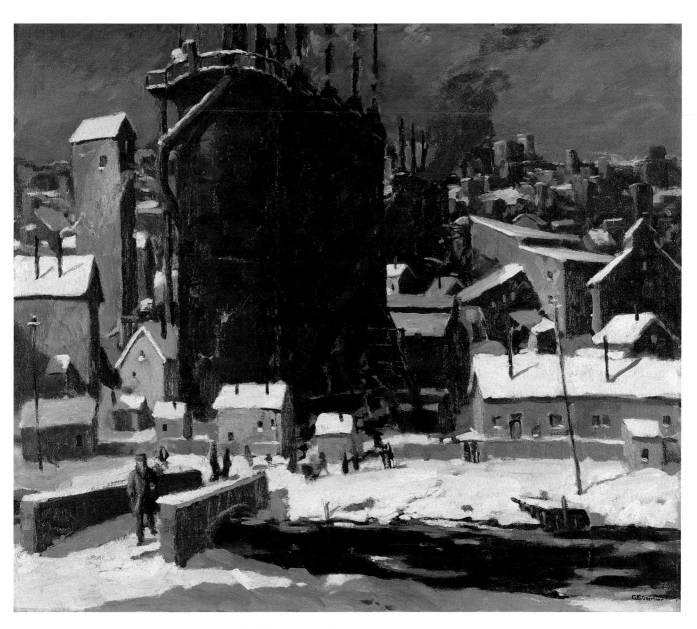

Carl Gaertner, *The Furnace,* 1924.

The American Scene Movement in Cleveland

THE SOCIAL AND POLITICAL UPHEAVALS that accompanied the First World War profoundly changed Cleveland's artistic community. To many Americans, the war seemed the last gasp of a dying civilization on the other side of the Atlantic. The Russian Revolution and the collapse of the Hohenzollern monarchy at the hands of radical labor and leftist movements raised the specter of worldwide class conflict. Hoping to isolate the United States from European affairs, Congress banned American participation in the League of Nations, restricted immigration, and passed anti-sedition laws to contain political agitation.

In Cleveland, the war brought to the surface long-festering fears of political radicalization in the city's immigrant labor force.[1] For decades Germans, Irish, Italians, Eastern Europeans, and other immigrant groups had poured in from abroad to fuel the city's expanding steel, oil refining, and manufacturing industries. From 1860 to 1900 Cleveland's population skyrocketed from 43,000 to nearly 400,000. During the next decade, the population, one-third of which was foreign born, nearly doubled. By 1910 Cleveland had become the nation's sixth largest city; by 1930 the metropolitan area would be the third most populous in the United States.

Anxieties over political agitation reached fever pitch in 1918 during the trial of the socialist leader Eugene Debs at a federal court in Cleveland. After declaring that the war was being fought by the working class to increase the profits of capitalists and urging Americans to resist the draft, Debs was sentenced to ten years in prison for sedition. The following spring one of his Cleveland lawyers, Charles Ruthenberg, protested the conviction by organizing a massive May Day parade. As marchers bearing red and American flags approached Public Square, they encountered police and hecklers. In the nine hours of rioting that ensued, two were killed, hundreds arrested, and Cleveland emerged as a flash point in the national "red scare" of 1919. The federal government responded with widespread police raids, arrests, and deportations. In 1920 Senator Warren Harding of Ohio was elected to the presidency by urging a "return to normalcy."

During this period, modern art became increasingly viewed as an aberrant vestige of elitist European culture. The magazine *Cleveland Town Topics* denounced modernism as the product of a Nietzschean "superiority" cult whose bizarre, cryptic art was created for the exclusive benefit of a small cadre of intellectuals. Rejecting this unwelcome intrusion of foreign culture into American life, art critics urged a purge of the modernist infection, accompanied by a return to native ideals and experiences. Artists responded by focusing on identifiable subjects rendered in a realistic style. Critics subsequently ballyhooed the new "American scene" art as more

"democratic" than modernism because it seemed comprehensible and accessible to the common people.

Regionalism developed as an offshoot of the American scene movement. Asserting that each section of the country has its own distinctive character, the regionalists hoped to initiate a rebirth of native culture by depicting the country's vastly diversified geography and climate.[2] Wrapping themselves in the rhetoric of America's evangelical and pioneer traditions, the regionalists aspired to cleanse American art of unholy foreign contagions. They denounced the perceived domination of the art world by a few eastern cities and considered regionalism the spearhead of a new movement toward cultural pluralism. In its most extreme form, as expressed in artist Grant Wood's essay *Revolt against the City,* regionalism became an anti-urban, anti-industrial movement that aspired to return America to a utopian agrarian past.[3] This romantic aspect of the regionalist ideology contained the seeds of its eventual demise.

CLEVELAND: URBAN AND INDUSTRIAL LANDSCAPES

THE AMERICAN SCENE MOVEMENT emerged early in Cleveland, spurred by reaction against European modernism and by civic leaders who campaigned for a rebirth of American art based on native ideals. Toward the end of 1917 Henry Turner Bailey, who was about to succeed Georgie Norton as dean of the Cleveland School (later Institute) of Art, began urging Cleveland artists to reject modernism and find beauty in their city.[4] Frederic Whiting, director of the newly opened Cleveland Museum of Art, shared Bailey's hope for a rebirth of native arts, achieved by returning to traditional pride in craftsmanship and renewed emphasis on civic identity. Addressing the Chamber of Commerce in 1919, Whiting urged Cleveland artists to paint its railroad yards, factories, rivers, and viaducts: "Even the masses of factory buildings with the smoke swirling over the tops may be caught by the artist to present an effect that is picturesque in the industrial landscape."[5]

To stimulate a new union of art and industry, the Cleveland Museum of Art instituted an annual juried exhibition for the city's artists and artisans that became popularly known as the May Show.[6] The Cleveland Society of Artists organized the first such exhibition, which opened at the museum in May 1918. After artists fought over hanging positions, the museum decided that in the future it would organize this annual event. Whiting's philosophy of promoting the applied arts as a means of spurring social reform and industrial development is reflected in his placing William Milliken, curator of decorative arts, in charge of the May Show.[7] The early exhibitions admitted objects in as many as twenty-seven categories, including paintings, sculpture, photography, basketry, embroidery, bookbinding, lace, furniture, jewelry, and enamels. Henry Turner Bailey lauded the museum's effort to unite the arts and crafts:

> The theorist must keep in touch with the "practical man," the technician, and both must go to the museum where the highest obtainable results of the union of theory and practice are to be seen. . . . The best trade of the world always goes to the nation that produces the finest things.[8]

Whiting believed that the quality of Cleveland products would rise through the reciprocal exchange of ideas between artists and craftsmen:

> If the museum can get factories to recognize the importance of design, of stimulating craftsmen to a new sense of responsibility and a new ambi-

Figure 108. Frank Wilcox, *The Old Market, Cleveland,* 1920, gouache on board, 28¾ x 22¾ in. (73 x 57.8 cm). The Cleveland Museum of Art, purchased with funds given by Friends of the May Show.

Figure 109. Carl Gaertner, *The Ripsaw,* 1923, oil on canvas. 35 x 41¼ in. (89 x 104.8 cm). City of Cleveland, the Mary A. Warner Collection.

tion in the elements of production, we shall accomplish wonderful results. What we want to inculcate in Cleveland is the old, guild spirit, the whole purpose of which was to develop skill and industry.[9]

Whiting also admonished the May Show artists of 1919:

Emphasis is again laid upon the responsibility of local artists to interpret Cleveland and the surrounding country to the people of this great city. The picturesque qualities of the city have not yet been adequately taken advantage of by many of our painters, etchers and photographers. There is a wealth of material here which needs but the artist's eye to reveal it in its true beauty.[10]

Whiting's strategy for accomplishing this goal included creating a special category in the May Show for industrial themes. Artists responded by focusing on subjects previously neglected as too unattractive for art. In the coming decade George Adomeit, Clarence Carter, Carl Gaertner, William Grauer, Elmer Novotny, and Frank Wilcox would emerge as significant painters of the Cleveland scene. Sculptors, photographers, and printmakers joined their exploration of the industrial city, and Karamu artists examined aspects of life in the city's African-American community.

After graduating from the Cleveland School of Art in 1910, Frank Wilcox painted post-impressionist works with Henry Keller in Berlin Heights. Around 1918, however, Wilcox repudiated modernism and began painting Cleveland's industrial harbor in a bold realist style. For these paintings he received first prize in the industrial-subject category of the 1919 and 1920 May Shows. *The Old Market, Cleveland* (fig. 108) conveys the vitality of modern urban life and the mixing of social classes in downtown Cleveland. Ignoring unnecessary details and conventional "finish," Wilcox applied paint quickly, sometimes not bothering to cover the cardboard support in his rush to capture the energetic movement of large, powerful masses.

Carl Gaertner began painting industrial subjects in the early 1920s while studying with Wilcox at the Cleveland School of Art. *The Ripsaw* (fig.

Figure 110. Carl Gaertner, *The Furnace,* 1924, oil on canvas, 37 x 42 in. (94 x 106.7 cm). Huntington National Bank Collection.

Figure 111. Carl Gaertner, *Steel Mills on the Cuyahoga,* ca. 1928, oil on canvas, 24½ x 28¾ in. (62.2 x 73 cm). Hahn Loeser & Parks Collection.

109), completed during his senior year, exhibits the thickly painted surfaces, muscular forms, and attention to light and shadow characteristic of his early style. Gaertner received first prize for industrial subjects in the 1923 and 1924 May Shows. Milliken pointed with pride to *The Furnace* (fig. 110), the 1924 winner, as the fruit of the museum's efforts:

> The Museum has attempted to encourage from the beginning the painting of local and particularly industrial subjects. It was for this reason that the class Industrial Painting was created. For the second year in succession Carl F. Gaertner was awarded the first prize.[11]

The *Cleveland Plain Dealer* asserted in a 1924 editorial about the May Show that the public also appreciated paintings of these subjects:

> It means much to an industrial community like this to have a group of men and women laboring in earnestness to produce objects of beauty. These artists and craftsmen are performing a real service by translating art into daily life. They are demonstrating the folly of believing there is anything antagonistic between the beautiful and the useful. America, and American cities in particular, need the lesson.[12]

In the late 1920s Gaertner's fascination with factories and laborers toiling in sooty snow—often enlivened with intensely colored shadows—gave way to a new preoccupation: dramatic night scenes. Blue snow covers the foreground of *Steel Mills on the Cuyahoga* (fig. 111), which transforms an industrial site known to Clevelanders into powerful patterns of abstract form and dramatic color. His paintings *Christmas Eve* (fig. 112) and *Flying Ponies* (fig. 113) treat equally familiar subjects as studies in subtly varied degrees of darkness. His monumental canvas, *Flying Ponies,* depicts a popular amusement park at night, daringly illuminated from within by the light of booths, a distant roller coaster, and the glowing top of a swirling carousel. Like William E. Smith (see fig. 177), who featured this carousel

Figure 112. Carl Gaertner, *Christmas Eve,*
1927, oil on canvas, 30 x 35 in. (76.2 x 88.9
cm). Robert H. DuLaurence Collection.

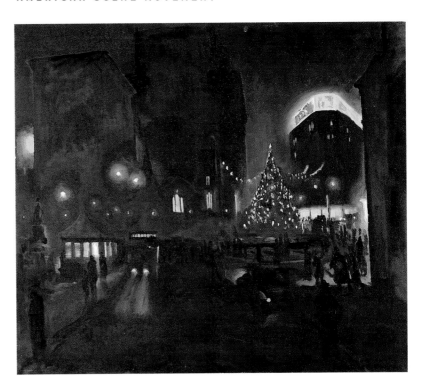

Figure 113. Carl Gaertner, *Flying Ponies
(Euclid Beach Park),* 1932, oil on canvas,
44½ x 66¾ in. (113 x 169.5 cm). Carol and
Michael Sherwin Collection.

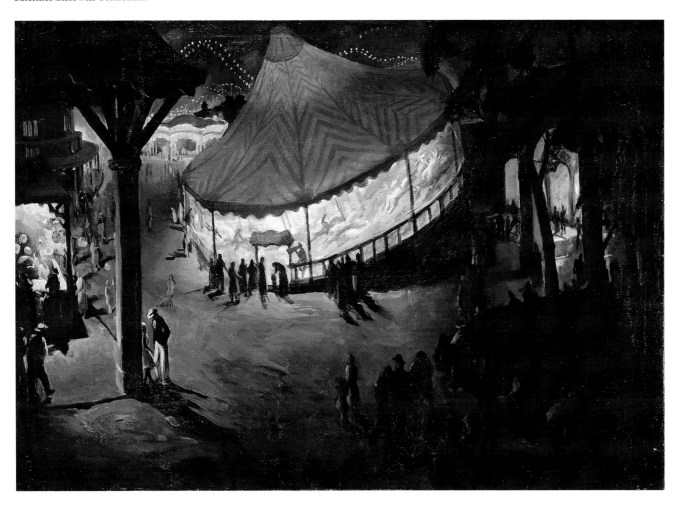

in a print about racial segregation, Gaertner identifies the park as a place of social interchange.

In the 1920s August Biehle, the modernist colleague of William Sommer, contributed to the painting of industrial subjects. Biehle's *Republic Steel on the Cuyahoga* (fig. 114) abandons the visionary modernism of his painting *Deposition* (see fig. 73). Like many Cleveland artists, Biehle never committed himself to a single style, shifting instead between realism and abstraction. This lack of commitment to a single style is one of the most distinctive features of Cleveland art between the world wars. The most likely explanation for this phenomenon lies in how most Cleveland painters supported themselves—as teachers or commercial artists, they had to demonstrate proficiency in a variety of styles to students and potential clients.

Figure 114. August Biehle, *Republic Steel on the Cuyahoga,* 1924, oil on canvas, 26 x 34 in. (66 x 86.7 cm). Courtesy Rachel Davis Fine Arts.

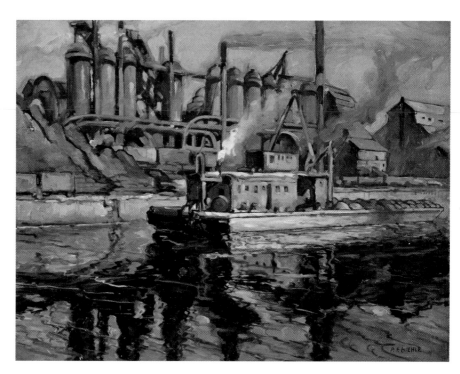

As Cleveland artists depicted their city, they created new icons of civic pride and identity. To many Clevelanders, the low-lying industrial area along the banks of the Cuyahoga River—popularly known as the Flats— represented the city's most unique, identifiable feature. In her autobiography, Margaret Bourke-White described this area, which she discovered in 1927 when she was an unknown twenty-three-year-old photographer:

In the mammoth backyard of Cleveland, stretching from the foot of soaring office buildings to the swampy shore of Lake Erie, lies a sprawling, cluttered area known as the Flats. Slashed across by countless railroad tracks and channeled through by the wandering Cuyahoga, the Flats are astir with nervous life. Locomotives slap and shove reluctant coal cars; tugboats coax their bulging ore barges around the river bends. Overhead, traffic roars into the city on high-flung bridges. At the far edge of this clanging confusion, smokestacks on the upper rim of the Flats raise their smoking arms over the blast furnaces, where ore meets coke and becomes steel.[13]

Bourke-White had come to Cleveland to live with her widowed mother. Attempting to support herself as a free-lance photographer, Bourke-White began photographing the homes and estates of the affluent, but it was the steel mills of the Flats that aroused her emotions. Her description of approaching this industrial valley in her car (nicknamed "Patrick") conveys the excitement these mysterious giants evoked in her imagination:

Dawn was coming with a rush as I drove along the upper rim of the Flats. I parked Patrick on a high rise overhanging the riverside plant of Otis Steel. As though sealed away from the daylight, the steel mills lay in a fog-filled bowl, brooding, mysterious, their smokestacks rising high above them in ghostly fingers. Suddenly the mist was warmed with flame as a line of slag thimbles shot out of the dark and, like a chain of

Figure 115. Margaret Bourke-White, *Hot Pigs, Otis Steel Co., Cleveland,* ca. 1928, gelatin-silver print, 13 x 10 in. (33 x 25.4 cm). The Cleveland Museum of Art, gift of Mrs. Albert A. Levin.

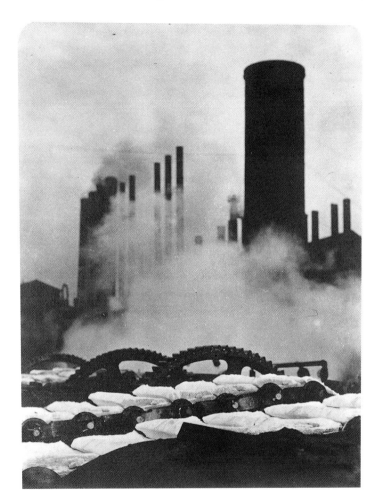

blazing beads, rolled over the tracks to the edge of an embankment, below where I stood. Car after car, they tipped their burning, bleeding loads down the slope, then rattled back to vanish into the murk again. . . . And I drove home in Patrick, wondering how I was going to get into that magic place.[14]

In contrast to the distant and impersonal views of the Flats that had for many years been a staple of the city's documentary photographers, Bourke-White created extreme closeups that bring the viewer directly and emotionally into the image (fig. 115).[15] By skillfully framing and cropping shapes at the picture edge, she transformed smokestacks and industrial machinery into elegant formal compositions. Bourke-White spoke for many Cleveland artists when she explained her fascination with these subjects:

Figure 116. Stevan Dohanos, *Blast Furnaces,* ca. 1933, wood engraving, 8 x 10 in. (20.2 x 25.4 cm). The Cleveland Museum of Art, gift of the Print Club of Cleveland.

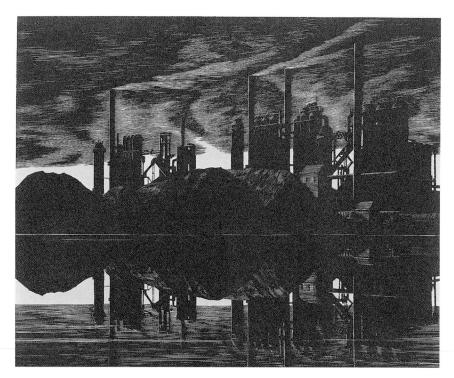

There is a power and vitality in industry that makes it a magnificent subject for photography, that it reflects the age in which we live, that the steel mills are at the very heart of industry with the most drama, the most beauty—and that was why I wanted to capture the spirit of steelmaking in photographs. . . . To me these industrial forms were all the more beautiful because they were never designed to be beautiful.

Figure 117. Margaret Bourke-White, *Otis Steel, Cleveland,* ca. 1928, gelatin-silver print, 4¾ x 3½ in. (12 x 8.9 cm). Peter and Judy Wach Collection.

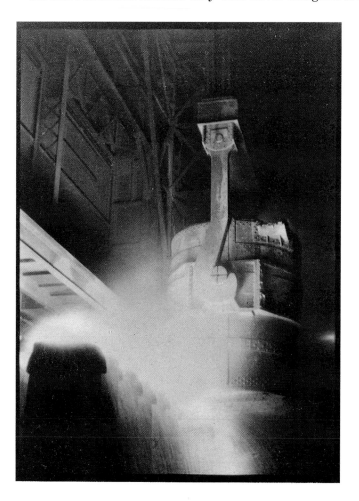

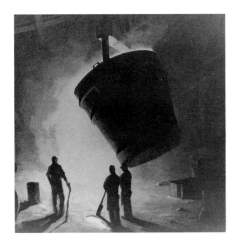

Figure 118. Carl Gaertner, *The Ladle,* 1928, oil on canvas, 40 x 39 in. (101.5 x 90 cm). Location unknown. [not in exhibition]

Figure 119. Margaret Bourke-White, *Steel Worker at the Furnace, Cleveland,* ca. 1928, gelatin-silver print, 13⅜ x 9½ in. (34 x 24.1 cm). Peter and Judy Wach Collection.

They had a simplicity of line that came from their direct application to purpose. Industry, I felt, had evolved an unconscious beauty—often a hidden beauty that was waiting to be discovered.[16]

Bourke-White's fascination with the drama and mystery of the steel mills is echoed in *Blast Furnaces* (fig. 116), a starkly elegant wood engraving by Stevan Dohanos. Her photograph of pouring molten steel (fig. 117) finds its kin in Carl Gaertner's painting *The Ladle* (fig. 118). Intrigued by the laborers who direct this industrial inferno, Bourke-White (fig. 119) and Gaertner used evocative backlighting to simplify and abstract forms, thereby creating powerful compositions that transform apparently mundane events into statements of timeless, universal beauty. Fire, smoke, and steam suggest the presence of some mysterious force, as if equating steel production with the creation of life.

In 1921 Max Kalish, Cleveland's leading sculptor of the early twentieth century, began a series of sculptures on the subject of labor, a theme that would preoccupy him for nearly two decades. Kalish was born to a family of Lithuanian immigrants and studied with Horace Potter at the Cleveland School of Art. In 1912 he briefly shared a studio with William Zorach. After attending classes at the École des Beaux-Arts in Paris,

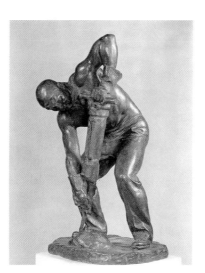

Figure 120. Max Kalish, *The Driller,* 1926, bronze, 16 x 9½ x 7¾ in. (40.6 x 24 x 19.7 cm). The Cleveland Museum of Art, gift of friends of the artist.

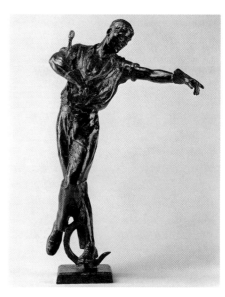

Figure 121. Max Kalish, *Steel Worker (Steel into the Sky),* ca. 1928, bronze, 18¾ x 11 x 4½ in. (47.6 x 27.9 x 11.4 cm). The Cleveland Museum of Art, gift of friends of the artist.

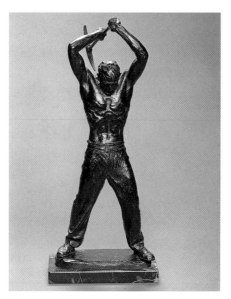

Figure 122. Max Kalish, *Road Worker,* 1930, bronze, 19½ x 7 x 8½ in. (47.6 x 17.8 x 21.6 cm). Betty and Kenneth Lay Collection.

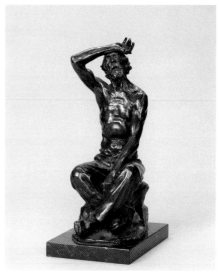

Figure 123. Max Kalish, *Despair,* 1926, bronze, 14½ x 7 x 9 in. (36.8 x 17.8 x 22.9 cm). The Western Reserve Historical Society. [not in exhibition]

Kalish spent three years producing architectural sculpture at the Panama-Pacific Exhibition in San Francisco. He returned to Cleveland with high ambitions, declaring: "It is the big idea in art that counts."[17] By 1917 he had concluded that art should have a social mission: "After the war every artist will have to carry the message of democracy through his medium to a free people of the world."[18]

In 1924 Kalish received first prize in sculpture for five works submitted to the May Show, including four bronze laborers. These sculptures (figs. 120–23), most of which were cast on his annual trips to Paris, combine the muscular, plastic forms of Auguste Rodin with the reality of life in industrial America. Kalish noted that the subjects were derived from sketches made on the streets and in the steel mills:

As I mingle among the workers in the factories or in the open, I find them in their natural poses. Their bodies swing gracefully to the action, their muscles strain or relax in response to their task. In the performance of their daily task, there is strength and grace, while at rest there is a sense of rhythm and beauty. . . .We must learn to create from the living present. In this great modern industrial age, tremendous, heroic tasks are being performed and it is here that we will find our greatest art expression.[19]

In 1926 the Cleveland Trust Company acquired a set of six of Kalish's labor sculptures and displayed them in its various branches around the city, until more permanently placing them in the window of its building on Public Square. Beginning with *The Driller* and culminating with *Despair*, this group has been interpreted as representing the financial stages of the worker's life.[20]

Figure 124. Lawrence Schreiber, *Churning By*, ca. 1940, bromoil transfer photograph, 9½ x 7½ in. (24.1 x 19 cm). William and Mary Kubat Collection.

CIVIC ICONS

CLEVELAND PAINTERS, PRINTMAKERS, AND PHOTOGRAPHERS found a source of endless fascination and inspiration in the Cuyahoga River, which snakes its way through the Flats and bisects the city before emptying into Lake Erie. Lawrence Schreiber, a leading Cleveland pictorialist, photographed the river traffic for several decades. He produced the delicate tones of *Churning By* (fig. 124) through expert manipulation of the bromoil process, in which oil pigment is selectively added to the emulsion. This technique produces gritty atmospheric effects that are highly successful at evoking the visual texture of industrial Cleveland.

Cleveland artists were particularly fascinated by the numerous bridges that span the Cuyahoga, literally and symbolically linking the city's east and west sides. Of all the various bridges—vehicular and railway, high fixed spans and low movables, draws and swings, cantilevers and lifts—the

one that most captured the imagination of artists was the High Level Bridge (also known as the Detroit-Superior). In 1926, when New York printmaker Rudolph Ruzicka was commissioned to create a print for the Cleveland Print Club, he spent several months sketching in the Flats, then selected this bridge as his icon of the city (fig. 125). Ruzicka's wood engraving looks across the Cuyahoga toward the east, with the future site of Terminal Tower in the upper right. The viewer stands below the west pier of this two-level bridge, an engineering marvel completed in 1918, with an upper deck for vehicular traffic and a lower deck for electric streetcars. Like other artists, Ruzicka was attracted to the formal structure of the bridge: massive concrete piers on each bank connected by an arched steel span in the center. Bourke-White photographed the High Level Bridge from the same river bank (fig. 126), barely showing part of the arcaded concrete pier, whose dramatic shape echoes the arch of the central steel span and reaches toward the sky like a taut bow. George Adomeit painted numerous views of the High Level Bridge and the surrounding working-class neighborhoods. The dilapidated building at the foot of the bridge in *A Cool Refreshing Drink* (fig. 127), for instance, hints at the toll years of industrial production have exacted on the city and its residents.

Figure 125. Rudolph Ruzicka, *The High Level Bridge,* 1926, wood engraving, printed in color, 7⅛ x 5 in. (17.9 x 12.9 cm). The Cleveland Museum of Art, gift of the Print Club of Cleveland.

Figure 126. Margaret Bourke-White, *The High Level Bridge,* ca. 1928, gelatin-silver print, 13 x 10 in. (33 x 25.4 cm). Peter and Judy Wach Collection.

Figure 127. George Adomeit, *A Cool Refreshing Drink,* 1931, oil on canvas, 26½ x 31½ in. (67.3 x 80 cm). Miss Ruth E. Adomeit.

Figure 128. Walter Bruning, *The Vision,* 1927, bromoil transfer photograph, 8⅞ x 6¾ in. (22.6 x 17.2 cm). Peter and Judy Wach Collection.

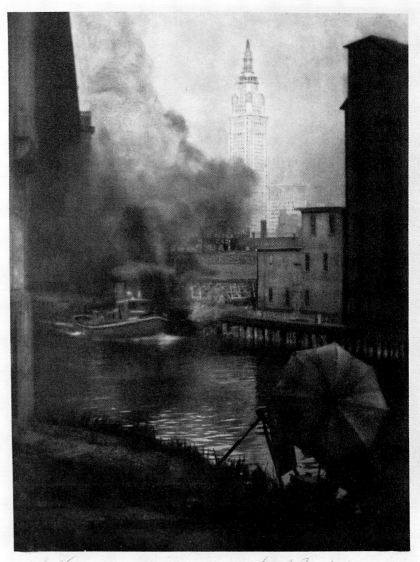

Figure 129. Margaret Bourke-White, *Terminal Tower with High Level Bridge,* 1928, gelatin-silver print, 13⁷⁄₁₆ x 10¼ in. (34.1 x 26 cm). Peter and Judy Wach Collection.

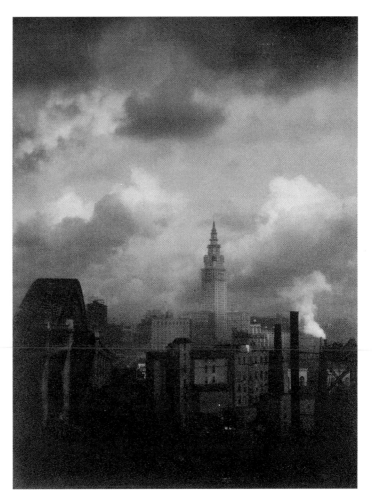

In 1924 construction began on the Terminal Tower, which immediately replaced the High Level Bridge as city's most recognizable icon. Constructed on the southwest corner of Public Square, and at the time of its construction the second tallest building in the world, Terminal Tower was connected to a complex of shopping malls and hotels. At its heart was the city's central depot for passenger trains and streetcars. Walter Bruning's photograph *The Vision* (fig. 128) depicts the building during construction. Using the same painterly bromoil process as Schreiber, Bruning creates an evocative image of the tower rising like a ghostly apparition from the banks of the Cuyahoga, where settlers had founded the city in 1796. In the lower right an artist shielded by an umbrella paints at an easel, apparently documenting the city's transformation from a canal village into a modern metropolis.

Bourke-White photographed the Terminal Tower from various angles and with different motifs juxtaposed in the foreground. One of her photographs is composed so that the tower appears at the apex of a visual pyramid (fig. 129), as if ascending from a smoky pit, flanked by the High Level Bridge in the lower left and the smokestacks of the Flats to the right. Schreiber's *Early Traffic* (fig. 130) similarly presents the tower as a dynamic symbol of the modern city—a faceless giant of inhuman scale ascending through mist and fog.

Although the Terminal Tower was Cleveland's most identifiable icon, it was not the only motif that artists employed to define their vision of civic identity. *Monuments* by Ora Coltman (fig. 131) presents the Erie Street Cemetery, where many of the city's founders are buried, as a foil to the newly constructed Ohio Bell Telephone Building. By juxtaposing the old

Figure 130. Lawrence Schreiber, *Early Traffic,* 1933, gelatin-silver print, 7¼ x 10 in. (18.4 x 25.4 cm). William and Mary Kubat Collection.

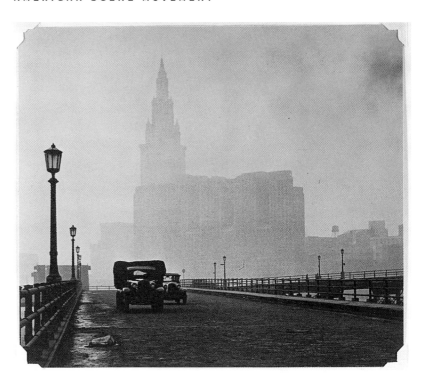

cemetery with a new skyscraper, Coltman created another visual allegory of the modern industrial city rising from the ashes of the old canal village.[21] Adomeit repeated this theme, but included the Terminal Tower behind the Ohio Bell Building in his painting, *Memorials* (fig. 132). Gaertner's *Christmas Eve* (see fig. 112) similarly alludes to the city's transformation from the old to new Cleveland. Modern streetcars jostle before

Figure 131. Ora Coltman, *Monuments,* ca. 1928, oil on canvas, 36 x 30 in. (91.4 x 76.2 cm). Cleveland Public Library.

Figure 132. George Adomeit, *Memorials ("They Do Not Answer"),* 1928, oil on canvas, dimensions unknown. Location unknown. [not in exhibition]

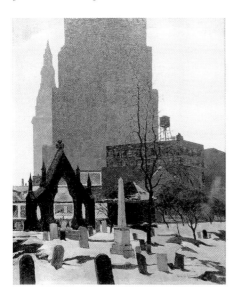

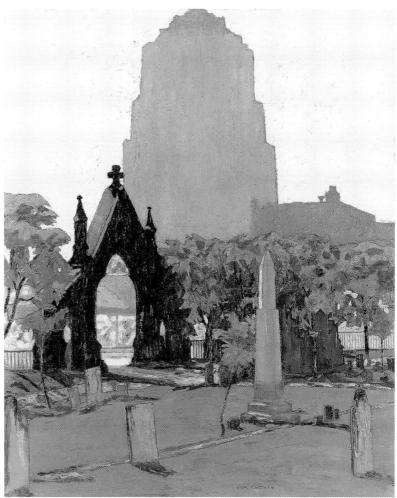

Figure 133. Margaret Bourke-White, *Public Square (Terminal Tower) at 5:00, Seen through a Williamson Building Grille,* 1928, gelatin-silver print, 13¾ x 10¼ in. (35 x 26 cm). Joyce Edson Collection.

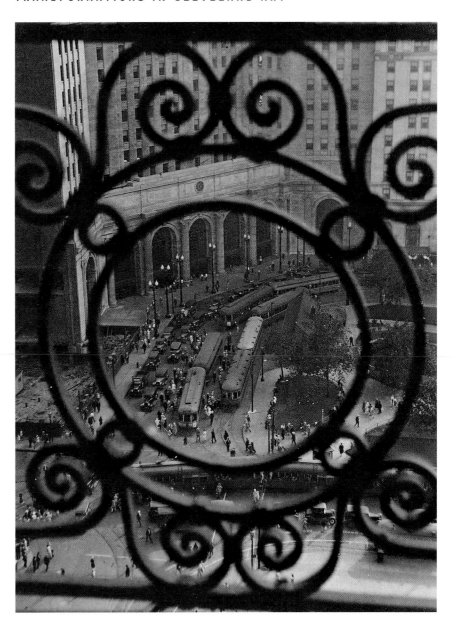

the distinctive facade of the Old Stone Church (1855), the oldest surviving building on Public Square, while another familiar landmark, the statue of Moses Cleaveland (the city's founder seen carrying his surveyor's stick) appears like a ghostly apparition in the lower left.[22]

Bourke-White's photograph *Public Square (Terminal Tower) at 5:00, Seen through a Williamson Building Grille* (fig. 133) provides a daylight glimpse of the spot where Gaertner was standing when he conceived *Christmas Eve.* For this photograph Bourke-White selected a highly unusual viewpoint: from inside a tall office building, the spectator looks down at the tops of electric streetcars stopped to load passengers between the main entrance to Terminal Tower and a waiting pavilion on Public Square. Lawrence Blazey employed the same pictorial device of a high vantage point and converging diagonals to evoke a sense of dramatic excitement in his view of *Playhouse Square, Cleveland* (fig. 134), which defines the modern city as a hub of social and business exchange.

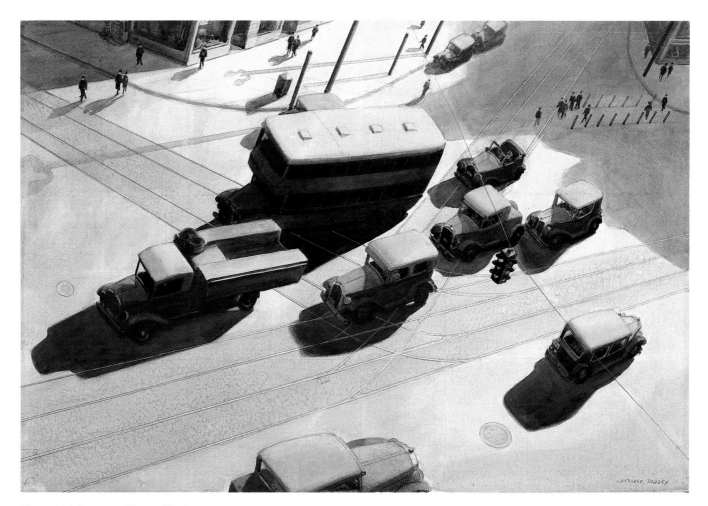

Figure 134. Lawrence Blazey, *Playhouse Square, Cleveland,* 1935, watercolor, gouache, and graphite with collage, 20¼ x 30 in. (51.3 x 76.2 cm). The Cleveland Museum of Art, gift of Joseph M. Erdelac.

REGIONS BEYOND THE CITY

NOT ONLY DID CLEVELAND ARTISTS of the 1920s and 1930s seek to define the unique character of their city, they also set out to explore more distant regions. Before 1914 most Cleveland artists had aspired to visit Europe. When World War I restricted travel abroad, they sought alternatives in the vastness and diversity of their own country. In the summer of 1918 Cleveland artists began traveling *en masse* to paint in Provincetown on the tip of Cape Cod. Other popular destinations for summer painting excursions included rural Ohio, West Virginia, New England, the Rocky Mountains, and the California coast.

At the age of sixteen George Adomeit received a scholarship to attend the Cleveland School of Art, but for financial reasons he declined the offer and began a lifelong career in commercial lithography. After cofounding his own engraving company in 1902, he became financially secure enough to devote considerable time to painting, and later developed the habit of taking annual summer painting trips away from the city. During his early years he painted evocative landscapes filled with soft, glowing sunlight (see fig. 48). By 1920 he had abandoned that early impressionist style for a hard-edged realism, in which shapes are defined by sure, crisp drawing gained from years of experience in commercial art. As a result of increasing attention to modeling, his forms also gained greater weight and sub-

Figure 135. George Adomeit, *In Port,* 1926, oil on canvas, 25 x 30¼ in. (63.5 x 76.9 cm). City of Cleveland, the Mary A. Warner Collection.

Figure 136. George Adomeit, *Hillside Farm (Provincetown),* 1941, oil on canvas, 37 x 41 in. (94 x 104 cm). Miss Ruth E. Adomeit.

Figure 137. Frank Wilcox, *The Bee Tree,*
1930, oil on canvas, 30 x 40 in. (76.2 x 102
cm). The Wilcox Estate.

stance. *In Port* (fig. 135), one of his many paintings of the rugged Maine coast, is an American scene subject that incorporates the intense blue-violets of the Berlin Heights style. This lingering preoccupation with decorative color, also seen in the shadowed foreground of *Hillside Farm* (fig. 136), creates a regionalist-modernist fusion that is characteristic of Cleveland painting between the world wars.

The American scene and regionalist movements embraced a desire for escape to what some Americans imagined as an innocent past—before cities were overrun with pollution, unwelcome immigrants, gangsters, labor strikes, and political turmoil. Responding to the isolationist and nationalist sentiment of the era, many Cleveland artists turned to themes of American folklore and rural life. Frank Wilcox's *The Bee Tree* (fig. 137), depicting the felling of a tree to extract the honeycomb in its trunk, responded to the public's appetite for earthy, whimsical subjects. The same populist spirit informs Wilcox's paintings of Ohio pioneer history and Indian folklore.

In 1927 Paul Travis, who had previously associated with Charles Burchfield and the Cleveland modernists, received a year's sabbatical to travel to Africa, where he hoped to find alternative sources of artistic inspiration. Before departing, Travis was given money by the Gilpin Players, the theatrical company of Cleveland's Playhouse Settlement (later renamed Karamu House), so that he could acquire examples of African art for distribution to the settlement, the Cleveland Museum of Natural History, and the Cleveland Museum of Art.

Travis recorded his impressions of Africa in notebook sketches that were to provide him with painting subjects for years to come. In 1931 he commented:

Figure 138. Paul Travis, *Campfire Scene, Africa,* 1928, watercolor, 14 x 20 in. (35.6 x 50.8 cm). Dr. and Mrs. Michael Dreyfuss Collection.

Africa as a source of new motifs and schemes of color is inexhaustible, I tried to view it abstractly, to simplify the scenes to their basic power, to get the spring of great full-blooded plants . . . and so on over the tops of infinitely varied trees and buttressed hills to where the iridescent horizon met the flaming sky.[23]

His evocative *Campfire Scene, Africa* (fig. 138), depicting a night in Kenya as reconstructed from his notebooks, employs a sophisticated watercolor technique of translucent washes and rich, luminous color. The gestural brushstrokes and decorative shapes of the tree leaves reflect the influence of Chinese scroll paintings.[24]

Travis contributed significantly to Cleveland's growing reputation as a national center of watercolor painting. Henry Keller, whose first assignment at the Cleveland School of Art was to teach the watercolor class, is

Figure 139. Henry Keller, *The Cove at La Jolla, California,* 1935, watercolor and graphite, 14¾ x 20¾ in. (37.5 x 52.7 cm). The Cleveland Museum of Art, gift of Mrs. Edd Ruggles.

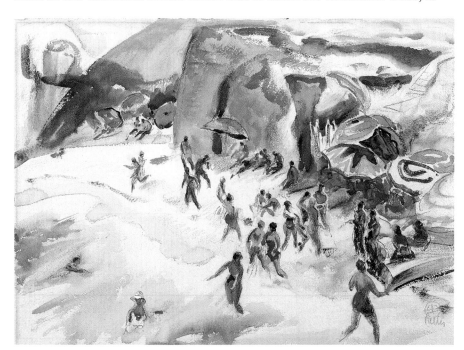

Figure 140. Clarence Carter, *Jesus Wept,* 1936, watercolor, 14⅞ x 22 in. (37.8 x 55.9 cm). Southern Ohio Museum, Portsmouth, purchase: James and Tabitha Pugh Trust, Scioto County Area Foundation.

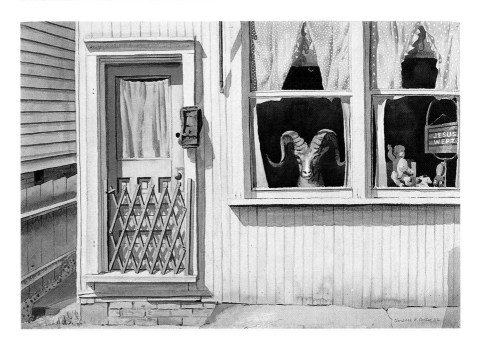

widely considered the founder of the city's tradition in the medium, partly because the techniques he developed at Berlin Heights were so widely emulated by Cleveland watercolorists. Keller's approach to watercolor was significantly influenced by his admiration for the economical brushwork, simplified forms, and rhythmic movement he observed in Chinese scroll paintings. Keller emulated those qualities in his mature watercolors, such as *The Cove at La Jolla, California* (fig. 139), which he painted while touring the West in search of American scene subjects. In 1936 Charles Burchfield, who after studying with Keller made watercolor his principal medium, commented:

> Some of his [Keller's] best work has been done in transparent watercolor. In many of them he shows somewhat the influence of the Chinese, whom he has always admired and studied, not in any imitative manner, but in the fundamental sense that he has learned to say a great deal with economy of means and little apparent effort.[25]

Still underrated as a watercolorist, Clarence Carter was one of Cleveland's finest painters of the American scene. A native of Portsmouth, Ohio, Carter studied with Keller, Travis, and Wilcox at the Cleveland School of Art from 1923 to 1927. William Milliken of the Cleveland Museum of Art was so impressed with Carter's student work that he provided Carter with the resources to travel in Europe for nearly a year. In 1930 Carter returned to Cleveland, where he taught studio classes at the Cleveland Museum of Art until 1937. He painted *Jesus Wept* (fig. 140) while visiting his hometown on the Ohio River, just across the border from Kentucky. The subject presented itself entirely by chance. Carter was driving along Waller Street one day when he saw a clapboard house with a ram and a sign in the window that read: "Jesus Wept." The juxtaposition of the sign and ram appealed to Carter's taste for incongruous, humorous subjects. Since his paints were already in the car, he parked and started to record the scene. This so annoyed the occupant that he took a hose and sprayed the car, but Carter just rolled up the window and continued painting. The man grew increasing incensed and returned to shake a box of writhing snakes at Carter, but to no avail.[26]

CITIZENS: THE BODY POLITIC

CLEVELAND ARTISTS documented not only the unique features of their city, but also the diversity of its inhabitants. They catalogued the variety of races, sexes, and social classes, from powerful politicians to young African-Americans struggling for a place in the city's economic system. Although Cleveland artists painted portraits on commission for affluent patrons, their favorite subjects were themselves, their colleagues, and the people with whom they shared their daily lives.

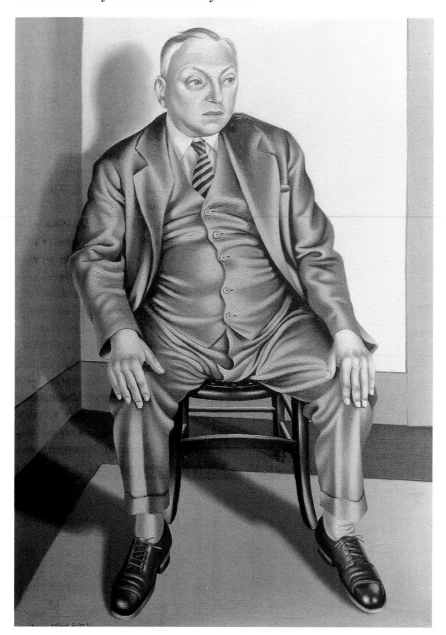

Figure 141. Clarence Carter, *William Stolte, Ex-Councilman,* 1932, oil on canvas, 50 x 35½ in. (127 x 90.2 cm). Steve Turner, the Steve Turner Gallery.

In 1932 Carter painted a portrait of his landlord, former city councilman William Stolte (fig. 141). With only five dollars in the bank at the onset of the Depression, Carter was grateful to Stolte for having converted a room in his rented house into a studio.[27] Despite this act of generosity, Carter did not flatter his landlord with sentimental emotions. Rather, he displays Stolte's ample girth honestly, using harsh lighting and a pose that exaggerates the sitter's belly, turning it into a humorous counterpoint to his dour face. For his part, Stolte seems uncomfortable at being subjected to Carter's intense gaze, sensing perhaps that the artist is probing for unflattering psychological insights. Rather than greeting the viewer, Stolte gazes suspiciously sideways toward an undefined light source, while his

tightly laced shoes and taut fingers contribute to the anxiety of this confrontation between sitter and artist.[28]

Hughie Lee-Smith, one of the city's most distinguished African-American artists, began his art studies in Carter's studio classes at the Cleveland Museum of Art. Smith had moved to Cleveland from the South at the age of ten with his widowed mother, a professional singer. His mother took him to the art museum, where a budding relationship devel-

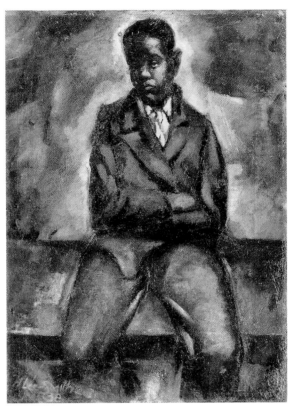

Figure 142. Hughie Lee-Smith. *Portrait of a Boy,* 1938, oil on canvas, 24 x 18 in. (61 x 45.7 cm). Collection of Patricia Lee-Smith, courtesy June Kelley Gallery.

Figure 143. Elmer Novotny, *John Cherry,* 1929, oil on panel, 18¼ x 14¼ in. (46.4 x 36.2 cm). Cleveland Artists Foundation.

oped with Carter. Lee-Smith also visited the older artist in his studio, and it was Carter's example that inspired the young man to think of becoming an artist himself. In 1935 Lee-Smith received a scholarship to attend the Cleveland School of Art, where he studied with Gaertner, Wilcox, and Travis. Like Carter, Lee-Smith displayed a gift for psychological insight in *Portrait of a Boy* (fig. 142), a painting completed during Lee-Smith's senior year at art school that seems to capture the gloomy spirit of the Depression. Carter remained a friend and mentor to Lee-Smith, and in 1938 helped him obtain employment in the Ohio division of the Federal Art Project. In 1940 Lee-Smith, Elmer Brown, Charles Sallée, and several other Clevelanders formed Karamu Artists, Incorporated, one of the most significant organizations of African-American artists in the country.[29]

Elmer Novotny, Sandor Vago, and Rolf Stoll made singular and varied contributions to Cleveland's regional-realist tradition through their portraits and figure paintings. Novotny was born in Cleveland and began painting as a child under the direction of his father, a self-taught commercial artist who had emigrated from Czechoslovakia and apprenticed at Morgan Lithography. Novotny carried forward the family tradition of careful observation of the natural world. "I've been a realist from the start," he observed. "I became interested in people as subject matter at an extremely early age and did my first portrait for commission at the age of thirteen."[30] He painted his portrait of John Cherry (fig. 143) during his junior year at the Cleveland School of Art. The sitter, a fellow student, painted the still life in the upper left signed "John Cherry" (Novotny's signature appears in

Figure 144. Sandor Vago, *The Artist's Wife,* 1930, oil on canvas, 36 x 32 in. (91.4 x 81.3 cm). Renee and Richard Zellner Collection.

Figure 145. Sandor Vago, *The Artist and His Wife,* ca. 1938, oil on canvas, 38 x 48 in. (96.5 x 122 cm). William R. Joseph and Sarah J. Sager Collection.

the lower right of the portrait). The cubist style of the still life is echoed by the tilting diagonal plane that bisects the portrait's upper right, providing a dynamic counterpoint to the sitter's erect pose and aloof face, with its pristine oval shape. The lack of any defined purpose for this diagonal, created by an unexplained shift in light, inserts an element of mystery into this otherwise straightforward portrait.

Figure 146. Elmer Novotny, *The Artist and His Wife* (Virginia Novotny), 1938, oil on canvas, 52 x 44 in. (132 x 112 cm). Karen N. Tischer Collection.

Sandor Vago painted a variety of subjects, but attained critical recognition for his portraits, which in their sensual color and lively brushwork establish a counterpoint to Novotny and Carter's cool, linear styles. Born in Hungary and trained in Budapest and Munich, Vago immigrated to Cleveland in 1921. Most of his early work was destroyed during World War I while he was a prisoner of war in Russia. Soon after arriving in the city, he established himself as one of Cleveland's finest portrait painters. By working quickly and ignoring nonessential details, he hoped to capture the sitter's mental state. "I do not want to paint just the mask," he asserted, "but I seek to put the inner self in the portrait as well."[31] A striving for psychological intimacy informs *The Artist's Wife* (fig. 144), which contrasts the cool intelligence in her expression with the sexuality of her subtly exposed breast. By strategically placing her hand in the foreground with a prominently displayed wedding ring, Vago is careful to ward off potential competitors. Only one subject fascinated Vago more than his wife: himself. They appear together in *The Artist and His Wife* (fig. 145), in which Vago greets the viewer with a brooding swagger—holding a paintbrush at the hip, thrusting his coat aside, and dangling a cigarette from his lips in Humphrey Bogart fashion.

Novotny's *The Artist and His Wife* (fig. 146) presents the same subject, a double portrait set in the painter's studio, but with less bravado. Rather than psychological complexity, Novotny creates an intriguing composition of sharply defined planes folding and receding in space, at times turned parallel to the picture surface. The viewer's eye moves through this space as if gazing at a multifaceted mirror until it focuses on the juxtaposition between the artist's profile and the drawing of a nude on the distant wall.

Figure 147. Rolf Stoll, *Anne Stanger,* 1941, oil and egg tempera on fiberboard, 29 x 22 in. (73.7 x 60 cm). Private collection, courtesy Vixseboxse Art Galleries.

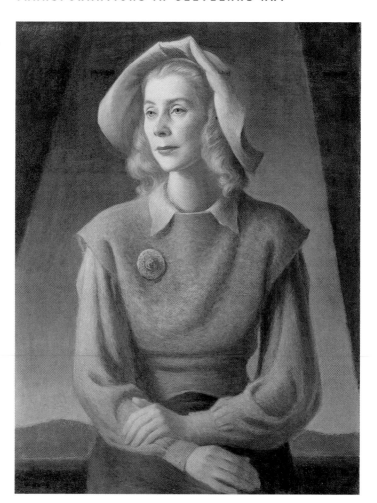

Figure 148. Allen Cole, *Self-Portrait,* ca. 1920, gelatin-silver print, 7 x 5 in. (17.8 x 12.7 cm). The Western Reserve Historical Society. [not in exhibition]

Rolf Stoll, who also made his reputation as a portrait painter, was born in Germany and studied at art academies in Karlsruhe and Stuttgart around 1910. Like Vago, he came to Cleveland in the 1920s. Exhibiting in his first May Show in 1925, Stoll won first prize for oil painting. In 1926 he joined the faculty of the Cleveland School of Art as an instructor of portrait painting. Within two years he was appointed director of the school's portrait painting department, a position he retained until 1957 and through which he influenced the training of local portrait painters.

Stoll's *Anne Stanger* (fig. 147) depicts a colleague about whom little is known, except that Stanger was another artist who exhibited paintings in five May Shows from 1940 to 1945, then mysteriously disappeared from the art scene. She never registered as a student at the art school but may have studied privately with Stoll. The extremely fine detail in the face and hair, as well as the transparent reds of the bodice and the cracking pattern in various paint surfaces, suggest that Stoll used an oil-egg tempera technique associated with the Neue Sachlichkeit (new objectivity) paintings of the German artist Otto Dix. This technique involves painting the underlayers in egg tempera, over which the artist slowly builds up translucent oil glazes and then reinforces the fine details with tempera. These paintings are usually executed on a rigid wood support that, because it does not flex or sag, enhances the artist's ability to attain extremely fine detail. Like Dix and the Neue Sachlichkeit artists, Stoll may have derived this technique from the popular painting manuals published in Germany during the 1920s by the conservation scientist Max Doerner, who analyzed the methods and materials of Albrecht Dürer, Hans Holbein, and other Renaissance masters.[32]

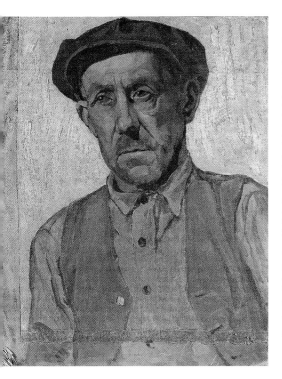

Figure 149. George Adomeit, *WPA Worker,* ca. 1935, oil on canvas mounted to board, 20 x 16 in. (50.8 x 40.7 cm). Miss Ruth E. Adomeit.

Figure 150. Allen Cole, *Kyer's Service Station,* ca. 1932, gelatin-silver print, 8 x 10 in. (20.3 x 25.4 cm). The Western Reserve Historical Society.

While Stoll and Vago documented the lives of citizens in their communities, Allen Cole spent over forty years photographing the city's African-American population. Born and raised in West Virginia, Cole moved to Cleveland around 1918 and for many years remained the only African-American member of the city's Society of Professional Photographers. Rather than locating in the downtown business district where most white photographers worked, Cole opened a studio in his eastside home and devoted himself to serving the needs of the local community. This afforded him a unique position to chronicle the rise of the New Negro movement in the prosperous 1920s, as well as the hardships endured by African-Americans during the Depression. As a staunch advocate of the New Negro philosophy of self-sufficiency and self-reliance, Cole assumed a leadership role in the Cleveland Board of Trade, an African-American business association.[33] Around 1920 he photographed himself (fig. 148) as a self-confident businessman wearing a suit and tie, just as Novotny presented his artist friend John Cherry and as Vago portrayed himself in *The Artist and His Wife.* In contrast to Adomeit's *WPA Worker* (fig. 149), the attire of these men indicates that they identified with the middle rather than the working class.[34] The self-confidence and pride in success that informs Cole's self-portrait is also conveyed in his photographs of African-American athletes, musicians, politicians, and businessmen. Cole's photograph *Kyer's Service Station* (fig. 150) depicts a Shell station purchased by Richard Kyer, a laborer who after years of hard work and saving his money was able to purchase his own piece of the American entrepreneurial dream.[35]

The social classes meet in Novotny's painting *Gathering at the Bar (Les Habitués)* (fig. 151), in which a bartender acts as the node of interchange between a mechanic in a blue jumpsuit, a man wearing a leather jacket, and a man in a trench coat that presumably protects a suit and tie. The men are surrounded by the accoutrements of their daily lives: a folded newspaper, a coffee pot, liquor bottles, and a pin-up reflected in the mirror. Although sharing this daily ritual, the men appear weary and bored, weighed down by the meaningless routine of lives confined to predetermined social relationships and unfilled dreams. Cole's photograph *Lucille's Sandwich Shoppe* (fig. 152) is similarly encoded with references to social interchange and relationships. African-Americans at the lunch counter sit beneath a parade of white faces: cutout advertisements of movie stars and

Figure 151. Elmer Novotny, *Gathering at the Bar (Les Habitués),* 1941, oil on panel, 42 x 55 in. (107 x 140 cm). Private collection, courtesy D. Wigmore Fine Art.

Figure 152. Allen Cole, *Lucille's Sandwich Shoppe,* ca. 1940, gelatin-silver print, 8 x 10 in. (20.3 x 25.4 cm). The Western Reserve Historical Society.

glamorous people. The advertisements suggest a cruel constellation of impossible dreams for African-Americans—the attainment of fame, wealth, and acceptance in a racially segregated society. Even though the African-Americans in Cole's photograph are citizens of the same republic as the men gathered around Novotny's bar, they are confined to separate roles and destinies.

AFTER THE CRASH

IN OCTOBER 1929 fourteen billion dollars was lost in the single greatest stock market collapse in history. This debacle did not immediately alter life in Cleveland because projects already under way continued to bolster the city for nearly six months. After the completion of the Terminal Tower in the summer of 1930, however, Cleveland's economy spiraled quickly downward. As national orders for goods fell, industrial production in Cleveland plummeted. From 1930 to 1933 unemployment in Cuyahoga County rose from 41,000 to 219,000; between 1929 and 1933 wages paid to workers fell by more than a half.[36] Of the city's sixteen major banks, twelve failed. To compensate for declining tax revenues, the city slashed the salaries of public employees. By 1933 building construction had fallen by seventy-five percent. With nearly one-third of the work force unemployed, malnutrition and hunger became widespread. As the economic collapse spread throughout the city, commercial lithographers lost their jobs and declining enrollment forced the Cleveland School of Art to lay off faculty. Throughout the winter of 1932–33, one of the bleakest in the country's history, thousands went hungry and the unemployed staged violent demonstrations. As the country teetered on the brink of anarchy, President Herbert Hoover doubted if president-elect Franklin Roosevelt could do anything to improve conditions when he assumed office the following spring.

After his inauguration in March 1933, Roosevelt quickly pushed a host of relief programs through Congress. The first program specifically designed to aid artists, the Public Works Administration Project (PWAP), was approved in December. It authorized the expenditure of federal funds to decorate public buildings with murals and other works. Barely a week after the PWAP's founding, William Milliken, director of the Cleveland Museum of Art, rushed to Washington and pleaded for Cleveland artists with such ardor that Eleanor Roosevelt reportedly set aside her knitting.[37] Milliken returned to Cleveland as the head of PWAP district nine, a four-state region that included Ohio, Michigan, Indiana, and Kentucky. The day after the news was announced, sixteen Cleveland artists joined the federal payroll. During the two winter days that followed, artists formed long lines around the museum seeking jobs on the project. Murals were quickly commissioned for the Cleveland Public Library and Public Auditorium. Following both his own inclinations and national directives from the PWAP, Milliken asked Cleveland artists to focus on subjects that would lift spirits and restore the unraveling social fabric. He declared that artists should think "in terms of a particular community, stressing the qualities of that community, and the elements important to it," and that the PWAP must bring "the artist and public together in a fashion . . . [as] too often the creative worker has lived in a world shut away from human realities."[38]

Cleveland artists had little experience working on large-scale architectural commissions, and in their rush to fulfill their contracts, they encountered unforeseen formal and technical problems. Rather than painting directly on the wall, they painted most of their "murals" in the familiar oil on canvas method, with compositions blown up to fill the required space. They then transported their paintings to the site and attached them to the

Figure 153. Clarence Carter, *Study for Barnesville Post Office Mural,* 1935, oil on board, 16½ x 39 in. (42 x 99 cm). Collection of John P. Axelrod, courtesy Michael Rosenfeld Gallery.

walls. In 1933–34 Clarence Carter, Ora Coltman, and William Sommer received commissions to paint murals.

In 1935 the PWAP was succeeded by the Federal Art Project of the Works Progress Administration (WPA) and the Treasury Relief Art Project (TRAP). During their seven years of existence these programs employed hundreds of Cleveland artists, including Carter, Coltman, Lee-Smith, and Sommer, as well as Alexander Blazys, Elmer Brown, Edris Eckhardt, and Charles Sallée. Carter received commissions to paint post office murals in the Ohio towns of Barnesville, Ravenna, and Portsmouth. His *Study for the Barnesville Post Office Mural* (fig. 153) presents symbols of modern transportation in a striking precisionist style. In 1936 he was appointed supervisor of district four of the Ohio WPA, a position he held until 1938.[39]

Eckhardt directed the sculpture and ceramics division of the Ohio WPA from 1935 to 1941. Born in Cleveland to a family of foundry workers, she attended children's classes at the Cleveland Museum of Art and studied with sculptor Alexander Blazys at the Cleveland School of Art in the late 1920s. After a year of study with sculptor Alexander Archipenko in New York, she returned to Cleveland in 1932 to teach at the Cleveland School of Art. Although admiring unique pieces of sculpture, she realized that making multiples was more practical during the Depression and began working extensively with ceramics. She became known for emphasizing the sculptural qualities of clay and for experimenting with colored clays and unusual glazes. Inspired by the plight of Polish refugees in World War II but alluding more broadly to the tragedy and suffering all wars inflict on the innocent, *Exodus* (fig. 154) is a rare but poignant social commentary in her oeuvre.

Figure 154. Edris Eckhardt, *Exodus,* 1945, earthenware, 12½ x 7 x 6½ in. (31.8 x 17.8 x 16.5 cm). Dr. Paul A. Nelson Collection.

Figure 155. Russell Aitken, *Student Singers,* 1933, glazed ceramic, 12 x 12 x 5½ in. (30.5 x 30.5 x 14 cm). Everson Museum of Art, gift of the artist.

Figure 156. Walter Sinz, *Beautiful Isle of Somewhere,* 1940, glazed ceramic, 13½ x 7¼ x 4¼ in. (34.3 x 18.4 x 10.8 cm). The Cleveland Museum of Art, Dudley P. Allen Fund.

Figure 157. Thelma Frazier Winter, *The Daring Young Men,* 1940, glazed ceramic, 22 x 13½ x 9¼ in. (55.9 x 34.3 x 23.5 cm). The Western Reserve Historical Society.

Figure 158. Viktor Schreckengost, *Apocalypse '42,* 1942, glazed ceramic, 16 x 20 x 8 in. (40.6 x 50.8 x 20.3 cm). National Museum of American Art, Smithsonian Institution, gift of the artist.

Eckhardt belonged to a group of Cleveland artists of the 1930s who aspired to raise ceramics from mere craft to sculpture. She was joined in this effort by Russell Aitken (fig. 155), Walter Sinz (fig. 156), Thelma Frazier Winter (fig. 157), and Viktor Schreckengost (fig. 158). These artists had all worked at Cowan Pottery prior to its closing in 1931, and they combined technical innovation with a love of populist subjects. Many, but not all, were employed in the sculpture and ceramics division of the WPA. They used humor—sometimes burlesque satire—as an antidote to the dispiriting psychological pressures of the era. "It was such a sad, dark time during the Depression," Schreckengost observed, "and many of the ceramists became involved in doing things that had another commentary on the times."[40] To break through the gloom, they filled their ceramic sculptures with energy, life, and humor. As seen in Winter's *Daring Young Men,* these artists moved away from wheel-thrown toward fully three-dimensional carved ceramic sculpture. Their activities brought national acclaim to Cleveland artists of the 1930s. "Ceramics had a real renaissance in the early 1930s," Schreckengost commented, "and Cleveland was right up on top. We won everything on the national scene in prizes. Our works were shown throughout Europe."[41]

While the ceramicists and painters of the Cleveland WPA generally avoided provocative subjects, the printmakers confronted the pressing issues of unemployment, racism, and poverty. From its inception in 1935, Kálmán Kubinyi headed the WPA's local graphic arts workshop.[42] Art historian Karal Ann Marling has observed that unlike the mural painters who strove for a "timeless quality" because their works were intended for long-term public display, the printmakers enjoyed far greater freedom in subject matter and style.[43] The employment of more politically oriented artists on

Figure 159. Kálmán Kubinyi, *The Worker*, ca. 1936, offset soft-ground etching, 8¹⁵⁄₁₆ x 7³⁄₁₆ in. (22.7 x 18.2 cm). Ohio Art Program, long-term loan to the Cleveland Museum of Art.

Figure 160. Dorothy Rutka, *Strike Talk,* ca. 1935, aquatint, 6¼ x 8 in. (15.9 x 20.3 cm). Ohio Art Program, long-term loan to the Cleveland Museum of Art.

Figure 161. Dorothy Rutka, *Eviction,* ca. 1936, aquatint, 11 x 8½ in. (27.9 x 21.6 cm). Ohio Art Program, long-term loan to the Cleveland Museum of Art.

Figure 162. Dorothy Rutka, *Striker's Wife,* ca. 1936, aquatint, 8 x 6¼ in. (20.3 x 15.9 cm). Ohio Art Program, long-term loan to the Cleveland Museum of Art.

the graphics project can also be attributed to Kubinyi, an active communist and labor organizer. According to Kubinyi's wife, Doris Hall, they never hid their political affiliations:

> Mr. Milliken, the Director of the Cleveland Museum, never minded one bit when Kalman and I wore "Wallace for President" badges. Mr. Milliken always made us feel welcome. It never occurred to us that when I paraded down Euclid Avenue in the Mothers March for Peace back in the 30s that the F.B.I. would look into it.[44]

Kubinyi attended the national Artist's Congress of 1936 and attempted to organize a Cleveland branch of the Artists Union. While many local artists admired Kubinyi (fig. 159), conservatives associated with Winter's

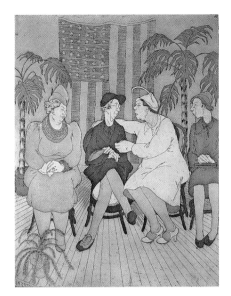

Figure 163. Leroy Flint, *Speaker's Platform,* 1936, aquatint and etching, 9¼ x 7¼ in. (23.5 x 18.4 cm). Ohio Art Program, long-term loan to the Cleveland Museum of Art.

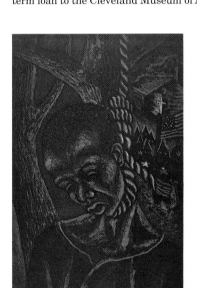

Figure 164. Abraham Jacobs, *The Patriots,* 1936, etching and aquatint, 5⅜ x 8⅜ in. (13.7 x 21.3 cm). Ohio Art Program, long-term loan to the Cleveland Museum of Art.

Figure 165. Hughie Lee-Smith, *The Artist's Life, No. 1,* 1939, lithograph, 11 x 8⅝ in. (27.9 x 21.9 cm). Ohio Art Program, long-term loan to the Cleveland Museum of Art.

circle did not. According to Hall, Winter tried to prevent Kubinyi's works from appearing in art exhibitions. Hall also recalls a remark made by Winter's husband, Edgar, as she was delivering works for exhibition at the Cleveland Museum of Art: "Ed Winter came up to me and pointed to his brand new Cadillac parked at the curb. 'See, if you were a capitalist, you could own a car like that.' "[45]

To help as many artists as possible, Kubinyi employed printmakers on a rotating basis at the graphic arts workshop. In the early years, before rules were instituted requiring artists to work on site, they were given credit for prints produced in their own studios. These artists considered printmaking the ideal medium for producing socially meaningful art for the masses because of its capacity for generating cheap multiples. Dorothy Rutka, a member of the Artist's Union, developed unusual aquatint techniques for her rugged depictions of strikers, evictions, and impoverished families (figs. 160–62). Leroy Flint lampooned affluent conservatives in *Speaker's Platform* (fig. 163), and Abraham Jacobs, a radical political organizer, depicted a lynching with an American flag in the background in *The Patriots* (fig. 164).[46] Kubinyi also employed Lee-Smith, Sallée, and other Karamu artists in the graphic arts workshop. One of Lee-Smith's prints, *The Artist's Life, No. 1* (fig. 165), depicts a young African-American artist in the fore-

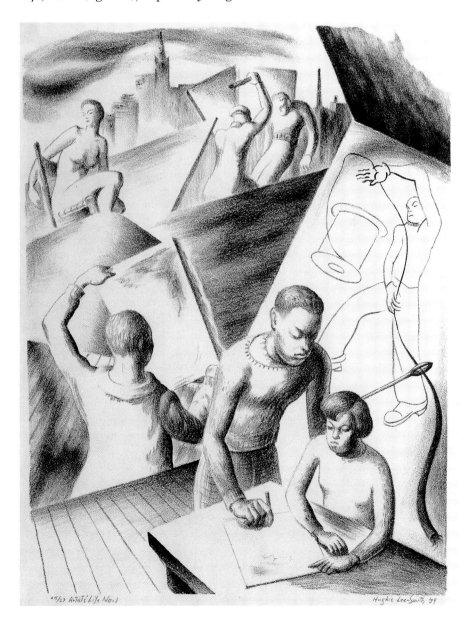

ground surrounded by a confusing, chaotic world of collapsing buildings and a policeman clubbing a man in the shadow of Terminal Tower.

Jolán Gross-Bettelheim, a Hungarian immigrant, was perhaps the most accomplished printmaker associated with the workshop. In 1933 she traveled to Moscow to receive payment for three works from the International Office of Revolutionary Artists, including an earlier version of her WPA lithograph *In the Employment Office* (fig. 166).[47] Her prints of the 1930s, when she participated in antiwar exhibitions in Cleveland, champion various labor, political, and civil rights causes. *Worker's Meeting (Scottsboro Boys)* (fig. 167) depicts a gathering of people of various genders and races to protest the country's most notorious civil rights controversy of the 1930s.[48] One man clutches a copy of the *Daily Worker,* while others raise their fists and chant: "The Scottsboro Boys Shall Not Die." The Scottsboro boys, nine African-American youths, were accused and convicted of raping two white women in Alabama. The hysteria-ridden trial, notorious for its lack of evidence and disregard for fair legal procedures, outraged many Americans and provoked protests across the country. Gross-Bettelheim's *Civilization at the Crossroads* (fig. 168) confronts the growing threat of fascism and war through a nightmarish vision of insect-like soldiers marching relentlessly forward behind rows of cannons.

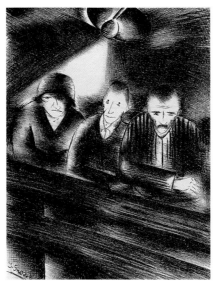

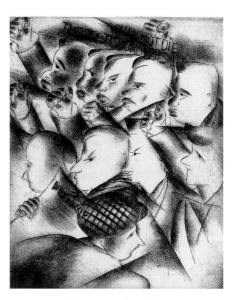

Figure 166. Jolán Gross-Bettelheim, *In the Employment Office,* ca. 1936, lithograph, 10⅞ x 8½ in. (27.7 x 21.6 cm). Ohio Art Program, long-term loan to the Cleveland Museum of Art.

Figure 167. Jolán Gross-Bettelheim, *Worker's Meeting (Scottsboro Boys),* ca. 1935, drypoint, 8½ x 6⅞ in. (21.6 x 17.5 cm). The Cleveland Museum of Art, gift of the Print Club of Cleveland.

As demonstrated most clearly by the prints produced at the graphic arts workshop, Cleveland artists tended to avoid the ultrapatriotic vitriol of the right-wing regionalists of the 1930s. The popular press was only too glad to print the views of these extremists, even though their denunciations of the cultural "effete" of eastern cities were often a fig leaf for racist, anti-Semitic, and homophobic attitudes. Cleveland artists were not very receptive to the isolationist, reactionary mood that swept the country during the Depression because the city's immigrant traditions were too strong and its ethnic communities too diverse.

In 1937 a controversy erupted when Schreckengost, following his third trip to Europe, exhibited a ceramic sculpture titled *The Dictator* that incorporated satirical representations of Hitler, Hirohito, Stalin, and Mussolini. The principal criticism was that Schreckengost had debased art by inject-

ing partisan politics into a realm where it did not belong. Within months after the bombing of Pearl Harbor, Schreckengost produced another controversial sculpture, *Apocalypse '42* (see fig. 158). This burlesque parody of the four riders of the Apocalypse from the Book of Revelations combines an allegory of death wearing a German military uniform and holding a bomb, with representations of Hitler, Hirohito, and Mussolini—all seated on a horse flying over a globe dripping with blood. His allegorical composition culminated the efforts of Cleveland artists to achieve a new status for ceramic sculpture. "Up until the end of World War II," Schreckengost recalled, "ceramic artists had great difficulty in getting their work into legitimate art shows. Ceramic art was considered fit only for craft shows."[49] *Apocalypse '42* struck a nerve because it was temporarily removed from a Cleveland exhibition in response to protests from the city's Italian-American community.[50]

THE END OF AN ERA

THE SECOND WORLD WAR signaled the end of an era in Cleveland art. Lee-Smith, Sallée, Schreckengost, and Russell Aitken enlisted in the military. Others went to work designing products for the war industries, and the Cleveland School of Art altered its curriculum to aid the war effort. In

Figure 168. Jolán Gross-Bettelheim, *Civilization at the Crossroads (Fascism II)*, 1936, lithograph, 12¾ x 10 in. (32.4 x 25.4 cm). Reba and Dave Williams Collection.

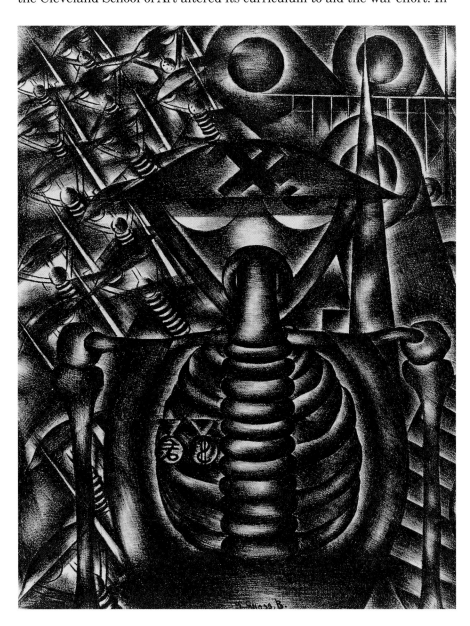

1943 the government closed the WPA. Frederick Gottwald had died in 1941; Max Kalish would follow in 1945 and Sandor Vago in 1946. Henry Keller retired from the Cleveland School of Art in 1945, and William Sommer, following the death of his wife and renewed bouts with heavy drinking, was declared incompetent by a probate court in 1946. By that time Charles Burchfield, Margaret Bourke-White, Jolán Gross-Bettelheim, and Clarence Carter had left the city permanently. They would be replaced by a new generation of students flooding the Cleveland School of Art on the G.I. Bill. To the new generation regionalism seemed old-fashioned and provincial. Concern with world events replaced isolationism and sectionalism, and the art scene became dominated by an international movement toward abstraction. The combination of economic prosperity and political backlash against postwar communist expansion prompted many artists to abandon their social protest themes of the 1930s. In the postwar era television would weld the country's disparate regions into a national culture. By 1946, the year of citywide parades and pageants celebrating Cleveland's 150th birthday, the American scene and regionalist movements had faded into history.

NOTES

1. Historical information about Cleveland is derived from *The Encyclopedia of Cleveland History,* ed. David D. Van Tassel and John H. Grabowski (Bloomington and Indianapolis: Indiana University Press, 1987); and Carol Poh Miller and Robert Wheeler, *Cleveland: A Concise History, 1796–1990* (Bloomington and Indianapolis: Indiana University Press, 1990).

2. The terms *American scene* and *regionalism* are sometimes used interchangeably, although many historians divide the American scene into two major submovements: regionalism and social realism. Major studies of the subject include: Matthew Baigell, *The American Scene: American Painting of the 1930s* (New York: Praeger, 1974); Nancy Heller and Julia Williams, *The Regionalists* (New York: Watson-Guptill, 1976); Mary Scholz Guedon, *Regionalist Art: A Guide to the Literature* (Metuchen, N.J.: Scarecrow Press, 1982); and Robert L. Dolman, *Revolt of the Provinces: The Regionalist Movement in America, 1920–1945* (Chapel Hill: University of North Carolina Press, 1993).

3. Grant Wood, *Revolt against the City* (Iowa City, Iowa: Clio Press, 1935).

4. Edith Sommer, "To Stimulate Art in Cleveland," *Cleveland Town Topics* (1 December 1917), 28, and *Cleveland Plain Dealer,* "Modern Art Work Shown to Women: Distorted Figures of Cezanne Criticized by Mr. Bailey" (28 January 1918), 11. Bailey made some of these remarks in an address to the Cleveland Society of Artists, whose members included George Adomeit, Ora Coltman, William Edmonson, Frederick Gottwald, Adam Lehr, Herman Matzen, and Louis Rorimer. Bailey, dean of education at the Cleveland School of Art, succeeded Norton as dean of the school in 1919.

5. "Dr. Whiting Addresses Chamber of Commerce," *Cleveland Town Topics* (3 May 1919), 13. Whiting had been the manager of the Society of Artists and Craftsmen in Boston and later became the director of the John Herron Art Institute in Indianapolis.

6. The exhibition traditionally (but not always) opened in May. Originally known as the *Annual Exhibition of Cleveland Artists and Craftsmen,* the reference to Cleveland was later replaced by "Western Reserve" when eligibility was expanded to include several surrounding counties. The exhibition was held on an annual basis until 1992.

7. Holly Rarick Witchey observed that "Whiting was neither an artist nor an art historian . . . [but] a social worker and reformer. Before coming to Cleveland he had held many jobs. He had worked with the impoverished textile employees in Lowell, Massachusetts. . . . Because of his work in Lowell, Whiting developed a strong sense of the role the artisan would play in an increasingly industrial society." Witchey, *Fine Arts in Cleveland: An Illustrated History* (Bloomington: Indiana University Press, 1994), 66. Milliken continued to organize the exhibition even after being appointed the museum's director in 1930, only relinquishing that duty with his retirement in 1958.

8. Henry Turner Bailey, "The Art Museum as a Factor in Industrial Development," *Bulletin of the Cleveland Museum of Art* 5 (December 1918): 129.

9. E. Arthur Roberts, "Asks Craftsman's Pride in his Work," *Cleveland Plain Dealer* (9 December 1921), 4.

10. Frederic Whiting, "Annual Exhibition of Work by Cleveland Artists and Craftsmen," *Bulletin of the Cleveland Museum of Art* 6 (June 1919): 79.

11. William Milliken, "The Annual Exhibition: Foreword," *Bulletin of the Cleveland Museum of Art* 11 (May 1924): 98. Gaertner originally titled this painting *The Shops,* later changing it to *The Furnace.*

12. "Cleveland Arts and Crafts," *Cleveland Plain Dealer* (8 May 1924), 12.

13. Margaret Bourke-White, *Portrait of Myself* (New York: Simon and Schuster, 1963), 33.

14. Ibid., 46.

15. Suzanne Ringler Jones and Marjorie Talalay, *Margaret Bourke-White: The Cleveland Years, 1927–1930,* exh. cat. (New Gallery of Contemporary Art, 1976), unpaginated.

16. Bourke-White, *Portrait of Myself,* 49.

17. D. Undine Baker, "Sculptor Has Many Statuette Commissions," *Cleveland Town Topics* (5 August 1916), 17.

18. Edith Sommer, "Mr. Kalish's Prophecy of Future Art," *Cleveland Town Topics* (10 November 1917), 29–30.

19. Max Kalish, quoted by N. Lawson Lewis in *The Sculpture of Max Kalish* (Cleveland: Fine Arts Publishing, 1933), 3.

20. This information is based on research provided by the Western Reserve Historical Society.

21. Erie Street has been renamed East 9th Street, but the cemetery retains its original title.

22. Gaertner apparently altered and reconstructed the scene for artistic purposes. The building with the illuminated top story (upper right), for instance, does not conform to the structure at that location.

23. Paul Travis quoted in "Paintings of Africa," *Bulletin of the Milwaukee Art Institute* (March 1931): 8.

24. The connection between Cleveland watercolor traditions and Chinese painting continued in the life of Sherman Lee, who studied in Cleveland. Lee wrote his doctoral dissertation at a local university on the subject of American watercolor painting, the introduction of which reveals his sensitivity to the fundamental aesthetics of the medium. He subsequently became an expert on Chinese art and returned to Cleveland to become the director of its art museum, at which he assembled one of the finest Asian art collections in the world.

25. Charles Burchfield, "Henry G. Keller, an Appraisal by His Best Known Student," *American Magazine of Art* 29 (September 1936): 592.

26. My thanks to Sara Johnson, director of planning at the Southern Ohio Museum, for providing this information about the painting.

27. *Twentieth Century American Art,* exh. brochure (Steve Turner Gallery, 1995), no. 6.

28. Carter's meticulous style is often compared with that of Otto Dix and German Neue Sachlichkeit painting. Other possible sources include the American precisionists and the Italian Renaissance paintings Carter had seen in Europe.

29. The origins and activities of this group are discussed in detail in this catalogue. See Mark Cole's essay, " 'I, Too, Am America': Karamu House and African-American Artists in Cleveland."

30. Helen Borsick Cullinan, "Paving the Way for More Painting," *Plain Dealer* (6 January 1974), E–14.

31. "Hungarian Artist Will Exhibit Works in City," *Akron Times* (23 March 1930); Sandor Vago File, Ingalls Library, Cleveland Museum of Art.

32. These studies of the techniques and materials were also translated into English and published in Max Doerner, *The Materials of the Artist and Their Use in Paintings, with Notes on the Techniques of the Old Masters* (New York: Harcourt, Brace, and World, 1934). German Neue Sachlichkeit artists and their techniques are discussed by William Robinson and Bruce Miller in "Otto Dix's *Portrait of Josef May*" and "Otto Dix and His Oil-Tempera Technique," *Bulletin of the Cleveland Museum of Art* 74 (October 1987): 306–55.

33. Among Cole's clients was S. V. Robertson, a sanitation worker who became a union leader and president of the Cleveland branch of Marcus Garvey's Universal Negro Improvement Association.

34. The man in Adomeit's portrait was a vagrant whom the artist hired to perform odd jobs around the studio.

35. The service station, at 7901 Cedar Avenue, was owned by Richard Kyer, who lived with his wife, Florence, at 2263 E. 69th. Kyer is listed in city directories as a laborer until 1931.

36. Information about this period in Cleveland's history derives from Robert Wheeler, "Cleveland: A Historical Overview," in *Encyclopedia of Cleveland History,* xliii–xlv; and Karal Ann Marling, *Federal Art in Cleveland: 1933–1943* (Cleveland: Cleveland Public Library, 1974), 2–4.

37. Marling, *Federal Art in Cleveland,* 14–15. The following information on Milliken and the PWAP in Cleveland derives largely from Marling.

38. Milliken quoted on April 1934, in Marling, *Federal Art in Cleveland,* 20.

39. Carter's mural for the Barnesville Post Office was never executed because he gave the commission to another artist, Michael Sarisky. Carl Broemel served as the first supervisor of Ohio WAP district four (1935–37), succeeded by Clarence Carter (1937–38) and Earl Neff (1938–42).

40. Lois Cooper, "'30s Art Revived," *Sun Press* (27 March 1980), Viktor Schreckengost File, Ingalls Library, Cleveland Museum of Art.

41. Ibid.

42. This number reflects new research by Sabine Kretzschmar, which she presents in her essay in this catalogue, "Art for Everyone: Cleveland Print Makers and the WPA."

43. Marling, *Federal Art in Cleveland,* 27, 55.

44. Doris Hall quoted in Ruth Dancyger, *Kubinyi and Hall: Cleveland's Partners in Art,* Cleveland Artists Series (Cleveland: John Carroll University, 1988), 27.

45. Dancyger, *Kubinyi and Hall,* 41.

46. Leroy Flint interviewed by Michael Moss, 7 March 1974, Karal Ann Marling Papers, Special Collections, Case Western Reserve University.

47. János Frank, *Jolán Gross-Bettelheim Retrospektíiv Kiállíása* (Budapest: Kiállítóterem, 1988), 219.

48. This print was apparently not produced on the project.

49. "Viktor Schreckengost of Ohio," *The Studio Potter* 11 (December 1982): 78.

50. Christina Corsiglia, "Viktor Schreckengost: Evolution of a Cleveland Ceramist," in *Cleveland as a Center of Regional American Art* (Cleveland: Cleveland Artists Foundation, 1993), 109.

"I, Too, Am America": Karamu House and African-American Artists in Cleveland

THROUGHOUT THE 1930S and into the 1940s, several young African-American painters and printmakers affiliated with Karamu House, a multiracial community art center in Cleveland, gained both local and national recognition for distinguished artistic achievements.[1] During this period, these artists repeatedly exhibited and won awards in the annual juried May Shows held at the Cleveland Museum of Art, and in 1941 the museum hosted a group show featuring more than fifty examples of their work.[2] On a national level, their art traversed the country, appearing in venues from Los Angeles to Hartford, Detroit to Atlanta, with several stops—Chicago, Philadelphia, Indianapolis, Washington, D.C.—in between. The occasion of a traveling exhibition that opened during the winter of 1942 in New York City at the Associated American Artists Galleries perhaps best exemplifies Karamu artists' renown. With First Lady Eleanor Roosevelt serving as honorary chair, and with many prominent cosponsors including Marian Anderson, Langston Hughes, James Weldon Johnson, and Ethel Waters, critics hailed the exhibition as the largest and most important showing of work by black artists yet mounted in the city.[3]

Among the most accomplished of the Karamu artists were Elmer Brown, Hughie Lee-Smith, Charles Sallée, and William E. Smith, all of whom maintained successful careers after their initial achievements.[4] In terms of style, their work from the 1930s and 1940s closely relates to a variety of realist and surrealist modes then popular in Cleveland. Yet, in terms of its subject matter, it differed markedly from most of what their local colleagues were producing. Traditionally, European-American artists in Cleveland rarely depicted African-Americans in their work, and on the unusual occasions when they did, tended to use derogatory stereotypes. By contrast, Karamu artists produced African-American subject matter on a consistent basis and rendered it from a much more discerning perspective, creating empathetic representations and chronicling social conditions, both positive and negative, that affected their communities.

Two works, Sallée's *Girl with a Pink Geranium* (fig. 169) and Smith's *My Son! My Son!* (fig. 170) exemplify this approach. Sallée's painting, a half-length portrait of a young woman positioned at an uncluttered table-top against a plain background, is a sparsely composed image that draws the viewer's attention toward the sitter's warm and thoughtful gaze. The woman shares the pictorial space with a blossoming geranium; the artist has made a visual correlation between the two to intimate the beauty and vitality of each. Smith's linoleum-cut print depicts a father sharing a contemplative moment with his child, whom he cradles against his chest. Gently raking light bathes the two figures, underscoring the quiet dignity of the moment. According to the artist, the image was inspired by a particu-

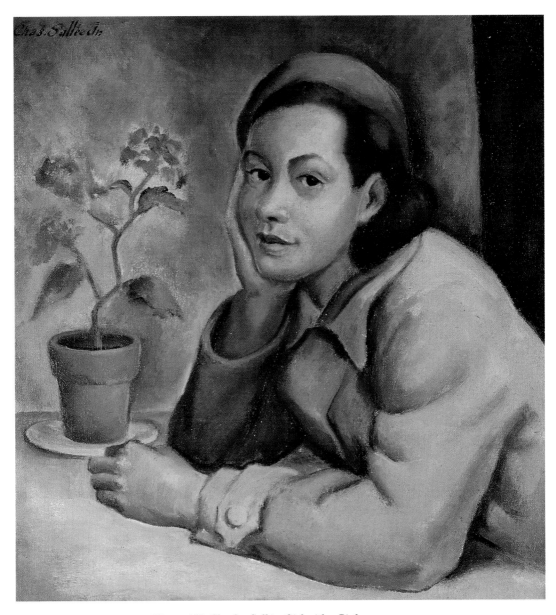

Figure 169. Charles Sallée, *Girl with a Pink Geranium,* 1936, oil on canvas, 22½ x 21¼ in. (57.2 x 54 cm). The Harmon and Harriet Kelley Collection of African-American Art.

lar scene he witnessed, one that prompted him to make a general statement about parent-child relationships.

> I saw a man with large rough hands handling his infant son with great tenderness. I knew that he thought of the life that was ahead of his son and wished that it might not be as cruel for the son as it had been for him. I knew at that moment that this is the wish of every parent. I wanted to get this into my print as well as the joy of the child in being close to the father.[5]

By recording people, places, issues, and concerns drawn from their own immediate experiences, Karamu House artists created autobiographical African-American presences in Cleveland's art community, presences that had seldom been seen before. Before this generation, African-American participation in Cleveland's artistic mainstream appears to have been very limited.[6] Extensive research conducted for the current exhibition has identified only one black professional artist in Cleveland before the 1930s: Robert Moxley, who gave drawing instruction around the turn of the century.[7] That there were few African-American artists working in the city should not, of course, be inferred from absences in historical records. Nonetheless, in light of the many powerful social factors that obstructed mainstream cultural opportunities—factors such as pervasive racist doctrines and escalating trends in segregation and economic disenfranchisement—it seems almost inevitable that black Clevelanders had little input in the local art community throughout the first century and a quarter of the city's existence. Indeed, current research indicates that it was only with the creation of a formal studio art program during the late 1920s at Karamu House, a program specifically committed to fostering opportunities in the arts, that African-American visibility in the city's professional art world became pronounced.

In the past, a key obstacle limiting African-American participation in the country's artistic mainstream was the widely held racist myth that

Figure 170. William E. Smith, *My Son! My Son!,* 1941, linoleum cut, 7¹³⁄₁₆ x 5⁷⁄₁₆ in. (19.8 x 13.8 cm). The Cleveland Museum of Art, gift of the Print Club of Cleveland.

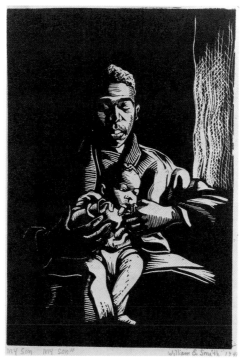

men and women of African descent were inherently incapable of creating art. This myth was an offshoot of a broader ideology that denied their humanity, a denial that served to maintain European-American policies of racial oppression. It effectively distanced African-Americans from all aspects of professional artistic production. When internalized, it stifled artistic initiatives and, in the exceptional cases when it did not, virtually guaranteed that black artists would find no crucial support—occupational networks, critical reception, or widespread patronage, for example—to sustain their careers.

The power of this myth among members of Cleveland's formative art community is evidenced in a newspaper notice written in 1853 by Jarvis Hanks, one of the first easel painters to establish a career in the city (see fig. 4). In the notice, Hanks tells of his visit some years earlier with land-scape painter Robert S. Duncanson in Cincinnati. Having just learned that Duncanson was of African descent, the surprised Hanks describes the painter's light skin color, reassuring the newspaper's readers that:

> This worthy artist and gentleman can, at least, have so little of the despised color and blood, as to have nothing to fear from this cause. His talents and merit as an artist, elevate him far above such contingencies.[8]

The degree to which biases of this sort were predominant is thrown into sharper relief with the knowledge that Hanks held what was considered a progressive attitude toward race during his day. He was an ardent member of the Cuyahoga County Anti-Slavery Society and had at least once attempted to shelter a fugitive slave from Tennessee by hiring him as an apprentice.[9] Lest this episode appear to contradict his sentiment regarding race and artistic talent, it should be noted that the fugitive slave was biracial; Hanks probably felt that a sufficient amount of European blood flowed in the fugitive's veins to make him suitable for artistic training.

The prevailing conviction that African-Americans were by nature not predisposed to artistic ability persisted into the early twentieth century, a time when even harsher social circumstances developed to thwart entrance into the city's art community. During the great migration that began around 1915, a reactionary backlash arose against rural African-Americans from southern states moving to Cleveland in search of employment in its booming industries.[10] As a result, economic and social conditions for most black residents worsened considerably, tarnishing the city's long-standing reputation as a comparatively accommodating place for African-Americans. Prior to this period, Cleveland had maintained a relatively low rate of racially based occupational discrimination, and although there was not equal access by any means, employers tended to provide black citizens with a wider range of job opportunities, especially in skilled professions from which they had been traditionally excluded. That the social status of black Clevelanders had historically been better than in many other cities is also indicated by the city's relatively early integration of public schools and public accommodations.[11]

By 1920, however, the backlash against the migration was in full force and segregation in Cleveland had become commonplace. A ghetto formed as arrivals were forced to move into a circumscribed area on the city's near East Side, an overcrowded and impoverished neighborhood that came to be known as the "Roaring Third."[12] Public schools in the city were increasingly segregated, and African-Americans were routinely barred from res-

taurants, theaters, hotels, and amusement parks. Occupational discrimination became customary. Frequently denied employment training, apprenticeships, as well as memberships in labor unions, black Clevelanders were excluded from many industrial and professional jobs.[13]

KARAMU HOUSE AND ITS STUDIO ART PROGRAMS

KARAMU HOUSE OPERATED AT THE CENTER of this social setting with a mission for reform.[14] Established in 1915 at East 38th Street and Central Avenue, a location soon to become the heart of the Roaring Third, Karamu was founded and directed by Russell Jelliffe and Rowena Woodham Jelliffe, both sociologists educated at Oberlin College and the University of Chicago.[15] Initially, Karamu functioned as a settlement house offering social services to ethnically and racially diverse groups in its neighborhood. However, during the next few years, the demographics of the neighborhood changed substantially as a large number of southern black migrants settled in the area. This change in demographics meant a shift in the constituency of Karamu House, so that by the early 1920s, services were geared primarily, though not exclusively, toward African-Americans. As such, it was a unique institution in Cleveland. The city's other settlement houses either refused black members or segregated them from white members by offering services to each group on different days of the week.[16]

Integration, fostered by mutual respect between African- and European-Americans, was the governing philosophy behind Karamu activities.

> The basic efforts of Karamu during its history, have been to furnish and to espouse a larger direct participation of Negroes themselves on all civic projects, boards of institutions and organizations and communities, affecting the building of a sound and intelligent unity between all Americans of diverse racial and social backgrounds.[17]

Although Karamu House aimed to promote a fuller participation of African-Americans in American society, the inclusion was not meant to be attained by sacrificing group identity.

> There is no attempt to forget or gloss over race or nationality. On the other hand, it is explored as a basis for racial self-respect. But the purpose is always to keep our minority groups headed into the main stream of American life.[18]

Racial separatism, whether advocated by European-Americans or by African-Americans, was viewed as mutually detrimental. The challenge of maintaining an integrationist stance in a majority culture that was opposed to it put Karamu periodically at odds with its own ambitions, and in some instances it made concessions to its integrationist philosophy. For example, during World War II, Karamu House widely assisted in various war efforts and did not encourage its conscripted members to refuse segregated assignments, despite its indignation over such arrangements.[19]

The arts were considered important vehicles through which Karamu's integrationist goals could be realized, and one of the institution's core undertakings was the development of nascent artistic talents that otherwise might lie fallow because of an immediate lack of inspiration or resources. Karamu's focus on art was sparked by James Weldon Johnson, who personally advanced his ideas to the Jelliffes during several visits to Cleveland while working for the National Association for the Advancement

of Colored People (NAACP).[20] Championing the belief that individuals understand one another best by sharing knowledge of their cultures, Johnson was highly influential in the decision to develop programs in theater, music, dance, and the studio arts at Karamu.[21] In many respects, Karamu's activities can be interpreted as a regional manifestation of the burgeoning New Negro movement for which Johnson played a significant promotional role. Advanced by several members of the African-American intelligentsia, the New Negro movement emphasized the expedience of culture to dispute myths of racial inferiority.[22]

According to Rowena Jelliffe, visual art undertakings at Karamu House were introduced gradually so as not to alienate constituents who might have been suspicious of the privileged-class associations of art—the primary reason why most social agencies such as settlement houses traditionally avoided art programs.[23] Informal art and craft sessions were first held at Karamu House around 1919, when members such as high-school-aged Langston Hughes took drawing lessons. Subsequently, clay modeling, charcoal sketching, and linoleum block printing were introduced.

In 1927 an impetus for organizing a more formal art department arose out of a need to decorate the interior of Karamu Theatre, the newly established resident venue of the Gilpin Players, Karamu House's theatrical troupe. Inspired by a New Negro aesthetic doctrine to use African sources rather than European sources in creating art—a doctrine aimed to invoke psychological emancipation and racial pride—Karamu members fashioned theater decorations based on African tribal art, which they researched at the Cleveland Public Library and at the library of the Cleveland Museum of Art. Because of this association, African art became a visual trademark of the Karamu Theatre. As the handbill designed by Elmer Brown in 1939 for the Gilpin Players' production of *One Hundred in the Shade* (fig. 171) attests, African designs and motifs continued for several years to be associated with Karamu Theatre—even though, as will be discussed, such imagery was routinely absent in work Karamu artists created outside the theater's realm.

The successful decorating project of Karamu Theatre galvanized interest in the studio arts, and Karamu soon established a more comprehensive studio program, one that expanded to include oil and watercolor painting, ceramics, and metalwork. It also hired a series of professional artists as instructors, the most important of whom was Richard Beatty. A lithographer trained at the Carnegie Institute of Art and the School of the Art Institute of Chicago, Beatty joined Karamu in 1933 to teach printmaking and to head the studio department. Well respected in Cleveland art circles, he served as a mentor to Brown, Lee-Smith, Sallée, and Smith, advising them how to negotiate the personal politics of the local art community.[24]

To generate citywide enthusiasm and support for their studio program, Karamu House members nurtured an appreciation among Clevelanders for African and African-American art. The same year that Karamu Theatre opened, the Gilpin Players enlisted Cleveland artist Paul Travis to purchase art and ethnographic objects during his extensive travels through Africa (see fig. 138). With Gilpin funds earned over the years from theatrical productions, and with funds provided by the African Art Sponsors specifically solicited for the undertaking (from drives organized in African-American churches, for example), Travis acquired approximately five hundred items that were donated by Karamu to the Cleveland Museum of Art and the Cleveland Museum of Natural History in 1928. The excitement surrounding the Gilpin gifts touched off a sustained local interest. African-

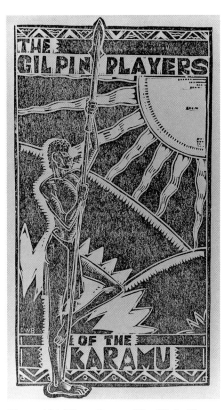

Figure 171. Elmer Brown, *The Gilpin Players of Karamu House,* 1939, linoleum cut, 7⅞ x 3 in. (20 x 7.6 cm). The Western Reserve Historical Society. [not in exhibition]

American business owners in the Roaring Third set up displays of African objects borrowed from private collections.[25] At the art museum, the new African holdings were showcased through a series of educational lectures, including one delivered by Alain Locke, professor of philosophy at Howard University and an intellectual leader of the New Negro movement.[26]

Contemporary African-American art also elicited attention from many Clevelanders. In 1929, under the auspices of the African Art Sponsors, the first exhibition of African-American art to be shown in the city was mounted, a nationwide survey that included work by such esteemed talents as Richmond Barthé, Malvin Gray Johnson, and Archibald Motley.[27] Conspicuous to Cleveland viewers was the absence of local participants, and, in this respect, the exhibition became an incentive. In press releases publicizing the show, the African Art Sponsors stated their hope that black artists from Cleveland would soon be joining national ranks.[28] This hope became reality less than two years later in 1931, when Karamu artists began showing in national juried exhibitions, a practice they maintained throughout the next decade and a half.

Along with expanding its studio art program, Karamu House worked in various capacities to facilitate its members access into many of Cleveland's other art institutions. Automobile shuttle service was provided for Karamu members, many of whom lacked transportation, to attend free art history lectures and studio art classes held at the Cleveland Museum of Art. During the early 1930s, a Gilpin Players' Scholarship Fund was created for those displaying exceptional mastery to attend the John Huntington Polytechnic Institute, as well as the Cleveland School (later Institute) of Art, the city's most prominent facilities for studying the commercial and fine arts.[29] All the Karamu artists discussed here honed their skills at the Huntington Polytechnic, and in 1938, Gilpin Scholarship recipients Hughie Lee-Smith and Charles Sallée graduated from the Cleveland School of Art, apparently the first African-Americans to do so.[30]

Yet not all local art establishments accepted Karamu members. Despite the professional progress made by Karamu artists, many European-American colleagues did not regard them as peers, and some private organizations remained imperious in their refusal to associate with African-Americans. One example was the Kokoon Klub, one of the most important networking associations for Cleveland artists and literary figures. During the 1930s, poet and playwright Langston Hughes, a Karamu alumnus visiting Cleveland from his home in New York, was to be hosted by the club until members learned that he was black and canceled the plans.[31] Undoubtedly with such experiences in mind, Karamu artists found it necessary to create their own professional network, and Karamu Artists Incorporated was formally established in 1940. As stated in the organization's constitution and bylaws, its purpose was to bring members' work to a wider audience by mounting regular exhibitions, setting up an art lending service, and issuing portfolios of prints.[32] Unfortunately, these stated aims did not have a chance to reach fruition. Shortly after its creation, mobilization began for the World War, and several core members of Karamu Artists Incorporated were consequently dispersed.

Throughout the period, Cleveland's black communities took express interest in the efforts made and successes attained by Karamu artists. The local African-American press routinely publicized the artists' achievements with a shared sense of accomplishment. However, at times a mitigating sense of disappointment surfaced as well, a feeling resulting from the

knowledge that African-American representation in the local art world still remained highly disproportionate despite the significant inroads made. Claire Davis, for instance, writing in her weekly arts column for the *Call & Post,* had this to say regarding the 1937 May Show:

> Being particularly interested in the Negro's progress in art, my visit to the show was not entirely futile. Although I very definitely did not experience a single new sensation as I took in the exhibitions of the somewhat famous artists represented I must confess a feeling of deep racial pride was mine as I noted the names of [Karamu artists].[33]

KARAMU ARTISTS AND THEIR WORKS

THE WORKS PRODUCED by Elmer Brown, Hughie Lee-Smith, Charles Sallée, and William E. Smith during the 1930s and 1940s are as diverse as the artistic imaginations of the individuals who created them. There is no readily discernible institutional style in their art, for Karamu House operated more as a center for personal creative expression and less as an academy where artistic conventions were promulgated. The considerable range of style exhibited in Karamu works is demonstrated by two linoleum-cut prints, both inspired by the same subject matter—the urban landscape of the Roaring Third—as interpreted by different artists.

William E. Smith's *Leaning Chimneys* (fig. 172) offers an intimate look at the Roaring Third, depicting not the public facade of the street, but rather a more private backyard view. Over the roof and beyond the fence that occupy the foreground of the image, the viewer encounters a group of small dwellings crouched next to two bulky tenements. It is a tranquil scene, its stillness broken only by a clothesline of laundry fluttering in the breeze. The calm character of the subject is matched by Smith's orderly composition, which consists of well-defined spatial relations rendered in evenly balanced patterns of light and dark. Carefully articulated details—such as cast shadows, and sunlight reflected in individual windowpanes—contribute to the visual clarity of the image. The most discordant elements in Smith's depiction are the eponymous leaning chimneys, which lend an air of uneasiness to the surroundings.

Hughie Lee-Smith's *Landscape No. 1* (fig. 173) is a visionary evocation of urban decay and disorder where buildings collapse into piles of rubble before an ominous audience of lifeless trees and hovering birds. Two houses are shown in increasingly advanced stages of ruin. In the background, an awning falls from an otherwise intact structure; in the left foreground, a single wall tips precariously upon an exposed foundation. Lee-Smith skillfully accentuates the turmoil of the scene by creating inconsistent spatial relations between the various elements in the composition, and by rendering the elements out of staccato clashes of light and dark shapes.

Stylistically, Smith's prosaic realism differs significantly from Lee-Smith's expressionism, yet both artists employ their respective styles toward similar iconographic ends. In both images, urban decay functions as a metaphor for the disheartened spirits of those who must endure its conditions. According to Smith, the leaning chimneys in his print "speak for the people huddled around the hidden stoves below. . . . These leaning chimneys seemed, somehow, out of joint and not at all as I wished they might be."[34] Similarly, Lee-Smith says of his print:

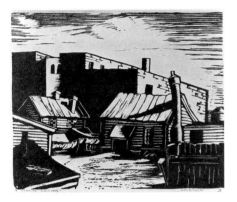

Figure 172. William E. Smith, *Leaning Chimneys,* 1938, linoleum cut, 9 x 11 in. (22.9 x 28 cm). Cleveland State University. [not in exhibition]

Figure 173. Hughie Lee-Smith, *Landscape No. 1,* ca. 1939, linoleum cut, 9 x 10½ in. (22.9 x 26.8 cm). Cleveland State University.

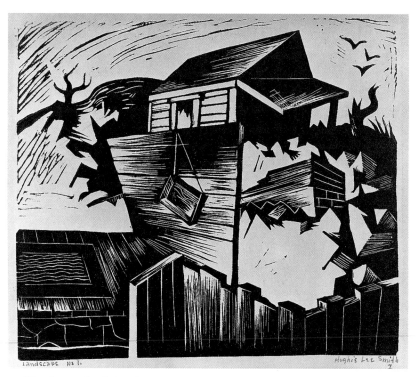

I had watched the Central Avenue area rapidly deteriorating; its houses falling down, and too many of its people going to pieces as well. It depressed me beyond words. I could only express my feeling about it all by drawing, not that the drawing was altogether realistic. The way I felt about it got blended with the way it actually looked.[35]

The urban landscape was just one category of subject matter popular with Karamu artists; other categories frequently treated were portraiture and genre. These subjects fall under the rubric of the American scene movement that gained wide acceptance in national art circles during the 1930s and early 1940s. Nationalistic in focus, American scene work reflected a commitment on the part of artists to address contemporary political, social, and cultural issues. Among African-American art critics, James A. Porter, a painter and professor of art history at Howard University, was the most vocal advocate of American scene subject matter. Countering Locke's earlier call for African-American artists to champion Africanisms in their work in order to establish a racially based identity, Porter argued that African-American artists were more closely tied to American culture than to cultures in Africa, and thus should focus their art upon their identities as Americans.[36] Porter regarded the Africanist approach to be segregationist in spirit because it emphasized racial differences between African- and European-Americans instead of shared social concerns. At Karamu House, Porter's ideas about the nature of African-American art came to predominate over those of Locke, a circumstance that, according to Porter's line of reasoning, underscored the integrationist philosophy behind the institution's operations.

Lee-Smith's series of three lithographs entitled *The Artist's Life* presents an allegorical—yet autobiographical—story of an artist who forsakes a purely academic approach to art in order to respond in a socially conscious way to the American scene. In the foreground of *The Artist's Life, No. 1* (see fig. 165), two students are engaged in a drawing lesson. Behind them, an artist—Lee-Smith's surrogate, who reappears throughout the series—positions a canvas, preparing to execute a common studio exercise, the rendering of a nude model. A line drawing at right, depicting a man

who has successfully threaded a needle, suggests the difficulty involved in achieving artistic proficiency. In the background, beyond the walls of the studio and under the shadow of the Cleveland skyline (readily identifiable by the presence of the Terminal Tower), a policeman brandishes a baton on a man who reels backward from the blow. Lee-Smith's surrogate, completely absorbed in his work, is oblivious to this incident. A different scenario is presented in the second image in the series, where an event in the world outside the studio captures the artist's attention. In this image, Lee-Smith's surrogate pauses from painting a nude and turns his head to witness a labor strike that has turned violent. The transformation into a socially conscious artist is completed in the final image, where the artist sits upon a promontory to diligently record the urban landscape. Sharing the promontory is the artist's alter ego, who flies a kite, a recurring motif in Lee-Smith's oeuvre symbolizing hope. Lee-Smith suggests that his commitment to the American scene has a purpose, that through his work he aspires to encourage social improvement.

Portraits by Karamu artists take on social and political overtones by virtue of the simple, yet profound fact that they depict African-Americans —that is, individuals who as a group were routinely ignored in the art of their European-American colleagues. In essence, Karamu artists render

Figure 174. Elmer Brown, *Dorie Miller Manning the Gun at Pearl Harbor*, 1942, oil on canvas, 48 x 61¾ in. (122 x 157 cm). Cleveland Artists Foundation, gift of the Elmer W. Brown Estate.

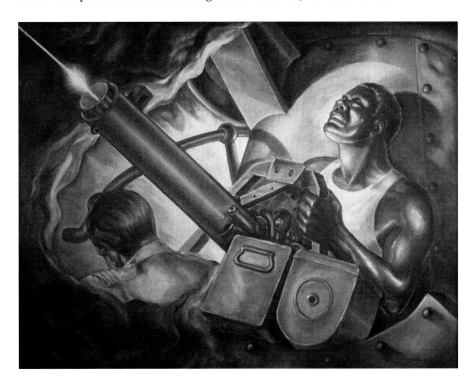

African-Americans visible and viable through their portraits, asserting their identities as integral members of the American scene. It seems significant that Karamu artists produced very few portraits of European-Americans during the period, for it is as if the artists were deliberately seeking to redress racial imbalances in the field of visual representation. Much of Karamu portraiture consists of uncommissioned images of family, friends, or fellow members of Karamu House, such as Sallée's portrait *Girl with a Pink Geranium*. In addition, however, Karamu artists executed commissioned portraits of historical figures.

One of the most striking of these historical portraits is Elmer Brown's *Dorie Miller Manning the Gun at Pearl Harbor* (fig. 174), which memorializes the first national African-American hero of World War II. A messman on the battleship *Arizona*, Dorie Miller was awarded the Navy Cross for

Figure 175. Charles Sallée, *Juke Box Jive,* ca. 1937, aquatint, 10¼ x 7⅜ in. (26 x 18.7 cm). Karamu House Collection.

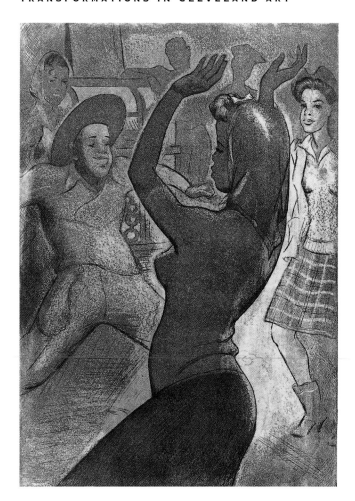

shooting down four Japanese planes during the attack on Pearl Harbor, a feat accomplished despite the fact that he was not trained in weaponry because by policy the navy restricted African-Americans to noncombat positions. Brown's painting captures the epic intensity of the moment. Dramatically illuminated by the fiery battle that surrounds him, Miller clutches and aims the antiaircraft weapon with an awesome show of strength, indicated by his set jaw, clenched teeth, and tightly flexed arm muscles.

By showing Miller valorously and triumphantly engaged in combat, Brown's painting is visual testimony for those promoting full and unsegregated participation of African-Americans in the war, an antiestablishment stance at odds with the official mandates of the country's armed forces. It seems ironic, then, that Brown's painting was commissioned by a propagandistic bureau of the armed forces, which wanted an image of Miller mass-reproduced in poster form for morale-boosting display in the segregated quarters of black servicemen during the war.[37] Yet, unlike Brown's painting, other images of Miller used for propagandistic purposes did not show him in combat. One such famous example is an Office of War Information poster shrewdly inscribed "Beyond the Call of Duty," which presents a bust-length portrait of Miller displaying his Navy Cross.[38] Evidently the armed forces' plans to reproduce Brown's painting were not carried through—although probably not because of the painting's subversive imagery, but rather because the morale potential of Miller was prematurely squelched by his death. Less than two years after his heroic act, Miller drowned when the battleship on which he served was torpedoed.

Genre subjects comprise the final category of American scene work by Karamu artists. These subjects run the gamut from lighthearted images of

Figure 176. William E. Smith, *Maybe Tomorrow,* ca. 1938, linoleum cut, 10 x 7⅜ in. (25.4 x 18.7 cm). Cleveland State University.

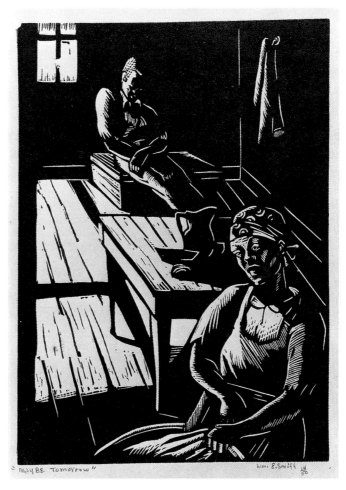

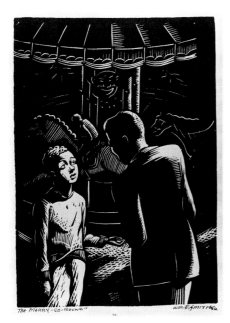

Figure 177. William E. Smith, *Merry-Go-Round,* 1939, linoleum cut, dimensions unknown. Collection unknown. [not in exhibition]

entertainment and leisure to solemn images addressing social ills. Charles Sallée created a large suite of the former. Representative among this group is *Juke Box Jive* (fig. 175), an image of trendily dressed nightclub dancers and their watchful admirers. Sallée was closely involved in the African-American nightclub scene in Cleveland during this time, working on a series of interior design commissions creating club décors.[39] The exuberance of works in this vein, and their frequency in the artist's oeuvre, prompted Porter to comment that Sallée's art "is joyously animate . . . as though the artist found nothing but transporting gladness in life."[40]

More so than any of his colleagues at Karamu, William E. Smith created genre images that dealt with serious social problems facing many black Clevelanders. Unemployment is confronted in his linoleum-cut print *Maybe Tomorrow* (fig. 176), which presents the despair of a couple after the husband has returned home from an unsuccessful job search to deliver the bad news to the wife.[41] The couple is pictured in a sparsely furnished interior. The man sits, his head downcast; the woman dejectedly stares into space while washing clothes. Smith's title provides an element of hope—albeit a tentative one—that is otherwise absent in the image.

Racial discrimination is the subject of Smith's *Merry-Go-Round* (fig. 177), a linoleum-cut print that depicts an African-American boy offering a coin to a man in charge of operating a carousel. The sad expression on the boy's face indicates that despite his ability to pay, he will not be allowed to ride. Smith's image was inspired by Langston Hughes's poetic vignette of the same title, which presents the scenario of a black child from the South attending a carnival.[42] Remembering the Jim Crow sections encountered on trains and buses, the perplexed child asks where such a section is located on the carousel. The poem ends with the child imploring, "But there

ain't no back / to a merry-go-round! / Where's the horse / For a kid that's black?"[43] In his print, Smith takes Hughes's figurative theme and recasts it into a topical subject for his Cleveland audience. At the time of the print's creation, Euclid Beach Park (see fig. 113), the city's largest amusement park, was under considerable protest for its long-held racially discriminatory policies. In 1934 the Youth Council of the Cleveland NAACP filed several lawsuits, and the desegregation of Euclid Beach Park remained fiercely—and sometimes violently—contested until 1947, when legal decisions in favor of the NAACP were obtained.[44]

EPILOGUE: A FIRE AND A REBIRTH

AFTER THE ONSET OF THE SECOND WORLD WAR, Karamu House's studio art program was at a crossroads. The military draft began depleting some of the program's finest talents and, with them, some of its inspirational energy. As a physical entity, the program was essentially without a home, having been so since 1939 when a fire of suspicious origin destroyed the building that housed the art studios, along with Karamu Theatre. In the interim, studio classes were being held under extremely cramped conditions in makeshift, dilapidated quarters on Karamu's property. Shortly after the fire, in dire need of new facilities and capital to ensure the continuance of its services, Karamu House launched a half-million-dollar building and endowment campaign that was nationwide in scope. Contributions and support came from many who knew of Karamu's achievements, including those sponsors mentioned at the beginning of this essay in conjunction with the Associated American Artists Galleries exhibition in New York City. Local benefactors and institutions supported the campaign as well.[45] Because of the war, it took nearly a decade to raise the necessary funds, and as a result, the momentum of the studio program was temporarily lost. When the new Karamu facilities, including the new art studios, finally opened with much fanfare in 1950, several key members of the famed prewar group had either left the city permanently or moved on to other careers and activities. A new chapter in the history of Karamu studio art was thus inaugurated.

NOTES

1. Karamu House, named from a Swahili word roughly translated as "a place of joyful gathering," was the designation officially adopted by the institution circa 1941. Previously it had been incorporated as the Playhouse Settlement of the Neighborhood Association of Cleveland. For the sake of clarity and convenience, the institution is referred to throughout this essay as Karamu House, regardless of chronology. Karamu House is still in operation, celebrating its 80th anniversary as of this writing (1995).

2. Formally titled the *Annual Exhibition of Artists and Craftsmen of the Western Reserve,* the May Show endeavored to showcase the best contemporary works of art produced in the Cleveland area. Artists associated with Karamu House exhibited continuously in May Shows from 1932 to 1946—with the exception of 1942, a year of conscription into the armed forces for many regular contributors. The group show, *Exhibition of Karamu House Work of Graphic Artists,* was held at the Cleveland Museum of Art (25 February–30 March 1941).

3. *Exhibit by Karamu Artists* was on view in New York at Associated American Artists Galleries (7–22 January 1942) and in Philadelphia at Sullivan Memorial Library, Temple University (2–16 February 1942). The show attracted much publicity, including the following notices and reviews: Milton Widder, "14 Karamu Artists Show in New York," *Cleveland Press* (3 January 1942), 5; Howard Devree, "An Exotic Note," *New York Times* (11 January 1942), IX–9; "Negro Art from Cleveland's Karamu House," *Art Digest* 16 (15 January 1942): 19; George Baer, "Negro Art Enriches America's Culture," *Daily Worker* (15 January 1942); "Karamu Artists 'Stealing' New York Art Exhibition," *Call & Post* (17 January 1942), 1–B; "Negro Students of Karamu House Exhibit at Associated American Artists Galleries," *Pictures* 5 (January 1942): 31–32; "Karamu House of Cleveland Has Art Exhibit in N.Y.," *Opportunity* 20 (February 1942): 59.

4. For overviews of these artists' careers, as well as the careers of additional Karamu artists, see Alfred L. Bright, "Cleveland Karamu Artists 1930 to 1945," in *Cleveland as a Center of Regional American Art* (Cleveland: Cleveland Artists Foundation, 1993), 72–83; and Ellen Schulz, "The Russell and Rowena Jelliffe Collection: Prints and Drawings from the Karamu Workshop, 1929–1941," exh. booklet (Cleveland Heights, Ohio: St. Paul's Episcopal Church, 1994), unpaginated. Schulz's material is recapitulated in "The Russell and Rowena Jelliffe Collection: Prints and Drawings from the Karamu Workshop, 1929–1941," exh. booklet (Cleveland State University Art Gallery, 1994), unpaginated.

5. Quoted in "Copy of descriptive paragraphs used in display of work of Karamu artists at Cleveland Museum of Art—March 1941," typewritten manuscript, container 36, folder 639, Karamu House Records, Western Reserve Historical Society (WRHS), Cleveland. The quote is reprinted in Schulz, "Jelliffe Collection."

6. When interviewed in 1932 on the subject of African-American history in Cleveland—a subject on which he was an authority—attorney, novelist, and essayist Charles W. Chesnutt concluded that visual art vocations were "never" pursued by local African-Americans—an illuminating statement, despite its slight inaccuracy ("Reported Interview with Charles W. Chestnutt" [sic], 29 March 1932, in George W. Brown, "The History of the Negro in Cleveland from 1800 to 1900" [Ph.D. diss., Western Reserve University, 1934], 152).

7. Various sources were consulted in the search to locate African-American professional artists in Cleveland. Primary and secondary sources relating to the local art scene were consulted, as were those relating to the local African-American community. Primary sources such as newspaper articles and autobiographies provided the few leads that were discovered. Robert Moxley, for example, is cited as giving private drawing lessons in Abel G. Warshawsky, *The Memories of an American Impressionist,* ed. Ben L. Bassham (Kent, Ohio: Kent State University Press, 1980), 1–2. Although Warshawsky describes Moxley as a graduate of the Cleveland School of Art, the assertion is not substantiated by school records. Moxley is listed as an artist in Cleveland city directories from 1898–1900 and 1901–2; and from 1906–8 he is listed as a photographer. He is absent from subsequent directory listings, which suggests he moved away, but to where is not presently known. Upon his death in 1922, Moxley was buried in Cleveland, according to microfilm 137, Cleveland Necrology File 1951–1975 (the citation is belated), Cleveland Public Library.

8. J. F. H[anks], "A Colored Artist," *Daily True Democrat* (28 March 1853), 2.

9. Why Hanks did not ultimately do so remains unclear. The incident is recounted in John Malvin, *North into Freedom: The Autobiography of John Malvin, Free Negro, 1795–1880,* ed. Allan Peskin (Cleveland: Press of the Western Reserve University, 1966), 68–74.

10. Between 1910 and 1920, Cleveland's African-American population increased more than 300%; during the 1920s, this new total more than doubled. See Kenneth L. Kusmer, *A Ghetto Takes Shape: Black Cleveland, 1870–1930* (Urbana: University of Illinois Press, 1976), 157, 160.

11. For studies of 19th-century African-American history in Cleveland, see: Russell H. Davis, *Black Americans in Cleveland from George Peake to Carl B. Stokes, 1796–1969* (Washington, D.C.: Associated, 1972), 7–219; David W. Demming, "A Social and Demographic Study of Cuyahoga County Blacks, 1820–1860" (M.A. thesis, Kent State University, 1976); Thomas J. Goliber, "Cuyahoga Blacks: A Social and Demographic Study, 1850–1880" (M.A. thesis, Kent State University, 1972); Brown, "The History of the Negro in Cleveland."

12. By 1930 at least 90% of the 72,000 African-Americans residing in the city lived within the area bounded on the north by Euclid Avenue, on the south by Woodland Avenue, and on the east by East 105th Street (Kusmer, *A Ghetto Takes Shape,* 165).

13. Kusmer, *A Ghetto Takes Shape,* 174–205. See also Kusmer's articles, "Racism at High Tide: Cleveland 1915–1920," in *Ohio's Western Reserve: A Regional Reader,* ed. Harry F. Lupold and Gladys Lupold (Kent, Ohio: Kent State University Press, 1988), 238–48; and "Black Cleveland and the Central-Woodland Community, 1865–1930," in *Cleveland: A Metropolitan Reader,* ed. W. Dennis Keating et al. (Kent, Ohio: Kent State University Press, 1995), 265–82. An important primary source is Charles W. Chesnutt, "The Negro in Cleveland," *Clevelander* 5 (November 1930): 3–4, 24–27.

14. For a history of Karamu House, see John Selby, *Beyond Civil Rights* (Cleveland: World, 1966); Cora Geiger Newald, "Karamu: Forty-Eight Years of Integration through the Arts," unpublished typewritten manuscript, ca. early 1960s, WRHS; and Kenneth Silver, "A History of the Karamu Theatre of Karamu House, 1915–1960" (Ph.D. diss., Ohio State University, 1961). Extensive primary source material on Karamu House is available in the Karamu Records, WRHS.

15. The Jelliffes held the directorship of Karamu House until their retirement in 1963. Much information relating to their careers is in Selby's book, *Beyond Civil Rights*. Primary source material is available in the Russell and Rowena Jelliffe Papers, WRHS.

16. Rowena Woodham Jelliffe, recorded interview by Dorothy Silver, Cleveland Museum of Art (CMA), 19 July 1989, CMA Archives.

17. Untitled typewritten manuscript, 9 February 1943, container 36, folder 636, Karamu Records, WRHS.

18. Russell W. Jelliffe, "Weaving a Minority into the Major Pattern," *Progressive Education* 12 (March 1935): 170.

19. Selby, *Beyond Civil Rights,* 131.

20. Some of Johnson's visits in 1915 and 1919 are documented in Russell H. Davis, "Civil Rights in Cleveland, 1912 through 1961: An Account of the Cleveland Branch of the N.A.A.C.P.," typewritten manuscript dated 1973, 27, 35–36, WRHS.

21. Selby, *Beyond Civil Rights,* 181, 204.

22. The principal text of the movement is Alain Locke, ed., *The New Negro: An Interpretation* (New York: Albert and Charles Boni, 1925).

23. Jelliffe interview, CMA Archives.

24. For information on Beatty, see Schulz, "Jelliffe Collection."

25. Newald, "Karamu: Forty-Eight Years," 107.

26. Locke's lecture is mentioned in Gordon H. Simpson, "Negro-in-History Session on Today," unidentified newspaper clipping, CMA Archives. The position of the clipping in the scrapbook indicates that the event took place ca. October 1930. Another lecture on the African collection was presented by museum director Frederick Whiting for an audience of NAACP national conference attendants (Davis, "Civil Rights in Cleveland," 55).

27. The show, held at the Cleveland Art Center, was circulated by the Harmon Foundation.

28. Grace V. Kelly, "American Negro Exhibition," *Cleveland Plain Dealer* (9 June 1929), 3–F.

29. For the fall semester in 1934, for example, scholarship funds were awarded in the amount of $10 to attend the John Huntington Polytechnic Institute (tuition was free, although students needed to cover the cost of their studio materials), and $152 to attend the Cleveland School of Art.

30. School records are not very helpful in determining whether there were previous African-American graduates, as they contain no information regarding race. Research conducted by the Cleveland Institute of Art alumni office supports Sallée's and Lee-Smith's precedences. I am grateful to Georgianne Wanous, director of alumni relations, for this information. The earliest known discussion centered around African-American graduates at the art school appears in a letter from 1934, in which a member of the faculty states, "As long as I have been connected with the School either as student or faculty member, (since 1916,) and indeed, I believe even in the history of the School, there has never been a colored person who carried through and graduated" (Alys Roysher Young to Mr. and Mrs. Russell Jelliffe, 10 April 1934, container 28, folder 500, Karamu Records, WRHS).

31. Philip Kaplan, *The Making of a Collector: Laukhuff's of Cleveland* (Akron: Northern Ohio Bibliophilic Society, 1990), 6.

32. "Karamu Artists Incorporated Constitution and By-laws," typewritten manuscript, container 21, folder 363, Karamu Records, WRHS.

33. Claire Davis, "The Arts," *Call & Post* (13 May 1937), 8.

34. Quoted in "Copy of descriptive paragraphs," WRHS. A copy of the quote is reprinted in Schulz, "Jelliffe Collection."

35. This quote is attached to the back of *Landscape No. 1* in the Roger and Rowena Jelliffe Collection, Cleveland State University Art Gallery. The quote is reprinted in Schulz, "Jelliffe Collection."

36. For an extended discussion of Porter's views in relation to those of Locke, see Starmanda Bullock Featherstone, *James A. Porter, Artist and Art Historian: The Memory of the Legacy,* exh. cat. (Howard University Art Gallery, 1992), 21–46.

37. Rotraud Sackerlotzsky, *Cleveland's African Images Circa 1920–1960,* exh. booklet (Cleveland Artists Foundation, 1990), unpaginated.

38. A copy of this poster is in the collection of the National Portrait Gallery, Smithsonian Institution, Washington, D.C.

39. Claire Davis, "The Arts," *Call & Post* (20 August 1936), 6; Helen Cullinan, "Artist's 50-Year-Old Etchings Draw Him Back into Limelight," *Plain Dealer* (2 August 1992), 3–H.

40. James A. Porter, *Modern Negro Art* (New York: Dryden, 1943), 129.

41. Smith's comments regarding the print are found in "Copy of descriptive paragraphs," WRHS, and reprinted in Schulz, "Jelliffe Collection."

42. William E. Smith and Marjorie Witt Johnson, *The Printmaker: "From Umbrella Stave to Brush and Easel": William E. Smith, the Story of a Man and His Works, 1926–1976* (Cleveland: privately printed, 1976), 8.

43. Langston Hughes, "Merry-Go-Round," in *Shakespeare in Harlem* (New York: Alfred A. Knopf, 1942), 80.

44. For primary sources bracketing this period of discrimination, see C. E. Lee, "Euclid Beach Park Draws Color Line on High School Students," *Call & Post* (9 June 1934), 1; and Bob Williams, "Mayor's Plea Routs Foes of Law to End Beach Jim-Crow," *Call & Post* (22 February 1947), 1–A, 11–B. Secondary sources outlining the history of racial bias at the park include Davis, *Black Americans in Cleveland,* 274, 310; and Davis, "Civil Rights in Cleveland," 86.

45. The Cleveland Museum of Art and the Cleveland Museum of Natural History were two such institutions. Grateful for the African material donated more than a decade earlier, the museums joined forces in 1942 to offer a series of educational programs and to host a reception in order to publicize and raise money for Karamu's campaign ("Two Museums to Help in Karamu Campaign," *Cleveland Plain Dealer* [13 March 1942], 12).

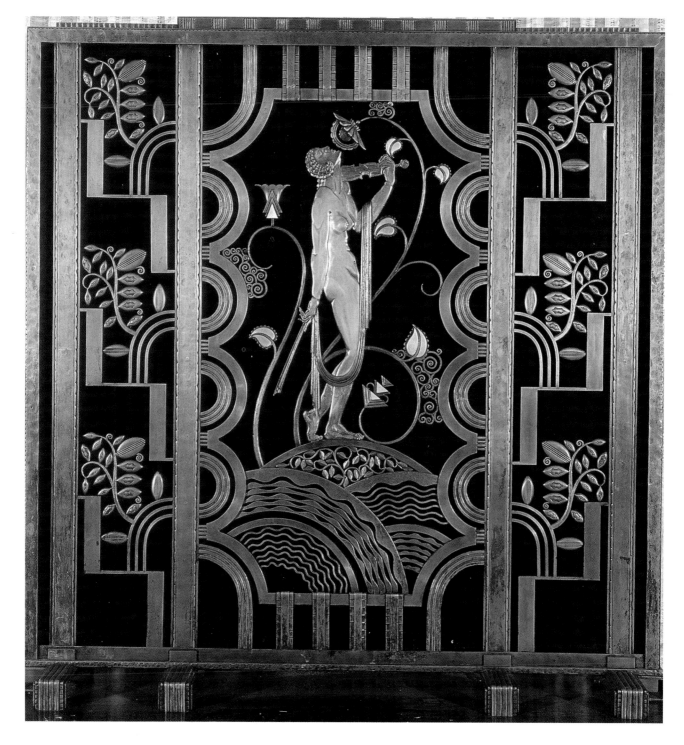

Cleveland Craft Traditions

WHEN, IN AUGUST OF 1796, Moses Cleaveland and his surveying team laid out the basic street pattern of what would become the city of Cleveland, it had been decided that the site where the Cuyahoga River flowed into Lake Erie was the proper location for the chief town of the Western Reserve because it offered the best "communication either by land or water."[1] In time this decision proved to be entirely correct, but in the short term the nearby malarial swamps and the beginning of Indian lands just west of the Cuyahoga River inhibited growth. A few adventurous settlers did arrive before 1800, but by April of that year most had departed, and Lorenzo Carter was the only resident of Cleveland. At the end of the next decade, the population had increased to ten families, or fifty-seven residents, but despite its slow growth the hamlet was beginning to assume the character of a permanent settlement. A treaty of 1805 opened the lands west of the Cuyahoga to whites, and soon after crude roads were hacked through the wilderness from Cleveland eastward to Buffalo and to the Huron River to the west. Water transportation was even more important. The completion of the Erie Canal in 1825 meant that travel by ships and barges was possible from Cleveland all the way to New York City. An even greater spur to the growth of the village was the construction of the Ohio Canal connecting Lake Erie to the Ohio River, with Cleveland as its northern terminus. This project had been under consideration for several years when it was finally adopted in February of 1825. Construction began in 1827 and two years later Akron and Cleveland were joined by a canal. The entire project was completed in 1834. Cleveland's importance as a transportation hub was clearly established and its future growth assured. By 1840 Cleveland was the most populous town in the Western Reserve with 7,500 inhabitants. But at that date, Cleveland was almost entirely devoted to commerce. Seventy percent of the population was dependent economically on this activity. Only in the second half of the nineteenth century did manufacturing become an important factor in the town's economy, and by the time of its emergence, the industrial revolution was well advanced. Cleveland became a center of the iron and steel industries, oil refining, and a wide variety of other manufacturing activities, most of them accomplished by machines and a work force trained to use them.

The traditional crafts were not entirely neglected during Cleveland's first half century. In 1802, when Lorenzo Carter built the town's first frame house to accommodate his tavern (which also served as the town's first hotel), the lumber was brought from Detroit.[2] A local carpenter built the furniture, which presumably was of a simple sort. In the period before 1850, more than a hundred furniture- and cabinetmakers were active in Cleveland, and there may well have been others, especially in the early

Rose Iron Works, Inc., designer Paul Feher, *"Art Deco" Screen,* 1930.

years, who left no record of their activities.[3] One of the first was a man named Ashel Abel (or Abell), who was in partnership with a person named Frisbie in 1818 and was working on his own in 1827. He taught his trade to William Hart, who had become an independent craftsman by 1837 and at the century's midpoint was a successful businessman. In 1848 he advertised that he had recently installed a steam engine that permitted him to fill orders for furniture very quickly. He also made coffins and functioned as an undertaker.

It is clear that some persons were both makers and retailers of furniture. In 1835 Daniel A. Shephard advertised himself as a maker of fancy, Windsor, and cottage chairs, claiming, "The citizens of Cleveland and its vicinity, who are disposed to encourage a home manufactory, will do well to examine [my chairs] for themselves." A few years later, however, Shephard notified the public that he had "also a lot of Eastern chairware at exceedingly low prices."[4]

Some cabinetmakers were specialists or worked for others. Christopher Schonetovar and John Seaborn were turners, Charles Prescott a cabinet finisher, and Davison (or Davidson) a carver. A man named Martin worked for William Hart. In 1816 in Bedford, a separate town in the vicinity of Cleveland, Benjamin Fitch established a chairmaking concern.[5] It passed to his descendants through the female line, became the Taylor Chair Company, and still exists today. Although much information can be gleaned about furnituremaking in Cleveland through literary sources, unfortunately almost none of the furniture itself can now be identified. Probably much of it was utilitarian, discarded when damaged or outmoded, and difficult to identify as having been made in Cleveland when by chance it survives.

Silversmithing was a somewhat different situation, but the results were hardly more propitious.[6] Cleveland's first silversmith, William Bliss, arrived in 1815. He does not seem to have found much outlet for his skills, for by 1818 he was advertising a variety of merchandise for sale, including "a few thousand American segars." The same year he offered his house and lot for sale and moved away for three years. When he returned, he tried wool carding and then cabinetmaking, but seems to have found no real success before his death from malaria at the age of thirty-seven.

Quite different circumstances were enjoyed by Newton E. Crittenden. He arrived in Cleveland in 1826 with $500 worth of jewelry purchased on credit. Canal building had at last brought a strong cash economy to Cleveland, and Crittenden quickly sold his stock and returned east to buy more. He became perhaps the single most successful Cleveland retailer of his time. In 1833 he rebuilt a small structure on Superior, making it a combined residence and place of business. Ten years later he purchased an elegant stone house on Public Square, on the site of the present Society Bank Building. Finally, in 1868, he occupied a newly constructed place of business on Water Street.

Crittenden seems to have had the proper flair for offering luxury goods to an eager frontier clientele. He is also said to have made silver spoons, but the extant examples bearing his name seem mostly to have been made elsewhere and merely struck with his mark and retailed by him. Five men—Charles G. Aiken, Lucius Benton, Jeremiah Coon, Bernard Dietz, and Richard Pugh—trained with Crittenden and later went off on their own, but none enjoyed his great success. His significant rival was Royal Cowles, who began his career in Cleveland about 1846, was in partnership with New York silversmith J. R. Albertson for nine years beginning in

1849, and was then again on his own until 1889. Like Crittenden, Cowles seems to have had considerable commercial success, but also like Crittenden, he was essentially a retailer.

Bricks were made in Cleveland, but other clay products sold locally were largely produced elsewhere, notably in Akron, which had access to good raw materials for utilitarian stoneware and pottery.[7] Glass was made in the nearby Portage County villages of Mantua, Kent, and Ravenna.[8] In its earliest days, Cleveland clothing, especially that of men, made use of homespun textiles.[9] Around 1830 a brief experiment with silkworm culture and the spinning and knitting of the resulting fibers was undertaken, but the results do not seem to have been significant.[10] Just east of Cleveland the Shakers established a colony known as the North Union in 1823. There they produced woolen textiles, tanned leather, and made woodenwares, including furniture.[11]

The evidence available to us, meager as it is, indicates that though various craft traditions were practiced in Cleveland and its close vicinity, the resulting products lacked technological complexity or stylistic sophistication. In the realm of precious metals, importations from the East Coast centers of production in Rhode Island, Connecticut, and New York quickly dominated the local market. Probably because its greater bulk made shipping more expensive, furniture seems to have been made locally in considerable quantity through the middle of the century. Thereafter a few makers that adopted factory production methods, such as the Taylor Chair Company, survived, but luxury furniture was often brought in from New York, while Grand Rapids, Michigan, supplied the growing middle-class market. The expansion of rail transportation after the Civil War must have encouraged this development. Undoubtedly the traditional crafts techniques did not entirely disappear from the Cleveland scene in the last half of the nineteenth century. Cabinetmakers were still needed to repair furniture and provide architectural fittings. Some special-order jewelry—for example, pieces employing gemstones—was no doubt produced locally. But in large measure Cleveland seems to have unhesitatingly embraced the industrial revolution and abandoned the craft traditions.

The situation was different in Cincinnati, the other major Ohio metropolis, where in the 1870s, inspired by Japanese style and by recent developments in France and the ideals of England's arts and crafts movement, individuals began to participate in the international effort to reinvigorate traditional crafts media.[12] What had begun as the genteel pastime of ladies soon became a serious effort to produce distinguished objects. Ceramics was the most important medium of this Cincinnati renaissance, and, especially at its inception, the surviving local craft traditions were an essential ingredient of its success. Rookwood pottery was the major, but by no means the only, achievement of the Cincinnati enthusiasts.[13] At Rookwood, a division of labor between the potters and the decorators, and the often repetitive production of ceramic forms in molds, precluded realization of the highest arts and crafts ideals. The pottery produced there was never the result of the imagination and skill of a single artist-craftsman. Nevertheless, it represented a clear departure from tightly controlled contemporary factory methods of producing luxury ceramics employing the specialized skills of many workers. Rookwood decorators at least had the freedom to formulate and execute their own designs.

Although some china painting and fancy needlework certainly were practiced in Cleveland in the last half of the nineteenth century, the arts and crafts movement seems to have arrived here in a recognizable form only at the very end of the century, and unlike the Cincinnati ladies who

spearheaded those activities in southwestern Ohio, in Cleveland three professionally trained men led the way. Although all were accomplished designers and artisans, their success was in large measure due to their talents as entrepreneurs. In Cleveland it was capitalism, not style or anti-industrial ideology, that plotted the way.

LOUIS RORIMER

THE ELDEST OF THESE THREE entrepreneurs, Louis Rorimer was, in worldly terms, perhaps the most successful.[14] He was born in Cleveland in 1872, the son of German parents who had immigrated to the United States in 1847 and settled in Cleveland in 1849. His father, Jacob Rohrheimer, operated a successful tobacco business.[15] The precise dates of events in Louis's youth remain a bit fuzzy, but at least they can be recounted. He attended Newton M. Anderson's Cleveland Manual Training School, the fore-runner of present-day University School, presumably in the 1880s. At the age of fourteen, Rorimer began taking courses at the Cleveland School of Art. At both institutions the sculptor Herman Matzen, an instructor in modeling and carving, offered special encouragement to the young man. In 1890 Rorimer persuaded his family to send him to Europe to pursue his studies in the visual arts.[16] He went first to Munich, where he was enrolled in the Kunstgewerbeschule, an institution devoted to what was then described as the applied or industrial arts. In 1893, Rorimer moved on to Paris, where he worked at the École des Arts Décoratifs, a public institution of similar orientation, and at a private art school, the Académie Julian. He also did some traveling, visiting several German cities and perhaps London as well.

Rorimer returned to Cleveland toward the middle of the decade, probably in 1895.[17] The next year he was in partnership with James Bowman. Working from an office in the Old Arcade, they described themselves as designers. This partnership lasted only a few years. Next, Rorimer formed what seems to have been a much more ambitious undertaking with Louis Hays, for not only did they have studios in the Garfield Building but also extensive furnituremaking and upholstery workrooms at another location, on Champlain Street. Hays withdrew in 1904, and the firm carried only Rorimer's name until 1910, when it joined with the Brooks Household Art Company to become the Rorimer-Brooks Studios. The union seems to have been less a partnership than a buyout, with Rorimer the owner of the resulting firm. Finally, in 1916, the Rorimer-Brooks Studios occupied a specially constructed building at 2232 Euclid Avenue, which continued to be its address until Rorimer's death in 1939. The firm then became a corporation owned by former employees and continued to occupy the Euclid Avenue premises until 1957, when it was dissolved.

There is no doubt that Louis Rorimer played a large and perhaps crucial role in the development of the arts in Cleveland before World War II. His influence was strongest in the fields that paralleled his own professional activities, particularly the crafts, but his interests were by no means confined to this sphere. Most important was his role as a teacher at the Cleveland School of Art.[18] Rorimer joined the faculty in 1898, when he was in his mid-twenties and had only recently returned from his studies abroad. Until 1904 he taught modeling and casting. After the school moved to its first specifically designed quarters on Juniper Road in 1905, Rorimer taught courses in decorative design and later headed the department of design and interior decoration. He remained a member of the faculty until 1918, and thereafter continued to be a loyal supporter of the school. His personality and enthusiasm seem to have endeared him to his students,

many of whom were almost as old as he. For example, Horace Potter, who was only a year younger than Rorimer, is said to have been his pupil, presumably in his first year of teaching, since Potter graduated in 1899. Another of his students was the distinguished jeweler and metalsmith Jane Carson Barron. Undoubtedly the most famous of Rorimer's former students today is the watercolorist Charles Burchfield, but others who built careers of considerable distinction were the painters Ferdinand Burgdorff and Abel Warshawsky, and the sculptor Max Kalish.

About 1904, Rorimer gathered together three of his former students— Carolyn Hadlow, Mary Blakeslee, and Ruth Smedley—to form a group in which he himself participated and which, a short time later, was given the name of the Rokesley Shop, a designation derived from a compounding of their surnames.[19] With some changes of personnel, the Rokesley Shop survived until the death of Ruth Smedley in 1920, and during that period maintained quarters in close proximity to those occupied by Rorimer's interior design firm and its workshops. The Rokesley Shop produced metalwork of various kinds (fig. 178), especially silver and enamel jewelry. They also made items of copper, including lighting fixtures, which were available for use in conjunction with Rorimer's interiors.[20] The personal role played by Rorimer in the activities of the Rokesley Shop cannot be precisely defined, but he probably acted as a sort of editor of design, making recommendations about the appearance of objects produced. It is doubtful that he himself contributed to their actual manufacture. Special pieces, such as the tea and coffee service made for the personal use of his family, were probably designed by him virtually in toto.

Although his association with the Cleveland School of Art was almost certainly Rorimer's most significant relationship with a local arts organi-

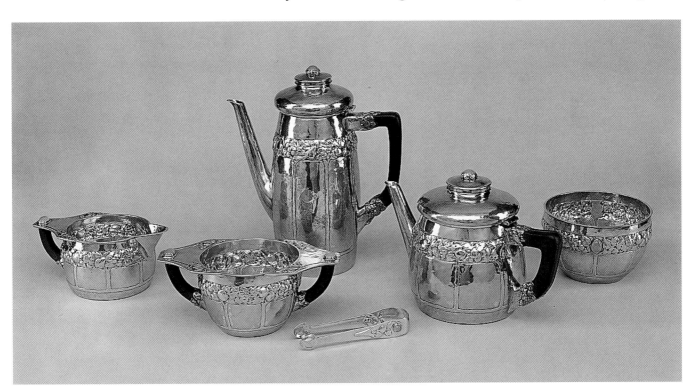

Figure 178. Louis Rorimer and the Rokesley Shop, *Tea and Coffee Service* (six pieces), 1904–20, silver, ebony, and moonstone; coffee pot: 11 x 9⁹⁄₁₆ in. (28 x 24.2 cm). The Cleveland Museum of Art, gift in memory of Louis Rorimer from his daughter, Louise Rorimer Dushkin, and his granddaughter, Edie Soeiro.

zation, it was by no means his only one. For the Cleveland Museum of Art he was a source of furnishings, and also of advice about the international art market. Toward the end of his life, his help over the years was recognized through his election to the museum's Advisory Council. Rorimer had joined the Cleveland Society of Artists by 1914, the year after its founding, and was an active member, serving as president in 1920 and 1921. This organization supported the welfare of local artists and raised money for scholarships at the Cleveland School of Art. The Cleveland Art Association, organized in 1915, was similar in purpose, but its membership was open to interested laypersons and included among its intended beneficiaries was the Cleveland Museum of Art. Rorimer was also associated with a number of other Cleveland and national organizations, some related to the arts, others of a commercial nature. Clearly he was a man of wide interests and a gregarious nature.

It is when one turns to Rorimer's activities as a designer and manufacturer of furniture and metalwork that the picture becomes murky and somewhat difficult to understand. He seems to have been pulled in several directions by frequently competing objectives. As a designer he wished to create useful and decorative objects that would fulfill his aesthetic impulses, while as an entrepreneur he was aware of the need to offer his clients what they wanted. The result was considerable eclecticism of style in his productions. From the beginning, most of Rorimer's furniture seems to have been in some sort of identifiable revivalist mode. In the early years his furniture was usually in a Renaissance revival style and later, in the twenties and thirties, in the Anglo-American eighteenth-century taste. Only occasionally in the period prior to World War II does one encounter pieces of great simplicity or with characteristics of form and ornament which can be recognized as reflecting arts and crafts principles of design. On the contrary, virtually all the products of the Rokesley Shop are clearly of an arts and crafts persuasion and only now and then do motifs suggesting styles of the past intrude. It is difficult to explain this dichotomy. Perhaps with jewelry and objets d'art, patrons were willing to tolerate a more adventuresome style than with their furniture. Occasionally after World War I, Rorimer-Brooks produced work in a simplified version of the contemporary French style which is today called art deco. Rorimer himself professed a liking for such furniture, but claimed that his clients were generally less enthusiastic. However, Rorimer also indicated his continued admiration for fine craftsmanship and his displeasure with a machine aesthetic, which meant that most of the products of the Bauhaus, widely praised by avant-garde critics of the period, were outside the realm of what he found acceptable.

Rorimer seems to have enjoyed considerable success as a supplier of interior decorations for both residential and commercial clients. Perhaps the single most significant of these was the Statler chain, with whom he first worked in 1912, when one of their hotels was built in Cleveland. Eventually Rorimer became a stockholder in the firm and a member of its board of directors. It was probably because of his association with Statler Hotels that Rorimer-Brooks was able to weather the Great Depression of the 1930s with comparative ease.

In the absence of most of the records of the Rorimer-Brooks firm, it is difficult to determine precisely the role of Louis Rorimer in its productions. Certainly he exercised a general control over the style and technical quality of its furniture, but other designers are known to have been employed, and there are no clearly visible characteristics that make its furniture immediately recognizable. In contrast to Louis Comfort Tiffany, whose career

his to some degree paralleled, Rorimer did not develop an identifiable personal style. He accommodated his taste to that of his clients, rather than persuading them to follow his lead. Therefore, despite his indisputable talents as a designer, his accomplishments must be viewed as fundamentally commercial rather than aesthetic, but that is not to deny the important role he played as a facilitator in Cleveland's artistic community of his day.

HORACE POTTER

INFORMATION ABOUT HORACE POTTER'S EARLY LIFE is a bit vague, perhaps because he seems not to have been a very successful student.[21] He was born on his family's farm near what is now the intersection of East 123rd Street and Superior Avenue in Cleveland. His family were early settlers of Ohio. In 1890 he was enrolled in the ninth grade at University School during its first year of operation. Its founder, Newton M. Anderson, had previously operated the Cleveland Manual Training School, which Potter is said to have also attended, but the appropriate records are not available. At University School, he repeated the tenth grade and left in 1893 without graduating.[22] At that date, he was about twenty.

Potter graduated from the Cleveland School of Art in 1898. Presumably, it was immediately after his graduation that he was a student of Amy Sacker in Boston and worked at the Boston Society of Arts and Crafts. From 1899 until 1904 he is said to have had a shop in the Rose Building. At this time he also joined the faculty of the Cleveland School of Art, where he taught decorative design and historic ornament and was an assistant to Louis Rorimer.[23] He continued on the faculty there until 1910.[24] In 1905 he first established a cooperative venture in metalcrafts with Wilhelmina Stephan and Ferdinand Burgdorff, occupying space in buildings at the Potter farm on Superior.[25]

About 1907 Potter made an important trip to England, coming into close personal association with the arts and crafts movement there. He worked under one of its leading figures, Charles R. Ashbee, at the School of the Guild of Handicraft at Chipping Camden. He also was in contact with the well-known enamelist Alexander Fisher. It is not certain precisely how long Potter was in England. Perhaps it was less than a year. He continued to be listed as a member of the faculty of the Cleveland School of Art through the entire first decade of the century. He was certainly back in Cleveland by 1909, and in that year rented a house at 10646 Euclid Avenue that was large enough for him to sublet rooms to other young artists, notably R. Guy Cowan. In 1914 Potter married Florence Loomis, who shared his interest in design, and went to live on Lamberton Road in Cleveland Heights. A year later he moved Potter Studios to the Hubbell & Benes Building at 4418 Euclid Avenue, and in 1928 relocated to space in a newly constructed building on Carnegie near East 105th Street, where the firm of Potter-Mellen remains today.

Workers in the arts and crafts movement tended to favor collaboration with one another, and Horace Potter subscribed to this practice. Perhaps it enabled him to devote more of his time to designing and less to execution. Certainly after Potter Studios was well established it must have been necessary to hire employees to accomplish all that needed to be done. That the situation at Potter Studios was more than a simple division of labor is clearly indicated by the description of jewelry and metalwork exhibited at the Cleveland Museum of Art's first May Show in 1919. Here we find listed under "The Potter Studio":

169 Silver and Enamel Pin Set with Sapphires and Moonstones
Designed by H. E. Potter
Made by Nathan Brody and C. Kurz

171 Bar Pin
Designed by H. E. Robus
Made by Nathan Brody

178 Gold and Enamel Ring with Black Opal
Designed by Florence L. Potter
Made by H. E. Potter and Nathan Brody

351 Silver and Ivory Dish
Designed by H. E. Potter
Made by Nathan Brody and Emil Prevratsky

358 Silver Teapot, Coffee-pot, Creamer and Sugar Bowl
By Emil Prevratsky and Carl Kurz

356 Silver Syrup Pitcher and Tray
Designed by Florence L. Potter
Made by Emil Prevratsky[26]

Over the years, the personnel of the Potter Studios changed, but the methods of working seem to have remained constant. Among the later associates of the firm were John S. Burton and Henning Naukler. The productions of the Potter Studios are poorly documented. No modern

Figure 179. Horace Potter, *Tea Strainer,* ca. 1910, silver, 5¹⁄₁₆ x 3⁷⁄₁₆ in. (12.7 x 8.6 cm). The Cleveland Museum of Art, John L. Severance Fund.

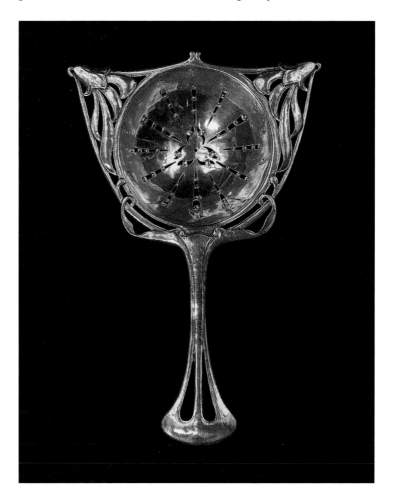

monograph has been published, and only a few pieces have been publicly sold or exhibited. Nevertheless, some generalities can be attempted about the character of the work, based in part on contemporary photographs.[27] It seems that until the war years of 1916–18, virtually everything sold by the Potter Studios was made there. An article of 1910 says, "In [Potter's] work the influence of the historic styles is evident, there being a happy avoidance of the art nouveau."[28] The art nouveau style in its French manifestations may have been avoided, but naturalistic plant forms and Celtic interlaced patterns, clearly derived from British arts and crafts design and historically among the antecedents of Continental art nouveau, can certainly be recognized in the works of Potter Studios (fig. 179).[29]

In the postwar period, the influence of simple Anglo-American silver of the eighteenth century becomes paramount in the hollowware produced by the Potter Studios. With jewelry, however, arts and crafts taste seems to have continued to dominate their designs right through the twenties and thirties. However, at this time greater use was made of faceted jewels. These decades also witnessed a metamorphosis of Potter Studios first into Potter-Bentley Studios in 1928, and then into the Potter-Mellen firm a few years later. A wide variety of goods from both manufacturers and craftsmen were retailed. Much of what was made locally incorporated antique elements, particularly Chinese metalwork and carvings.[30] In the aftermath of the Second World War, antique English silver became a significant staple of Potter-Mellen offerings, but work made on the premises, particularly jewelry, was never totally abandoned.[31]

R. GUY COWAN

IN SEVERAL RESPECTS the circumstances of R. Guy Cowan's life differed from those of his slightly older contemporaries, Rorimer and Potter.[32] Prior to his birth in 1884 in the Ohio pottery town of East Liverpool, Cowan's family had been engaged in ceramicmaking for at least two generations, and from an early age he was associated with his father and grandfather in the ceramics industry. But his training was also academic, for in 1902 he was among the first students to attend the New York State School of Clayworking and Ceramics at Alfred, New York. This school was headed by a remarkable Englishman, Charles F. Binns, who insisted that students at the school receive both technical and artistic training. The latter consisted of imparting an essentially arts and crafts point of view, which valued simple forms covered with monochrome glazes, owing much to classic Chinese porcelains.

Cowan graduated from Alfred in 1907 and the following year came to Cleveland to establish a ceramics course at East Technical High School. For a short time, about 1910 or 1911, he lived in the house on Euclid Avenue that was then home to the Potter Studios. While there, he is said to have set up a kiln and begun making personal ceramics. Some pieces were created in cooperation with the studio: Cowan supplied ceramics which were fitted with metal covers by Potter. In 1911 Cowan married and moved to his wife's home on Cleveland's West Side. In 1913 he established the Cleveland Pottery and Tile Company and soon found a location for the firm in Lakewood, where a natural gas well fueled the kilns. Cowan's pottery first gained significant recognition in 1917, when twenty-two pieces were exhibited at the Art Institute of Chicago, winning a prize for their design. Although the precise pieces shown there cannot be identified, wares with simple, wheel-thrown forms decorated with drippy glazes exist that probably illustrate the variety of ceramics shown in Chicago.

The war years and the immediate postwar period were difficult ones for Cowan and his ceramics firm. First, he was called upon to contribute to the war effort and temporarily neglect ceramics, and then was forced to find a new home for his pottery when his gas well gave out at the Lakewood site. In 1921 he acquired property in Rocky River just to the west, and soon was again producing ceramics using a local gas supply. Cowan's work was once more shown in Chicago in 1924 and again won a prize, but now the character of the pieces was quite different. The ceramics were chiefly mold made with monochromatic glazes on an almost white, porcelain-like body. Cowan met with much success in the mid-1920s by creating sets of table ornaments consisting of a bowl, a figural frog to hold flowers in its center, and matching candlesticks. With their simple shapes and little if any variation in surface pattern or texture, these Cowan pieces suggest the taste of the twenties that we call art deco (see fig. 105), but without the radical stylizations of form and decoration found in the most extreme examples of this style. The great popularity of these pieces indicates that Cowan discovered a formula that was fashionable enough to attract attention, but not too extravagant for middle America. These sets and other functional pieces such as flower vases, pitchers, and bowls became the economic mainstays of the Cowan Pottery Studio, as the firm came to be called.

Clearly, however, Cowan's ambitions for his pottery extended beyond mere commercial success. Almost from the beginning of his Cleveland residency, Cowan had developed close connections with the Cleveland School of Art. Horace Potter taught there and the sculptors Herman Matzen and Stephen Rebeck worked with Cowan in the firm's earliest years. After the war, two other Cleveland sculptors on the faculty of the Cleveland School of Art, Frank Wilcox and Walter Sinz (see fig. 156), created figural pieces for Cowan. In 1925 the versatile and sophisticated European-trained sculptor Alexander Blazys arrived in Cleveland. The following year he joined the faculty of the art school and soon was creating dramatic figures for Cowan (see fig. 104). They apparently were not terribly popular with the public, since they seem to have been executed in rather small numbers. Perhaps their geometric simplifications of form were too radical. Then in 1928 a young and very talented sculptor, Waylande Gregory, was brought to Cleveland by Cowan. Gregory produced human and animal figures in eclectic styles ranging from the realistic to the highly stylized (fig. 180). He also designed for Cowan a series of functional pieces, such as boxes and candelabra.

While Cowan also modeled independent figures with some success in the late 1920s, the most important development for the future of ceramic-making in Cleveland, in the years just before the Cowan Pottery declared bankruptcy and closed its doors at the end of 1931, was the arrival of a group of talented young artists who had been students at the Cleveland School of Art, perhaps of Cowan himself, as he served on the faculty there from 1928 to 1933. They were hired by Cowan and received important early training and experience at his pottery. The first to arrive was Elizabeth Anderson, who, about 1928, designed a pair of figures entitled *Spanish Dancers* that proved very popular with the public. Strangely enough, she does not seem to have done much else for Cowan. Thelma Frazier Winter (see fig. 157) may have begun her association with Cowan even before she graduated from the art school. She designed forms for him and supplied decoration for vessels designed by herself and others.

Perhaps the most important young associate at the Cowan Studios was Viktor Schreckengost (see fig. 106). After graduating from the Cleveland School of Art in 1929, Schreckengost became a student of Michael Powolny

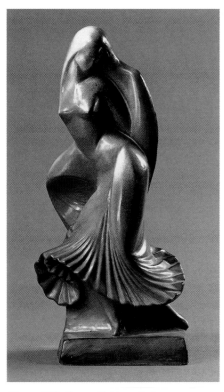

Figure 180. Cowan Pottery, designer Waylande Gregory, *Nautch Dancer,* earthenware, 17½ x 8¾ in. (44 x 22 cm). The Cleveland Museum of Art, Dudley P. Allen Fund. [not in exhibition]

at the Kunstgewerbeschule in Vienna. Cowan was in Europe in the spring of 1930 and visited Schreckengost in Vienna. He persuaded Viktor to return to Cleveland later that year and to accept a joint appointment at the Cowan Pottery Studios and the Cleveland School of Art. Although his association with Cowan was brief, it resulted in some of the most distinguished ceramics produced by the firm. Especially noteworthy are standard Cowan forms decorated by Schreckengost with motifs often inspired by the geometry of cubism.

Several other young artists are known to have had some sort of association with Cowan Studios, but their activities are ill defined. Paul Bogatay worked at the Cowan Studios around 1930 and then moved to Columbus and became a distinguished member of the faculty of Ohio State University. Whitney Atchley was employed by Cowan before his graduation from the Cleveland School of Art in 1932, but his association was limited by the firm's bankruptcy. He later made a career for himself on the West Coast. Like Ed Winter and Russell Barnett Aitken (see fig. 155), Atchley may sometimes have made use of marked Cowan blanks for decorating pieces not otherwise associated with the pottery. Edris Eckhardt (see fig. 154) was employed by Cowan at the end of the studio's operation, but at that time did not create works of her own design.

When the Cowan Pottery closed in 1931, some of the artists who had been associated with it soon moved away from Cleveland. Cowan himself went to Syracuse and obtained employment there with a ceramics firm. Waylande Gregory became associated with the Cranbrook Academy of Art near Detroit. Others stayed on at least for a while in Cleveland, and the presence of these talented young ceramists made Cleveland a national center, especially for sculpture in that medium, during the 1930s.

ROSE IRON WORKS

Figure 181. Rose Iron Works, Inc., designer Paul Feher, *"Art Deco" Screen,* 1930, wrought iron and brass with silver and gold plating, 61½ x 61½ in. (156.2 x 156.2 cm). The Rose Family Collection.

ALTHOUGH THE ARTS AND CRAFTS MOVEMENT was rather late in reaching Cleveland, once it was in place in the first decade of this century it matured rapidly and produced some distinguished work. For the most part, its leadership was tightly knit and focused on the Cleveland School of Art, with which virtually all of its practitioners were associated as either students or faculty members. However, there was also in Cleveland a surprising outpost of European taste that flowered briefly but brilliantly in the years around 1930. This was the result of the confluence of two talented personalities, Martin Rose and Paul Feher.[33] Rose, the elder of the two, was born in the eastern Austro-Hungarian Empire—now a part of Romania—in 1870. After training as an ornamental metalsmith in Vienna and setting up his own shop in Budapest in 1898, he decided to immigrate to the United States in 1902. By 1904 he had settled in Cleveland and soon established himself as a major local supplier of architectural ornament in metal. In the mid-1920s, on a return visit to Europe, Rose met by chance a fellow countryman, Paul Kiss, who was active in Paris as a metalsmith. Rose's son Stephen then spent a few months working in Kiss's shop, and there became acquainted with a gifted young designer of Hungarian extraction, Paul Feher.[34] Through this contact, the elder Rose invited Feher to come to Cleveland as designer for the Rose Iron Works. This he did, and for a few years around 1930 the team of Martin Rose, master craftsman, and Paul Feher, Parisian-trained designer, produced what was perhaps the most technically and stylistically sophisticated metalwork made in America in what has come to be called the art deco style (fig. 181).

Thus, in the period before the Second World War, Cleveland achieved a position of national leadership in a number of the major crafts media. Louis Rorimer and the firms with which he was associated made furniture and metalwork of distinction. Horace Potter not only headed his own firm of silversmiths and jewelers, but in his long career also was associated with a number of other distinguished craftspersons in these fields. R. Guy Cowan's potterymaking studio produced wares of distinction and provided a training ground for a bevy of young ceramists who achieved widespread recognition on their own in the 1930s. And the Rose Iron Works and its designer Paul Feher challenged Parisian achievement in the realm of ornamental metalwork around 1930. These represent only the high points of local activity—all in all, an impressive accomplishment for a middle-sized, midwestern community that was a rather late starter in the arts and crafts movement.

NOTES

1. Robert Wheeler, "Cleveland: A Historical Overview," in *The Encyclopedia of Cleveland History, 1796–1990,* ed. David D. Van Tassel and John J. Grabowski (Bloomington and Indianapolis: Indiana University Press, 1987), xvii. The information about Cleveland's development presented here derives from Wheeler's article.

2. William Ganson Rose, *Cleveland, The Making of a City* (Cleveland and New York: World Publishing, 1950), 49.

3. Jane Sikes Hageman and Edward M. Hageman, *Ohio Furniture Makers, 1790 to 1860,* vol. 2 (privately published, 1989). The information on Cleveland's early furniture- and cabinetmakers derives from this source.

4. Ibid., 2:190, 2:193.

5. According to Hageman and Hageman (2:117), Benjamin Fitch arrived in the Western Reserve in 1801 and began making chairs in Bedford in 1815, but the Taylor Chair Company considers 1816 the year of its foundation.

6. Information on early silversmithing in Cleveland derives largely from a pamphlet written and published by Muriel Cutten Hoitsma, *Early Cleveland Silversmiths* (Cleveland, 1953). Much of the material was included in an article by the same author in *Antiques Magazine* (February 1953).

7. The first brick house in Brooklyn, a Cleveland suburb, was built in 1825 (Rose, *Cleveland,* 102). One stoneware pottery was listed in the *Directory of Cleveland and Ohio, For the Years 1837–38* (Rose, *Cleveland,* 119). Akron's pottery is also mentioned by Rose (174).

8. Several authors mention glassmaking in Portage County. Perhaps the best is Duncan B. Walcott, "Glass from Portage County, Ohio, Mantua—Kent—Ravenna," *Spinning Wheel,* no. 243 (April 1965): 8–10.

9. Rose, *Cleveland,* 95.

10. Ibid., 111–12.

11. Ibid., 98.

12. The arts and crafts movement in Cincinnati is reviewed in the catalogue accompanying the exhibition at the Cincinnati Art Museum, *The Ladies, God Bless 'Em* (19 February–28 April 1976).

13. The definitive book on Rookwood has not yet been written. At present the best available is Herbert Peck, *The Book of Rookwood Pottery* (New York: Crown Publishers, 1968).

14. A monograph on Rorimer has been published: Leslie A. Piña, *Louis Rorimer: A Man of Style* (Kent, Ohio: Kent State University Press, 1990). Except where otherwise indicated, information on Rorimer's life and professional activities are derived from that source.

15. In his youth, Louis Rorimer followed his father's spelling of their surname. About 1906 the first "h" was dropped, and the spelling became "Rorheimer," and in 1917 during World War I the name was anglicized to Rorimer (Piña, *Louis Rorimer,* 123 n. 1). That spelling is used here consistently, even in reference to events before 1917.

16. The precise dates of Rorimer's stay in various European cities is not entirely clear, but he was certainly there in the first half of the 1890s. See *Cleveland Town Topics* (20 January 1917), 26.

17. Piña, *Louis Rorimer,* 13.

18. Ibid., 13–15.

19. Hadlow, Smedley, and Blakeslee exhibited together twice in 1904, first in Cincinnati at the Handicraft Exhibition, 11–18 May, and second at the Art Institute of Chicago, 6–21 December. Both times their address is given as 285 Erie Street, Cleveland, part of the space occupied by Rorimer at that date. The name "Rokesley Shop" was used in 1906 for an invitation to an exhibition of their work at 285 Erie Street. On that invitation, Louis Rorimer's name is included as part of Rokesley Shop. In 1907 they exhibited in New York at the Arts and Crafts Exhibition (National Arts Club, 20 November–11 December). There the entry reads "Roheimer, Mr. (The Rokesley Shop)." About 1912 Mary Blakeslee withdrew from the partnership to return to Medina, Ohio, and help manage her family's farm. At the *Thirteenth Annual Exhibition of Examples of Industrial Art . . .* (Art Institute of Chicago, 1–25 October 1914), their entries are described as "Rokesley Shop—Cleveland, O. Exhibitor. Carolyn Hadlow, Ruth Smedley, Wilhelmina Stephan, designers, makers." This is the only mention of Stephan as a member of the group. Hadlow and Smedley continued to work together and to describe themselves as the Rokesley Shop as late as 1919. Ruth Smedley died in 1920 and "Rokesley" seems not to have been used after that date.

20. Pieces made of copper and brass, including a lighting fixture, are illustrated in *Catalogue of the Architectural Exhibition of the Cleveland Architectural Club* (Cleveland, 1909), unpaginated.

21. The best biographical sketch of Horace Potter is contained in Carle Robbins, "A Portrait of an Artist," *Bystander-Town Topics* (February 1930), 13–15, 63. Precise information about dates is vague and sometimes incorrect.

22. Information supplied verbally by the Alumni Office, University School.

23. *Scrapbook of the Cleveland Institute of Art 1* (1882–June 1901), 77. Clipping from the *Cleveland Plain Dealer* (8 June 1902).

24. Index file of faculty members maintained at Cleveland Institute of Art Library.

25. Potter and Stephan were joint exhibitors at the *Exhibition of the Society of Arts & Crafts* (Boston, 5–26 February 1907).

26. *First Annual Exhibition of Work by Cleveland Artists and Craftsmen at the Cleveland Museum of Art,* exh. cat. (Cleveland Museum of Art, 1919), 32–34.

27. The files in the registrar's office of the Cleveland Museum of Art contain photographs of a number of works by the Potter Studios submitted to May Shows over the years.

28. Spencer Adams [Gertrude Hunter], "Arts," *Cleveland Town Topics* (4 June 1910), 8–9.

29. Phillip M. Johnston, *Catalogue of American Silver: The Cleveland Museum of Art* (Cleveland Museum of Art, 1994), 121–22.

30. Potter and Mellen, *50 Years of Creating Beauty* (Cleveland, 1949), unpaginated pamphlet.

31. *Cleveland Plain Dealer* (24 February 1947), Clipping Files, Ingalls Library, Cleveland Museum of Art.

32. Much of the information about R. Guy Cowan and his pottery was originally published in Henry Hawley, "Cowan Pottery and The Cleveland Museum of Art," *Bulletin of The Cleveland Museum of Art* 76 (September 1989): 238–63. Factual details of Cowan's life are carefully documented there.

33. Information about the Rose Iron Works and Paul Feher is derived primarily from two sources: Jack Andrews, *New Edge of the Anvil* (Drexel Hill, Pa.: Skipjack Press, 1994), 129–41; and Melvin Rose, "Martin Rose Master Art Smith," *The Anvil's Ring* 19 (Summer 1991): 6–10.

34. Alastair Duncan, *Art Deco Furniture* (New York: Holt, Rinehart and Winston, 1984), 113, 181.

Art for Everyone: The Cleveland Print Makers and the WPA

Jolán Gross-Bettelheim, *Under the High Level Bridge,* ca. 1932.

IN THE MIDST OF the greatest economic debacle in American history, printmaking in Cleveland not only survived but flourished. The city's first two organizations devoted exclusively to supporting graphic artists, the Cleveland Print Makers and the local graphic arts workshop of the Works Progress Administration, functioned as catalysts. Throughout the country, printmaking enjoyed a remarkably improved status in the hierarchy of the fine arts during the Depression, as lithographs and wood engravings outgrew their association with commercial art and their potential to yield large editions was regarded as an advantage. This surge of interest in the graphic arts was part of a trend that had its roots in the 1920s.

After World War I, interest in prints had grown slowly but steadily. American collectors preferred prints by foreigners, especially the "fine-art" prints of the etching-revivalists, typically issued in small editions.[1] New art organizations appeared during the 1920s to foster the collecting and appreciation of the graphic arts. One group was the Print Club of Cleveland, founded in 1919 for the purpose of "promoting the development of art in the community by the acquiring and owning of prints and other art objects and things, and presenting prints and other art objects and things to The Cleveland Museum of Art."[2] Like similar groups, the club promoted prints by educating its members, publishing a print each year, and organizing print exhibitions. American museums were actively collecting and exhibiting prints. In Cleveland there were two competitive annual exhibitions featuring prints, the May Show at the Cleveland Museum of Art beginning in 1919 and the Ohio Print Makers Exhibition organized by the Dayton Art Institute beginning in 1928. While these activities helped to bolster interest in the graphic arts in Cleveland, they had a limited impact on artists working in the city. These exhibitions featured works by local artists, but they were far too infrequent to sustain Cleveland printmakers.

THE CLEVELAND PRINT MAKERS

ANY OF THE PAINTINGS, or any of the many more in the artist's studio, can be had for the following "prices":

Bicycle. Shoes, black, size 7. Cigarets. Staple groceries. Canned goods. Wine and whisky (Bourbon preferred). A Ford. Gasoline. A lady's dress. Stockings. Books. Cash. Bed. Round trip ticket to New York. Paints, brushes, canvas, etc. Electric phonograph. Records. Overcoat, topcoat or raincoat. Any reasonable offer considered.

—Posted in an exhibition of works by Russell Limbach in June 1932[3]

The stock market crash of 1929 and the economic hardships of the Depression virtually eliminated the market for luxury goods, but artists acted quickly to help themselves survive. In June 1930 Kálmán Kubinyi announced the formation of the Cleveland Print Makers (CPM), "a non-profit organization for fostering interest in the graphic arts and for rendering assistance to the individual artists." Organized and run by artists, the Print Makers' primary goal was to expand the existing art market because "the present so-called competitive or capitalistic system has not treated him [the artist] very kindly."[4] The CPM turned to the public and launched an energetic, educational, and creative marketing campaign that included a rigorous local and national exhibition schedule, founding and operating an art gallery to give the artists a direct link to the public, a print subscription series, and various other art-related events.

The choice to target the general public, aside from the potential economic gain, was in line with sentiments expressed nationwide by artists of the day. Already receiving varying amounts of support from a core of art patrons, typically members of the wealthier classes, artists looked to the working class as a desirable, untapped market that could solve their economic woes and harmonize with their social and political ideals. It was argued that art, having been the sole property of the wealthy, should belong to every member of society in order for a true democracy to prosper.[5] Prints were thought to be an excellent art medium to accomplish these goals because they could be produced cheaply and in large numbers and were thus accessible to a large public, even those with meager wages. Printmaker Elizabeth Olds articulated the sentiments of many artists when she wrote that "art will flourish on a democratic scale" when "prints can be created in an edition numbering thousands rather than tens"; "their price is low enough so that they can be bought by the average citizen"; they can be placed "before the people who can buy them"; and the task remains "of interesting these people in such an art."[6]

The CPM attracted a large and diverse membership of both novice and experienced printmakers as well as painters, architects, artisans, and commercial illustrators. Founded by 37 artists, reported membership peaked at 131 in 1933. The activities of the CPM dropped considerably around 1936, and there is no mention of the group after 1938. The leaders of the CPM were artists Phelps Cunningham, Stevan Dohanos, Sheffield Kagy, Russell Limbach, and Walter Richards, with Kálmán Kubinyi serving as president.

The driving force behind the Print Makers was painter, printmaker, and teacher Kálmán Kubinyi, who taught at the Cleveland Museum of Art, the Cleveland School of Art, and the Huntington Institute, a free school designed to offer instruction in the evenings to "residents of the city employed in some one of the applied arts or industrial occupations."[7] Enrollment was high in the 1930s, classes filled to capacity, and waiting lists were common. The dingy basement of the Huntington Institute was the best-equipped print workshop in Cleveland in the early 1930s. Use of the printing equipment was free to the CPM each Thursday evening from 6:00 until 10:00.[8] In addition to presses for block printing, etching, and lithography, there was an aquatint box, a hot plate, rollers, a grinding table, and other printmaking necessities.

The CPM's largest undertaking was the Print Mart or Print Market, an artist-run affordable art gallery that would function as a "complete clearing house for contacts between public and artists." It would serve a "broad and hungry market," and if the price was "very modest," artists could "put their things into Cleveland homes" rather than "littering studios."[9] The

Figure 182. The Cleveland Print Makers'
booth at the 8 August 1933 Curb Market,
behind Severance Hall.

Print Market opened in August 1932, renting space in the Dunham Tavern, a building with historical significance at 6709 Euclid Avenue that was awaiting restoration. The Print Makers tried to run it themselves, but after a series of administrative difficulties they hired a business manager, Edmond Travis, in early 1934. Travis worked for a few months and was replaced by Kálmán's brother, Lazslo Kubinyi. Intimately connected with the CPM, the mart eventually became a separate organization and survived until at least 1940. It sold prints by Cleveland artists, mounted frequent exhibitions, kept a card index of local artists for any kind of specific commission, and even ran a "tea room" where lunch was offered in "a comfortable living room atmosphere."[10] Other artwork for sale by local artists included bookplates, etched invitations, place cards, Christmas cards, jewelry, metal work, sculpture, and ceramics.

The Dunham Tavern became the home of the CPM. Members gathered there for meetings, lectures, and social functions. A bulletin board held notices of local, national, and international competitive exhibitions, and reference materials were available to artists as well. Eventually Kubinyi put a few presses on site for members' use. Yet the workshop in the Huntington Institute remained the principal site for print production.

The Print Makers organized and participated in countless events from educational (lectures, exhibitions, and printmaking demonstrations) to social (a masked ball and afternoon teas).[11] The largest and most ambitious undertakings were the three Curb Markets of 1932, 1933, and 1934. Similar events were held in New York, Chicago, Dallas, and San Francisco.[12] Organized by up to five Cleveland artist organizations, including the CPM, these massive fairs were open for a day or two and attracted 12,000 to 15,000 visitors.[13] Artists donated their work to be sold at "depression prices" at the booths set up by the various organizations (fig. 182). There was an admission charge of $.10. The profits were divided among the sponsoring groups. Artists spent weeks making the decorations (also for sale at the conclusion of the fair) and posters based on the annual theme.[14] The first Curb Market was held at the Elysium Skating Rink, E. 107th and Euclid, and the theme was Montmartre, Paris. After a parade down Euclid Avenue to the Elysium, artists roamed the grounds in berets and smocks ready to make portrait sketches or silhouettes, while models in bohemian dress and bands of strolling gypsy musicians greeted the public. Kubinyi, in charge of the second fair, stated: "The Curb market this year will be in the American spirit. It will be a portrayal of the fine work being done today by native artists in their interpretation of the essential American scene."[15] It was held on the athletic field of the Flora Stone Mather College behind

Severance Hall, in a huge tent supposed to represent "the great circus tent, characteristic of American carnival . . . adorned inside in the native tradition."[16] The theme of the 1934 Curb Market, again of local interest, was a "dizzy" view of the city, containing caricatures of Clevelanders from the corner cop to leading citizens. Attracting 13,000 people, it was held at Danceland, on E. 90th Street and Euclid Avenue. A huge costume ball capped off the day's events. In all three fairs the Print Makers brought their presses, did on-site demonstrations, and sold their prints directly off the presses. Profit from art sales the first year was $3,900, but by 1934 that number had been cut in half, even though more than 4,000 works of art were sold.[17]

The inaugural project in an ambitious exhibition schedule was a show in November 1931 of members' work alongside prints by contemporary American artists such as John Taylor Arms, Wanda Gág, Rockwell Kent, and Louis Lozowick.[18] Julia Raymond, the secretary/treasurer and an ardent supporter of the organization, arranged the exhibition, which was held in the old Wade mansion. Apparently a success, a second venue at the Builder's Exchange was added in December 1931.[19] The Print Makers continued to organize exhibitions, primarily of their own work, in community settlement houses and other public spaces until the Print Market opened in August 1932. During its first year, the CPM held at least fourteen exhibitions in the gallery at Dunham Tavern, with themes such as contemporary American aquatints, circus prints, color prints, and linoleum cuts made by children from Karamu House. Consistent with the group's educational aims, several of these exhibitions included plates, progressive proofs, and explanatory texts describing printmaking techniques. The Print Makers were especially interested in contemporary American graphic arts and hosted exhibits including *50 Modern Prints of the Year* in 1934 and 1935 (organized by the Wehye Gallery in New York), prints by Rockwell Kent in February 1934, and works by Emil Ganso in June 1935. In November 1936 the Print Market showed *America Today,* an exhibition held simultaneously in thirty cities across the country. It consisted of one hundred prints by members of the American Artists' Congress, a national organization of artists bound by the belief that, collectively, they could affect social, political, and economic issues through their art. Members from Cleveland who contributed works to the exhibition included Limbach, Kubinyi, Leroy Flint, Jólan Gross-Bettelheim, and Dorothy Rutka.[20] The CPM also organized traveling exhibitions of works by Cleveland printmakers with venues throughout the Cleveland area and Ohio, as well as California, Colorado, Hawaii, Illinois, Massachusetts, New Hampshire, New York, Pennsylvania, South Carolina, and Tennessee.

The Print Makers are best known today for the formation of the Print-a-Month series, which they claimed was the first of its kind in the country. It was preceded by the distribution to its members of two single prints published in 1931 and 1932.[21] Announced in April 1932, the Print-a-Month series offered subscribers twelve prints by Cleveland artists for $10 (the 1935–36 series was $12); the $1 extra for mailing included a portfolio. The series, published in editions of 250, ran continuously for four years from June 1932 to May 1936. Each print was accompanied by a cover sheet that discussed the artist, print, and process. A fifth series was started in January 1937, but only two prints are known to have been issued, bringing the total number of prints in the series to fifty.[22] The artists received $50 for each commission (out-of-towners could be paid as much as $100) and provided their own plates. The paper, printing (if the artist so wished), and distribution were the responsibility of the CPM. By 1934 two nonresident

artists per year were commissioned to make a print for the series. Among them were Adolph Dehn, Emil Ganso, Rockwell Kent, and Yasuo Kuniyoshi. Local artists who contributed prints included Cunningham, Dohanos, Flint, Gross-Bettelheim, Kagy, Kubinyi, Limbach, and Rutka as well as George Adomeit, Clarence Carter, Honore Guilbeau, Henry Keller, Walter Richards, William Sommer, Paul Travis, and Frank Wilcox.

The series was billed as "the biggest bargain ever offered Clevelanders" by Robert Bordner, art editor of the *Cleveland Press* and a champion of the CPM.[23] The $50 fee was "a great sacrifice on the part of these artists. They are doing it purely to COMPEL a new group of Clevelanders to take art into their homes." This assertion seems to be true considering that Keller, one of the Print-a-Month artists, received $500 in 1938 for a similar commission from the Print Club of Cleveland. Bordner defined this "new group" as the ninety-nine percent of May Show visitors who did not purchase works of art because they could not afford them. He praised this effort because people who had not bought art before now had occasion to do so. To be sure the opportunity reached a broad audience, radio was used for publicity. In one broadcast, Kubinyi announced and described the series; in another, a museum employee, a teacher, and a layman discussed the value of prints in the home.

Early reports indicated that the CPM successfully reached its targeted audience. As of 12 June 1932, 170 subscriptions had been sold. According to an article in the *Cleveland News,* Julia Raymond found that "almost all the subscribers are people who have hitherto been unable to purchase prints." In addition, only four museum members subscribed although letters had been sent to 1,000 members. People who reportedly took advantage of the opportunity were artists, the museum staff, and a woman from a small town. Even "a chicken farmer downstate is paying his subscription off when his chicks are ready for the market." A local newspaper praised this outreach, writing, "In this one performance alone the Cleveland Print Makers have richly justified their existence."[24] In addition, profits from the subscription sales seemed substantial enough to allow the CPM go to ahead and open the Print Market just a few months after the first subscription drive began.[25]

In 1932 Kubinyi, promoting the success of the Print Market, said: "There ain't no depression," referring to the thirty to fifty prints being sold each day.[26] According to a letter dated April 1934, the CPM had made $3,000 profit and paid the $80 per month rent at the Dunham Tavern as well as purchased equipment and supplies.[27] Yet by 1934 reported membership in the CPM had dropped to sixty and never recovered. The 1935 annual of the Print Makers, however, proudly bragged of the organization's successes. "The CPM has weathered a long period of economic stress" and "CPM—the 'irresponsible artists' is still solvent."[28] The organization was able to generate its operating costs from the sale of members' work at the Curb Markets, the subscription series, the Print Market, and the annual membership fees. The Print Makers also regretfully admitted, "in more prosperous days the organization's Projects might have been more extensive, more obviously successful, more spectacular."[29] The Print Makers did succeed, however, in creating and distributing original art to the public. A total of 12,500 impressions were printed for the Print-a-Month series alone. Thousands more were sold at the Curb Markets, the Print Market, and a variety of exhibitions.

By the middle of 1936 the CPM had ceased virtually all its activities, although it remained in existence until the late 1930s. The last complete Print-a-Month series appeared in May 1936, and the last Print-a-Month

print was published in February 1937. Julius Kubinyi closed the Print Market in May 1936 because "the public is not manifesting sufficient interest to support the institution."[30] He opened a scaled-down version in October 1936 in the Chester Arcade of the Union Trust Building that functioned primarily as a gallery, hosting exhibitions of local and national importance but no longer serving as a focal point for printmaking activities in Cleveland.

Despite their success, CPM activities did not generate enough earnings to provide a living wage for member artists. The only income they received was the $50 fee for each Print-a-Month print and the price of each print sold at the Print Market minus the gallery's twenty-five percent commission. The need to make a living forced many artists to find a means of support outside the fine arts. Many of the city's best printmakers left during the 1930s, moving to New York or elsewhere, which contributed in part to the demise of both the CPM and printmaking in general in Cleveland toward the end of the decade. Around the end of 1934 Limbach left for New York, where he was an editor for the periodical the *New Masses* and became the technical supervisor for the graphics project of the Works Progress Administration (WPA) in 1935. Dohanos and Richards, who had worked together in Cleveland as commercial artists in Tranquillini Studios, both found commercial work in New York with the Charles E. Cooper Art Studios by 1936. Kagy went to Washington, D.C., in 1936 and taught at the Abbott School. The final blow came when Kálmán Kubinyi chose to shift his considerable energies from the CPM to the newly formed Federal Art Project of the Works Progress Administration.

With the coming of the WPA, artists saw the potential for a real solution to their problems. Unlike the CPM, which by design could offer only limited assistance and depended on print sales, the WPA was created both to provide a living wage for artists and to produce works of art for the government. Many artists and arts administrators embraced the WPA, seeing its potential to fulfill their ideological beliefs. In an essay about printmaking for the WPA, Limbach described this utopian vision: "With an opportunity to work unhampered by the demands of unprogressive private patronage, and with the time and equipment necessary for real research and experiment, the graphic artists of America may yet develop an idiom that will enrich the culture of this country and lay the cornerstone of a great tradition."[31] Despite its ambitious plans, the WPA lasted only a short time and included fewer artists than anticipated. For at least three years, however, it fueled the enthusiasm for the graphic arts that the CPM had cultivated and expanded.

THE WPA GRAPHIC ARTS WORKSHOP

CLEVELAND SUFFERED badly during the first three and a half years of the Depression, and by the time the federal government began relief programs, the situation was grim. Nearly one-third of the population was unemployed.[32] In 1933 Franklin D. Roosevelt began to implement his New Deal, a plan for economic recovery and social reform. America soon saw a stream of various federal programs, the largest of which was the Works Progress Administration. Rather than a direct handout the government provided employment for the needy. Jobs were created by commissioning public construction projects, especially those that used large numbers of unskilled laborers, little equipment, and few materials, such as recreation facilities and transportation networks. At its height in 1939, the WPA employed about 79,000 people in Cleveland, providing aid for an estimated twenty-seven percent of the city's workers and families.[33]

Remarkably, Roosevelt's New Deal included the largest federal patronage of the arts in the history of America. In 1934 the first of several New Deal art programs in Cleveland was initiated, the Public Works of Art Project. In 1935 that project was replaced by the largest and most important of the New Deal programs for Cleveland artists, the Federal Arts Project of the Works Project Administration.[34]

The WPA funded a variety of visual art programs designed not only to create fine art but also to teach artistic skills, make art accessible to all, and provide educational opportunities for the public. Holger Cahill, national director of the WPA, saw this relief program as an opportunity to bring about the democratization of art in America. He believed "that art, the highest level of creative experience, should belong to everybody."[35] Approximately 370,000 works of art were produced by WPA workers between 1935 and 1943.[36] These government-owned works were exhibited nationwide and decorated public schools, libraries, museums, housing projects, governmental offices, and other tax-supported public buildings.

The sixteen graphic arts workshops across the country under the auspices of the WPA employed about 250 people and produced an estimated 240,000 copies of 11,285 original designs.[37] These workshops were critically important in training and organizing American artists. Cleveland was one of the five important graphic art centers responsible for the vast majority of prints made for the entire WPA. Like other graphics projects, Cleveland also produced posters and illustrations for the Index of American Design in addition to fine art prints.[38] Cleveland's workshop was officially operational from December 1935 until 1943, but the most intense years of production were 1936 and 1937. Although fine art printmaking activities slowed around 1938, outstanding examples continued to be produced up to and including 1940.

In a report dated October 1935, Mildred Holzhauer, Cahill's assistant, reported on the progress of the formation of the WPA in Cleveland. Looking for supervisory personnel, she went to Kubinyi at the suggestion of William Milliken, director of the Cleveland Museum of Art, who shared his plan for a graphics workshop that would meet Cahill's two main requirements for the project, namely, to provide relief for artists and to support the growth of American culture. The workshop would be set up and run by one outstanding artist each month who would supervise the design of prints, which would be executed by those who knew printing processes. By 4 December 1935 the project had been approved and Kubinyi was appointed supervisor of Graphic Arts Project No. 8048.

Setting up the workshop was initially a slow process as funds for payroll and purchasing presses, equipment, and supplies were received later than expected.[39] Printmakers began working in the first few months of 1936 in the basement of the Huntington Institute, where Kubinyi had arranged free use of the presses. In May 1936 they moved to a more suitable location, a warehouse on W. 80th Street where they had a workshop, fully supplied with presses and other equipment. In June 1937 they moved again, to 4300 Euclid Avenue, where they were able to expand their facilities to include a gallery. By 1940 the project had moved the studios to Perkins Avenue and the gallery to the Lakeview Terrace Housing Project. Each remained at that location until the program ended.[40]

The organization of the workshop came very close to Kubinyi's original idea, with some modifications. Initially designed to employ twenty-three people, the project used about fifteen people at any given time.[41] Of those fifteen, usually seven to ten were trained artists. Rather than having one artist in charge each month, Kubinyi ran the project until 1939, when

Frank Fousek took over.[42] An estimated total of seventy-five people worked on the Cleveland graphics project during its existence, of which at least forty were fine artists, often with art-school training.[43] Kubinyi rotated them on and off, "looking around to see who needed work most."[44] For example, Honore Guilbeau, who did not qualify for relief, was on the project for only two weeks. In that time she created three lithographs. Commercial lithographers copied designs on stones and did the printing. Most had worked as printers and technicians in the sizable printing industry in Cleveland and printed posters and other work in addition to the designs of the fine artists. The artists generally praised the printers' abilities, even though tensions existed between the two groups.[45] Flint called Ed Haill a miracle worker. "You could breath on a stone and he would print it."[46] The artists, however, printed their own intaglio prints. Approximately 6,100 impressions of about 300 designs were created in Cleveland.[47]

Public outreach was built into the WPA through a series of exhibitions and programs. One of the more successful ventures of the project was the popular and widely distributed Graphic Process portfolio.[48] The impetus came from a letter to Cahill in which Dorothy Rutka, writing on behalf of the Artist's Union in 1936, called for an expansion of Cleveland's art project.[49] Kubinyi compiled the portfolios from the inventory of prints made during the first few years of the project. By the end of 1938, editions were in Washington and had been distributed nationwide. The portfolio contained a silkscreened cover sheet that read "Graphic Processes/Planographic, Intaglio, Relief," a blue fabric-covered case, and fifteen prints of varying techniques.[50] A sheet with typed text including technical descriptions, art historical notes, and, sometimes, books for suggested reading accompanied each print. Because the selection in each portfolio varied, each block of text was generic, relating only to technique. All the prints and texts were in matching mats, ready for installation. They were used for exhibitions in WPA community art centers and galleries as well as schools, libraries, and museums.

The WPA exhibitions, which began once the workshop had moved to the 4300 Euclid Avenue building in the middle of 1937, were held in a 90-square-foot room directly adjacent to the project's studios. The print exhibitions, like those Kubinyi held at the Print Market, focused on technique. Using parts of the Graphic Processes portfolio, the shows also included plates and stones, tools, multiple impressions of a print showing the stages of production, and lengthy text labels. Exhibitions were creatively presented; for example, one used decorative abstract collages of the tools used in the work.[51] The prints were also included in many exhibitions such as the May Shows at the art museum and several national print exhibitions in Washington and New York.[52] Always devoted to educational outreach, Kubinyi continued to lecture frequently, as shown in the WPA gallery (fig. 183).

Critical response to the prints was on the whole favorable, especially relative to other aspects of the project in Cleveland. A 1936 report by Mildred Holzhauer singles out the Cleveland graphics project as "outstanding."[53] In a 1936 letter to Cahill, Milliken praised the work done under Broemel, writing, "to have accomplished only the prints would have been an achievement."[54]

Streams of vacillating policies concerning the amount and allotment of funds were issued from Washington throughout the history of the WPA that directly affected its regional centers. Wage cuts, stringent qualification standards for relief, and frequent layoffs plagued the project in Cleveland. When Congress voted to discontinue full funding for the WPA for 1939–40,

Figure 183. Kálmán Kubinyi speaking to a group in the WPA Gallery, 4300 Euclid Avenue, ca. 1937.

the program changed dramatically.[55] The state of Ohio attempted to fill the gap by contributing significant support. In 1942 the Ohio Art Program (as the regional WPA was then officially titled) dismantled the project and distributed the remaining works to public institutions. In 1943 Washington officially terminated the WPA. Conceived as a temporary solution to the economic crisis, it was not designed to be a permanent government program.

While the WPA was fraught with problems, artists generally considered the project worthwhile. Flint recalled the single best benefit was being able to work at all. He had been inspired by the opportunity to work with the WPA's equipment, the stimulation provided by the collective workshop experience, and the feeling that they were doing something of value by making "art for the masses."[56] Several Cleveland artists, mostly printmakers, believed so strongly in the project that they supported the Coffee-Pepper bill in 1938, legislation that in essence would have made the WPA a permanent government institution.[57] Kálmán Kubinyi, among others, felt that "it is the obligation of the government to recognize that culture as represented by the arts is a social necessity consistent with democracy and also to recognize that such culture must be encouraged and developed."[58] The Artist's Union and the American Artists' Congress were also in favor of the bill. A vote taken in Cleveland found that while a majority of artists supported federal funding for the arts, most did not approve of the bill as it stood. It failed, and as America entered World War II, artists were once again left to fend for themselves.

ART FOR THE MASSES: SUBJECTS, STYLES, AND MEDIA

THE CLEVELAND PRINT MAKERS and the WPA graphics workshop, while differing greatly, were very closely connected. Kálmán Kubinyi created and organized both, and leading printmakers such as Leroy Flint, Jólan Gross-Bettelheim, Sheffield Kagy, Russell Limbach, and Dorothy Rutka produced prints for both. Kagy even recycled his CPM work for the WPA. The linoleum cut *Symphonic Reaction* (fig. 184), which was published for the WPA in about 1936, first appeared in a CPM exhibition in January 1933. The Huntington Institute, the heart of printmaking activities for the Print Makers, was the first home of the graphics workshop. In essence, the workshop grew out of the foundation laid down by the CPM. This continuity is also reflected in the resulting prints, which stylistically are almost impossible to separate. These two organizations provided the means for artists to create, exhibit, and distribute their works to their targeted new audience and patron—the general public. Increasingly, artists turned to subjects and styles that seemed relevant, comprehensible, and meaningful to

the masses. Equally important, their work had to be produced in adequate quantities for their sizable new audience.

Prints made in Cleveland during the 1930s reflect the many different artistic styles of the period, ranging from abstraction to realism, with a higher concentration on the latter. Some prints were made in the etching-revivalist tradition, but that style declined sharply as the decade progressed. Most of the leading printmakers were in step with national trends. As noted by the critic Edward Alden Jewell in a review of an exhibition at the Whitney Museum of American Art in 1937: "While principles of abstraction are detected now and then, most of the work tends to be pretty straightforward, often marked by intelligent simplification and seldom confining itself to academic conventions."[59] If abstraction was present in these prints, it did not cloud their meaning. The style, title, and subject generally left little doubt about the artist's message.

Although most Cleveland artists did not wholeheartedly adopt modernism, many printmakers were familiar with and influenced by the various trends of the time. Precisionism is evident in the sharp contours, smooth machine-like surfaces, and geometric shapes in such works as *Pennsylvania Station* by Clarence Carter (fig. 185) and *Blast Furnaces* by Stevan Dohanos (see fig. 116). Surrealism was a source of inspiration for a few Cleveland printmakers like Hughie Lee-Smith, but the resulting prints often combine a surrealistic veneer with social-realist subject matter. Lee-Smith's three-print series *The Artist's Life* (one of which is reproduced as fig. 165) has surrealist overtones, and yet, the autobiographical character of the work makes at least its theme clear—the relationship of the artist to industrial America. Another artist who acknowledged surrealism was Louis Grebenak.

Figure 184. Sheffield Kagy, *Symphonic Reaction,* ca. 1933, linoleum cut, 9¾ x 8¾ in. (24.8 x 22.2 cm). Ohio Art Program, long-term loan to the Cleveland Museum of Art.

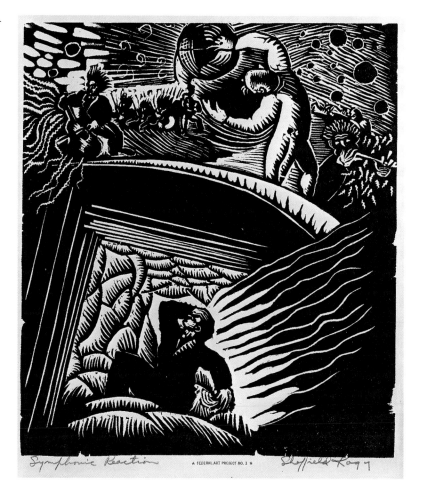

Figure 185. Clarence Carter, *Pennsylvania Station,* 1932, etching and aquatint, printed in color, 6⅞ x 11 in. (17.5 x 28 cm). The Cleveland Museum of Art, the Mary Spedding Milliken Memorial Collection, gift of William Mathewson Milliken.

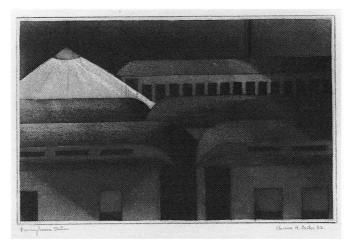

The purest modernist and perhaps the best known of the Cleveland printmakers was Jólan Gross-Bettelheim. Raised in Europe in an ethnically Hungarian family, she was trained in Budapest, Berlin, Vienna, and Paris in the 1920s and came to Cleveland around 1925. Her works reflect her familiarity with cubism, constructivism, and German expressionism. While she demonstrated a full understanding of these European trends, her prints, whether depictions of groups or individuals, such as *Worker's Meeting (Scottsboro Boys)* (see fig. 167), or landscapes, such as *Under the High Level Bridge* (fig. 186), never stray into the esoteric or embrace total abstraction.

Figure 186. Jolán Gross-Bettelheim, *Under the High Level Bridge,* ca. 1932, drypoint, 9⁷⁄₁₆ x 7 in. (24 x 17.7 cm). The Cleveland Museum of Art, gift of the Print Club of Cleveland.

Figure 187. Dorothy Rutka, *Under Bridges,* ca. 1936, etching, 10⅞ x 8⁷⁄₁₆ in. (27.6 x 21.4 cm). Ohio Art Program, long-term loan to the Cleveland Museum of Art.

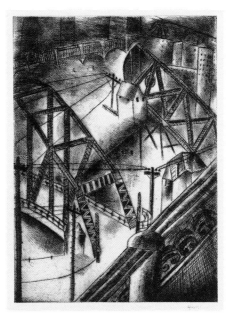
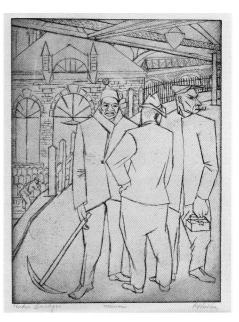

Artists felt free to work in several styles simultaneously. For example, *Under Bridges* by Dorothy Rutka (fig. 187) and Kagy's *Symphonic Reaction* represent departures from their typical styles. *Under Bridges,* a line etching of three men drawn with summary, angled contours against a flat, patterned background, is stylistically closer to the works of Gross-Bettelheim than Rutka's characteristically tonal compositions (see fig. 194). *Symphonic Reaction* is a decorative collage of varied patterns in an unusually fanciful abstracted image. This is again a departure from Kagy's straight-

forward realist style and socially minded subject matter. In another example, Limbach was known for his figurative, satirical prints but painted a series of pure abstractions, now lost, titled *A–2, A–3, . . . , A–6* that were included in an exhibition at the Kokoon Klub in 1931.

Regionalism, a term most closely associated with the depictions of midwestern, rural life of the 1930s, is most evident in the works of Phelps Cunningham, Stevan Dohanos, Leroy Flint, and Walter Richards. During the Depression, the backlash against modernism resulted in a surge of realist American rural imagery. *Amish* by Flint (fig. 188), *Sorghum Mill, Tennessee* by Cunningham (fig. 189), and *Man of the Soil* by Dohanos (fig. 190) exemplify this trend.[60] The solid, volumetric forms in *Amish* and *Man of the Soil* fill the front of the picture plane in a manner typical of regionalist works by John Steuart Curry and Grant Wood. The landscape in *Sorghum Mill* appropriates the patterned fields, raised horizon lines, rounded contours, impenetrable surfaces, and tilted perspectives associated with regionalism.

American scene subjects appealed to Cleveland printmakers, both realists and modernists, partly because they want their work to be relevant to the lives of their popular audiences. Consequently, their prints emphasized recognizable, familiar places and contemporary settings rather than the exotic, rare, foreign, mystical, and esoteric. In a literal application of the American scene new emphasis was placed on representing the land and its people. Printmakers looked to Cleveland and the surrounding area for their subjects. The blast furnaces along the Cuyahoga River and the bridges that span the river in the industrial Flats downtown were a staple for Cleveland printmakers of the era.

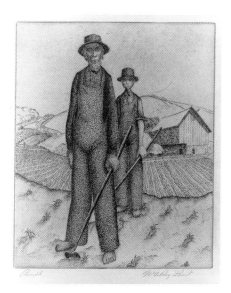

Figure 188. Leroy Flint, *Amish,* ca. 1937, engraving, 7 x 6 in. (17.7 x 15.2 cm). Mrs. Leroy W. Flint Collection.

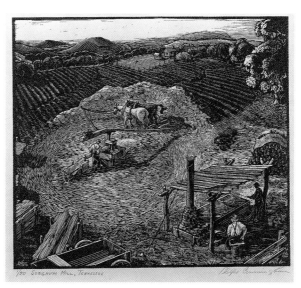

Figure 189. Phelps Cunningham, *Sorghum Mill, Tennessee,* ca. 1937, wood engraving, 6¹¹⁄₁₆ x 7⅝ in. (16.9 x 19.4 cm). The Cleveland Museum of Art, gift of the Print Club of Cleveland.

Far more than the city's painters or photographers, Cleveland printmakers explored the social and political life of the American scene. Flint, Gross-Bettelheim, Jacobs, Kubinyi, Limbach, and Rutka made some of the decade's most socially conscious images in Cleveland. These artists also had leftist affiliations. Gross-Bettelheim and Kubinyi were members of the Communist Party. Jacobs is reported to have been a communist organizer.

Kubinyi, and his friends Rutka and Flint, were members of the American Artists' Congress and the Artist's Union. Both Gross-Bettelheim and Limbach, members of the John Reed Club, also contributed to the leftist cultural periodical the *New Masses*. Although affiliation with the Communist Party could carry social stigma, it was not considered as subversive in the 1930s as it would become during and after the McCarthy era. Many of the artists of the day and most of the leading printmakers in Cleveland, even those who did not join the leftist organizations, were sympathetic to the issues raised by these groups. The sentiments of these artists were summarized in a mission statement published by the *New Masses* in 1934:

> *The New Masses* will reach out to those workers and farmers whose interest in the revolutionary movement extends beyond the economic and political to the cultural front. We hope to become a strong factor in uniting groups of the middle class with the working class in a fight for immediate demands of fundamental importance to their welfare: against imperialist war, against Fascism, evictions, hunger and wage-cuts, lynchings and oppression of the Negro people.[61]

Many prints by Cleveland artists seem to respond to this or similar calls.[62] Depictions of workers and their plight make up one of the single largest subject groups. Work-related themes such as strikes, unemployment, and hard-labor appear in Flint's *Strikebreakers* (fig. 191), Gross-Bettelheim's *In the Employment Office* (see fig. 166), Kubinyi's *The Worker* (see fig. 159), and Limbach's *Laying the Cornice Stone of the Cleveland Post Office* (fig. 192). Works dealing with the hardships of the farmer were also common.

Figure 190. Stevan Dohanos, *Man of the Soil (Connecticut Yankee)*, 1934, lithograph, 16⁷⁄₁₆ x 12⁷⁄₁₆ in. (41.8 x 31.6 cm). The Cleveland Museum of Art, gift of the Print Club of Cleveland.

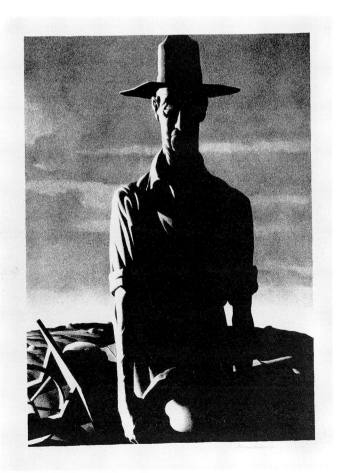

Figure 191. Leroy Flint, *Strikebreakers,* ca. 1937, etching, 5¹⁵⁄₁₆ x 8¹⁄₁₆ in. (15.1 x 20.4 cm). The Cleveland Museum of Art, gift of Harriet V. Fitchpatrick.

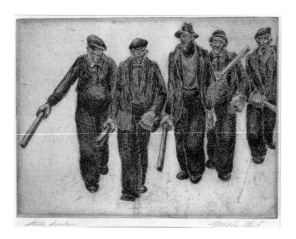

Flint's *Sun and Dust* (fig. 193), a beautiful, melancholy aquatint, refers to the Dust Bowl of the Great Plains during the early 1930s. As seen in *Poverty* (fig. 194) and *Eviction* (see fig. 161), Rutka's bleak aquatints concentrate on social ills. *American Tragedy* (fig. 195), a linoleum cut by Kagy, is a moving depiction of the day after a lynching. *Sharecropper* by William E. Smith (fig. 196) and Gross-Bettelheim's *Workers Meeting (Scottsboro Boys)* both relate directly to the emerging social consciousness concerning oppression of African-Americans. While fewer works concern war and fascism, Gross-Bettelheim's lithograph *Civilization at the Crossroads* (see fig. 168) comments explicitly on the growing menace to peace. These prints avoided elitism by placing workers and issues relevant to their lives at center stage.

Figure 192. Russell Limbach, *Laying the Cornice Stone of the Cleveland Post Office,* 1934, lithograph, 17⅝ x 12 in. (44.8 x 30.4 cm). United States Government, Public Works of Art Project, long-term loan to the Cleveland Museum of Art.

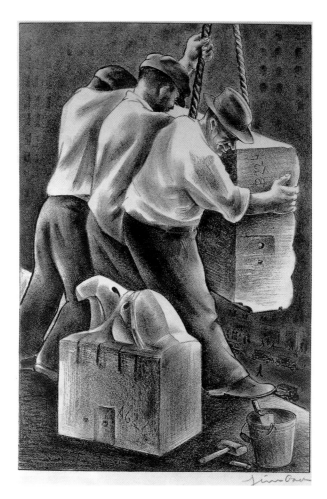

Figure 193. Leroy Flint, *Sun and Dust,* ca. 1936, aquatint, 7 x 8¹⁵⁄₁₆ in. (17.8 x 22.7 cm). Courtesy Rachel Davis Fine Arts.

Figure 194. Dorothy Rutka, *Poverty,* ca. 1936, aquatint, 8½ x 10⅞ in. (21.5 x 27.5 cm). Ohio Art Program, long-term loan to the Cleveland Museum of Art.

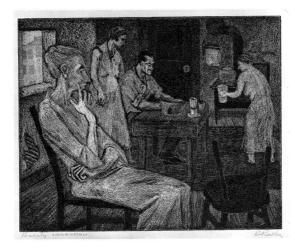

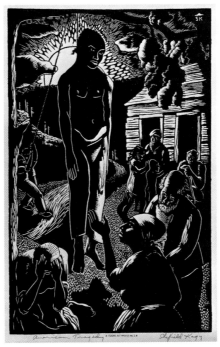

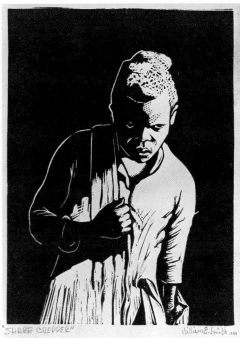

Figure 195. Sheffield Kagy, *American Tragedy,* ca. 1933, linoleum cut, 13¹⁵⁄₁₆ x 9 in. (35.3 x 22.8 cm). Ohio Art Program, long-term loan to the Cleveland Museum of Art.

Figure 196. William E. Smith, *Sharecropper,* 1940, linoleum cut, 8¹⁄₁₆ x 6¹⁄₁₆ in. (20.4 x 15.3 cm). The Cleveland Museum of Art, gift of the Print Club of Cleveland.

Figure 197. Russell Limbach, *The Reviewing Stand,* 1934, lithograph, 9⅞ x 14¼ in. (25.1 x 36.2 cm). The Cleveland Museum of Art, gift of Mrs. Malcolm L. McBride.

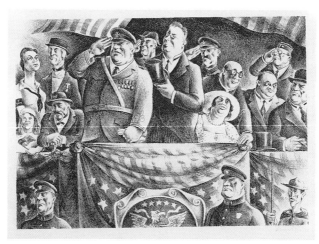

Figure 198. Leroy Flint, *Amazons,* ca. 1937, etching and aquatint, printed in color, 9⅜ x 7⅚ in. (23.8 x 18.6 cm). The Cleveland Museum of Art, gift of the Print Club of Cleveland.

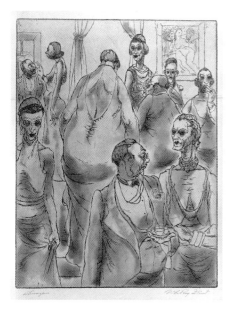

Current issues were also addressed in satirical prints, of which Flint and Limbach were masters. Limbach's *The Reviewing Stand* (fig. 197) caricatures a spectrum of stereotypes from American society, including a boy and girl scout, a priest, veterans, and various political and military leaders.[63] Flint's works are on the whole more humorous than Limbach's biting satires and caricatures. An exception, however, is Flint's *Amazons* (fig. 198), a scathing depiction of social degeneracy among the wealthy.

Many Cleveland prints present scenes of generic American life. *Furnace Floor* by Dohanos (fig. 199) and *Country Church* by Richards (fig. 200) depict common American subjects—30-foot cauldrons for hot molten steel and a familiar-looking Greek revival church. The titles of these prints

Figure 199. Stevan Dohanos, *Furnace Floor,* 1933, wood engraving, 10 x 7⅞ in. (25.4 x 20 cm). The Cleveland Museum of Art, gift of the Print Club of Cleveland.

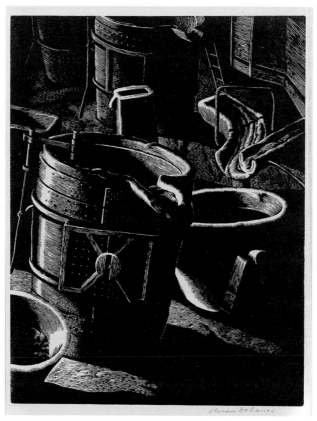

often suggest a desire to transform specific subjects into broadly generic "types," as if allegories of American civilization. Richards made a lithograph of a man he knew but titled it *Ohio Farmer*.[64] Flint simply titled his depiction of a campground at the Cleveland Great Lakes Exposition (1936–37) *Tourist Camp* (fig. 201). Other Cleveland prints of the Depression era, such as *Labor, Beggar, The Worker, Man of the Soil, Mourner, Judgment,* have no proper nouns in their titles, making them so universal they can apply to all Americans.

Figure 200. Walter DuBois Richards, *Country Church,* ca. 1935, lithograph, 10⁵⁄₁₆ x 6³⁄₁₆ in. (35.1 x 26.2 cm). The Cleveland Museum of Art, Mr. and Mrs. Lewis B. Williams Collection.

Figure 201. Leroy Flint, *Tourist Camp,* ca. 1937, etching, 11 x 8½ in. (27.9 x 21.5 cm). Ohio Art Program, long-term loan to the Cleveland Museum of Art.

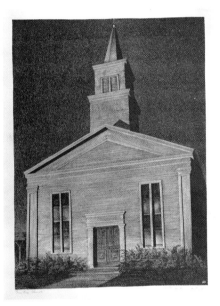

As the subjects and styles were directed toward the general public, so were the mechanics of printmaking. Printing techniques and styles that yielded larger editions became increasingly popular with Cleveland artists. Lithography and relief printing, the techniques of the commercial world, had the potential for the largest editions. Intaglio plates generally produce fewer impressions, but if they were steel-faced and the design was not too delicate, editions could also be sizable. To be avoided at all costs was the induced rarity of works produced by previous generations of American printmakers. The technical and stylistic fragility of the etching-revivalist works made printing large editions difficult and time consuming. Thin, delicate lines on copper plates wear quickly under the pressure of the press, and hand-pulled prints with unique wipings are labor intensive. In contrast, bold simple shapes on lithograph stones or wood blocks hold up well during the printing process.

Cleveland printmakers made a significant number of intaglio prints largely because of Kubinyi, who learned a number of intaglio techniques from an uncle during a trip to Europe in 1927. He refined those processes, continued to experiment, and introduced them to a number of artists in Cleveland. In 1935 and 1936 he published two articles in the *American Magazine of Art* describing the stylotint and the offset soft-ground, both variants of the traditional soft-ground etching technique.[65] Offset soft-ground etchings bear a resemblance to and are often mistaken for lithographs, and Kubinyi claimed the technique was even better than lithogra-

phy. He also made a number of mezzotints and sugar-lift etchings, which he called "pen-process aquatints." Most of his prints were intaglio, although he did a few lithographs and relief cuts. His prints on the whole are most interesting for their technique, and his subject matter ranged from pseudo-surrealist, deco-inspired compositions to straightforward images of the Cleveland scene.

Kubinyi encouraged other artists, including Rutka and Flint, to experiment with intaglio, and through him tonal intaglio methods spread among Cleveland printmakers. Rutka is known for her aquatints, which she called "crayon manner" because crayons were used as an acid-resist in multiple acid baths (see fig. 194). Flint made a few experimental aquatints with varying grays such as *Sun and Dust*. The etching and aquatint *Amazons* demonstrates his interest in color printing. He applied colored inks directly to the plate, which then combined with the black ink to produce subtle, unusual colors.[66]

In a review of the 1926 May Show, Milliken noted that very few lithographs had appeared in previous May Shows.[67] As true with the rest of the nation, lithography was a new medium to many artists in Cleveland and soon became one of the most popular techniques. Russell Limbach was perhaps Cleveland's premier artist-lithographer. In 1932 the Print Market held an exhibition of his color lithographs, a rare showing of what was virgin territory for American artists. Richards and Dohanos were two of Cleveland's best lithographic artists. They studied lithography with Stow Wegenroth in Maine in the summer of 1932 and became adept at creating deep, rich, even tones. While the two did not print their own lithographs, they found skilled commercial printers in Cleveland. Flint, Grebenak, Gross-Bettelheim, Lee-Smith, and Manuel Silberger also created designs that were printed by the WPA lithographers.

Relief, a medium that rose in popularity as did lithography, was not only durable but also the simplest and most inexpensive technique to learn and practice. Linoleum was even free to artists who wished to contribute works to *IV Arts,* a monthly journal of the arts published in Cleveland during 1934 and 1935 that included prints by the CPM. Free linoleum was also given to artists such as Fred Carlo, Lee-Smith, and Smith who worked at Karamu House.[68] Cunningham, Dohanos, Kagy, and Richards were also skilled relief printmakers.

By the mid-1940s, most of Cleveland's leading printmakers of the Depression had either abandoned the graphic arts or left the city. The prints that survive from that era are a legacy of the tremendous energy, talent, and skill Cleveland artists devoted to printmaking during the 1930s. While Cleveland was recognized as an important center for the graphic arts during the Depression, today most of the printmakers responsible for bringing attention to the city are virtually unknown. Yet their efforts in the Cleveland Print Makers and the WPA graphics workshop left a remarkable testament to artistic creativity and human ingenuity in the face of the worst economic crisis of the century.

NOTES

1. Until the second half of the 19th century, American prints were made mostly for utilitarian or commercial purposes. Mass-produced engravings and color lithographs dominated the market. The American tradition of fine art printmaking began when a number of American artists, inspired by the etching-revival in Europe, embraced the art of etching. Rebelling against the impersonal nature of commercial prints, these etchings, largely landscapes and scenic foreign views emphasized qualities which convey a sense of the artist's hand: individual wipings, draftsmanship, and uniquely inked proofs. James A. McNeill Whistler and Seymour Haden were particularly influential for American etchers such as Frank Duveneck, Thomas Moran, and native-Clevelander Otto Bacher, considered to be the first etcher in Ohio. By the turn of the century, almost all of the leaders of the etching-revival had died or abandoned printmaking. American print collectors, whose tastes had been developed during the etching-revival, preferred works by the European artist-etchers. For more information see James Watrous, *A Century of American Print-making 1880–1980* (Madison: University of Wisconsin Press, 1984).

2. *The Print Club of Cleveland 1919–1969* (Cleveland: Print Club of Cleveland, 1970), 10.

3. Robert Bordner, "Offers to Trade Art for Shoes," *Cleveland Press* (18 June 1932), 5.

4. *CPM Annual* (Cleveland: Cleveland Print Makers, 1935), 2.

5. For a representative argument see Holger Cahill, "American Resources in the Arts," in *Art for the Millions,* ed. Francis O'Connor (Greenwich, Conn.: New York Graphic Society, 1973), 33–44.

6. Elizabeth Olds, "Prints for Mass Production," in *Art for the Millions,* 142.

7. *Cleveland Student Life* (Cleveland: Cleveland Conference for Education Cooperation, 1930), 63. The John Huntington Polytechnic Institute was founded in 1913, based on similar schools in England. As of September of 1933, the Huntington Institute was located in the former Otis-Sanders mansion at 3133 Euclid Avenue. Before that the Huntington Institute occupied a floor of the Walker and Weeks building at 2341 Carnegie Avenue.

8. By November 1934 the free time was Friday evening. Kubinyi, who was also in charge of the workshop, was often available to offer technical advice.

9. Robert Bordner, "Artists Open Low Price Art Mart in Fall," *Cleveland Press* (30 July 1932), 5.

10. Robert Bordner, "Print Makers Open Market in Old Tavern," *Cleveland Press* (20 August 1932), 5.

11. On 14 December 1933 the Bal Graphique, a masked ball featuring singing waiters and Greek and Hungarian dancers, was billed as a "double funeral of Old Man Depression and his wife Recession." Guests were to wear self-designed headdresses and were eligible for a print raffle ("Among Galleries and Artists," *Cleveland Plain Dealer* [17 December 1933], 10).

12. William McDonald, *Federal Relief Administration and the Arts* (Columbus: Ohio State University Press, 1969), 348.

13. The other organizations were the Cleveland Society of Arts, the Kokoon Klub, the Woman's Art Club, and the Cleveland Student's League. Cleveland—Artists Curb Market, Clipping Files, Ingalls Library, Cleveland Museum of Art (CMA).

14. The printing was donated by Continental Lithography. On the day of the Curb Markets "sandwichmen" carried the posters over their shoulders throughout the streets of Cleveland. Limbach made the poster for the 1932 Curb Market, Geoffrey Archibald was the artist for 1933, and Joseph Jicha was the designer in 1934. My thanks to Rob Lacefield for informing me that an impression of Limbach's poster is in the Limbach archive (a bequest of works from the artist) in the Davison Art Center at Wesleyan University, Middletown, Connecticut.

15. "America, Not Paris, Motif of 1933 Art Curb Market," Cleveland—Artists Curb Market, Clipping Files, CMA.

16. The Wagner Awning company donated the tent, which measured 50 x 80 feet and had been built the previous year for a wedding on the Mather estate ("Big Top Goes Up as City Prepares for Second Artists' Curb Market," *Cleveland Weekly* [5 August 1933], 21).

17. The CPM share was $400 plus a portion of the gate receipts ("13,000 Enjoy Curb Market," *Cleveland Press* [18 August 1934], 11; see also Cleveland—Artists Curb Market, Clipping Files, CMA).

18. "Print Makers' Show Proves Novelty at Old Wade Mansion," Cleveland Print Makers and Print Market, Clipping Files, CMA.

19. "Art Realm Notes," *Cleveland Plain Dealer* (13 December 1931), 16.

20. Limbach and Gross-Bettelheim were the only printmakers from Cleveland to attend the first meeting in New York City in 1936. See Jerome Klein et al., ed., *Artists against War and Fascism, Papers of the First American Artists' Congress* (1936; reprint, Rutgers, N.J.: State University, 1986), and *America Today,* exh. cat. (New York: Equinox Cooperative Press, 1936).

21. *The Picking of Grapes*, an aquatint printed in color, by Clarence Carter in 1931, and in 1932, *Pigeon Roost*, a block print, by Stevan Dohanos.

22. The series contained 22 intaglios, 15 relief cuts, and 13 lithographs. Seven were printed in colors.

23. Robert Bordner, "Print Makers Offer Bargain," *Cleveland Press* (23 April 1932), 5.

24. Cleveland—Print Makers and Print Market, Clipping Files, CMA.

25. Robert Bordner, "Artists Open Low Price Art Mart in Fall," *Cleveland Press* (30 July 1932), 5.

26. "Art Realm Notes," *Plain Dealer* (16 October 1932), 11.

27. Invoice from Cleveland Print Makers to Edmond Travis, 4 April 1934, Donald Gray Papers, Western Reserve Historical Society (WRHS) Archives, Cleveland. My thanks to Elizabeth Shearer for bringing this material to my attention. I would also like to express my gratitude for her invaluable assistance with this project.

28. *CPM Annual* (Cleveland: Cleveland Print Makers, 1935), 5.

29. Invoice from Cleveland Print Makers to Edmond Travis, Gray Papers, WRHS Archives.

30. "Print Makers Quit," *Cleveland Press* (21 March 1936), 5.

31. Russell Limbach, "Lithography: Step-child of the Arts," in *Art for the Millions*, 145.

32. Karal Ann Marling, *Federal Art in Cleveland, 1933–1943* (Cleveland: Cleveland Public Library, 1974), 3.

33. *The Encyclopedia of Cleveland History, 1796–1990*, ed. David D. Van Tassel and John H. Grabowski (Bloomington and Indianapolis: Indiana University Press, 1987), 1069.

34. Much of the information about the WPA in this essay comes from Richard McKinzie, *The New Deal for Artists* (Princeton, N.J.: Princeton University Press, 1973); Marling, *Federal Art in Cleveland;* and McDonald, *Federal Relief Administration and the Arts.*

35. Francis O'Connor, "Introduction," in *Art for the Millions,* 36.

36. McKinzie, *New Deal for Artists,* 105.

37. Variations exist in the reported number of WPA graphic arts projects across the nation. Sixteen was the largest figure, mentioning five shops in New York, four in California, and the other seven in Colorado, Connecticut, Florida, Maryland, Michigan, Ohio, and Pennsylvania ("Exhibition and Notes," *Prints* 6 [April 1936]: 233). See McDonald, *Federal Relief Administration and the Arts,* 434, for the employment figures and McKinzie, *The New Deal for Artists,* 105, for the number of prints.

38. See McDonald, *Federal Relief Administration and the Arts,* 433–58, for an overview of the graphic arts workshops under the Federal Arts Project. In addition to Cleveland, other important centers included New York, Philadelphia, Chicago, and San Francisco. The New York City project was the largest, employing about 50 people.

39. Most of the information about the Cleveland WPA graphic arts workshop was derived from the Karal Ann Marling Papers, Special Collections, Case Western Reserve University (CWRU), Cleveland. Portions of the collection were microfilmed in 1973 by the Detroit regional office of the Smithsonian Institution's Archives of American Art, reels 603 through 606.

40. John K. Civic, "Long Pants for the Art Project," *Crossroads* (January–March 1940).

41. For example, as of 29 January 1936 there were 15 people on the payroll. Around February 1936 there were 18 and, in a report for January to March 1937, there were 14.

42. Frank Fousek (America, 1913–1979), see Rachel Davis, *Frank Daniel Fousek, Prints and Paintings from the WPA Era* (Shaker Heights, Ohio: Rachel Davis Fine Arts, 1995).

43. Student paper by Carol Clark, "Government Support for the Graphic Arts in Cleveland during the 1930s," Marling Papers, CWRU.

44. Honore Guilbeau, interview with the author, 28 July 1995. Kubinyi chose the relief and non-relief artists from a pool that had already been approved by the Cleveland supervisor, Carl Broemel.

45. Marling, *Federal Art in Cleveland,* 54.

46. Leroy Flint interviewed by Michael Moss, 7 March 1974, Marling Papers, CWRU.

47. Although Marling states there were about 6,000 separate images (*Federal Art in Cleveland,* 55), such a figure is unlikely. Since about 11,000 images were made nationwide, that would mean the workshop in Cleveland produced over 50% of the plates and stones while employing only about 6% of the graphic arts workers. In addition, only about 300 images are known today. That would mean over 5,700 images would have vanished without a trace.

Edition sizes depended largely on technique. Clark estimated editions were between 25 and 50 ("Government Support for the Graphic Arts in Cleveland during the 1930s," Marling Papers, CWRU). Editions varied anywhere from 25 to 100 (Flint interview, Marling Papers, CWRU).

48. Marling, *Federal Art in Cleveland,* 56–57.

49. Dorothy Rutka to Holger Cahill, 28 July 1936, Marling Papers, CWRU.

50. The portfolio was made by the Milwaukee Handicraft Project of the Wisconsin WPA. Complete portfolios exist in Extensions Collection, CMA, and Special Collections, CWRU.

The techniques, as they are referred to in the portfolio, are as follows: Linoleum Cut, Color Linoleum, Wood Engraving, Line Engraving, Drypoint, Line Etching, Softground, Off-set Softground, Stylotint, Aquatint, Color Aquatint, Pen Process Aquatint, Lithograph, and Stencil.

51. Three specific exhibitions, all held in the WPA galleries in 1937, are known through their posters, also made by project artists: *Ceramics and Prints Exhibit*, *Poster Exhibition*, and *William Sommer Paintings* (Marling, *Federal Art in Cleveland,* 123).

52. Among the important exhibitions were *New Horizons in American Art* (Museum of Modern Art, 1936), *Prints for the People* (International Art Center, New York, 1937), and *Paintings and Prints by Cleveland Artists* (Whitney Museum of Art, 1937).

53. Mildred Holzhauer to Holger Cahill, Marling Papers, CWRU.

54. William Milliken to Holger Cahill, Marling Papers, CWRU.

55. Marling, *Federal Art in Cleveland,* 52.

56. Flint interview, Marling Papers, CWRU.

57. McKinzie, *The New Deal for Artists* (Princeton, N. J.: Princeton University Press, 1973), 151–55.

58. "Art Bureau Bill Debate Set Here," *Cleveland Plain Dealer* (8 March 1938), 15.

59. Edward Alden Jewell, "Cleveland Artists Have Display Here," *New York Times* (17 March 1937).

60. The work by Dohanos is alternatively titled *Connecticut Yankee*. There are two versions. This large one in an edition of 20 and a smaller one in reverse published for the Print-a-Month series. Dohanos wrote about this work: "Years ago while driving through New England for my first look at this area surrounding nearly every field and lining country roads. These walls are all man-made, a laborious process made as a result of clearing tillable land. My concept for this lithograph print grew out of this experience and expresses my admiration for those who performed the backbreaking labor clearing the land and building the walls" (Dohanos, *American Realist* [Westport, Conn.: North Light Publishers, 1980], 70).

61. *New Masses* (2 January 1934), 1.

62. The only pressure reportedly exerted on artists on the WPA project was from other artists, specifically those with communistic sympathies. Hoping to help the masses, they tried to pressure their colleges to create socially conscious scenes.

63. This print was shown in the 1935 May Show and was also published in 1934 in the Contemporary Print Group's second portfolio, *The American Scene No. 2*.

64. Telephone interview with Walter Richards, 2 June 1995.

65. Kálmán Kubinyi, "Tools and Materials, Offset Soft Ground—A New Etcher's Medium," *American Magazine of Art* (November 1935): 679–83; and Kálmán Kubinyi, "Tools and Materials, A New Etcher's Medium II: Stylotint," *American Magazine of Art* (October 1936): 646–51.

66. Flint interview, Marling Papers, CWRU.

67. William Milliken, "Review of the Exhibition," *Bulletin of the Cleveland Museum of Art* 13 (May 1926): 119.

68. William E. Smith and Marjorie Witt Johnson, *The Printmaker* (Cleveland: William E. Smith, 1976).

From Entrepreneurial to Corporate and Community Identities: Cleveland Photography

WHO WERE the early photographers of Cleveland? Simply put, they were urban professionals who defined their roles and work according to generally acknowledged standards of excellence set by leaders of business and industry. Cleveland photographers were consummate craftsmen and marketers—self-motivated, self-made individuals. They were technical innovators. They were both regionalists, keyed to the development of the city and surrounding area, and nationalists, synthesizing sophisticated methods of visualizing and image-making. Finally, they were idealists and visionaries whose work shows Cleveland in a magnificent state of being and becoming.

The photographs presented here, taken between 1870 and 1940, are by known and unknown photographers. Because so many of the works are anonymous, the focus is on the influence of societal forces rather than the evolution of individual personalities. The discussion is structured around three key stages in Cleveland photography that correspond to corporate development in America: 1860–80, the independent entrepreneurial years; 1880–1919, the emergent corporate years, marked by a search for a transurban identity; and 1920–40, the years of fully developed managerial corporatism and the independent pictorialists.[1] When interpreted as texts (with less emphasis on technical analysis), these photographs become linked to the evolution of Cleveland's commercial identity from an entrepreneurial community to a corporate hierarchy.[2]

1860–80: MERCANTILE IDENTITIES, FRATERNITY, AND OASES OF CULTURE

FROM THE WINDOWS of our daguerrean rooms in the Merchants' Bank building, at the corner of Superior and Bank streets, we look over and across the street and see the old City Mills Store, Morgan and Root, proprietors; next west, Smith & Dodd, shoe merchants; next Chas. P. Born, stoves, tinware, and plumbing; following next, the "Old City Buildings" . . . the Athenaeum Theatre, where sang Jenny Lind . . . and other bright stars of that period. . . . On the corner opposite our studio was the Weddell House, the finest hotel in Cleveland at that time.
—James F. Ryder, 1902[3]

Viewed from the upper floors of the Johnson daguerreotype studio at what is now Superior Avenue and West Sixth Street, Cleveland in 1860 was a cluster of mercantile establishments centered around Public Square. Businesses proliferated along Superior, the city's "Main Street," and the north-south arteries of Seneca and Bank streets (now West Third and West Sixth, respectively). Consumer goods and services shared these major arteries with culture and cosmopolitanism. To the southeast of Public

Square, Euclid Avenue was becoming lined with prestigious homes built by wealthy merchants. To the north, the lakefront was the after work destination for Clevelanders of all stripes in spring and summer. For James Ryder, who arrived from upstate New York in the 1860s, a sunset stroll along the Lake Erie shore was the ultimate Cleveland experience, one that would remain vivid fifty years later.[4]

This is the Cleveland that the local photographic community pictured and celebrated. Strategically staged views and portraits document the emergence of that community in the 1860s, when new frameworks for business and pleasure supplanted the old. The photographers of this era were doing more than representing Cleveland; in essence, they were the custodians of the city's vision of itself as a mercantile center.

Panoramas of New York City in the 1840s and 1850s were often composed with Broadway, the main business thoroughfare, extending out to the horizon and organizing the pictorial space. Cleveland photographic views composed on this model proliferate from at least the 1870s. The city extends westward along Superior (fig. 202), with attention paid to the intersections at Seneca, Bank, and Water streets. Besides Johnson's Photo Gallery, the major photographic studios on Superior during the 1870s included those of J. H. Copeland, Thomas Sweeny, and Edward Decker. By 1872 Ryder's Gallery of Photographic Art was featured in images of the

Figure 202. Anonymous, *Superior Avenue, Cleveland,* ca. 1870, copy photograph from vintage negative, 8¼ x 15½ in. (21 x 39.4 cm). The Western Reserve Historical Society. [not in exhibition]

city; it recurs in views through the 1890s. Stereoscopic view sets produced throughout the period included Superior Street, the best hotels (Weddell House, Kennard House), key public buildings, Public Square (fig. 203), gardens, clubs, and the various churches and famous residences of Euclid Avenue. After its completion in 1890, the skyscraping Society for Savings Building on the square became a favorite vantage point for panoramas of the city (fig. 204).

The intent of the scenographic photographers of Cleveland, following those of the prosperous cities of the East, was to demonstrate economic viability and a potential for growth. Seen in a national context, these photographs tell a "tale of boundless commercial potential," suggesting "a solid basis for future growth through the building by building, street by street documentation of a city's development" and the views that "echoed the painted panorama."[5] Equally important, they tell of how business was conducted in commercial centers and give valuable credibility to photographers as those who best understood how those economic codes could be translated into visual ones.

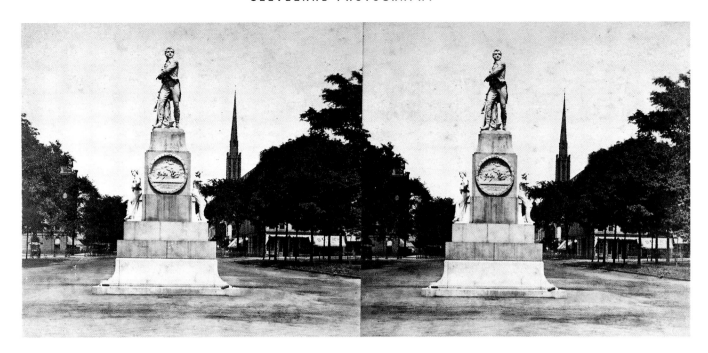

Figure 203. Henry T. Anthony, *Commodore Perry's Monument,* 1870, albumen stereo-view, 3½ x 6¾ in. (8.9 x 17.1 cm). Peter and Judy Wach Collection.

James Ryder is one of the few American photographers of the previous century to have published an autobiography detailing virtually every aspect of his operations. His book, *Voigtländer and I,* is a crucial source of information about commercial interchange among photographic studios, not only in Cleveland but throughout the eastern/midwestern commercial circuit. Ryder's success hinged on creating a competitive edge. In the language of late-nineteenth-century salesmanship, he drummed up business. By transforming his studio into an art gallery containing reproductions of popular paintings, and by designing his store as a high-class emporium modeled on New York photography establishments and department stores, he promoted Superior Street as a prime business location.

He also fabricated idealized personas for his clients. To reconfigure one's appearance, to be what one is not but what one dreams to be, was, in business handbooks of the late nineteenth century, to effect "success" *avant la lettre.* In the language of this literature, which prefigured corporatism, to

Figure 204. Anonymous, *Aerial View of Downtown Cleveland,* 1896, photogravure, 5¹⁵⁄₁₆ x 9⅛ in. (15.1 x 23.2 cm). The Western Reserve Historical Society. [not in exhibition]

Figure 205. James Ryder, *Gen. Jas. A. Garfield,* 1880, cabinet card, 5⅞ x 3⅞ in. (14.9 x 9.8 cm). International Museum of Photography at George Eastman House. [not in exhibition]

will was to achieve, to perfect and strategize desire was to prepare for the fulfillment of that desire, not in the next life, but in this, wrapped up in lucrative orders and business deals.

Ryder's camera effected visages of success. In his portrait of James A. Garfield (fig. 205), handwork is evident in the eye areas where, in Garfield's words, by "rounding and strengthening the outlines [the re-toucher] was able, at length, to print from the negative a photograph more perfect than any I had seen with an India ink finish."[6] In 1869 Ryder had received national attention for a series of negative-retouched portraits that he exhibited first in Boston, then in Cleveland. These were completed according to a German process that he imported by means of the services of three expert German retouchers. Key to successful retouching, Ryder explained, was converting "coarse skin texture, the pimple and freckle blemishes . . . into fine, soft complexions, most gratifying to the eye, and especially to the eye of the person represented in the picture."[7] Equally important to those who aspired to success was proper emphasis of the areas of the eyes and hair.

Known as a master at projecting "winning images," Ryder personified, pictured, and helped bring about what has been called the essence of corporate bureaucratic hegemony, quantified by Dale Carnegie as "the salesmanship of the system selling itself to itself."[8] It stands to reason, then, that corporate image-making strategies should be carried out in the community in which they in part originated and from which they were rapidly disseminated.

Boosted by Ryder's success, the Cleveland photography community be-came an integral part of the city's economic system, with connections to and influence on merchants in other cities. Nowhere are these linkages better demonstrated than in the second annual convention of the National Photographic Association, which convened in Cleveland in 1870 (fig. 206). This event prefigured the city's transition to a center of national and inter-national commerce.

Formed in New York City in 1868, the National Photographic Association was the first major professional society for photographers. Its initial con-ventions, held in Boston, Cleveland, and Philadelphia, respectively, from 1869 to 1871, were dominated by a fraternal consortium of photographers, publishers, and manufacturers of photographic supplies. The association established a power base whose major accomplishment was the denial of a patent renewal application that would have given unrestricted rights in commercial work to a single individual, thereby virtually eliminating the independent community. This victory for entrepreneurship, albeit short-lived (Eastman Kodak's rise to monopoly status in the 1880s and

Figure 206. Anonymous, *National Photo-graphic Association Exhibition, Cleveland,* 1870. From William Welling, *Photography in America: The Formative Years, 1839–1900* (New York: Thomas Y. Crowell, 1978), 207.

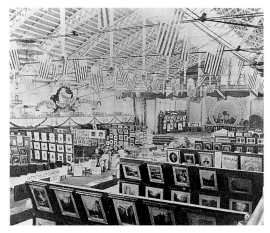

Figure 207. Thomas Sweeny, *National Photographic Association Convention, Cleveland,* 1870. From William Welling, *Photography in America: The Formative Years, 1839–1900* (New York: Thomas Y. Crowell, 1978), 205.

1890s was predicated on buying patent and process exclusives), had important implications. It upheld the conviction that steady progress could be achieved by maintaining open lines of communication among independent photographers, particularly with regard to new products, inventions, and improvements.

Cleveland photographers, led by local secretary and national vice-president James Ryder, played a crucial role in the early National Photographic Association, particularly in organizing its 1870 convention. Rooms in the Weddell House and Kennard House were reserved; railroad companies operating lines through Cleveland were solicited to reduce their rates; the new Central Skating Rink on Public Square was rented; and honored guests were housed. Mechanisms for receiving and displaying photographs, products, and apparatus by 250 exhibitors were devised; Thomas Sweeny, assisted by Thomas H. Johnson, took on the task of documenting the event. Ryder, Sweeny, and a number of other members of this thriving photographic community were commended in the minutes of the meeting.[9]

Stephen H. Buhrer, mayor of Cleveland, officially welcomed the convention delegates. Major addresses were given by renowned Boston photographer Albert S. Southworth and Berlin photochemist Hermann Vogel, the German technical correspondent for the *Philadelphia Photographer*. A relief fund was established for needy members. One member's debts incurred in litigation were wiped out by contributions solicited during the event. Medals were awarded by the Committee on the Progress of Photography.

Convention speakers remarked on Cleveland's transformation from a frontier village to a busy metropolis. In his opening address, association president Abraham Bogardus fondly remembered "the log-cabin with its latch-string hanging out as a welcome." Now, upon returning to the city, he found that "busy streets and palatial residences have taken the place of the log-cabin, yet the welcome is just as hearty."[10] With pride of place, Sweeny photographed the delegates in front of the Perry Monument in the center of Public Square (fig. 207). This view by Sweeny was also a tactic that associated the convention with Cleveland, injecting a substantial dose of boosterism and linking local and national ideals.

Photographs and stereoviews taken and distributed by the Cleveland photographic studios, along with a number of studios based outside Ohio, reveal that the square was more than a convenient meeting site. It was the nexus and calling card of Cleveland's merchant and political elite, within which the photographers played active roles.

Standing prominently in the middle of the square and the subject of a number of views from the 1860s and 1870s, the Perry Monument had been erected in 1860 to commemorate Commodore Oliver Hazard Perry's victory in the Battle of Lake Erie and also to celebrate Cleveland's mercantile dominance in the Lake Erie region. In 1864 the Northern Ohio Sanitary Fair, held in a temporary structure built around the Perry Monument and extensively photographed, had solidified and expanded this position.

Two years after the photographic convention, the first major improvement project by the Cleveland Board of Park Commissioners totally revamped the quadrants making up the square, refocusing it from the Perry Monument and altering its open, small-town feeling. The new Public Square was a totally constructed gardenesque environment, comprising stages for the display, development, and celebration of entrepreneurial character. As described by historian William Ganson Rose:

> The Square took on a rustic, rest-provoking air, where citizens could enjoy concerts and oratory, or spend leisure time in familiar exchanges

Figure 208. Studio of K. A. Liebich, *Public Square with Miniature Boat Advertising E. B. Nock's Photographic Studio,* ca. 1870, albumen stereoview, 3½ x 6¾ in. (8.9 x 17.1 cm). Peter and Judy Wach Collection.

Figure 209. James Ryder, *Lipsy Smith,* undated, cabinet card, 5⅞ x 3⅞ in. (14.9 x 9.8 cm). International Museum of Photography at George Eastman House. [not in exhibition]

with friends and neighbors. On the broad avenues that crossed it, horse-drawn buggies and aristocratic carriages carried men and women on errands of business and society.

An artificial pond was created in the southwest section, with a waterfall that tumbled into a pool nestled in a rock garden below. Over it a quaint bridge was built. Circling the fountain in the upper pool was the *E. B. Nock,* a three-foot, working model of a steamboat. . . . Nock . . . was an Ontario Street photographer. In the northeast section of the Square, under the tall, shady trees, a large rustic pavilion was built of logs and bark-covered branches, over which creeping vines trailed. Flowers bloomed from hanging boxes, and a platform served as a stage for public events for many years.[11]

Stereoviews of the redesigned quadrants show a profusion of greenery and garden forms, such as the tree stump fountain in the "E. B. Nock" quadrant (fig. 208). This installation may have been a memorial to Nock, an Ontario Street photographer, but more than likely it referred to the ubiquity of photographic studios in the city. Landscape also proliferated in studio photographs, as prominent photographic studios such as Ryder's used nature-inspired elements as props and backdrops for portraiture (fig. 209). The lily pool and E. B. Nock quadrants, two outdoor "floral halls," established a symbolic landscape in the heart of the city, thereby providing a respite from shopping while encouraging store patrons to linger.

The leisurely contemplation of nature was not the only aim of Cleveland's park commissioners; Public Square was a place for production, and photographers noted that fact. The pavilion in the northwest quadrant housed music performances as well as speeches, thus serving as a summer concert hall to supplement the cultural offerings in Case Hall across the street.

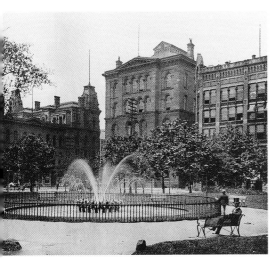

Figure 210. Anonymous, *Public Square,* 1889, photogravure, 7¼ x 8⅞ in. (18.0 x 25.5 cm). The Western Reserve Historical Society. [not in exhibition]

When spectators appear, they are artfully and thoughtfully posed, signifying varied attitudes of dignified repose (fig. 210). The notion that public space served as a moral directive for a democratic society led by an upwardly mobile elite was articulated by landscape designer Frederick Law Olmsted:

> The vast wealth of such a people . . . their general education and refined tastes,—the intense community of ideas . . . all inevitably cooperate with commercial necessities to create great cities,—not merely as the homes of the mercantile and wealthy class, but as centers where the leisure, the tastes, the pride, and the wants of the people at large repair more and more for satisfaction.[12]

In an important 1879 address Olmsted also stated: "A great object of all that is done in a park, of *all* the art of a park, is to influence the minds of men through their imagination."[13]

Photographs by K. A. Liebich and others acknowledge the intimate relationship of repose and commerce, which would come to fruition in images of the Cleveland Group Plan of 1903 and grand style photography. The reconfigured quadrants of Public Square were meant to revitalize civic idealism and heighten cultural consciousness, all within perfect miniature symbolic worlds. Consumers of the multiple views that issued from the Ryder, Sweeny, Liebich, and other studios were guided, as it were, right into Cleveland's public spaces in order to recapture the restfulness, vitality, and sense of cultural renaissance they provided. With that foundation, the stage was set for Cleveland's gilded age of prosperity, during which photography became key to reimaging Cleveland as a city of grand style.

1880–1919: INDUSTRIAL IDENTITIES, EMPIRES, AND OASES OF LEISURE

BY THE 1880S Cleveland had emerged as a major center of transportation, oil refining, and steel production. Linked by boat and rail to New York and cities around the Great Lakes, Cleveland established itself as a key distribution point and financial center in a growing network of managerial capitalism. These circumstances stimulated a market demand for photographs of trains, trolleys, mills, machinery, and factories. According to economic historian David Nye, early industrial photography was characterized by large numbers of unsigned photographs, produced in groups with recurrent subjects and standardized techniques. No longer meant for a localized, commodity-oriented mercantile community, industrial photography depicted the workplace as a system empowered by a corporate ideology.[14] This was the ideal medium for corporate self-expression.

The Detroit Photographic Company was the country's most successful photograph and postcard agency at the turn of the century, specializing in views and panoramas of industrial districts and railway freight yards. This agency also marketed a type of image that cultural historian Terry Smith has called "direct functionalism," defined as a descriptive way of seeing marked by "plain precision" and compositional integration. The direct functionalist view centralized and monumentalized the industrial scene, making it a wonder to behold.[15] Curator Marianne Doezema has traced this way of seeing to the late-nineteenth-century illustrated American magazine, a key locus for the development of a "celebratory attitude toward the machine" manifested in heroic proportions, "angular, hulking shapes . . . glowing fires, and belching smoke."[16] Whereas illustrations derived from engravings rendered the machine as a "clean," engineered implement, photographs described it in operation.

Figure 211. Anonymous, *Steam Engine*, undated, printed from a lost photograph, dimensions unknown. The Western Reserve Historical Society. [not in exhibition]

Figure 212. Anonymous, *Cleveland Rolling Mills Company*, 1890s, albumen print, 4 x 6 in. (10.1 x 15.2 cm). The Western Reserve Historical Society.

Direct functionalist photographs of Cleveland blast furnaces, trolley cars, bridges, and railways enhance the feeling of industry by emphasizing dirt, grime, and smoke (fig. 211). The celebratory, almost hieratic images of the Emma furnace at the Cleveland Rolling Mills (fig. 212) exhibit a highly refined sense of structure, massing, and tone, indicating the services of a photographer familiar with the conventions of the picturesque. By taking a position directly in front of the industrial complex and centralizing the smokestack between the two flanking buildings, the photographer synthesized their varied forms and profiles.

The 1880s and 1890s were years of industrial mergers and monopoly capitalism.[17] To Americans at the turn of the century, the Standard Oil Company embodied monopoly capitalism. The company's founder, John D. Rockefeller, began his career as a Cleveland bookkeeper in 1855. An interest in speculation led him into railroad stocks, then into the construction of an oil refinery that by 1867 was producing 1,500 barrels a day. He convinced his partners to engage in strategies designed to absorb and eliminate the competition, consisting of 130 firms in Cleveland and Pittsburgh. In 1870 he reorganized the firm as the Standard Oil Company, which within a few decades was transformed into a corporate empire, the Standard Oil Trust. A contemporary aerial photograph of Standard Oil (fig.

213) adheres to the style of direct functionalism. It shows a smoothly working plant, with the smokestacks in the distance providing a vertical thrust and the diagonals of other structures and tracks balancing the verticals into an interlocked factory network. The landscape is transformed into a vast "industryscape," with no vestiges of the picturesque.

In this climate of emergent monopoly capitalism, the movers and shakers of the corporate world became figures of intense public interest. They proved themselves capable of making decisions with national and international implications, and they could shift the balances of the corporate structure virtually overnight. Photojournalism in Cleveland emerged as a response to the demand to unmask the privacy of empire builders such as Rockefeller. The targets of photojournalism, however, were equally adept at exploiting the value of positive publicity, staging "pseudo-events," captured and translated by capable professional photographers.[18] Rockefeller's

Figure 213. Anonymous, *Aerial View of the Standard Oil Company*, 1889, photogravure, 7¹⁄₁₆ x 8¾ (18.0 x 22.2 cm). The Western Reserve Historical Society. [not in exhibition]

Figure 214. Louis van Oeyen, *John D. Rockefeller,* 1905, copy photograph from vintage negative, 4¾ x 6¾ in. (12 x 17 cm). The Western Reserve Historical Society. [not in exhibition]

Figure 215. Louis van Oeyen, *John D. Rockefeller,* 1905, copy photograph from vintage negative, 4¾ x 6¾ in. (12 x 17 cm). The Western Reserve Historical Society. [not in exhibition]

gift of Rockefeller Park to Cleveland in 1896 was one such event. Another was an unprecedented 1905 tour of Forest Hill, the oil magnate's Cleveland estate. Cleveland, the center of Rockefeller's empire-on-the-make, became a focus of this photographic genre.

It has been suggested that Cleveland photojournalism was invented by Louis van Oeyen.[19] Van Oeyen's photo essays of Rockefeller (figs. 214, 215) show John D. arriving and circulating at his Forest Hill estate, conversing with Cleveland mayor Tom L. Johnson and members of the American Press Humorists, and officiating at golf tournaments. These should be read as collaborative efforts, manifesting Rockefeller's desire for positive publicity and van Oeyen's skill in making the corporate capitalist of the day seem approachable. Rockefeller and President Theodore Roosevelt championed the concept of the successful executive as a man of action and virility. Such a man did not merely preside and direct, he moved and directed. He was an avid sportsman who reinvigorated his spirit in the great outdoors. Van Oeyen showed these ideals clearly, but with a twist: Rockefeller is pictured surrounded by people, and thus, van Oeyen suggests, he was accessible to all.

On 22 July 1896, proclaimed Founders Day in Cleveland, it was reported that:

> The Centennial celebration was interrupted to permit J. G. W. Cowles, president of The Cleveland Chamber of Commerce, to announce a generous gift of $300,000 in cash by John D. Rockefeller that would make possible completion of the boulevard between Wade Park and the Shaker Heights Park. In addition, Rockefeller had deeded to Cleveland 276 acres of Doan Brook land, valued at $270,000, that became Rockefeller Park, thus completing a seven-mile chain of picturesque lands for public enjoyment.[20]

Unfortunately, the names of the photographers hired to document the construction of Rockefeller Park, Wade Park, and Ambler Park are unknown. Nevertheless, they created a coherent group of stunning images that may be described as the Rockefeller Park series. These photographs exemplify what photohistorian Peter Hales has called "grand style" imagery. The grand style monumentalizes the artifact or environment and clarifies its relationship to a surrounding context by means of high-angle views, closeups, and narrative accompaniment.[21] Almost always modulated by nature, buildings are seen through screens of trees or across a landscaped space. Park environments frequently reflect the symmetry and axial order of the Beaux-Arts ideal of architecture and urban design. Grand style pho-

Figure 216. Anonymous, *Mirror Lake in Jackson Park, World's Fair Site, Chicago,* ca. 1891. From *World's Columbian Exposition Illustrated* 1 (April 1891): 7.

tography appropriated elements of the picturesque to encode its own meanings into Rockefeller's philanthropic gestures.

Photographs of the Chicago World's Fair and its city park prototypes (fig. 216) were the most important instruments in shaping Cleveland grand style photography. Appearing prominently in World's Fair publications documenting the reconstruction of Jackson Park (1892–93), these views situate the viewer not only outside the official spaces of commerce but outside the mundane altogether, in a fantasy realm of magnified natural features and gentle promenades. Atmospheric effects supersede landscape objects; pictorial effects, particularly water reflections, supersede landscape. The consumer is on a never-ending gondola ride or promenade.

In the Rockefeller Park series (figs. 217, 218), immersion in effects, particularly those associated with ritual promenading and boating, is equivalent to immersion in a dream of nature. The main bicycle/carriage road is the circuitous drive laid across the level ground of the Doan Creek valley. The roadway repeatedly describes the axis of the picture as well as the direction of vision. These images emphasize certain key views, such as picturesque tree stands, gently curving roads, and idyllic lagoons with fountains and miniature islands. Views were often selected to suggest the process of moving through the landscape. Like photographs of the Chicago

Figure 217. Anonymous, *Wade Park,* ca. 1880–1900, printed from a lost photograph, dimensions unknown. The Western Reserve Historical Society. [not in exhibition]

Figure 218. J. D. Cox, Jr., *Wade Park,* 1889, gelatin-silver print, 8 x 6 in. (20.4 x 15.2 cm). The Western Reserve Historical Society. [not in exhibition]

World's Fair, this focus on process emphasized the superiority of the designed landscape to the purely natural one. The long paths in this constructed environment control the viewer's movement through the park, which in many respects suggests an extended private estate. While Cleveland's Public Square was designed to function in the context of daily commercial life, Rockefeller Park was meant to be looked at from strategic vantage points. It refocused the discourse of leisure from the urban oasis to the suburban promenade, from the "open market" of mercantile exchange to the secluded wood of corporate leisure.

1920–40: CORPORATE STYLE AND INDEPENDENT PICTORIALISTS

THE CAMERA OF MARGARET BOURKE-WHITE, of Cleveland, is achieving unique results in two departments of the photographic art, the *industrial* and the *architectural*. . . . Miss Bourke-White's studies reveal a vision that eschews the obvious while concentrating on latent and elusive elements that impart atmosphere and life. . . . This Cleveland girl's studies reveal what someone has termed the "seeing eye." She has framed the colossal masses of steel plants and towering spires in the aura of morning mists, billows of black smoke and overcast skies. Puffs of white steam—hindrances to the ordinary photographer—become to her the accents of contrast revealing line and form and balance inherent in these great structures.

　　　　—Press release, Korner & Wood Company, Cleveland, about 1929

Cleveland photography after World War I was led by corporate image-making strategies and independent pictorialists. Innovation in the professional sphere did not come from local photographers, but from New York-based advertising agencies and corporate public relations departments. Pictorialism was perfected by artists who inherited the conventions of the grand style and picturesque industrialism, both of which appeared in the same New York periodicals. *Century* was the major instrument for disseminating the grand style and picturesque industrialism. The magazine's leading artist-illustrators were painter Childe Hassam, etcher Joseph Pennell, watercolorist André Castaigne, Beaux-Arts architecture renderer Jules Guérin, and art photographer Alfred Stieglitz.

Originally a specialist in genre images indebted to European salon prototypes, by 1893 Alfred Stieglitz was working on a photographic series of Battery Park, Central Park, and Fifth Avenue, which he called "Picturesque Bits of New York." Subsequently he extended it into the New York Central's freight yards. Stieglitz's photographs were acclaimed throughout the amateur and professional photography circuit for their atmospheric, tonal richness. His craftsman-like manipulation of the print process was particularly admired by "fine art" photographers. Following his example, photographers around the world began practicing manipulative photo-chemical techniques—the hallmark of the international movement called pictorialism. The foundation of pictorialism was the romantic industrialism that Stieglitz helped to coin and transmit to the corporate image-makers of the twenties.

From the beginning, these photographs were surrounded with equally adulatory texts, giving additional power to the images while alluding to corporate greatness. The mundane world is left far behind, journalist and artist F. Hopkinson Smith wrote in *Pastels of New York*:

When the shadows soften the hard lines and the great mass looses [sic] its details, and skyscrapers melt into a purple grey . . . when the glow

worms light their tapers in countless windows, when the towers and steeples flash greetings to each other . . . when the streets run molten gold and the sky is decked with millions of jewels.[22]

Once refined by the Stieglitz group, romantic industrialism became the key trope of corporate image making, lasting virtually unaltered through the twenties and into the thirties, although it would share center stage with a new, machine style "engineered" by artists associated with advertising agencies. This style of approach persevered throughout these decades because it fit corporate image-making needs. Also fostering its continuity were two corporate-keyed venues: the Clarence White School of Photography, which Margaret Bourke-White attended in the early twenties, and the early issues of *Fortune* magazine, to which she regularly contributed in the thirties. Even more important, romantic industrialism had an unbroken continuity with the heroic imagery of the industrial heartland, specifically in Detroit, Chicago, and Cleveland.

These cities had been the nexus of corporate growth and imagery in their emergent phase. In Cleveland, romantic industrialism continued to hold sway and compel the attention of powerful executives. It was the success of Bourke-White's Cleveland imagery that propelled Henry Luce of *Fortune* to call her to New York. Astute early reviews called attention to the socioeconomic aspects of her work. In 1931 a New York writer claimed:

> [Bourke-White's] subjects are mostly mechanical and therefore, modern, but her very personal attitude is that of an industrial romantic. There is a great deal of literary pathos about her factory chimneys and her machinery is rather sentimental. Such an attitude, however, has its sociological justification and is equally apt to enchant the American executives.[23]

Although Cleveland's major clients were modern managerial corporations, they saw themselves in the heroic guise of imperial conquerors, a cue that Bourke-White did not miss when she marketed her photographs to them, featuring her updated version of grand style imagery. Commissioned by the architects, Bourke-White's photographs of the Sherwin, Clapp, Harwin, and other estates show a masterly grasp of grand style conventions. Not only is the view manipulated, but soft focus comes into play as a differentiating tool, further excerpting the image from reality—from "business" (fig. 219). Gardens predominate over structures, and garden sculptures become convenient springboards to fantasy. The rich tones, intimate closeups, and artful emphasis of the gaze—situating the viewer in front of a window or a highly ornamented, openwork gate—recall the photographs Clarence White published in Stieglitz's high-art, turn-of-the-century journals *Camera Notes* and *Camera Work*. The strategic manipulation of focus recalls the poetic, soft-focus landscapes of Alvin Langdon Coburn, Stieglitz's protégé.

These are the same ideas Bourke-White marketed to the corporate community, reconfiguring them in the office building and the industrial "garden." As she stated in an early autobiographical sketch of 1928–33:

> I had always been fascinated with smoke stacks, oil wells, bridges, and whenever I had any time I wandered around in the flats of Cleveland and took pictures. I had no idea that I could sell these industrial pictures, nor did I have any idea that I was doing anything particularly interesting. I took the pictures for fun, until one of the Cleveland banks

Figure 219. Margaret Bourke-White, *Garden of Mrs. Homer H. Johnson,* ca. 1929, gelatin-silver print, 12⅞ x 9 in. (32.8 x 22.9 cm). The Cleveland Museum of Art, gift of Mrs. John B. Dempsey.

began buying them for their industrial advertising. As soon as I saw that I had a market in this field that I wanted most to follow, I said goodbye to the architects and went into the factories.[24]

Bourke-White's subsequent story is well told in her autobiography *Portrait of Myself* (1963) and need only be summarized here. The "Cleveland bank" was the Union Trust, then the fifth largest bank in the country and the local financier for M. J. and O. P. Van Sweringen's Terminal Tower project. The "industrial advertising" was the bank's monthly magazine, *Trade Winds,* a high-end glossy produced by Union Trust's public relations staff for distribution to investors. The "industrial pictures" used for the frontispieces of the January through August 1928 issues included titles such as *Mountains of Ore* and *A Study in Steel*. Finally, the most important of the "factories" was Otis Steel, where Bourke-White perfected her photographic style of romantic industrialism (figs. 220, 221).

Other independent pictorialists also emerged on the Cleveland scene. Since the late 1880s the city had supported two photographic societies, the Amateur Camera Club and the Cleveland Camera Club, which was reorganized as the Cleveland Photographic Society in 1913. These photographic fraternities had their own club rooms, social events, and contests. They

Figure 220. Margaret Bourke-White, *Blast Furnace Operator with "Mud Gun," Otis Steel Co., Cleveland,* ca. 1928, gelatin-silver print, 13 x 10¼ in. (33 x 26 cm). The Cleveland Museum of Art, gift of Mrs. Albert A. Levin.

Figure 221. Margaret Bourke-White, *Terminal Tower Seen through a Railroad Bridge, Cleveland,* 1928, gelatin-silver print, 14 x 11 in. (35.5 x 28 cm). Herbert and Christine Ascherman Collection.

helped members use the media and manipulative techniques associated with international pictorialism, including bromoil, platinum, carbon, and multiple gum processes. In the 1920s the Photographic Society organized traveling exhibits, established a journal, and formed a photography school. By 1926, when the Smithsonian Institution held an exhibition by the Cleveland Photographic Society, pictorialism had emerged as the "official" club style.[25]

Walter Bruning, Arthur Gray, Albert Schaaf, and Lawrence Schreiber were among the leading pictorialists of the Cleveland Photographic Society. Like Bourke-White, their favorite subjects were the industrial Flats and harbor (figs. 222, 223). They created an evocative poetry of space and light through a mastery of manipulative printing techniques, as well as a sensitivity to compositional arrangement and the sources of fine art photography, including impressionism, Barbizon paintings, and the tonalist style of James A. McNeill Whistler. In her study of modern camera clubs, photohistorian Dona Schwartz has described the soft focus and painterly effects of pictorialism as the style of choice across the national amateur spectrum, noting that "a beautiful [camera club] picture shows beautiful subject matter. If the subject isn't beautiful, a picture can be if the *rendition* of the subject is beautiful."[26]

Why was pictorialism so popular? Critic Barbara Rosenblum has suggested that its "fine art" orientation was associated with individuality and a self-conscious control of space, light, and content: "The fine arts photographer determines for himself practically all aspects of the labor process. . . . He determines what techniques will be employed. . . . He controls each of the hundreds of little decisions that go into making the picture."[27] Seen in this context, Cleveland pictorialism—the fine art camera club mode par

Figure 222. Lawrence Schreiber, *Eagle Street Bridge,* 1930s, gelatin-silver print, 9½ x 7½ in. (24.1 x 19 cm). William and Mary Kubat Collection.

Figure 223. Arthur Gray, *Train on Trestle over the Cuyahoga,* 1940s, gelatin-silver print, 10½ x 13¼ in. (26.8 x 33.6 cm). Cleveland Public Library.

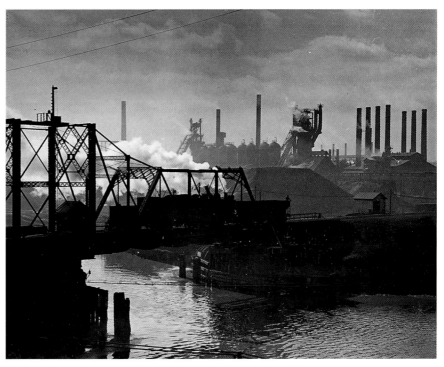

excellence—signifies the maintenance of individual control in a market where such control was possible only in sequestered, artificial situations, such as camera club rooms and exhibitions.

A history of Cleveland photography subsequent to 1940 has yet to be written. Yet the two paths traced here, one through the corporate world and the other through the independent art-photography circuit initiated by the camera clubs, should illuminate the most recent developments.

The history of Cleveland photographs from 1860 to 1940 surely can be viewed as a trajectory from entrepreneurship to corporatism and community identities. The cultural references are rich; the archives are comprehensive and multireferential; the continuity of commercial enterprise and initiative, from individual entrepreneur to corporate manager, is strong. Throughout the period, community identities thrived—both formal fraternities pledged to mutual support and the numerous anonymous photographers who created functionalist and grand style image bases to support Cleveland's commercial and industrial growth.

Yet, embedded within the notion of community identity is the caveat of corporate culture. By institutionalizing photography, corporate strategies and functions have shadowed, if not actually empowered and controlled, the work of key practitioners. Cleveland contributed much to this process. From turn-of-the-century efforts to Bourke-White's photographs of the city, Cleveland was a fundamental matrix in the evolution of the semantics of the modern industrial corporation.

NOTES

1. The three stages of corporate development were defined by economic historian Alfred Chandler, Jr., in *The Visible Hand: The Managerial Revolution in American Business* (Cambridge, Mass: Belknap Press 1977) and its sequel, *Managerial Hierarchies: Comparative Perspectives on the Rise of the Modern Industrial Enterprise* (Cambridge, Mass.: Harvard University Press, 1980).

2. For the basis of my argument that Cleveland photography is a socioeconomic construct whose primary meanings and referents derive from the American system of production, marketing, and exchange, I am indebted to photohistorian Alan Trachtenberg as well as photography critics Allan Sekula and Abigail Solomon-Godeau.

3. James F. Ryder, *Voigtländer and I: In Pursuit of Shadow Catching* (Cleveland: Cleveland Printing & Publishing, 1902), 142.

4. Ryder, *Voigtländer and I,* 137–50.

5. Martha A. Sandweiss, "Undecisive Moments: The Narrative Tradition in Western Photography," in *Photography in Nineteenth-Century America,* ed. M. A. Sandweiss (New York: Harry N. Abrams, 1991), 112.

6. James A. Garfield, referring to an event in 1869, quoted in Ryder, *Voigtländer and I,* 215.

7. Ryder, *Voigtländer and I,* 232.

8. Karen Halttunen, *Confidence Men and Painted Women: A Study of Middle-Class Culture in America, 1830–1870* (New Haven and London: Yale University Press, 1982), 208–9.

9. *Philadelphia Photographer* 7 (July 1870): 226, 251.

10. Ibid., 227.

11. William Ganson Rose, *Cleveland: The Making of a City* (Cleveland and New York: World Publishing, 1950), 366, 383–84.

12. Henry Bellows, "Cities and Parks: With Special Reference to the New York Central Park," *Atlantic Monthly* 7 (April 1961): 420, cited in Susanna S. Zetzel, "The Garden in the Machine: The Construction of Nature in Olmsted's Central Park," *Prospects* 14 (1989): 311.

13. Zetzel, "The Garden in the Machine," 329, 331.

14. David E. Nye, *Image Worlds: Corporate Identities at General Electric, 1890–1930* (Cambridge, Mass.: MIT Press, 1985), 148–52.

15. Terry Smith, *Making the Modern: Industry, Art, and Design in America* (Chicago: University of Chicago Press, 1993), 126–31.

16. Marianne Doezema, "The Clean Machine: Technology in American Magazine Illustration," *Journal of American Culture* 11 (1988): 73–92.

17. Harold C. Livesay, "From Steeples to Smokestacks: The Birth of the Modern Corporation in Cleveland," in *The Birth of Modern Cleveland, 1865–1930,* ed. Thomas F. Campbell and Edward M. Miggins (Cleveland: Western Reserve Historical Society, 1988), 62.

18. Ulrich Keller, "Photojournalism around 1900: The Institutionalization of a Mass Medium," in *Shadow and Substance: Essays on the History of Photography in Honor of Heinz K. Henisch,* ed. Kathleen Collins (Bloomfield Hills, Mich.: Amorphous Institute Press, 1990), 293–96.

19. Louis van Oeyen Photographs, Western Reserve Historical Society Photograph Collection, Cleveland.

20. Rose, *Cleveland: The Making of a City,* 573.

21. Peter B. Hales, *Silver Cities: The Photography of American Urbanization, 1839–1915* (Philadelphia: Temple University Press, 1984), 90–109.

22. F. Hopkinson Smith, *Charcoals of New and Old New York* (New York, 1909), 98, quoted in Merrill Schleier, "The Image of the Skyscraper in American Art, 1890–1931" (Ph.D. diss., University of California, Berkeley, 1983), 73.

23. M. F. Agha, "Photography," in *Margaret Bourke-White, Ralph Steiner, Walker Evans: Photographs by Three Americans,* exh. brochure (John Becker Gallery, 1931), unpaginated.

24. Margaret Bourke-White, unpublished autobiographical draft, ca. 1928–33, Margaret Bourke-White Papers, Syracuse University.

25. Sarah L. Evanko, *The First 100 Years: The History of the Cleveland Photographic Society, 1887–1987* (Cleveland: Cleveland Photographic Society, 1987).

26. Dona Beth Schwartz, "Camera Clubs and Fine Art Photography: Distinguishing between Art and Amateur Activity" (Ph.D. diss., University of Pennsylvania, 1983), 97.

27. Barbara Rosenblum, "Style as Social Process," *American Sociological Review* 43 (June 1978): 425, 432.

A CLEVELAND ART CHRONOLOGY

1796

Cleveland founded by settlers from Connecticut led by surveyor Moses Cleaveland.

1801

Chairmaking firm established in Cleveland.

1802

First frame house built in Cleveland.

1803

Ohio admitted as the seventeenth state of the Union.

1807

Samuel Dearborn of Boston, Cleveland's first portrait painter, arrives from Pittsburgh, stays for two years; helps found the Apollonian Society, an organization devoted to choral music.

1815

William Bliss, Cleveland's first silversmith, arrives for a three-year stay.

1825

Erie Canal opens, establishing a water route between Cleveland and New York City.

Jarvis Hanks, an itinerant portrait painter, spends about a year in Cleveland.

1832

Ohio and Erie canals completed, connecting Lake Erie at Cleveland with the Ohio River at Portsmouth.

1835

Hanks returns to Cleveland, becoming the first easel painter to sustain a career in the city.

1842

Allen Smith, Jr., trained in New York City and previously active in Detroit, moves to Cleveland, where he lives until ca. 1859; returns to the city in 1865 and remains until retiring to Painesville in 1883.

1844

Benjamin West's *Christ Healing the Sick* exhibited at the First Presbyterian Church. Court House hosts a traveling exhibition of Old Master copies.

1845

Sebastian Heine and Louis Chevalier open a decorative painting firm.

1851

Cleveland's first railroad line completed.

1859

Julius Gollmann, a German immigrant who had arrived in Cleveland in 1857, paints *An Evening at the Ark* for $400.

Edgar Decker establishes a lucrative photography studio.

1860

Short-lived Cleveland Sketch Club organized. Members are largely amateur artists who bring drawings on a preselected topic to each meeting.

1861

Civil War begins. Of Cleveland's 15,000 eligible men, 10,000 serve in the war.

Caroline Ransom, the city's first professional woman artist, arrives from Sandusky.

1864

Northern Ohio Sanitary Fair, a civic affair organized to raise funds for Civil War veterans, features a section devoted to work by local artists, including part of Smith's 1848 suite of doctor portraits for the medical department of Western Reserve College.

1865

Civil War ends.

1867

Western Reserve Historical Society founded.

Ransom travels to France, Germany, and Italy.

1870

First Northern Ohio State Fair opens and includes an art exhibition with prizes.

Second annual convention of the National Photographic Association, the first major professional society for photographers, convenes in Cleveland.

John D. Rockefeller charters the Standard Oil Company.

1872

James F. Ryder sets up a photography studio and art gallery.

1874

De Scott Evans, leaving his position as professor of art at Mount Union College in Alliance, Ohio, opens a studio that Otto Bacher and Adam Lehr enter as students.

1875

Archibald Willard of Wellington establishes a studio; in 1876 his painting *The Spirit of '76* appears in the Philadelphia Centennial Exposition. Chromolithographs of the painting published by Ryder make the image nationally famous.

1876

Bacher, Evans, Willard, William Eckman, and Sion Wenban among others establish the Art Club, which remains active until 1900, with classes and annual exhibitions (beginning in 1877) held on the top floor of City Hall.

1877

Evans studies in Paris with William Bouguereau; upon his return in 1878, Evans begins teaching at the Art Club.

Violent labor strikes in the city.

1878

Cleveland Loan Exhibition 1878, held at the High School Building, includes work by local and national artists as well as European and Asian paintings; attendance exceeds 40,000. Profits donated to social relief.

Bacher, Wenban, and Willis Seaver Adams go to study in Europe. Bacher attends the Royal Academy of Art in Munich, 1878–79, and studies with Frank Duveneck in Munich and Florence, before going to Venice, where he becomes a colleague of James A. McNeill Whistler.

1881

Cleveland Academy of Art incorporated.

1882

Oscar Wilde lectures on the English arts and crafts movement, urging Clevelanders to set up a design school.

Western Reserve School of Design for Women established to prepare women for jobs in local industries. By mid-1880s men are admitted as well. Incorporated as the Cleveland School of Art in 1891, it became the Cleveland Institute of Art in 1948.

Art Students League established in Cleveland.

1883

Bacher, recently returned from Europe, and Joseph DeCamp open a summer school at Richfield, Ohio.

Cleveland Academy of Art publishes the periodical *The Sketch Book,* which lasts a little more than a year.

1885

Bacher moves to Paris and then to New York City, returning to Cleveland only for short visits for the balance of his career.

Frederick Gottwald returns from Munich, begins teaching at Western Reserve School of Design and remains on the faculty until retiring in 1926.

1887

Cleveland Camera Club established. Reorganized as Cleveland Photographic Society in 1913.

1888

Henry Church, Jr., opens Church's Art Museum at Geauga Lake Park.

1894

January: Amid economic depression, local labor strikes, and riots, the Cleveland Art Loan Exhibition, organized by Charles Olney in the Hickox Block, benefits the city's poor and unemployed, raising more than $13,000.

1895

January-February: Exhibition of the Cleveland Art Association reprises success of previous year's show.

Brush and Palette Club, consisting exclusively of professional painters, established and mounts semi-annual exhibitions until about 1898.

Watercolor Society established, with George Bradley as first president.

Louis Rorimer returns from Europe and in 1896 opens a studio for producing handmade furniture, architectural moldings, and crafts.

1897

Gottwald opens his summer school in Zoar.

1902

Henry Keller returns to Cleveland after three years of study in Germany.

George Adomeit and W. H. Webster establish Caxton Engraving Company.

1903

Keller spends first summer painting on family farmland in Berlin Heights. He also begins teaching watercolor painting at the Cleveland School of Art and remains on faculty until 1945.

1905

Carl Moellmann, pupil of Robert Henri, arrives from New York City to work for a Cleveland lithography company.

Cleveland School of Art opens a new building in University Circle, housing the largest art gallery in the city.

1906

Art school sponsors first in a series of annual exhibitions of works by Cleveland artists.

Gottwald begins spending summers painting in Italy. In the fall he exhibits these paintings at the Cleveland School of Art.

1907

William Sommer begins working at a Cleveland lithograph company, where he meets William Zorach.

1908

Abel Warshawsky leaves for a two-year stay in Paris, encountering impressionist and post-impressionist paintings.

George Gage of New York is hired to manage the Taylor Gallery in Cleveland.

1909

Keller's summer school is officially open at Berlin Heights and remains active until the early 1920s, attracting August Biehle, Clara Deike, William Eastman, Grace Kelly, and Frank Wilcox.

Horace Potter establishes Potter Studio.

1910

Cleveland becomes the nation's sixth most populous city.

Keller initiates scientific experiments in color theory with John MacCleod of Western Reserve Medical School.

Gottwald again exhibits paintings of Italy at the art school.

Jane Carson Barron, Mildred Watkins, and members of the Rokesley Studio exhibit at Korner & Wood as the Decorative Arts Club.

Two design companies merge to form the Rorimer-Brooks Studios.

Biehle begins two years of study in Munich.

Zorach leaves with Elmer Brubeck for Paris.

Fall: Warshawsky returns from Paris and exhibits impressionist paintings at Rorimer-Brooks Studios that impress Sommer and Zorach.

1911

Mural by Kenyon Cox installed at the Federal Building in Cleveland.

Japanese prints exhibited at Korner & Wood Galleries.

Magazine *Cleveland Town Topics* publishes an article about cubism that first appeared in *Figaro* and *Literary Digest.*

February: Sommer, Keller, Warshawsky, and others exhibit as "secessionists" at Rorimer-Brooks Studios.

Summer: Warshawsky leaves for Europe.

Kokoon Klub established by Sommer, Moellmann, and other commercial lithographers. The club holds its first exhibition in November and remains active until 1956.

1912

Women's Art Club established with more than 25 members; it institutes annual exhibitions, competitions, and lectures and stays active until the 1950s.

Charles Burchfield enters the Cleveland School of Art to learn commercial illustration; studies with Gottwald but dislikes conventional studio classes and gravitates toward Eastman, Keller, and faculty members in applied art and design.

February: Zorach, having recently returned from Europe, exhibits with "secessionists" at Taylor Gallery. Visitors are bewildered by his pure, primary colors.

March: Zorach's first solo exhibition at Taylor Gallery.

Summer: Biehle returns from Munich. In September he exhibits modernist paintings influenced by the German Blue Rider group at Rorimer-Brooks Studios.

December: R. Guy Cowan and Mildred Watkins exhibit ceramics at Taylor Gallery. Gage leaves managerial position at Taylor Gallery to establish Gage Gallery.

1913

A year of great excitement, upheaval, and controversy in Cleveland art. Open conflicts arise between modernists and conservative painters.

Keller and MacCleod publish "The Application of the Physiology of Color Vision in Modern Art."

Cleveland Museum of Art incorporated; construction soon begins.

Cowan opens Cleveland Pottery and Tile Company, later incorporated as Cowan Pottery Studio.

Gage Gallery opens, exhibits American impressionist paintings borrowed from MacBeth Galleries in New York.

Eastman and Wilcox join the faculty of the Cleveland School of Art as instructors of design.

January: Kokoon Klub holds first masked ball, a fund-raising event that becomes a popular annual social event until 1946.

February: Keller exhibits works in the Armory Show, visits the exhibition, which he urges his colleagues to see, and delivers five public lectures about modern art at Potter Studio.

March: Cleveland Society of Artists founded as conservative rival to the Kokoon Klub by Adomeit, Coltman, Gottwald, William Edmondson, and others. They meet at Gage Gallery. The society aspires to continue traditions of academic art and craftsmanship. After 1918 modernists will join, including Biehle, Eastman, Keller, and Wilcox.

June-July: An exhibition of ten French cubist paintings opens at Taylor Gallery. Keller writes the catalogue essay. *Cleveland Plain Dealer* ridicules this exhibition of "freak" art, while *Leader* is sympathetic.

1914

Sommer converts a schoolhouse in Brandywine into a studio.

Hatch Galleries opens a group exhibition that includes works by Biehle, Eastman, Keller, Kelly, and Wilcox.

Eastman and Keller lecture about modern art at the Cleveland Inter-Arts Club.

January: Exhibition of American cubists and post-impressionists opens at Taylor Gallery and includes paintings by Sommer, Warshawsky, Wilcox, Zorach, Marsden Hartley, and Max Weber. Gottwald denounces the new art as "all rot!"

August: World War I begins.

October: Hatch Art Studios and Gallery established and sponsors an exhibition of Chinese scroll paintings.

November: Newspapers praise exhibition of Gottwald's Italian paintings at the Cleveland School of Art.

1915

Playhouse Settlement, from which Karamu House evolves, founded as a social settlement but soon expands services to include an arts center.

Cleveland Art Association established to promote local artists by purchasing their works and donating them to the art museum, offering scholarships to the art school, sponsoring lectures, and organizing exhibitions.

Murals by Cox and Edwin Blashfield installed in the Citizen's Savings and Trust Building.

Sommer and Zorach exhibit paintings at Kokoon Klub's "Nuit Futuriste," during which the "blasts" (Eastman, Keller, Wilcox, and Walter Heller) read an artistic manifesto accompanied by futurist signs and bizarre "noise."

Burchfield, impressed with Sommer's work, visits him in Brandywine.

Society of Cleveland Artists holds an exhibition at Korner & Wood Galleries that includes paintings by Adomeit, Coltman, Edmondson, and Gottwald.

Max Kalish returns from working on Panama-Pacific Exposition in San Francisco.

June: Kokoon Klub hangs selection of paintings by Sommer and Zorach. Burchfield wins third prize in the promotional poster competition for the Cleveland Museum of Art's inaugural exhibition, scheduled for the following spring.

1916

Richard Laukhuff, a German immigrant, opens a bookstore in the Taylor Arcade that becomes a meeting place for intellectuals; exhibits paintings by Sommer.

Cleveland Art Association established to sponsor scholarships for art study and to purchase Cleveland art for donation to Cleveland Museum of Art.

Cleveland Play House (or "Little Theater") established as an experimental workshop for collaborative productions by artists, poets, dancers, and musicians. Raymond O'Neil elected first director.

June: Cleveland Museum of Art opens to the public with a large loan exhibition that includes works from Cleveland private collections as well as Chinese scroll paintings from the Freer Collection.

Summer: Burchfield graduates, has his first solo exhibition at the Cleveland School of Art.

1917

Burchfield's second solo exhibition opens at the art school.

Henry Turner Bailey, dean of education at the Cleveland School of Art, urges artists to find beauty in their city and champions the notion that art should aid industry.

In response to rising anti-German and anti-Semitic sentiment, Louis Rorheimer changes his surname to Rorimer.

United States enters World War I.

1918

Sommer designs sets and costumes for a production of *Everyman* at the Play House, where an exhibition of modernist paintings includes works by Sommer and Deike.

January: Exhibition of modernist paintings opens at the Play House, including work by Biehle, Burchfield, Deike, Keller, Sommer, Wilcox, and Zorach.

March: Exhibition by Pictorial Photographers of America opens at the art museum.

May: Cleveland Museum of Art makes its galleries available for the annual juried exhibition of works by local artists organized by the Cleveland Society of Artists. Controversy erupts over the hanging, prompting the art museum to assume control over the exhibition the following year (the first May Show).

Fall: Willard dies.

November: World War I ends.

1919

February: Play House opens two exhibitions: paintings by Zorach and his wife, Marguerite, and watercolors by Burchfield.

May Day riots on Public Square.

May: Frederic Whiting, director of the art museum, urges artists to paint the city and find beauty in its factories. William Milliken, curator of decorative arts, placed in charge of the May Show; newspapers praise the exhibition, which features the "sane" modernism of Keller and Wilcox.

1920

William Grauer, trained in Philadelphia, settles in Akron.

Cleveland Print Club established.

1921

Moellmann leaves Morgan Lithography to establish own company, Continental Lithography.

Sandor Vago moves to Cleveland.

June: Art museum institutes an annual exhibition of contemporary American painting, a balanced selection of national and local artists. The exhibition remains an annual event at the museum until 1935, after which it occurs only in 1940.

Summer: Burchfield, Keller, and Wilcox go on an extended sketching trip through eastern Ohio. Burchfield has his third solo exhibition at the Cleveland School of Art.

November: Burchfield's job as an account clerk in Salem eliminated. Dean of art school helps him find a position as a wallpaper designer in Buffalo.

1922

Allen Cole opens a photography studio in the African-American community on Cleveland's east side.

1923

Kokoon Klub's annual masked ball banned by Mayor Fred Kohler for "drunkenness" and "immorality." Reinstated the following year but closely monitored by police. The mayor requests that members wear formal attire and refrain from dancing.

1925

Ohio Watercolor Society established, with Keller as Cleveland vice-president.

Rolf Stoll moves to Cleveland.

Russian-born sculptor Alexander Blazys arrives in Cleveland.

1926

Gottwald retires from the art school, moves to Italy.

1927

Paul Travis travels to Africa and—with funds supplied by the African Art Sponsors of the Playhouse Settlement (Karamu House)—purchases African art for the settlement, the natural history museum, and the art museum.

Clarence Carter graduates from the Cleveland School of Art. Milliken creates a private scholarship fund that Carter uses to travel in Europe.

Margaret Bourke-White opens a studio; begins photographing steel mills in the Flats.

1928

William Grauer commissioned to paint two large murals of the Flats for Cleveland Builders Exchange.

1929

Sommer, laid off from Otis-Morgan Lithography, begins a period of unemployment and heavy drinking.

Carter returns from Europe, teaches studio classes at the art museum from 1930 to 1937.

Bourke-White leaves Cleveland to accept a photojournalist position with *Fortune* magazine.

October: Stock market crashes.

1930

Milliken named director of the Cleveland Museum of Art; continues to organize May Show until retiring in 1958.

Cleveland Print Makers established by Kálmán Kubinyi.

Cleveland Union Terminal (Terminal Tower) opens.

1931

Unemployment and bank failures reach alarming levels as the nation sinks into the Great Depression.

Cowan Pottery Studio closes.

Viktor Schreckengost returns after a year studying ceramics in Vienna.

1932

Cleveland Print Makers opens a gallery where it sponsors lectures, demonstrations, and exhibitions.

Summer: First Cleveland Curb Market held at University Circle to sell works by hundreds of unemployed artists. Many Cleveland artists are in desperate circumstances over the winter.

1933

March: Franklin Roosevelt assumes presidency and initiates the New Deal.

Summer: Second Curb Market for artists; sales are few. Third and last in 1934.

December: Roosevelt administration creates Public Works of Art Project to provide work relief for artists.

Milliken appointed director of PWAP region nine, encompassing four states. Hundreds of Cleveland artists apply for work but only 69 can be hired.

PWAP murals for the Cleveland Public Library are commissioned from Carter, Coltman, Sommer, and Ambrozi Poliwada.

1935

Federal Art Project of the Works Progress Administration succeeds PWAP in providing work for artists.

Exhibition of works created under the auspices of PWAP and WPA held at the Cleveland Museum of Art.

Traveling exhibition, organized by the art museum, of paintings by Cleveland artists circulates to seven venues.

Edris Eckhardt named district supervisor of WPA ceramics and sculpture division; Kubinyi serves in the same capacity for the graphic arts division.

1936

WPA employs 75 Cleveland artists to create art for factories.

Great Lakes Exposition opens.

City of Cleveland establishes a program of acquiring local art for its municipal collection; Grauer appointed curator.

Anti-fascism art exhibition mounted under auspices of the American League against War and Fascism, and the Cleveland chapter of the American Artists Congress.

Local chapter of the United Artists Union, a leftist group, elects Dorothy Rutka executive secretary. In subsequent years, Leroy Flint and Kubinyi serve in same capacity.

1937

Whitney Museum of American Art in New York presents an exhibition of Cleveland art.

1938

Charles Sallée and Hughie Lee-Smith graduate from the Cleveland School of Art, apparently the first African-Americans to do so.

Carter moves to Pittsburgh.

Jolán Gross-Bettelheim moves to New York City.

1939

Exhibition *American Painting from 1860 to Today* organized by the Cleveland Museum of Art.

Kubinyi named supervisor of entire WPA in Cleveland.

World War II begins in Europe.

1940

Although still the nation's sixth largest city, Cleveland's population decreases for the first time in its history.

African-American artists at Karamu House organize Karamu Artists Incorporated.

Lee-Smith moves to Detroit.

1941

Gottwald dies.

December: Japan bombs Pearl Harbor and the United States enters World War II; during the war, 160,000 Clevelanders serve in the armed forces.

1942

Lee-Smith, Sallée, Schreckengost, Raphael Gleitsmann, William E. Smith, and numerous other artists enter military service. As attention turns to the war effort, attendance at cultural events declines, and enrollments drop at the Cleveland School of Art.

1943

WPA ends.

Demand for war materiel boosts industrial production in Cleveland and employment rises.

1945

Kalish dies.

Keller retires from the Cleveland School of Art.

World War II ends.

1946

Vago dies.

Sommer, drinking heavily after the death of his wife, is declared incompetent by a probate court.

Increasing automobile ownership and highway construction accelerate migration of Cleveland residents to the suburbs.

Cleveland commemorates its 150th birthday with citywide parades and pageants. The high-spirited festivities also welcome the new postwar era by celebrating the victorious end of the war and the city's economic recovery.

ARTIST BIOGRAPHIES

The artist files maintained by the Ohio Artists Project at Oberlin College Library and Ingalls Library at the Cleveland Museum of Art are invaluable resources for learning about Cleveland artists. Although these files are not listed in the selected references sections below, they have nonetheless been used extensively.

Little information has yet come to light on a number of artists whose works appear in the exhibition. For this reason, no biographies are presented for Albert Bisbee, Walter Bruning, William Eckman, Charles Fairbanks, J. M. Greene, K. A. Liebich, Thomas Sweeny, H. D. Udall, and Webster and Albee. Because Henry T. Anthony did not have a prominent role in the history of Cleveland art, no biography appears for him.

GEORGE ADOMEIT

(1879–1967)

CA. 1912

A major painter of American scene subjects, George Adomeit was born in Memel, Germany, and came to Cleveland at the age of four with his family. He worked as a commercial printer and lithographer for most of his life. After serving an apprenticeship in a local photo-engraving shop, he cofounded the Caxton Company, an engraving and commercial art firm that gained national acclaim. He eventually served as company president, and, although his duties at the firm were time-consuming, he continued to pursue painting and printmaking. His talent for drawing led to formal art training, first at the Art Club with Frederick Gottwald, Max Bohm, and Ora Coltman and later at the Cleveland School of Art, from which he graduated in 1911. Adomeit's first solo exhibition, at Taylor Gallery (1912), was of work painted during previous summers in Zoar, Ohio, a popular outdoor painting locale for artists interested in rural subject matter. One of the founders of the Cleveland Society of Artists, Adomeit exhibited with that organization through the 1930s, and his paintings appeared regularly in the May Shows at the Cleveland Museum of Art (1919–59). His imagery was inspired by many locations, including the Cleveland area and vacation spots such as Cape Cod, Monhegan Island off the coast of Maine, and sites in Mexico, Canada, and Brazil. He also attained a national reputation by exhibiting in annual group shows at the Pennsylvania Academy of Fine Arts (1925–41), the Toledo Museum of Art (1928–35), the Corcoran Gallery of Art (1928–37), and museums in Detroit, Chicago, St. Louis, Pittsburgh, Buffalo, Los Angeles, and New York. During the 1940s, his paintings appeared in solo exhibitions at galleries in Cleveland and Washington, D.C. After his retirement from the Caxton Company in 1956, Adomeit continued to travel, paint, and exhibit.

Selected References

Keny, James M., and Nannette V. Maciejunes. *Triumph of Color and Light: Ohio Impressionists and Post-Impressionists,* 90. Exh. cat. Columbus, Ohio: Columbus Museum of Art, 1994.

Sommer, Edith. "Art and Artists." *Cleveland Town Topics,* 23 March 1918, 25.

RUSSELL BARNETT AITKEN

(b. 1910)

CA. 1934

A master of caricature, Russell Aitken is most noted for mock-heroic figures deftly executed in ceramic. Raised in an affluent family, Aitken seemed destined to follow his father's career in electrical engineering. At age ten, however, he became interested in clay modeling. He studied at the Cleveland School of Art, graduating in 1931, and spent the next two years working with Michael Polowny and Joseph Hoffmann at the Kunstgewerbeschule in Vienna. Upon returning to Cleveland, Aitken established a national reputation through repeated appearances in the annual May Shows at the Cleveland Museum of Art and the Ceramic Nationals at the Everson Museum in Syracuse, New York. In 1933 he cofounded the Pottery Workshop, where he worked as an instructor and experimented with glazes and techniques learned in Europe. After just two years the workshop closed for financial reasons. To expand his market Aitken opened a studio in New York in 1935 while retaining his two Cleveland studios. Although he enjoyed two successful solo exhibitions at the Walker Art Galleries in New York in the late 1930s, he could not produce enough income to sustain his lifestyle as a "playboy ceramist," in the words of a biographical feature in *Esquire* magazine. After military service during World War II, he developed other interests and abandoned his career in ceramic sculpture.

Selected References

Anderson, Ross, and Barbara Perry. *The Diversions of Keramos: American Clay Sculpture 1925–1950,* 74–80. Exh. cat. Syracuse, N.Y.: Everson Museum of Art, 1983.

Salpeter, Henry. "Aitken: Playboy Ceramist." *Esquire* (October 1939): 74–75, 183–86.

OTTO BACHER

(1856–1909)

1890s

Painter and print-maker Otto Bacher was the first artist from Cleveland to earn international renown in the art world. Born in Cleveland, Bacher grew up in a neighborhood bordering the east bank of the Cuyahoga River near the mouth of Lake Erie. A childhood pastime of sketching shipping activities in the busy port eventually led to a job painting inscriptions on commercial vessels. He became interested in art during his teen years and studied with De Scott Evans and also learned from Willis Seaver Adams and Sion Wenban. In 1876 Bacher helped found the Art Club and had a solo show at the Kemmer and Kushman Decorating Company. The following year he had his second solo exhibition, at J. W. Sargeant's Art Shop. He traveled to Europe in 1878, attended the Munich Royal Academy, and studied with Cincinnati native Frank Duveneck in Munich, Florence, and Venice. A chance meeting in Venice with James A. McNeill Whistler in 1880 led to a long friendship that had a decisive effect on Bacher's etching style. In 1883 Bacher returned to Cleveland and began teaching at the Cleveland Academy of Art and privately at a summer retreat he organized in Richfield, Ohio. He returned to Europe in 1885, hoping to stay for an extended period, but his financial situation forced him to come back to America. After a brief visit to Cleveland, Bacher settled in New York City. To support himself, he did illustrations for *Century Magazine* in 1888. In 1895 he moved to Bronxville, New York, and by that time his artistic style revealed a strong debt to impressionism. During the last two decades of his life, he exhibited in New York, London, Paris, St. Louis, Philadelphia, and Cleveland. Bacher died in Bronxville.

Selected References

Andrew, William W. *Otto H. Bacher*. Madison, Wis.: Education Industries, 1973.

Bacher, Otto H. *With Whistler in Venice*. New York: Century, 1908.

Keny, James M., and Nannette V. Maciejunes. *Triumph of Color and Light: Ohio Impressionists and Post-Impressionists,* 92–93. Exh. cat. Columbus, Ohio: Columbus Art Museum, 1994.

Otto Bacher 1856–1909. Exh. cat. Chicago: R. H. Love Galleries, 1991.

SOL BAUER

(1898–1982)

CA. 1949

Cleveland-born Sol Bauer carved soapstone as a young boy, but by the time he reached high school, he preferred the medium of wood. Along with his interest in art, he sought a career in engineering and attended the Case School of Applied Science in Cleveland, graduating in 1920. In the early 1920s, while working as a civil engineer, he studied sculpture with Walter Sinz in evening classes at the Cleveland School of Art. Bauer established his own engineering firm in 1926. Continuing to produce wood sculpture in his spare time, he exhibited in May Shows at the Cleveland Museum of Art (1928–56) and in annuals at the Pennsylvania Academy of Fine Arts in Philadelphia (1933–58). His sculptures appeared in solo exhibitions at Cleveland's Potter-Mellen Company (1929) and the Union Trust Arcade (1938). In the early 1940s he worked as a part-time instructor of sculpture at the Jewish Council for Educational Alliance. Bauer retired from civil engineering in 1969.

AUGUST BIEHLE

(1885–1979)

1911

A versatile painter who worked in a variety of genres and styles, August Biehle was active in Cleveland for more than three-quarters of a century. Born in Cleveland in 1885 to German immigrant parents, he apprenticed at an early age to his father, a painter trained in Germany who produced decorative murals for fashionable homes. In 1903 Biehle traveled to Europe to receive a formal art education. After a brief stint in Paris, he studied for two years at the Kunstgewerbeschule in Munich. Returning to America, he attended evening classes at the Cleveland School of Art, 1906–9, studying with Frederick Gottwald. Although Biehle worked as a consultant for the Sherwin-Williams Paint Company, his interest in easel painting compelled him in 1910 to make a second trip to study in Munich, where he was impressed by the expressionist paintings of the Blue Rider group. In the fall of 1912, after returning to Cleveland, Biehle exhibited his modernist paintings at the Rorimer-Brooks Studios and the Korner & Wood Galleries. To support himself, he worked as a commercial lithographer until he retired in 1952. Around 1913 he became friendly with

William Sommer and joined the Kokoon Klub. With Sommer and others he went on painting excursions to Berlin Heights, Ohio. Biehle participated in the exhibition of American modernists at the Taylor Gallery (1914). The following year his paintings were displayed in a solo exhibition at the Kokoon Klub, where he continued to show through the 1930s. Although his last solo exhibition was mounted in 1963, Biehle continued to exhibit in group shows through the late 1970s, including the annual May Shows at the Cleveland Museum of Art (1920–77).

Selected References

Sackerlotzky, Rotraud. *August F. Biehle, Jr.: Ohio Landscapes*. Exh. cat. Cleveland: Mather Gallery, 1986.

———. *Henry Keller's Summer School in Berlin Heights*. Cleveland: Cleveland Artists Foundation, 1991.

LAWRENCE BLAZEY

(b. 1902)

CA. 1935

An advertising artist and industrial designer by trade, Cleveland native Lawrence Blazey produced paintings and ceramics throughout his long career. After graduating from the Cleveland School of Art in 1924, he was awarded a scholarship to study at the Slade School in London. Returning to Cleveland, he taught advertising art in evening programs at his alma mater. From the 1930s through the 1980s, he worked in advertising and industrial design for various firms in Cleveland, Chicago, Detroit, and Toledo. In the 1930s and 1940s he painted regularly and showed his works in solo exhibitions at the Korner & Wood Galleries and at annual group exhibitions at the Cleveland Museum of Art, the Art Institute of Chicago, and the Pennsylvania Academy of Fine Arts in Philadelphia. In the late 1930s he studied ceramics at the Cranbrook Academy of Art in Michigan and subsequently showed in the annual Ceramic Nationals at the Everson Art Museum in Syracuse. He worked as a part-time instructor of ceramics at the Huntington Polytechnic Institute in Cleveland, 1948–56. Blazey continued to display his ceramics and paintings at various Cleveland exhibitions until 1992 and now lives in California.

ALEXANDER BLAZYS

(1894–1963)

Cleveland's leading modernist sculptor of the 1920s, Alexander Blazys was born in Poniewiesz, Lithuania. After graduating from military school, he studied sculpture for seven years at the St. Petersburg Academy of Fine Arts. He visited Paris frequently during this period and in 1920 decided not to return to the Soviet Union because of the political restrictions placed on modernist art. Working in Paris, he received critical acclaim for sculptures exhibited in the Salon des Indépendants. In 1923 he immigrated to Detroit, where he exhibited and received his first American commissions. The following year he moved to New York City but, upon the invitation of a friend, settled in Cleveland in 1925. Blazys' gracefully stylized sculptures of East European folk dancers and musicians in the 1926 May Show at the Cleveland Museum of Art established his reputation as "the sculptor of rhythms." He was immediately embraced by the Cleveland art community, receiving numerous commissions for portrait busts, from which he earned his primary income. He was head of the sculpture department at the Cleveland School of Art, 1926–38. In 1927 his large bronze figural work *City Fettering Nature* was installed on the grounds of the Cleveland Museum of Art. Around this time Blazys joined the staff of the Cowan Pottery Studio as a designer and encouraged the studio to experiment with ceramic sculpture. Cleveland's Eastman Bolton Gallery sponsored his first solo exhibition (1929), and his works subsequently appeared in group shows in Cleveland, Chicago, and Philadelphia. Although he remained active in the local art scene during the 1930s, his popularity waned, and in the early 1940s, after completing a Works Progress Administration commission to create stone relief carvings for the Woodhill Homes housing project, he moved to New Jersey and worked for a series of ceramic firms creating molds for mass-produced figurines. Blazys returned to Cleveland in 1952.

Selected References

Fort, Ilene Susan. *The Figure in American Sculpture: A Question of Modernity,* 180–81. Exh. cat. Los Angeles: Los Angeles County Museum of Art, 1995.

Hawley, Henry. "Cowan Pottery and the Cleveland Museum of Art." *Bulletin of the Cleveland Museum of Art* 76 (September 1989): 238–63.

MAX BOHM

(1868–1923)

1910

More than any other painter associated with Cleveland during the 19th century, Bohm achieved an international reputation, yet in this century that renown has gone into almost total eclipse. Born in Cleveland, where his German immigrant father was a wealthy lumber merchant, Bohm displayed an early talent for painting. By his mid-teens he was both a member of the Art Club and employed as a lithograph designer. In 1887 he traveled to Paris with his aunt, the artist Anna Stuhr Weitz, and studied with Jean-Paul Laurens and Benjamin Constant at the Académie Julian. He began to exhibit at the Paris Salon two years later and during the 1890s showed there as well as in several German cities. He also exhibited 12 large canvases at the Art Club during a year-long stay in Cleveland in 1892–93. After returning to France, he started teaching at the coastal town of Etaples on the English Channel north of Paris, where he produced imaginative figural subjects with marine settings. Bohm's professional breakthrough came when he received a gold medal at the Paris Salon for *En Mer* (1898, Alfred J. Walker Fine Art, Boston). This acclaim resulted in a hero's welcome from the Cleveland art community upon his return home at the end of 1901. With his Minnesota-born wife, whom he had met in Etaples in 1898, Bohm moved to London about 1905, continuing to summer in France. During a trip to Cleveland in 1909–10, he produced *Voting at New England Town Meeting,* a mural on a historical subject for the newly built Cuyahoga County Courthouse. Returning to Europe in 1910, he moved to Paris but relocated permanently to America at the onset of the World War I, settling in Bronxville, New York, and summering at the Provincetown, Massachusetts, art colony beginning in 1917. The Albright Art Gallery in Buffalo, New York, organized a memorial exhibition for Bohm in 1924.

Selected References

Akullian, Charleen. "Max Bohm: Romantic American Visionary." *American Art Review* 6 (October–November 1994): 116–21, 172.

Danforth Museum of Art. *Max Bohm, 1868–1923: Romantic American Visionary.* Boston: A. J. Walker/Townhouse, 1994.

Johnson, Allen, ed. *Dictionary of American Biography,* 2:411–12. New York: Scribners, 1929.

MARGARET BOURKE-WHITE

(1904–1971)

CA. 1929

One of the foremost photographers of this century, Margaret Bourke-White began her career in Cleveland. Born in New York, she first studied at the Clarence White School of Photography. After graduating from Cornell University, she moved to Cleveland in 1927 to live with her widowed mother. Bourke-White turned her interest in photography into a career by obtaining free-lance assignments from local society and business publications. Her greatest interest, however, was the steel-making process, and she received permission to photograph activities at the Otis Steel Company, a firm located in the Cleveland Flats. Her Otis Steel photographs caught the attention of Henry Luce, founder of *Time* magazine, who hired her to work as a photojournalist for his new publication, *Fortune.* Later in the 1930s she joined the burgeoning staff of *Life,* another magazine headed by Luce. Her photo essays published during the subsequent decades were highly regarded. At the age of 49 she was diagnosed with Parkinson's disease. Despite progressive physical deterioration, she continued to accept photographic assignments until 1957. Bourke-White died in Stamford, Connecticut.

Selected References

Bourke-White, Margaret. *Portrait of Myself.* New York: Simon and Schuster, 1963.

Brown, Theodore M. *Margaret Bourke-White: The Cleveland Years, 1927–1930.* Exh. cat. Cleveland: New Gallery of Contemporary Art, 1976.

Goldberg, Vicki. *Bourke-White: A Biography.* New York: Harper and Row, 1986.

ELMER BROWN

(1909–1971)

Painter and printmaker Elmer Brown was a leading Karamu artist of the 1930s and 1940s. Born in Pittsburgh, Brown moved to Columbus, Ohio, at an early age. After a series of family disruptions, the teenaged Brown became a vagrant. During his wanderings, he began to draw "anything, with a piece of coal, a pencil stub, or chalk, on sidewalks, walls, or freight car doors." In 1924 he was put on a chain gang for illegally riding freight trains, an experience that gave him a "sudden and harsh maturing." After moving to Cleveland in 1929, he associated with the art and theater departments of Karamu House, working as an actor and stage designer. He attended

the Huntington Polytechnic Institute in Cleveland, 1933–34, on a Gilpin Players scholarship supplied by Karamu. Brown exhibited in the annual May Shows at the Cleveland Museum of Art (1934–43). In 1936 he joined the Cleveland theater project of the Works Progress Administration, working in scenic design. He later worked in the departments of graphic arts and sculpture-ceramics of the WPA. In the late 1930s and early 1940s, under the auspices of the WPA Ohio Art Project, Brown painted three murals for Valleyview Homes in Cleveland, a federal housing project. He exhibited with other Karamu House artists in New York City and Philadelphia (1942). Also that year he received two major commissions: one from the Men's City Club of Cleveland to paint a mural on the subject "freedom of expression," and the other from the U.S. Army to create patriotic illustrations to be displayed in segregated accommodations for African-American soldiers serving in World War II. In the late 1940s he taught at the Cooper School of Art, a commercial art school under private operation in Cleveland. In 1953 the American Greetings Corporation hired Brown as the first African-American illustrator on the staff, and he worked there until his death.

Selected References

Bright, Alfred L. "Cleveland Karamu Artists 1930 to 1945." In *Cleveland as a Center for Regional American Art,* 72–83. Cleveland: Cleveland Artists Foundation, 1993.

Newald, Cora Geiger. "Karamu: Forty-Eight Years of Integration through the Arts." Typewritten manuscript, 1:118. Western Reserve Historical Society, Cleveland.

Porter, James A. *Modern Negro Art,* 128–30. New York: Dryden Press, 1943.

Schulz, Ellen. *The Russell and Rowena Jelliffe Collection: Prints and Drawings from the Karamu Workshop, 1929–1941.* Cleveland Heights, Ohio: St. Paul's Episcopal Church, 1994.

CHARLES BURCHFIELD

(1893–1967)

CA. 1917

Charles Burchfield was among the most original and poetic painters of the Cleveland modernist movement. Born in Ashtabula, he moved to Salem, Ohio, following the death of his father in 1898. After graduating from high school, he attended the Cleveland School of Art, studying with William Eastman, Frederick Gottwald, Henry Keller, and Frank Wilcox. In 1914 Burchfield began attending Kokoon Klub exhibitions, and in spring 1915 he went to Brandywine to meet William Sommer.

Around this time Burchfield began experimenting with the brilliant colors and simplified forms of the Berlin Heights painters. He painted his first mature works in 1915, and graduated from the Cleveland School of Art with a degree in illustration the following spring. That summer the Cleveland School of Art sponsored his first solo exhibition, and in the fall, after attending the National Academy of Design in New York for one month, he returned to Salem. In February 1917 the Cleveland School of Art mounted his second solo exhibition. Burchfield was inducted into the army that summer. After his return in 1919 he exhibited with other Cleveland modernists at the Play House, Laukhuff's Bookstore, and other Cleveland venues. In 1921 he went on an extended sketching trip through eastern Ohio with Keller, Wilcox, and Paul Travis, exhibiting these recent paintings at the Cleveland School of Art and in the May Show at the Cleveland Museum of Art. Later that year he moved to Buffalo to work as a wallpaper designer, a position he retained until he resigned in 1929 to become a full-time painter. Over the next 30 years he exhibited extensively at museums and galleries across the country. Solo exhibitions of his paintings were held at New York's Museum of Modern Art (1930), Pittsburgh's Carnegie Institute of Art (1935, 1938, 1946), and Buffalo's Albright-Knox Art Gallery (1944, 1955, 1963, 1967). In 1953 New York's Whitney Museum of American Art organized a major exhibition that traveled to the Cleveland Museum of Art. Burchfield died in West Seneca, New York.

Selected References

Baur, John I. H. *The Inlander: Life and Work of Charles Burchfield, 1893–1967.* East Brunswick, N.J.: Cornwall, 1982.

Burchfield, Charles E. Correspondence. Archives of American Art. Smithsonian Institution, Washington, D.C.

Maciejunes, Nannette V., and Michael D. Hall. *On the Middle Border: The Art of Charles Burchfield.* Exh. cat. Columbus, Ohio: Columbus Art Museum, 1996.

Townsend, J. Benjamin. *Charles Burchfield's Journals: The Poetry of Place.* Albany: State University of New York, 1993.

Trovato, Joseph S. *Charles Burchfield: Catalogue of Paintings in Public and Private Collections.* Utica, N.Y.: Munson-Williams-Proctor Institute, 1970.

Weekly, Nancy. *Charles E. Burchfield: Sacred Woods.* Albany: State University of New York, 1993.

CLARENCE CARTER

(b. 1904)

1932

One of Cleveland's most imaginative interpreters of the American scene, Clarence Carter was born in Portsmouth, Ohio, and developed a love of drawing at an early age. Encouraged by his family, he took private watercolor lessons and won art prizes in county and state fairs in his early teens. He studied with William Eastman, Henry Keller, and Paul Travis at the Cleveland School of Art, 1923–27. He exhibited in the annual May Shows at the Cleveland Museum of Art (1927–39). In 1927 William Milliken, then curator of paintings at the art museum, organized a subscription scholarship to allow Carter two years of travel through Italy, Switzerland, England, and France. In the summer of 1927 he studied in Capri with Hans Hofmann. On returning to Cleveland in 1929, Carter had his first solo exhibition at the Cleveland Art Center. He taught studio classes at the Cleveland Museum of Art, 1930–37. In 1934, under the auspices of the Public Works of Art Project, the first of the New Deal art programs, Carter was commissioned to paint two murals for Cleveland Public Auditorium. For a subsequent governmental art program, the Works Progress Administration, he served as a district supervisor for painting projects in northeast Ohio. After 1935 he completed two federal mural commissions: one for the post office in Ravenna, Ohio, and another for the post office in his hometown. In 1938 he moved to Pittsburgh to teach at the Carnegie Institute of Technology (now Carnegie-Mellon University). During the 1930s and 1940s he showed in annual exhibitions in Philadelphia, New York City, Chicago, and Washington, D.C. After more than 80 years of making and exhibiting art, Carter continues to paint at his home in New Jersey.

Selected References

Carter, Clarence Holbrook. Papers. Archives of American Art. Smithsonian Institution, Washington, D.C.

Trapp, Frank Anderson, Douglas Dreishpoon, and Ricardo Pau-Llosa. *Clarence Holbrook Carter.* New York: Rizzoli, 1989.

LOUIS CHEVALIER

(1823–1889)

Louis Chevalier worked in many formats, designing sets and scenery, painting signs, and creating newspaper cartoons. Born in Plattsburg, New York, he had moved to Cleveland by 1845, when he advertised his partnership in a sign and ornamental painting firm with Sebastian Heine. In

the late 1840s, Chevalier settled in Erie, Pennsylvania, where he spent much of his time until 1875. There he worked on a variety of projects, creating murals for churches and public halls, executing portraits of local notables, and painting signs and billboards. During the early 1860s, he traveled to Put-in-Bay near Sandusky to research his only known surviving easel painting, *Burial of the Officers Slain at the Battle of Lake Erie.* In conjunction with an 1861 wedding in Girard, Pennsylvania, he covered the walls of a chamber with a fresco and then hung his portraits, figure paintings, and landscapes. From 1875 until 1884 he lived in Detroit, where he worked as a decorative painter for the Pullman Palace Car Company, 1880–81. Throughout this period he appears to have maintained connections with Cleveland, exhibiting as a resident artist in the Cleveland Loan Exhibition (1878). That year he also won a prize for historical painting at the Michigan State Fair. In 1886 Chevalier relocated to Cleveland, where his daughters lived, remaining there until his death.

Selected References

Chevalier, Louis Bennett. File. Western Reserve Historical Society, Cleveland.

Steehler, Kirk W. "Erie Artists—A History of Heroes." Unpublished manuscript, 13–26. Erie Museum of Art.

HENRY CHURCH, JR.

(1836–1908)

CA. 1878

Henry Church is the best known self-trained artist to have worked in the Cleveland area. Son of a blacksmith and a teacher who moved from Massachusetts to Chagrin Falls in 1834, Church began work in his father's shop at age 13. He showed an early love of art, reputedly using charcoal from the shop to practice drawing. Moving to Parkman, Ohio, upon his marriage in 1859, Church returned to Chagrin Falls by 1861 and built a smithy. A pacifist, he bought his way out of military service in the Civil War. After his father's death in November 1878, Church opened an art studio above his shop, devoting himself to painting and, after 1885, to sculpture. Before 1885 he had only carved stone surreptitiously, apparently hoping that, upon discovery, his first monumental work (*The Rape of the Indian Tribes by the White Man,* also known as *Squaw Rock,* in what is now South Chagrin Reservation, Cleveland Metroparks) would be interpreted as a divine creation. Although it has been claimed that Church retired as a blacksmith at age 50 in 1886, according to the William's Ohio State Directory, he was still practicing that trade in 1888–89. In 1888

he opened the short-lived Church's Art Museum at Geauga Lake, Ohio, a popular picnic area; around the same time he rented out his blacksmith shop. Church's productivity declined at the turn of the century as the physical strain of working stone taxed his health. An avid spiritualist, he read the periodical *Banner Light.* Taking advantage of early phonograph technology, he recorded his own funeral speech, an oration that concluded with the line "Goodbye at present."

Selected References

Armstrong, Tom, and Jean Lipman, ed. *American Folk Painters of Three Centuries.* New York: Hudson Hills Press, 1980.

Babinsky, Jane E., and Miriam Church Stem. *The Life and Work of Henry Church, Jr.* Chagrin Falls, Ohio: privately printed, 1987.

Rosenberg, Sam. "Henry Church of Chagrin," 99–108. In Janis, Sidney. *They Taught Themselves: American Primitive Painters of the 20th Century.* New York: Dial, 1942.

GEORGE CLOUGH

(1824–1901)

CA. 1863

George Clough, a successful painter of landscapes, portraits, and genre subjects, worked for several years in Cleveland although he spent most of his career in New York state. Born in Auburn, New York, he had completed his first oil painting by the age of ten. In 1842 he took casual lessons from Randall Palmer, a local portrait painter with whom he worked as a studio assistant. Clough set up his own studio in Auburn in 1844 and during that year met visiting portraitist Charles Loring Elliott, who became his most important teacher. At Elliott's invitation, Clough spent part of 1847 in New York City and during the following year exhibited at the National Academy of Design. In 1850 he traveled to Europe, copying Old Master paintings in the Louvre and making excursions to Germany and Holland as well as to Rome, where he stayed four months. Back in Auburn the following year, he established a reputation as a painter of landscapes. Around 1863 he moved to Cleveland, where he attained critical success but little monetary reward. To supplement his income, he did free-lance work tinting photographs for J. Greene Photography. While in Cleveland, Clough exhibited at the Ohio State Fair and at the Sanitary Fair (1864). He moved to New York City around 1866, where he continued painting landscapes. During the 1870s, he specialized in genre scenes, but by 1875 he had relocated to

Auburn and returned to landscape painting, making at least one trip to Cleveland around this time. During the 1880s, he moved to Brooklyn, New York, where he was active in many local art organizations, including the Art Association, Art Club, and Brush and Palette Club. He returned to Auburn in 1896 and during the following year suffered a paralytic stroke that ended his painting career.

Selected References

Witthoft, Brucia. "George L. Clough, Painter." *The Magazine Antiques* 122 (July 1982): 130–37.

ALLEN COLE

(1883–1970)

For more than 40 years, Allen E. Cole was the foremost photographer in Cleveland's African-American community. He was born in rural West Virginia, the son of a blacksmith and the 11th of 13 children. After graduating from Storer College, he waited tables in Atlantic City, then went to Cincinnati around 1907 and spent two years working as a railroad porter before being promoted to cook. After injuries suffered in a train wreck forced him to leave the railway, he tried selling real estate, but business was so poor he left Cincinnati. Settling in Cleveland around 1918, he waited tables and spent his spare hours working part-time for Frank Moore, a white commercial photographer, from whom Cole learned to take and print photographs. Around 1922 Cole opened his own studio on the city's east side and until the 1960s served the photography needs of the city's African-American community. His clients included business leaders, politicians, musicians, and athletes. He was active in the Board of Trade, an African-American business association that advocated self-reliance, economic solidarity, and race pride. In the later 1920s Cole turned from his early pictorial style to a more sharply focused, documentary style, often employing an 8 x 10 format. Because of failing health, his production declined in his later years. After his death in 1970, his entire studio—including several thousand prints and more than 27,000 negatives—was donated to the Western Reserve Historical Society in Cleveland.

Selected References

Martin, Olivia J., and John J. Grabowski. *"Somebody, Somewhere Wants Your Photograph": A Selection of Work by Allen E. Cole (1893–1970).* Exh. cat. Cleveland: Western Reserve Historical Society, 1980.

Willis-Thomas, Deborah. *Black Photographers, 1840–1940: An Illustrated Bio-Bibliography.* New York: Garland Publishers, 1985.

ORA COLTMAN

(1858–1940)

CA. 1907

One of Cleveland's most popular painters of the early 20th century, Ora Coltman worked in a representational style that featured broad areas of bright color. Born in Shelby, Ohio, he came to Cleveland in the early 1880s to study law but soon abandoned the field for a career in art. He subsequently secured a job as a designer at the Joseph Carabelli Monument Works, a local marble carving firm. In the mid-1880s he traveled to Europe and studied painting at the Académie Julian in Paris and at a private studio in Munich. On returning to America, he studied with William Merritt Chase at the Art Students League in New York. Coltman returned to Cleveland and had his first solo exhibition in 1902 at the Case Library, showing watercolors painted in France and England. He continued to exhibit watercolors throughout the next decade but in the early 1920s worked more frequently in oil. In the 1920s and 1930s he exhibited in May Shows at the Cleveland Museum of Art, the annuals of the Art Institute of Chicago, and the Pennsylvania Academy of Fine Arts in Philadelphia. During this time he also exhibited at Cleveland's Gage Gallery, Women's City Club, and Lindner's Little Gallery. After 1918 he began spending his summers painting in Provincetown, Massachusetts, where he became an active member of the local art colony. In 1933, under the auspices of the Public Works of Art Project, he painted a large triptych titled *Dominance of the City* for the Cleveland Public Library. During the last years of his life, Coltman continued to paint despite being bedridden from illness.

R. GUY COWAN

(1884–1957)

CA. 1928

R. Guy Cowan was born into a family of potters of British origin living in East Liverpool, then the center of Ohio's thriving ceramic industry. Around 1900 he moved with his family to Syracuse, New York, where his father was the head decorator for the Onondaga Pottery Company. Shortly thereafter he was apprenticed at the company. He studied with Charles Binns at the New York State School of Clayworking and Ceramics, 1902–7. Cowan moved to Cleveland to teach ceramics at East Technical High School in 1908 and became acquainted with Horace Potter, who collaborated with him on early projects. In 1913 Cowan abandoned teaching to establish a commercial firm, the Cleveland Pottery and Tile Company, which was later incorporated as the Cowan Pottery Studio. His first significant recognition came when he was awarded a ceramics prize at the Art Institute of Chicago's Annual Exhibition of Applied Art (1917). He exhibited in the annual May Shows at the Cleveland Museum of Art (1919–32) and began teaching ceramics at the Cleveland School of Art in 1923. Under encouragement from Alexander Blazys, Cowan started producing ceramic sculpture in the mid-1920s, launching the studio's most fertile creative period. Many artists worked on collaborative projects at Cowan Pottery, including Waylande Gregory, Elmer Novotny, Viktor Schreckengost, Walter Sinz, Frank Wilcox, and Thelma Frazier Winter. After a period of commercial success, the Depression forced the studio into bankruptcy and it closed in 1931. Cowan subsequently worked for the Ferro Enamel Company in Cleveland as a research engineer. In the mid-1930s, he relocated to Syracuse, where he became art director of the Onondaga Pottery.

Selected References

Bassett, Mark, and Victoria Peltz. *Cowan Pottery and the Cleveland School*. Atglen, Penna.: Schiffer, 1996.

Hawley, Henry. "Cowan Pottery and the Cleveland Museum of Art." *Bulletin of the Cleveland Museum of Art* 76 (September 1989): 238–63.

Saloff, Tim and Jamie. *The Collector's Encyclopedia of Cowan Pottery*. Paducah, N.Y.: Collector Books, 1993.

PHELPS CUNNINGHAM

(1903–1980)

An architect by profession, Phelps Cunningham was active as a printmaker in the 1930s, specializing in meticulously crafted relief prints of the rural Midwest. Born in Humboldt, Kansas, he graduated in 1926 from the University of Kansas with degrees in science and architecture. He traveled to Europe for three months in 1929 just before accepting a position at the architectural firm C. B. Rowley & Associates in Cleveland. In 1930 he began making relief prints and regularly participated in the annual May Shows at the Cleveland Museum of Art (1930–41). He also contributed prints to annual competitive exhibitions in Philadelphia, Kansas City, and New York City. During World War II, Cunningham served in the government's war housing department for three years. His work was included in *Painting and Prints by Cleveland Artists,* an exhibition held at the Whitney Museum in New York City (1937) and at the New York World's Fair (1939). In 1946 he became a partner in the Carr and Cunningham firm. After his retirement in 1967, he worked for Damon-Worley, Cody, and Kirk until 1972. He served as president of the Cleveland Chapter of the American Institute of Architects. As an architect Cunningham is best known for the Saints Helen and Constantine Greek Orthodox Church in Cleveland Heights.

Selected References

Campbell, Margaret Mary. *Print-a-Month: Cleveland Printmakers, 1932–36,* 29. University Heights, Ohio: John Carroll University, 1982.

CLARA DEIKE

(1881–1964)

CA. 1918

A native of Detroit, Clara Deike attended high school in Cleveland and earned an associate degree in education from the Cleveland Normal School in 1901. In early 1909, after teaching elementary school in Ohio and Kentucky, Deike began studying art at the School of the Art Institute of Chicago. That fall she enrolled at the Cleveland School of Art, studying with Frederick Gottwald and Henry Keller. After graduating in 1912, she taught art in public schools until her retirement in 1945. During the summers, she took various art classes, including those organized by Henry Keller in Berlin Heights, 1910–20, and Hugh Breckenridge in Gloucester, Massachusetts, 1921–23. On a leave of absence from teaching, Deike studied with Hans Hofmann in Capri and Munich, 1925–27. She exhibited in the annual May Shows at the Cleveland Museum of Art (1919–59) and showed her work throughout the Cleveland area in various exhibitions, including those sponsored by the Women's Art Club, a professional organization she cofounded in 1912. The Lakewood Public Library sponsored her first solo exhibition (1918). Her paintings appeared in subsequent solo exhibitions at the Little Gallery in Cleveland and the Washington Art Club in Washington, D.C. (1924), Cleveland's Korner & Wood Galleries (1927), the Gladden Studios in Columbus (1935), the Canton Women's Club (1937), and the Women's City Club of Cleveland (1950). She participated in group exhibitions at Kraushaar Art Galleries in New York (1927) and the Gloucester Arts Festival in Massachusetts (1953–60).

Selected References

Sackerlotzky, Rotraud. *Henry Keller's Summer School at Berlin Heights*. Cleveland: Cleveland Artists Foundation, 1991.

STEVAN DOHANOS

(1907–1994)

CA. 1946

Born in Lorain to immigrant parents, Stevan Dohanos decided to pursue a career in art after selling sketches to his co-workers at the National Tube Co. He attended night school at the Cleveland School of Art and subsequently received a scholarship to attend full-time, 1929–32. In 1932, the year he began printmaking, he attended the George Pearce Ennis School in Eastport, Maine, where he and Walter Richards studied lithography with Stow Wengenroth. Continuing his art studies at night at the Huntington Polytechnic Institute, Dohanos worked at several commercial art agencies in Cleveland, including the Greene Art Studios and Tranquillini Art Studios. He left Cleveland in 1934 to pursue commercial art work in New York City. In 1936 he was commissioned by the Treasury Department to paint watercolors for the Federal Building in the Virgin Islands. He also made murals for the Forest Service Building in Elkins, West Virginia, and a post office in West Palm Beach, Florida. He exhibited prints and watercolors in annual exhibitions in Philadelphia, Chicago, New York City, and Cleveland, including May Shows at the Cleveland Museum of Art (1929–35). He was a member of the Cleveland Society of Artists and a director of the Cleveland Print Makers. In 1942, following his move to Westport, Connecticut, he pursued a career as a freelance graphic artist, and his work appeared in *Fortune, Good Housekeeping, Life, McCall's, New Yorker,* and *Saturday Evening Post.* He also designed and supervised the production of postage stamps during his tenure on the Postmaster General's Citizen Stamp Advisory Committee. In 1973 he was inducted into the Society of Illustrators Hall of Fame. Dohanos died in Westport.

Selected References

Bruner, Ray. "Cleveland Success Story, or from Steel Mill Hand to Ace Artist-Illustrator in N.Y." *Cleveland News* (1 March 1941), 12.

Cleveland Press Archive. Cleveland State University.

Dohanos, Stevan. *American Realist.* Westport, Conn.: North Light Publishers, 1980.

WILLIAM EASTMAN

(1888–1950)

CA. 1916

Born in Cleveland, William Eastman attended the Cleveland School of Art, graduating in 1912. That summer he moved to New York and studied briefly at the Art Students League. The following year he returned to Cleveland to become an instructor at the Cleveland School of Art, a position he held until his death. He had his first solo exhibition in 1911 at the studio he shared with Walter Heller. In 1913 Eastman befriended one of his students, Charles Burchfield, and the two became frequent sketching companions. Around 1915 Eastman began experimenting with gold- and silver-leaf grounds in paintings based on "principles of pure design." He exhibited in the annual May Shows at the Cleveland Museum of Art (1919–50). On sabbatical from the art school in 1922, he studied at the Académie Julian in Paris and spent the following year painting in France, Spain, Italy, Norway, Sweden, and Denmark. In the summer of 1925 he returned to Europe to paint. He directed the Eastman-Bolton Gallery, 1926–38, a decorative-design firm that he cofounded. In the summer of 1930 Eastman went on another painting excursion to France, Italy, and Holland. In 1931 he was elected president of the Cleveland Society of Artists. The following year he organized the city's first artist's Curb Market to stimulate sales of local artists' work. During the 1930s and 1940s his paintings appeared in solo exhibitions in Cleveland, Akron, Columbus, and the Addison Gallery of American Art in Andover, Massachusetts. In the summer of 1939 he made the first of many painting trips to the American West and Mexico. On returning from one of these trips in 1950, Eastman died of a heart attack. The Cleveland Institute of Art organized a memorial exhibition of his work the following year.

Selected References

"Mr. Eastman Creates a New Art." *Cleveland Town Topics* (23 December 1916), 24.

EDRIS ECKHARDT

(b. 1907)

CA. 1940

Born in Cleveland to a family of foundry workers, Edris Eckhardt began drawing and painting at the age of eight while convalescing from rheumatic fever. Subsequently, she attended children's studio classes at the Cleveland Museum of Art. After high school, she enrolled in the Cleveland School of Art in 1928, where she met instructor Alexander Blazys, who kindled her interest in clay sculpture. In 1930 she began working at Cowan Pottery. In 1931, on a postgraduate scholarship from the Cleveland School of Art, she studied with sculptor Alexander Archipenko in New York. Eckhardt exhibited in the annual May Shows at the Cleveland Museum of Art (1932–67) and throughout the 1930s participated in the annual National Ceramics Exhibitions held in Syracuse, New York. She also showed at the World's Fairs in Paris and New York. In 1935 she was appointed head of the ceramic division of the Works Progress Administration. For the WPA she created monumental ceramic sculpture for the city's Woodhill Homes housing project and a series of ceramic figures, inspired by children's literature, for the Cleveland Public Library. In 1942, after the demise of the WPA, Eckhardt accepted a five-year position as an affiliated instructor at the School of Applied Social Sciences, Western Reserve University, where she taught social workers how to use clay modeling as art therapy. In 1953 she turned her creative energies toward mastering the medium of glass sculpture and exhibited both locally and nationally in the following decades, including solo shows at the Museum of Contemporary Crafts in New York (1962) and the Corning (New York) Museum of Glass (1968). A retrospective exhibition of her work was held at the Beachwood (Ohio) Museum (1982). She currently lives in the Cleveland area.

Selected References

Anderson, Ross, and Barbara Perry. *The Diversions of Keramos: American Clay Sculpture 1925–1950,* 65–72. Exh. cat. Syracuse, N.Y.: Everson Museum of Art, 1983.

Dancyger, Ruth. *Edris Eckhardt: Cleveland Sculptor.* University Heights, Ohio: John Carroll University, 1990.

Eckhardt, Edris. Scrapbooks. Archives of American Art. Smithsonian Institution, Washington, D.C.

DE SCOTT EVANS

(1847–1898)

CA. 1875

The best interpreter of Cleveland's Gilded Age, De Scott Evans painted genre subjects with particular attention to the materiality of stuffs. Born David Scott Evans in Boston, Indiana, he briefly attended Miami University in Oxford, Ohio, before studying art with painter Albert Beaugureau in Cincinnati, 1864–65. Evans worked as a teacher, first at Smithson College in Logansport, Indiana, then at Mount Union College in Alliance, Ohio, where he was named chair of the fine arts department. His first solo exhibition was held at Mount Union (1873). Around that time he changed his name to De Scott Evans. In 1874 he opened his own studio in Cleveland and was a founding member of the Art Club in 1876. After studying in Paris with William Bouguereau, 1877–78, Evans returned to Cleveland, where he taught at the Art Club and then at the Cleveland Academy of Art, establishing a reputation as a genre painter and exhibiting at the Cleveland Loan Exhibition (1878), Ryder's studio, and at the National Academy of Design in New York. In 1887 Evans moved to New York City but continued to associate himself with Cleveland's art community. He may have painted a series of still lifes under various pseudonyms during this period of his career. In 1898 Evans drowned in a shipwreck while en route to Paris, where he was to paint decorative panels for Howell Hinds of Cleveland.

Selected References

Maciejunes, Nannette V. *A New Variety: Try One: De Scott Evans or S. S. David.* Exh. cat. Columbus, Ohio: Columbus Museum of Art, 1985.

———. "A Tangled Web: A *Trompe l'Oeil* Mystery." *Timeline* (October–November 1988): 34–43.

Troy, Nancy. "From the Peanut Gallery: The Rediscovery of De Scott Evans." *Yale University Art Bulletin* 36 (Spring 1977): 36–43.

PAUL FEHER

(1898–1990)

Little biographical information has surfaced regarding metalwork designer Paul Feher. Born in Nagy-Kanizsa, Hungary, he studied at the Royal Academy of Budapest and later collaborated with Romanian metalsmith Paul Kiss on wrought-iron furniture ensembles that were exhibited at the Salon des Artistes Décorateurs in Paris (1926–27). Shortly after, Feher moved to Cleveland to work as head designer of the

Rose Iron Works, a firm founded by colleague and fellow Hungarian immigrant Martin Rose. For the firm, Feher designed in a variety of metal media as well as carved and sandblasted glass. His largest body of work was executed for Severance Hall, the home of the Cleveland Orchestra, several pieces of which were exhibited in the May Show at the Cleveland Museum of Art (1930) and the Third International Exhibition of Contemporary Industrial Art organized in 1930 by the Metropolitan Museum of Art in New York. Shortly after exhibiting in the 1931 May Show, Feher moved to Los Angeles, where he continued to design metalwork.

Selected References

American Art Annual 27 (1930): 525.

Andrews, Jack. *New Edge of the Anvil: A Resource Book for the Blacksmith,* 129–41. Drexel Hill, Penna.: SkipJack Press, 1994.

Duncan, Alastair. *American Art Deco,* 96, 99. New York: Abrams, 1986.

Archives. Rose Metal Industries, Inc., Cleveland.

LEROY FLINT

(1909–1991)

CA. 1955

Although best known for his post-1945 modernist paintings, Leroy Flint's humorous and satirical prints of everyday life made during the Depression rank among his finest work. He was born and raised in Ashtabula, Ohio. Paying for his education through scholarships and odd jobs, he attended the Cleveland School of Art, 1932–36. After graduation, he worked for the Works Progress Administration on the graphic arts, mural, and adult education projects. On the graphic arts project Flint made a series of lithographs sketched while he was on a year-long shanty boat trip down the Ohio River. He lost his WPA salary, however, when he continued his trip outside the state of Ohio. Returning to Cleveland, he made murals for the Valleyview housing project, the community building of the Woodhill Homes housing project, and the Oxford School, all dated 1940. While on the WPA he was a member and executive secretary of the Cleveland Artist's Union and a member of the American Artists' Congress. During World War II, Flint was a senior instructor in the map reproduction department of the Army Corps of Engineering specialty school in Fort Belvoir, Virginia. He was the director of public information for the Cleveland City Planning Commission, 1946–49, quitting to teach at the Cleveland Museum of Art and pursue graduate studies at Western Reserve College. In the 1950s he became an

advocate of abstract art and began working at the Akron Art Institute, where he held the positions of instructor, curator of education, and director. He left the Akron Art Institute in 1965 to become professor of art at Kent State University, where he also worked as director of the University Galleries. Flint lived in Cuyahoga Falls until his death.

Selected References

Flint, Leroy. File. Cleveland Artists Foundation.

Turner, Terry. "Biography in Brief, Leroy Walter Flint." *Akron Beacon Journal,* 9 January 1955, 3–D.

CARL GAERTNER

(1898–1952)

CA. 1924

A specialist in American scene subject matter, Cleveland-born Carl Gaertner exhibited an early aptitude for drawing. As a high-school student he studied mechanical design, but during his senior year he decided to make painting his primary avocation. In 1920 he enrolled at the Cleveland School of Art, graduating three years later after studying with Henry Keller and Frank Wilcox. In 1925 the school hired Gaertner to teach painting. During the 1920s and 1930s he went on summer painting excursions to Provincetown, Massachusetts, with Ora Coltman and George Adomeit. One of the most widely exhibited artists working in Cleveland, Gaertner showed at the Cleveland Museum of Art (1922–53), the Pennsylvania Academy of Fine Arts in Philadelphia (1924–52), the Art Institute of Chicago (1925–49), the Whitney Museum of American Art in New York (1943–48), and the National Academy of Design (1944–50). The Cleveland School of Art organized solo exhibitions of his paintings (1928, 1941), as did the Philadelphia Art Alliance (1948). In 1945 he began a long association with the Macbeth Galleries in New York. In 1952, after experiencing a severe headache while teaching at the art school, he went home and died unexpectedly of a brain hemorrhage.

Selected References

Milliken, William M., and Laurence Schmeckebier. *Carl Gaertner Memorial Exhibition.* Exh. cat. Cleveland: Cleveland Museum of Art, 1953.

RAPHAEL GLEITSMANN

(1910–1995)

Born in Dayton, Gleitsmann moved to Akron at an early age when his father, an architectural engineer and amateur painter, secured a job in the area. After graduating from high school, he took private drawing lessons for one year with Katherine Calvin. Lacking the funds for tuition, he accepted the invitation of Paul Travis to attend classes informally at the Cleveland School of Art and became friends with other artists there. Primarily a landscape painter, he first exhibited in the annual of the Butler Institute of Art in Youngstown (1936) and had his first solo show at the Massillon (Ohio) Museum (1939). He also exhibited at the New York World's Fair that year. The Little Gallery of Cleveland College organized his second solo exhibition (1940). In 1943 he began an association with Macbeth Galleries in New York, where he was featured in solo exhibitions (1940s–50s). He exhibited in the annuals of the Art Institute of Chicago (1937–49), Pennsylvania Academy of Fine Arts in Philadelphia (1944–52), and Carnegie Institute of Art in Pittsburgh (1943–48). In 1944–45 he served in the U.S. Army as a combat engineer in Europe, an experience that profoundly affected his subsequent subject matter. Previously specializing in American scene depictions, after the war he created images inspired by the bombed cities of Europe. In the late 1940s and early 1950s he taught studio courses at the Akron Art Institute and continued to exhibit on a regular basis. The Akron Art Institute mounted a solo exhibition of his paintings (1948). By the early 1960s Gleitsmann had stopped painting "for reasons known entirely only to himself."

Selected References

Gleitsmann, Raphael. "A Painter Tells His Story." *American Artist* 12 (October 1948): 25–27.

Kendall-Hess, Wendy. *Early Works by Raphael Gleitsmann.* Exh. pamphlet. Akron: Akron Art Institute, 1990.

JULIUS GOLLMANN

(?–1898)

Julius Gollmann, a native of Hamburg, Germany, worked for several decades in the United States as a portrait and figure painter. His name is recorded in the United States as early as 1852, when he began exhibiting in the annuals of the National Academy of Design. Nothing is known about his artistic training. Between 1853 and 1856 he was primarily situated in New York City, spending summers upstate in Cooperstown, where he painted the figures in a landscape by Louis Rémy Mignot (*Three Mile Point,* New York State Historical Association). In 1857 Gollmann moved to Cleveland but went back to New York in 1860. His whereabouts between 1865 and 1870 are unknown, but he

surfaced in 1871 in Chicago, then subsequently again in Cleveland for about a year starting in 1872. By 1878 he had returned to Germany, where he exhibited at the Berliner Akademie (1878, 1890). Gollmann died in Berlin.

FREDERICK GOTTWALD

(1858–1941)

CA. 1912

Born in Vienna, Austria, Gottwald immigrated with his family to Cleveland in 1862. He studied privately with Archibald Willard at the artist's studio in Cleveland, 1875–80, then went to New York for a year of classes taught by William Merritt Chase at the Art Students League. Gottwald then traveled to Munich and attended the Kunstakademie, 1882–85. Returning to Cleveland, he began teaching at the Western Reserve School of Design for Women and remained on the faculty until retiring in 1926. He frequently participated in local group exhibitions at the Art Club, the Brush and Palette Club, the Cleveland School of Art, and the Cleveland Museum of Art. He also showed at the Boston Art Club and the National Academy of Design in New York. Around the turn of the century, he made several summer painting trips to Holland. Beginning in 1903, the Cleveland School of Art mounted the first of many solo exhibitions of his paintings. From 1907 to 1915 he produced a series of landscapes created during annual summer excursions to Italy. He exhibited these works, which yielded his greatest critical and popular acclaim, on a regular basis at the Cleveland School of Art. He was instrumental in founding the Cleveland Society of Artists in 1913. During the 1920s he painted in Italy, Southern France, Spain, and North Africa. His last exhibition was held in Cleveland (1931). The following year Gottwald retired to Pasadena, where he died.

Selected References

Keny, James M., and Nannette V. Maciejunes. *Triumph of Color and Light: Ohio Impressionists and Post-Impressionists,* 110–11. Exh. cat. Columbus, Ohio: Columbus Museum of Art, 1993.

"Mr. Gottwald's Fine Art Spirit." *Cleveland Town Topics,* 9 December 1916, 29.

Sackerlotzsky, Rotraud, and Mary Sayre Haverstock. *F. C. Gottwald and the Old Bohemians.* Cleveland: Cleveland Artists Foundation, 1993.

WILLIAM GRAUER

(1895–1985)

CA. 1927

Born in Philadelphia, William Grauer studied at the Philadelphia School of Industrial Design, 1914–19. In 1920 he moved to Akron, where his future brother-in-law had established an architectural practice. That year Grauer opened a studio in Cleveland, establishing a reputation as a specialist in mural painting. He received a commission to execute two murals celebrating labor for the Cleveland Builders Exchange in 1928. In 1932 he created a series of murals for the Greenbrier Hotel in White Sulphur Springs, West Virginia, a small resort town that was the site of an art colony he had established with his wife, the painter Natalie Eynon Grauer. He also painted murals for the Century of Progress Exhibition in Chicago (1933) and the New York World's Fair (1939). Grauer exhibited easel paintings in the annual May Shows at the Cleveland Museum of Art (1929–85). From 1935 to 1966 he taught art at Western Reserve University. During the 1940s he taught summer classes in Middlefield, Ohio; Bailey Island, Maine; and Gaspé Bay, Nova Scotia. Although Grauer retired from his post at Western Reserve University in 1966, he continued to paint until his death.

ARTHUR GRAY

(1884–1976)

An active member of the Cleveland Photographic Society, Arthur Gray specialized in urban and industrial subjects. He was born in Adams Mills, Ohio, and studied at Muskingham College and the Cleveland School of Art. After an early career in commercial art, he worked as an illustrator and designer for Standard Oil of Ohio from 1929 until his retirement in 1949. Around 1928 he became friends with Margaret Bourke-White, who at age 23 was just beginning her career in professional photography. For about a year they shared a darkroom and a fascination with industrial subjects, especially the construction of Terminal Tower and steel-making in the Cleveland Flats. Correspondence discovered in the Gray estate indicates that they collaborated in the darkroom and that Bourke-White printed some of Gray's negatives. After she left Cleveland in late 1929, Gray continued the tradition of industrial photography but evolved a distinctive style, concentrating on carefully selected views and compositional balance instead of manipulative techniques. His photographs of smoky factories, speeding trains, and bustling harbors are often

quieted by an eye for geometric structure. Gray's photographic oeuvre also includes portraits, landscapes, and Cleveland nightlife.

Selected References

"Arthur S. Gray Says to Make Better Pictures Study the Other Arts." *Pocket Photo Monthly* (February 1929): 102–3.

"The Photographs of Arthur Gray Chronicle Cleveland from the 1930s to the 1960s." Typed manuscript, dated 1994. Rachel Davis Fine Arts, Shaker Heights, Ohio.

LOUIS GREBENAK

(1913–1971)

Muralist, painter, and printmaker Louis Grebenak created modernist works with social themes during his career in Cleveland. His parents emigrated from Hungary in 1905, and his father worked in a coal mine near Wasson, Illinois, where Louis was born and raised. By 1934 his family had moved to Barberton, Ohio. Both he and his father were employed at the Seiberling Rubber Company during the 1930s. Grebenak graduated from the Cleveland School of Art in 1938, with a specialization in mural painting. In 1937 he married Dorothy Lee Rork, a social worker. They met while working together at the Alta House Social Settlement in Cleveland, where he was teaching art. He worked for the Cleveland graphic arts and mural projects of the Works Progress Administration, 1939–41. He made a few prints and around 1940 completed three murals for the Akron Board of Education, the Valleyview housing project in Cleveland, and the radio room at the Cleveland Board of Education. He served in the military during World War II and by 1947 was an instructor of painting and drawing in the Brooklyn Museum Art School. He was a member of the Cleveland cell of the United Artist's Union (CIO affiliate) and the Communist Party. He was a contributor to the magazine *Crossroads*. He exhibited works, mostly paintings, in several May Shows at the Cleveland Museum of Art (1932–45). He also showed at the New York World's Fair (1939) and in Cleveland at 1030 Gallery (1947). Grebenak died in New York.

Selected References

"Cleveland Artist No. 38. Louis Grebenak." *Cleveland Press,* 12 July 1947, 5.

JOLÁN GROSS-BETTELHEIM

(1900–1972)

CA. 1925

Jolán Gross-Bettelheim, a Hungarian artist, lived in the United States between 1925 and 1956. Although details about her life remain sketchy, she is best known for her social and political prints of industrial urban life. Born in 1900 in Nitra, then in the Austro-Hungarian empire but now in the Slovak Republic, she began her art studies in 1919 at the Budapest School of Fine Art, where she studied painting with Róbert Berény. In 1920 she studied with Emil Orlik at the Kunstgewerbeschule in Vienna and within a year went to Berlin and enrolled at the Akademie der Bildenden Künste. Between 1922 and 1924 she lived in Paris and studied at the Académie de Grande Chaumière. By 1925 she was living in Cleveland, married to Frigyes Bettelheim, a Hungarian-born radiologist. She exhibited in annual May Shows at the Cleveland Museum of Art (1927–37) and had her first solo exhibition at the Kokoon Klub (1932). In 1936, while on the Works Progress Administration graphic arts project in Cleveland, she made her first lithographs. In 1938 she moved to Jackson Heights, New York, with her husband, who opened a practice in Manhattan. A committed communist, Gross-Bettelheim was a contributor to the *New Masses* and the *Daily Worker* as well as a member of the John Reed Club and the American Artists' Congress. During the 1930s and 1940s her works were exhibited extensively in Ohio, Chicago, Philadelphia, New York, Seattle, and Washington, D.C. She was included in the exhibitions *America Today*, shown simultaneously in 30 cities (1936), *Artists for Victory* at the Metropolitan Museum of Art in New York (1942), and *America in the War*, shown simultaneously in 26 locations (1943). Following the death of her husband, she returned to Hungary after 1956. Gross-Bettelheim died in Budapest.

Selected References

Kádár, Kata, and Lóránd Hegyi, ed. *Gross-Bettelheim Jolán Retrospektív Kiállítása.* Exh. cat. Budapest: Budapest Kiállítóterem, 1988.

Williams, Reba and Dave. "Jolan Gross-Bettelheim: A Hidden Life." *Print Quarterly* 7 (September 1990): 303–7.

JARVIS HANKS

(1799–1853)

Jarvis Hanks, the earliest painter to sustain a career in Cleveland, led a colorful, peripatetic life during which he pursued many arts and political interests. He was born in Pittsford, New York, to a family of Dutch ancestry that moved to Pawlet, Vermont, in 1802. Around the age of 11 he learned to mix paints from his uncle, a joiner and carpenter who also painted houses, wagons, and chairs. Hanks saw service as a drummer boy in the War of 1812, later recalling those years in an extraordinary, still-unpublished autobiographical account. In 1817 the Hanks family moved to Wheeling (in what is now West Virginia), and the next year Hanks set out on his own, landing in Gallipolis, Ohio, where he became partners with a cabinetmaker. In 1820 he moved to Kanawha County, Virginia, joined the Masons, and married. He studied painting briefly in Philadelphia before returning to Virginia. Wanting to live in a free state, he moved to Ohio in 1825 and stayed in Cleveland for about a year. Like many others, he ended his involvement with the Masons following the disappearance of William Morgan in Batavia, New York, in 1826, but further expressed his disillusionment by founding *The Investigator,* a short-lived, anti-Masonic newspaper. He met William Dunlap during 1827 in New York City, which earned him a passing mention in the latter's *History of the Rise and Progress of the Arts of Design in the United States* (1834). Having added the art of silhouette cutting to his stock of skills, in 1827 Hanks worked in Toronto and Montreal with the Hubard Gallery, a collection of silhouettes that Englishman William Hubard had brought stateside in 1824. In 1828 Hanks toured the gallery along the eastern seaboard, stopping in Charleston, Baltimore, and Salem. In Salem he began a partnership with a Mr. Reynolds who added details in bronze paint to his silhouettes. In 1829 Hanks lived New York City and exhibited at the National Academy of Design. In the winter of 1830–31 he and Reynolds went to New Brunswick and Nova Scotia to cut silhouettes. Hanks had an exhibition of paintings in 1831 at Dalhousie College, Halifax, and he returned to New York and penned his autobiography. He settled in Cleveland in 1835, advertising skills in sign painting but specifying that he did not make signs for liquor stores or lottery offices. Painting offered but one vehicle among many for Hanks to participate in communal life. He found outlets for his lifelong interest in music by playing violin in the Mozart Society in 1838, teaching vocal music throughout the 1840s, and serving as a trustee of the Cleveland Mendelssohn Society in 1850. His political activities included years of service in the Cuyahoga Total Abstinence Society and participation in the county antislavery society. Although his painting

career centered on Cleveland for the balance of his life, he advertised in other Ohio cities, Erie (Pennsylvania), and Detroit. Hanks also conducted at least three "southern" tours in 1839, 1840–41, and 1852, although these may have only been to southern Ohio.

Selected References

Foy, Lydia. "Jarvis F. Hankes" and *"George Ramsay, 9th Earl of Dalhousie."* In *Painting in Quebec 1820–1850: New Views, New Perspectives.* Exh. cat. Quebec: Musée du Quebec, 1992.

Hageman, Jane Sikes. *Ohio Pioneer Artists: A Pictorial Review.* Cincinnati: Ohio Furniture Makers, 1993.

Hanks, Jarvis Frary. "A Biographical Memoir of Jarvis Frary Hanks, Written by Himself in 1831." Manuscript. Buffalo and Erie County Historical Society, New York.

SEBASTIAN HEINE

(1804–1861)

Born in Bavaria, Sebastian Heine immigrated to the United States around 1840. He is first recorded in Cleveland in 1845, when he advertised his skills as a "sign and ornamental painter" in a local newspaper. At this time he worked in a decorating firm he had co-established with Louis Chevalier. Over the next 15 years his name is mentioned in Cleveland city directories and newspapers in 1845–47, 1853, 1856, and from 1859 until his death. *Cleveland Courthouse on Public Square* is the only known extant work signed by Heine.

Selected References

Heine, Sebastian. File. Western Reserve Historical Society, Cleveland.

ABRAHAM JACOBS

(active in Cleveland, 1930s)

A mysterious figure, rumored to be a union agitator and a communist organizer, Jacobs made several politically and socially charged intaglio prints for the Works Progress Administration. Almost nothing is known about his life. The earliest reference to Jacobs is found in the 1930 May Show records, where his entry, *Head of a Man,* won an honorable mention for oil painting. In 1934 he was listed in the city directory as an artist. He had various addresses in or near downtown Cleveland between 1930 and 1936, after which no mention of him has been found. Originally hired as a skilled artist on the Cleveland WPA graphic arts project, he was reclassified as a professional artist sometime in 1936. His work was included in the exhibition *Paintings and Prints by Cleveland Artists* at the Whitney Museum of American Art in New York (1936). Jacobs was also a member of the Cleveland Artist's Union.

Selected References

Mallett, Daniel. *Mallet's Index of Artists.* Supplement, 138. New York: Peter Smith, 1948.

Marling, Karel Ann. Papers. Special Collections. Case Western Reserve University Library, Cleveland.

SHEFFIELD KAGY

(1907–1989)

Active as a printmaker in Cleveland in the 1930s, Sheffield Kagy specialized in block prints of contemporary scenes. Born and raised in Cleveland, he studied with Henry Keller and Paul Travis at the Cleveland School of Art and with Ernest Fiene at the Corcoran School of Art in Washington, D.C. In 1932 Kagy opened the short-lived Sheffield Studio School of Art in Cleveland, which offered basic art instruction taught by a faculty that included Kálmán Kubinyi. Kagy was one of only two Cleveland artists to make prints for the Public Works of Art Project in 1934. He made several linoleum cuts and at least one lithograph for the Cleveland graphic arts project of the Works Progress Administration in 1936. Kagy was a vice president of the Cleveland Print Makers and showed his work in many local exhibitions including several May Shows (1931–41). He participated in annual print exhibitions, in Chicago, Cleveland, and Dayton, and his work also appeared in New York City, Washington, D.C., and Venice, Italy. Kagy moved to Washington in 1936 and taught fine arts and printmaking at the Abbott Art School. He worked for the Treasury Department, 1937–40, and painted murals for post offices in Walterboro, South Carolina, and Luray, Virginia. Modeled on the Cleveland Print Makers, Kagy organized the Washington Print Maker's Club in 1940, whose members included Herman Maril and Prentiss Taylor. Kagy was head of the art department at Chevy Chase Junior College in Maryland, 1940–43, then served in the navy as a camouflage designer for the Bureau of Ships until 1945. After the war he became a professor of fine arts at the National Art School, a post he held until 1956. He was an exhibition officer and designer for the State Department, 1959–73. Kagy died in Washington.

Selected References

Kagy, Sheffield Harold. File. National Museum of American Art, Smithsonian Institution, Washington, D.C.

MAX KALISH

(1891–1945)

CA. 1918

Born in Valozin, Lithuania, Max Kalish immigrated with his family to Cleveland in 1898. Shortly after their arrival they changed the family name from Kalichik to Kalish. At the age of 15 he won a scholarship from the Cleveland School of Art and studied sculpture under Herman Matzen. In 1910 Kalish enrolled in the National Academy of Design in New York. After returning to Cleveland in early 1912, he briefly shared a studio with William Zorach. Kalish traveled to Europe in 1912–13, studying at the École des Beaux-Arts and the Académie Colarossi in Paris, and exhibiting in the Paris Salon (1913). He worked as a sculptor for the Panama-Pacific Exposition in San Francisco, 1913–14, returning to Cleveland the following year. His first solo exhibition was at Korner & Wood Galleries in Cleveland (1916). He served in the army during World War I. In 1921 he began creating bronze sculptures devoted to the theme of labor and completed the last in 1938. In 1923 Cleveland schoolchildren collected small change to fund the casting of Kalish's large-scale monument to Abraham Lincoln, which was installed in front of the School Administration Building. During the 1920s his sculptures appeared in solo shows in Cleveland and New York. He participated in the annual May Shows at the Cleveland Museum of Art (1924–30) as well as the annuals of the Pennsylvania Academy of Fine Arts in Philadelphia and the Art Institute of Chicago. In the late 1920s he began a series of marble figures that were exhibited at the Grand Central Art Galleries in New York. By 1933 he had moved to New York, where he established a private school for teaching sculpture techniques. Kalish died in New York.

Selected References

Fort, Ilene Susan. *The Figure in American Sculpture: A Question of Modernity,* 206. Exh. cat. Los Angeles: Los Angeles County Museum of Art, 1995.

Kalish, Alice. *Max Kalish—As I Knew Him.* Los Angeles: privately printed, 1969.

Lewis, N. Lawson. *The Sculpture of Max Kalish.* Cleveland: Fine Art Publishing, 1933.

JOHN KAVANAGH

(1857–1898)

CA. 1898

Born in Canada to Irish immigrant parents, John Kavanagh's name is first mentioned in Cleveland's historical record in 1875, listed as a photographic printer. Two years later he advertised himself as an artist. After studying briefly at the National Academy of Design in New York, he returned to Cleveland and established a reputation as a crayon portraitist. From 1882 to 1884 he lived in Munich, studying with genre painters Nikolaus Gysys and Ludwig von Löffitz. Kavanagh returned to Cleveland for two years, where he held a week-long solo exhibition at the James F. Ryder Gallery before leaving for Paris, where he studied under Gustave-Rodolphe Boulanger and Jules-Joseph Lefebvre at the Académie Julian. Kavanagh showed in the annual Paris Salon exhibitions (1887–89) and made summer excursions to Fontainbleau to paint landscapes. Back in Cleveland in 1889, he became director of the Art Club, where he taught portraiture and figure painting. Despite the visibility of his work, a lack of patronage left him destitute. In 1898 he was forced to sell the entire contents of his studio by public drawing. Kavanagh died the following month.

HENRY KELLER

(1869–1949)

CA. 1902

A leader of the Cleveland modernist movement, Henry Keller grew up in the city and enrolled in the Western Reserve School of Design for Women in 1887. In 1890 he went to Karlsruhe, Germany, for a year of study with Hermann Baisch. Unable to find a teaching position after returning to Cleveland, Keller worked for eight years at the Morgan Lithograph Company, where he specialized in designing circus posters. In 1899 he returned to Germany to study at art academies in Düsseldorf and Munich. In 1902, after receiving a silver medal at the Munich Kunstakademie's spring exhibition, he returned to Cleveland. Around 1903 he began teaching at the Cleveland School of Art, first as a part-time watercolor instructor, then as full-time instructor of decorative illustration. He also taught private classes on family-owned farmland in Berlin Heights, Ohio, during summers from 1903 to 1914. In the 1910s he championed the cause of modern art through lectures and teaching. He exhibited in the Armory

Show (1913) and the annuals of the Carnegie Institute of Art in Pittsburgh. The Cleveland School of Art sponsored several solo exhibitions of his paintings. He exhibited in the annual May Shows at the Cleveland Museum of Art (1919–50) and in annuals at Pennsylvania Academy of Fine Arts in Philadelphia and the Whitney Museum of American Art in New York. When he retired from the Cleveland School of Art in 1945, Keller moved to San Diego, where he died.

Selected References

Keny, James M., and Nannette V. Maciejunes. *Triumph of Color and Light: Ohio Impressionists and Post-Impressionists,* 116–17. Exh. cat. Columbus, Ohio: Columbus Museum of Art, 1994.

Leffingwell, Edward G. *Henry Keller 1869–1949: The Artist Was Teacher.* Youngstown, Ohio: Catholic Publishing, 1983.

Milliken, William. *The Henry G. Keller Memorial Exhibition.* Cleveland: Cleveland Museum of Art, 1950.

Robinson, William H. "Henry Keller: Paintings of a Traveler." *American Art Review* 5 (Winter 1994): 144–47.

Sackerlotzsky, Rotraud. *Henry Keller's Summer School at Berlin Heights.* Cleveland: Cleveland Artists Foundation, 1991.

GRACE KELLY

(1877–1950)

CA. 1893

Grace Kelly was an accomplished watercolorist and a prominent local art critic. Born in Cleveland, she entered the Cleveland School of Art at age 15, graduating in 1896. During the first two decades of the century, she taught watercolor painting and mechanical drawing at the school, while spending her summers painting under the direction of Henry Keller in Berlin Heights, Ohio. In 1912 she helped found the Cleveland Women's Art Club, with which she exhibited throughout her career. The Cleveland School of Art mounted solo exhibitions of her paintings (1916–17), and she exhibited in the annual May Shows at the Cleveland Museum of Art (1923–50). In the late 1920s she spent summers painting in Ireland and Guatemala. The Eastman Bolton Gallery sponsored a solo exhibition of her paintings (1927). In the 1930s she exhibited in Rochester, Toledo, and New York City. The Cleveland Women's Club mounted an exhibition of 70 of her works (1947). From 1926 to 1949 Kelly was the principal art critic for the *Cleveland Plain Dealer,* writing features and columns that championed local artists.

Selected References

Cleveland Town Topics, 22 July 1911, 7; 23 September 1911, 10; 21 October 1911, 9; 9 May 1925, 17; 30 October 1926, 20; 4 June 1927, 7.

Sackerlotzsky, Rotraud. *Henry Keller's Summer School in Berlin Heights.* Cleveland: Cleveland Artists Foundation, 1991.

KÁLMÁN KUBINYI

(1906–1973)

1932

Born in Cleveland, Kálmán Kubinyi was raised in the city's large Hungarian community. While a child, he attended art classes taught by William Zorach at the Jewish Council for Education Alliance. Primarily financed by scholarships, Kubinyi attended the Cleveland School of Art, graduating in 1926. In 1927 he studied in Munich with his uncle, Sándor Kubinyi von Deménfalva, who introduced him to intaglio processes. During the 1920s–40s, Kubinyi was active in the graphic arts as an artist, a teacher, and an administrator. He frequently participated in competitive print exhibitions in Cleveland, Dayton, Chicago, and New York City, including the annual May Shows at the Cleveland Museum of Art (1926–45), the Venice Biennale (1937), and the New York World's Fair (1939). He taught printmaking at the Huntington Polytechnic Institute and the Cleveland School of Art, 1936–40, as well as at the Cleveland Museum of Art. In 1930 he founded the Cleveland Print Makers and was listed as its president until 1941. He also organized the Cleveland Print Market in 1932 and was its director until 1934, when his brother took over the business end. In 1933 Kubinyi married his former classmate, the artist Doris Hall. He was the supervisor for the Cleveland graphic arts project of the Works Progress Administration, 1935–39, and district supervisor of the entire Cleveland WPA project, 1939. He was active in the Cleveland Artist's Union and a member of the American Artists' Congress, participating in their exhibition *America Today* (1936). He contributed to the Cleveland cultural periodicals *IV Arts* and *Crossroads.* After two sessions as a visiting instructor at the Cranbrook Academy of Art in Bloomfield Hills, Michigan, 1948–50, Kubinyi moved to Gloucester, Massachusetts, and opened a gallery. He and his wife worked at the Bettinger Company in Waltham, Massachusetts, making enameled murals, but were forced to quit because the process made Doris Hall severely ill. The

couple moved to Stockbridge, Massachusetts, in 1963. In 1967 Kubinyi began working for Stockbridge School as director of the art department.

Selected References

Bordner, Robert. "Kubinyi Brothers Put City on Map With Artistic Ideas." *Cleveland Press,* 6 July 1935, 5.

"Cleveland Artist No. 6. Kalman Kubinyi." *Cleveland Press,* 2 November 1946, 5.

Dancyger, Ruth. *Kubinyi and Hall.* Cleveland Artists Series. University Heights, Ohio: John Carroll University, 1988.

HUGHIE LEE-SMITH

(b. 1915)

CA. 1938

One of the most gifted figurative painters of his generation, Hughie Lee-Smith was born in Eustis, Florida. He moved to Cleveland in 1925 with his mother, a singer who recognized her son's talent and enrolled him in Saturday-morning classes at the Cleveland Museum of Art. While in high school, he took life-drawing classes at the Huntington Polytechnic Institute. After attending classes at the Detroit Society of Arts and Crafts, 1933–34, he studied with Carl Gaertner and Rolf Stoll at the Cleveland School of Art, graduating in 1938. During this period Lee-Smith taught drawing at Karamu House, then known as the Playhouse Settlement. For financial reasons he declined a fifth-year scholarship from the Cleveland School of Art in 1938 and began working for the Works Progress Administration's Ohio Art Project, where he learned lithography and etching. He exhibited in the annual May Shows at the Cleveland Museum of Art (1937–41). In 1939 he became a board member of the magazine *Crossroads* and later that year received a one-year appointment to teach art at Claflin College in South Carolina. In 1940 he cofounded Karamu Artists Incorporated and served as the organization's president. In the early 1940s he moved to Detroit, the hometown of his new wife. After serving in the navy during World War II, he returned to Detroit and attended Wayne University, where he earned a B.S. in education in 1953. He exhibited steadily throughout the 1940s and 1950s, showing at galleries in Cleveland, Detroit, Chicago, New York, Washington, D.C., and Philadelphia. In 1957 he won the prestigious Emily Lowe Award from the National Academy of Design and soon after moved to

New York. In 1967 he was elected a full-member of the National Academy of Design and began teaching there in 1972. In 1988 the Malcolm Brown Gallery in Cleveland mounted a solo exhibition of his work, and later that year the New Jersey State Museum in Trenton organized a retrospective. Lee-Smith lives and works in New Jersey.

Selected References

Bearden, Romare, and Harry Henderson. *A History of African-American Artists from 1792 to the Present,* 328–36. New York: Pantheon, 1993.

Hughie Lee-Smith: Retrospective Exhibition. Trenton: New Jersey State Museum, 1988.

ADAM LEHR

(1853–1924)

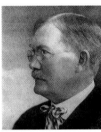

CA. 1918

Adam Lehr was born and spent most of his life in Cleveland. Upon his father's death, the adolescent Lehr supported his family by working as a house painter, then as a letterer and sign painter. Hearing of the young man's skills, a local carriage and wagon manufacturer, Rauch and Lang, employed him as a decorator. His most memorable design was images of polar bears for ice wagons. He studied with De Scott Evans in 1874 and then with Archibald Willard, 1875–80. Lehr exhibited at the Cleveland Loan Exhibition (1878) and the studio of James F. Ryder (1880). During the winter of 1880–81, Alexander Gunn and William Whitney provided Lehr with funds to attend the Art Students League in New York, where he studied with William Merritt Chase. On returning to Cleveland, Lehr established himself as a still-life painter, specializing in game, fruit, and flowers, but he also painted landscapes. Lehr exhibited actively in Cleveland and occasionally in New York for the balance of a career that lasted until 1919.

Selected References

Sackerlotzsky, Rotraud, and Mary Sayre Haverstock. *F. C. Gottwald and the Old Bohemians.* Cleveland: Cleveland Artists Foundation, 1993.

RUSSELL LIMBACH

(1904–1971)

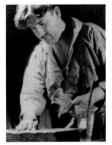

1932

Russell Limbach, known as "Butch," was born in Massillon, Ohio. After making his first lithographs as a teenager in a large commercial house, he attended the Cleveland School of Art, 1922–26. He quit and worked in Cleveland in a shop-ad agency for a few years. After he was fired, he went to work for the publicity department of the Union Trust Company. In 1929 and 1930 he traveled to Europe, visiting Vienna, Berlin, and Paris. Beginning in 1931, he made political cartoons for periodicals such as the *Cleveland Magazine* and the radical leftist publications the *New Masses* and the *Daily Worker.* An active member of the Cleveland Print Makers, he gave public demonstrations of printmaking and was one of the club's directors. Limbach exhibited widely during the 1930s. His first solo show was at the Kokoon Klub (1931), and he had a show devoted to color lithographs at the Cleveland Print Market (1932). He participated in the annual May Shows at the Cleveland Museum of Art (1926–35) and in numerous exhibitions in Los Angeles, Philadelphia, New York, and Cleveland (late 1920s, 1930s, and early 1940s). He was a member of the American Artists' Congress, taking part in the *America Today* exhibition (1936). He was one of two Cleveland printmakers commissioned by the Public Works of Art Project in 1934. He moved to New York in 1935 and became technical advisor for the Works Progress Administration graphics workshop in New York, making the project's first color lithograph. He taught at Walt Whitman High School in New York City beginning in 1939 and left the WPA in 1940. In 1941 Limbach joined the faculty at Wesleyan University in Middletown, Connecticut, and remained there until his death.

Selected References

Acton, David. *A Spectrum of Innovation, Color in American Printmaking 1890–1960,* 271. Exh. cat. Worcester, Mass.: Worcester Art Museum, 1990.

Bordner, Robert. "Limbach Found Shrewd, Bold New Prints." *Cleveland Press,* 28 November 1931, 5.

JAMES MOTT

(1819–1848)

Born in Rutland, Vermont, James Mott was living in Cleveland by 1835. At the age of 16 he joined the Center Family of the Shaker community of North Union (now Shaker Heights). In committing himself to the Shakers, Mott sacrificed any worldly ambitions in exchange for a carefully ordered, celibate, communal society. Because of Shaker beliefs in personal humility, no record exists of the role Mott played in the North Union community.

Selected References

Patterson, Daniel W. *Gift Drawing and Gift Song: A Study of Two Forms of Shaker Inspiration,* 10, 95. Sabbathday Lake, Maine: United Society of Shakers, 1983.

ELMER NOVOTNY

(b. 1909)

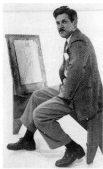

1938

Born in Cleveland, Elmer Novotny began painting landscapes around the age of six under the direction of his father, a commercial lithographer and amateur painter. He received his first portrait commission at the age of 13. After attending the Cleveland School of Art, 1927–30, he traveled to London to study at the Slade School on a postgraduate scholarship. Funds from two wealthy patrons in Cleveland enabled him to attend studio classes at an art academy in Zagreb, Yugoslavia, and at the Yale University School of Art. By 1933 he was an established artist carrying out portrait commissions in Cleveland, Boston, and New York. He received his B.A. from Western Reserve College in Cleveland in 1934 and his M.A. from Kent State University in 1935. The following year, he became an instructor at Kent State, a position he held for nearly 40 years. He also taught portraiture at the Cleveland School of Art, 1947–52. Novotny exhibited in the annual May Shows at the Cleveland Museum of Art (1930s–80s). The Akron Institute of Art and the Kent State University Art Gallery organized solo exhibitions of his paintings. After retiring in 1974, he traveled extensively and continued to paint. In 1981 the Butler Institute of Art in Youngstown mounted a solo exhibition of his paintings. Novotny currently lives in California.

JOSEPH PARKER

(active 1839–40)

Little is known of the life of Joseph Parker, an itinerant actor, comedian, and painter. His advertisements for theatrical productions appear in the *Cleveland Daily Herald* only during the summer months of 1839 and 1840. Together with his partner, J. H. Mueller, Parker managed a troupe of actors and singers in the Italian Hall in Cleveland. His career in the city came to an abrupt halt following the appearance of this announcement on page three of the 31 July 1840 edition of the *Cleveland Daily Herald*: "Notice is hereby given that the firm of Parker & Mueller, Theatrical Managers, is dissolved, the Treasurer J. H. Mueller having ran away on the night of July 20th. This is to inform the public that I will not be answerable for any debts of his contracting." The only evidence of his work as a painter, in addition to the work in the exhibition, is a reference appearing on page three of the 24 April 1839 issue of the *Cleveland Weekly Advertiser*: "Mr. Parker paints his own scenery and does it in good style."

HORACE POTTER

(1873–1948)

Horace Potter was among the most successful metalsmiths working in Cleveland in the early 20th century. A Cleveland native, Potter graduated from the Cleveland School of Art and subsequently earned an M.A. from the Boston Society of Arts and Crafts, specializing in silversmithing. Potter returned to Cleveland in 1899 and opened a design studio, working with assistants in a variety of media from silver to stained glass. He supplemented his income by teaching design part-time at the Cleveland School of Art. In 1907 he left for England to study at the Guild of Handicraft in Chipping-Camden, an international center of design in the arts and crafts tradition. He also learned enameling there. After an extended tour through Europe, he returned to Cleveland in 1909 and established the Potter Studio, where key figures in Cleveland's decorative arts community congregated, including R. Guy Cowan and Louis Rorimer. After 1910 Potter attained professional acclaim and received medals for works exhibited in San Francisco, Chicago, and Cleveland. In 1933 he merged his studio into a new business venture with Louis Mellen to create Potter-Mellen, Inc., a successful enameling and silversmith firm that produced a variety of objects, from jewelry to large liturgical items for religious institutions. Potter remained active in Cleveland until his death.

CAROLINE RANSOM

(1826–1910)

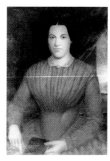

CA. 1864

Born in Newark, Ohio, Caroline Ransom was taught by her mother, an amateur artist, to draw and paint with watercolors. She received more formal art lessons from an unidentified itinerant painter commissioned to create portraits of several family members. In 1853 she went to New York and over the course of several years studied landscape painting with Asher B. Durand and figure painting and portraiture with Thomas Hicks and Daniel Huntington. She exhibited at the National Academy of Design in New York during this period. In 1861 she moved to Cleveland and worked in the city off and on for the next 25 years. Not long after her arrival she made her artistic debut, exhibiting portraits in the studio Allen Smith, Jr., had occupied prior to his move to Cincinnati. She also exhibited at the Northern Ohio Sanitary Fair held in Cleveland (1864). During the early 1860s she cultivated a friendship with future President James Garfield and his family, a connection that led to several important commissions and purchases. She traveled to Munich in 1867 and studied with Wilhelm von Kaulbach for a year. She participated in the Cleveland Loan Exhibition (1878). Although politically and socially well connected in Cleveland, Ransom received few commissions during the 1880s and decided to make Washington, D.C., her permanent residence in 1885. She did, however, continue to spend most summers in Cleveland. The abundant commissions Ransom had anticipated in Washington failed to materialize, and her output lessened considerably.

Selected References

W. W. Williams. "Caroline L. Ransom." In *History of Ashtabula County, Ohio, with Illustrations and Biographical Sketches of Its Pioneer and Most Prominent Men, 1798–1878,* 111–13. Philadelphia: Williams Brothers, 1878.

Woods, Marianne Berger. "C. L. Ransom in Cleveland: A Woman at Work," *Cleveland as a Center of Regional American Art,* 19–25. Cleveland: Cleveland Artists Foundation, 1993.

WALTER DUBOIS RICHARDS

(b. 1907)

Walter Dubois Richards is best known for his lithographs of the 1930s and 1940s, primarily classical, realist images of the American scene. Born in Penfield, Ohio, he was raised in Rocky River, just west of Cleveland. He studied with Henry Keller, Paul Travis, and Carl Gaertner at the Cleveland School of Art, graduating in 1930. He accepted a commercial art job with the Sundblom Art Group in Chicago in 1930. In 1931 he returned to Cleveland and worked at Tranquillini Advertising Art Studios, where he met Stevan Dohanos, who became a lifelong colleague and friend. In 1932 Richards and Dohanos spent a summer in Eastport, Maine, at the George Pearce Ennis School, where they studied lithography with Stow Wengenroth. In 1936 Richards joined Dohanos in New York City, where they worked together again in the Charles E. Cooper Studios. Practicing free-lance work exclusively, Richards moved to Connecticut. He has done commercial work for companies such as Anheuser-Busch, Campbell's Soup, Chrysler, General Electric, and Standard Oil. He designed more than 40 commemorative postage stamps and illustrated several books. He also served as the official history painter for the U.S. Air Force, traveling to Vietnam in the mid-1960s. His illustrations have appeared in *Reader's Digest, Colliers, American Legion, Life, Look,* and *Fortune* magazines. He has exhibited his works in the annual May Shows at the Cleveland Museum of Art (1930s) as well as in exhibitions in New York City, Chicago, and Philadelphia. He was a director of the Cleveland Print Makers. In 1950 he established the Fairfield Watercolor Group, an organization of artists and illustrators who met regularly to practice and discuss the fine arts. Richards currently lives in Connecticut.

Selected References

Richards, Walter. File. National Museum of American Art. Smithsonian Institution, Washington, D.C.

Whitaker, Frederic. "Walter Richards, Illustrator." *American Artist* 22 (March 1958): 50–55, 66–67.

LOUIS RORIMER

(1872–1939)

CA. 1925

Louis Rorimer was born Louis Rohrheimer in Cleveland to a German immigrant family. In the mid-1880s he studied at Cleveland's Manual Training School with sculptor Herman Matzen. Around the age of 16 Rorimer began taking classes at the Cleveland School of Art and later studied in Munich at the Kunstgewerbeschule, 1890–93, and in Paris at the École des Arts Décoratifs and the Académie Julian, 1893–95. He returned to Cleveland in 1895, opening a design studio for handmade furniture and interior design the following year. From 1898 until his retirement in 1936, he taught decorative art and design at the Cleveland School of Art, where his students included Horace Potter, Max Kalish, Abel Warshawsky, Grace Kelly, and Charles Burchfield. Rorimer merged his studio with another interior design company in 1910 to form the Rorimer-Brooks Studios, a commercial workshop and gallery. He encouraged progressive artists to meet and display their works at his gallery, which from 1910 to 1912 mounted early exhibitions by Warshawsky, William Zorach, and the Cleveland "secessionists." In 1913 Rorimer was promoted to head of the design department at the Cleveland School of Art, and his work appeared in May Shows at the Cleveland Museum of Art (1919–28).

Selected References

"Mr. Rorheimer's Decorative Department." *Cleveland Town Topics* (20 January 1917), 26.

Piña, Leslie. *Louis Rorimer: A Man of Style.* Kent, Ohio: Kent State University Press, 1990.

DOROTHY RUTKA

(1907–1985)

CA. 1935

Although active as an artist in Cleveland through the 1980s, Dorothy Rutka is best known for her sobering Depression-era intaglio prints depicting social ills. Born and raised in Grand Rivers, Michigan, Rutka moved to Ohio to attend the Cleveland School of Art. She graduated in 1929 with a specialization in portraiture and did additional course work in the Huntington Polytechnic Institute. She married Jack Kennon, political editor for the *Cleveland News.* In 1931

she toured Europe for seven months. In the early 1930s she worked as a writer and illustrator for the *Bystander* and in 1936 was part of the Cleveland graphic arts project of the Works Progress Administration. She joined the Cleveland Artist's Union and the American Artists' Congress. In Cleveland she showed at the Ross Widen Gallery, the 1030 Gallery, and the Art Colony (1940s–50s). She also exhibited frequently in the May Shows at the Cleveland Museum of Art (1929–66) and in exhibitions in New York, Philadelphia, Dayton, Brooklyn, and Washington, D.C. In 1960 she married Philip Porter, who was named executive editor of the *Plain Dealer* in 1963. They were killed by an unknown intruder in their home in Shaker Heights, Ohio.

Selected References

Bruner, Ray. "Art: Dorothy Rutka Learns Pigs Are Thin—And Now Prints Strike Sociological Note." *Cleveland News,* 31 December 1938, 10.

"Cleveland Artist No. 48. Dorothy Rutka." *Cleveland Press,* 11 October 1947, 5.

Rutka, Dorothy. File. Cleveland Artists Foundation.

RUDOLPH RUZICKA

(1883–1978)

Born in Bohemia, Rudolph Ruzicka immigrated with his family to Chicago in 1894. At the age of 14, he left school to become a wood-engraving apprentice at the Franklin Engraving Company in Chicago. He attended evening classes at the Art Institute of Chicago as well as weekend drawing classes at Hull House, 1897–1900. He moved to New York to work as a commercial printmaker in 1903. He had solo exhibitions in Cleveland at Korner & Wood Galleries (1913) and the Cleveland Museum of Art (1917). He traveled to Cleveland and sketched the city after receiving a commission to create work for the Cleveland Print Club in 1927. He moved to Boston during the late 1940s and over the subsequent decades added book illustration to his career achievements. Ruzicka died in Hanover, New Hampshire.

Selected References

Acton, David. *A Spectrum of Innovation, Color in American Printmaking 1890–1960,* 282–83. New York: Norton, 1990.

Nash, Ray. "The Genius of Rudolph Ruzicka." *American Artist* 31 (December 1967): 44–50, 71–73.

JAMES F. RYDER

(1826–1904)

CA. 1901

Although best known for his entrepreneurial activities involving other artists, James F. Ryder was himself an innovative photographer who introduced the technique of retouching negatives to American photography. Born in Ithaca, New York, he initially earned a living as a book printer but changed his career direction when he learned photography from a local daguerreotypist. In 1849 he launched a career as an itinerant photographer and after two years of travel settled in Elyria, Ohio. Subsequently he made frequent trips to Cleveland, first listing himself in the city directory in 1856. Ever intrigued by new photographic technologies, Ryder learned the process of retouching negatives from a German scientist in 1868. The following year he exhibited in Boston his first batch of retouched photographs, for which he won several awards. In 1872 Ryder opened a new photography studio and art gallery in Cleveland and shortly afterward became associated with the painter Archibald Willard. Recognizing the profit-making potential of the artist's images, Ryder marketed mass-produced chromolithographs of Willard's paintings, a commercial enterprise that was enormously successful for both men. From the 1870s until his retirement in the 1890s, he photographed Cleveland and many of its political leaders. Ryder died in Cleveland two years after publishing his memoirs.

Selected References

Ryder, James F. *Voigtländer and I: In Pursuit of Shadow Casting.* Cleveland: Imperial, 1902.

CHARLES SALLÉE

(b. 1913)

CA. 1940

Charles Sallée was born in Oberlin, Ohio, but later moved to Sandusky, where his father established a construction contracting company. Sallée learned the building trade from his father but decided to pursue a career in art. In 1931 he moved to Cleveland and attended art classes at Karamu House, then known as the Playhouse Settlement. He studied lithography and etching techniques at the Huntington Polytechnic Institute, 1932–33. He attended the Cleveland School of Art, 1933–38, studying with Carl Gaertner, Viktor Schreckengost, Rolf Stoll, and Paul Travis. In 1939 he earned a B.S. in education from Western Reserve College and began teaching art in the Cleveland school system. In 1936 he joined the local chapter of the American Artists' Congress. Sallée worked on several Works Progress Administration projects, 1936–41, first creating prints, then painting murals. His WPA commissions included work for Sunny Acres Hospital, the Outhwaite Homes, and Cleveland Municipal Airport, as well as the Fort Hays Homes in Columbus, Ohio. He exhibited in the May Shows at the Cleveland Museum of Art (1935–46), and in group exhibitions at Howard University (1937) and the Library of Congress in Washington, D.C. (1940), the Tanner Art Galleries of Chicago (1940), the Associated American Artists Galleries of New York (1941), and Atlanta University (1942). The North Canton Library in Canton, Ohio, organized his first solo exhibition in 1940. He was drafted into the Army Corps of Engineers during World War II and worked as a cartographer and camouflage designer. After the war, he began a career in interior design. For the next four decades, Sallée worked for various interior design firms in Cleveland, designing corporate offices, nightclubs, hotels, and restaurants for such clients as Cleveland Trust, Stouffer Hotel, and the Cleveland Browns.

Selected References

Bright, Alfred L. "Cleveland Karamu Artists 1930 to 1945." In *Cleveland as a Center for Regional American Art,* 72–83. Cleveland: Cleveland Artists Foundation, 1993.

Cullinan, Helen. "Artist's 50-year-old Etchings Draw Him Back into Limelight." *Plain Dealer,* 2 August 1992, H-3.

Schulz, Ellen. *The Russell and Rowena Jelliffe Collection: Prints and Drawings from the Karamu Workshop, 1929–1941.* Cleveland Heights, Ohio: St. Paul's Episcopal Church, 1994.

VIKTOR SCHRECKENGOST

(b. 1906)

1936

Born to a family of potters in Sebring, Ohio, Viktor Schreckengost studied at the Cleveland School of Art, 1924–29, supporting himself during that period by playing in jazz bands. Under the advice of ceramics instructor Julius Mihalik, Schreckengost went to Vienna for postgraduate study at the Kunstgewerbeschule, where received instruction from Michael Powolny. Schreckengost was visited in Vienna by his friend R. Guy Cowan, who encouraged him to return to Cleveland to work at the Cowan Pottery Studio. Schreckengost did so, creating functional ceramic pieces. In 1931 he began teaching at the Cleveland School of Art. He exhibited in the annual May Shows at the Cleveland Museum of Art (1931–66). From 1933 to 1956 his ceramics frequently appeared in the annual National Ceramic Exhibitions in Syracuse, New York. In the mid-1930s he designed commercially produced dinnerware, but he is best known for the sculptures he produced in the 1930s and 1940s. In 1958, after creating a number of large-scale ceramic works commissioned by various Cleveland institutions, he was awarded the Gold Medal of the American Institute of Architects for excellence in architectural sculpture. In the 1960s he became increasingly devoted to industrial design. Schreckengost retired from the Cleveland Institute of Art in 1976 but remains actively engaged in the local art scene, teaching privately, as well as creating and exhibiting his work.

Selected References

Anderson, Ross, and Barbara Perry. *The Diversions of Keramos: American Clay Sculpture 1925–1950,* 37–48. Exh. cat. Syracuse, N.Y.: Everson Museum of Art, 1983.

Corsiglia, Christina. "Viktor Schreckengost: Evolution of a Cleveland Ceramist." In *Cleveland as a Center of Regional American Art,* 100–12. Cleveland: Cleveland Artists Foundation, 1993.

Schmeckebier, Laurence. *Viktor Schreckengost Retrospective Exhibition.* Exh. cat. Cleveland: Cleveland Institute of Art, 1976.

Schreckengost, Viktor. Papers. Archives of American Art. Smithsonian Institution, Washington, D.C.

Stubblebine, James, and Martin Eidelberg. "Viktor Schreckengost and the Cleveland School." *Craft Horizons* 35 (June 1975): 34, 52–52.

LAWRENCE SCHREIBER

(1904–1982)

A specialist in the pictorialist techniques of bromoil transfer and gum bichromate, Lawrence Schreiber spent more than 40 years creating evocative photographs of Cleveland harbor and the Flats. While supporting himself until 1967 as the chief librarian of the *Cleveland Press,* he was active in local camera clubs, the Photographic Society of America, and the New Pictorialists Society. He preferred the bromoil and gum bichromate processes because they afforded more opportunities for manipulating the printing process, thus facilitating personal expression. Through these techniques he attained subtle tonal variations and emphasized qualities of abstract pictorial design. In 1954 he exhibited with the New Pictorialists at the Smithsonian Institution in Washington, D.C., and at the Pasadena Central Library. Posthumous exhibitions of Schreiber's photographs were organized by the Cleveland Public Library (1989–90) and the Beck Center in Lakewood, Ohio (1991).

Selected References

Cullinan, Helen. "Three Varied Visions of the Flats." *Plain Dealer,* 21 June 1991, 18.

A Pictorialist's View. Exh. pamphlet. Cleveland: Cleveland Public Library, 1989.

MANUEL SILBERGER

(1898–1968)

A commercial lithographer by trade, Manuel G. Silberger was active as a printmaker and portrait painter during the 1930s. Born in Bokovic, Hungary, the son of a merchant, Silberger received his first art training in Miskolz, Hungary before immigrating to America in 1921 to join his family in Cleveland. He attended night classes at the Huntington Polytechnic Institute, studying with Henry Keller and Paul Travis. From 1926 until his retirement in 1964, he was a lithographer at the Morgan Lithograph Company. He made lithographs and etchings for the Cleveland graphic arts project of the Works Progress Administration, 1936–37. Between 1939 and 1940 he was on the editorial board of *Crossroads* as well as a contributor. His prints and oil portraits were in the annual May Shows of the Cleveland Museum of Art (1935–52), and he also participated in exhibitions in Dayton, Chicago, and New York. He never married and lived in Cleveland with his sister Tessie until his death.

Selected References

Silberger, Manuel G. Papers. Mss. 4604. Manuscript Collections. Western Reserve Historical Society, Cleveland.

F. W. SIMMONS

(1859–1926)

CA. 1900

A painter of society portraits, Freeman Willis Simmons shuttled back and forth between Cleveland and Paris for much of his career. Born in the western Pennsylvania town of Fredonia, Simmons came to Cleveland because it was the nearest city where he could learn to paint. He studied with Frank Tompkins at the Art Club, but after a few years moved on to New York, where he learned from William Merritt Chase at the Art Students League. In 1886 Simmons went to Paris, where he trained with Jules-Joseph Lefebvre and Gustave-Rodolphe Boulanger at the Académie Julian and exhibited at the Salon the next year. In 1889 Simmons was back in Cleveland, teaching at the Art Club, opening a private art school, and the next year receiving an appointment in Akron as principal of the Buchtel College art department. He paid extended visits to Paris (and to Munich in 1893) no fewer than four times throughout the 1890s and 1900s, a practice brought to an end when bombs damaged his studio in 1914. At that time, Simmons returned to the United States, spending the last years of his life painting portraits and landscapes, sometimes in Cleveland but often visiting such Massachusetts coastal towns as Provincetown and Rockport.

WALTER SINZ

(1881–1966)

CA. 1930

Cleveland native Walter Sinz worked in a variety of media, including metal, stone, wood, and ceramic. He was the son of a lithography instructor at the Cleveland School of Art and learned printmaking at an early age from his father. After a year's apprenticeship in an architect's office, he entered the Cleveland School of Art in 1907, studying sculpture under Herman Matzen and later becoming Matzen's assistant. Sinz taught lithography and sculpture at the school, 1911–52, when he retired to work on sculptural commissions. He exhibited in the annual May Shows held at the Cleveland Museum of Art (1919–66). In 1924 he took a leave of absence from teaching to study at the Académie Julian in Paris. From 1928 to 1931 he produced ceramic sculpture at the Cowan Pottery studios. From the 1930s to the 1960s, he received numerous commissions for portrait busts, architectural orna-

ment, and monumental sculptures. The Cleveland Society of Artists organized a retrospective exhibition of his work in 1958.

Selected References

Anderson, Ross, and Barbara Perry. *The Diversions of Keramos: American Clay Sculpture 1925–1950,* 83–84. Exh. cat. Syracuse, N.Y.: Everson Museum of Art, 1983.

ALLEN SMITH, JR.

(1818–1890)

CA. 1859

Born in Rhode Island to a family of Puritan stock, Smith began his career as a professional painter making stage scenery in New York City before 1832. He soon studied portraiture with a local painter named Parisen, either Julian or William. Smith also drew at the American Academy of Art and at the National Academy of Design. He married during this New York period and in 1835 left for Detroit, where his parents had moved. There he completed at least two civic commissions, a flag design and a portrait of the state governor. He returned to New York as early as 1839, when he exhibited a sketch for his portrait of the governor at the National Academy of Design. By 1841 the Michigan legislature had not yet paid him for their version of that likeness, and Smith requested the portrait's return. His first Cleveland period ran for almost two decades beginning in 1842. In addition to the portraits on display in his studio, prospective patrons could occasionally see his genre paintings in storefronts. He began collaborating on photograph paintings in 1855, soon working with James F. Ryder in this medium. Even though he lived in Cleveland, Smith maintained a professional presence in places he had already worked by sending paintings for exhibition to New York and Detroit. His use of venues in Cincinnati in the early 1850s anticipated his move there about 1859, a change that may have been prompted by the opportunity to profit from the brisk market for photograph paintings. Smith lost his wife during his Cincinnati period, but soon remarried. These years must have been lucrative ones for him, because in the 1870 census he declared the value of his real estate holdings at the considerable sum of $15,000. By 1865 he had begun his second Cleveland period. He exhibited a painting in Chicago in 1871 and traveled to Evansville, Indiana, in 1873, which broadened his midwestern connections. Although not among the first Art Club members in 1876, he exhibited with them in

their first shows. His longevity in the town added legitimacy to the group, and probably for similar reasons he appeared among the incorporators of the Cleveland Academy of Art in 1881. Two years later Smith retired to Painesville, Ohio, where he devoted himself to landscape painting, a genre that he had pursued intermittently throughout his entire career.

Selected References

Steinberg, David. "Mr. Smith Goes to Cleveland, and Other Stories." In *Cleveland as a Center of Regional American Art,* 5–13. Cleveland: Cleveland Artists Foundation, 1993.

R. WAY SMITH

(1840–1900)

Rufus Way Smith was born in Bedford, Ohio. His family moved in 1850 to Cleveland, where he studied painting as an apprentice with Jarvis Hanks. The death of Hanks in 1853 disrupted Smith's career plans, and he subsequently studied law at Hiram (Ohio) College and Ohio State University. In 1864 he was admitted to the bar of Ohio and worked as an attorney in Cleveland. He pursued this career track until the early 1870s, when he relinquished law to practice painting full-time. Smith studied briefly in Philadelphia and New York before returning to Cleveland, where he worked as a landscape painter. During the 1880s, he held several solo exhibitions at the studio of James F. Ryder and was also included in group shows mounted by the Society of Cleveland Artists, of which he was a member. Smith was also active in the Art Club and the Cleveland Academy of Art. In the 1890s, he began to specialize in painting sheep, a subject that brought him his greatest success. Suffering from bad health, Smith moved in 1898 to live with relatives in California, where he died two years later.

Selected References

Sackerlotzky, Rotraud, and Mary Sayre Haverstock. *F. C. Gottwald and the Old Bohemians.* Cleveland: Cleveland Artists Foundation, 1993.

WILLIAM E. SMITH

(b. 1913)

A highly skilled printmaker, William Elijah Smith specialized in genre scenes of working-class African-American life in Cleveland. Born in Chattanooga, Smith moved to Cleveland at the age of 13 and became involved

CA. 1940

with Karamu House, learning printmaking and stage design. He studied art at the Huntington Polytechnic Institute, 1933–34. During this time he began teaching at

Karamu House and continued to do so until 1940. In 1941 he won the art competition for presenting one of his prints to the Library of Congress for its permanent collection. Smith exhibited at the Connecticut Academy of Fine Arts in Hartford (1935), in the annual May Shows at the Cleveland Museum of Art (1936–49), at the Associated American Artists Galleries of New York (1942), and at Atlanta University (1942). During World War II, he served as a photographer in the army's educational department. After the war, he returned to Cleveland and established a commercial silkscreening studio. In 1946 the Lyman Brothers' Gallery in Indianapolis mounted his first solo exhibition. From 1946 to 1948 he studied painting and printmaking at the Cleveland School of Art and the Cooper School of Art. In the late 1940s Smith moved to Los Angeles, where he associated with Curtis Tann, a former colleague from Karamu House. With Tann, Smith cofounded the Eleven Associated Artists Gallery, the first Los Angeles gallery devoted specifically to African-American art. In 1952 Smith was hired to work as a blueprint draftsman at Lockheed Aircraft, beginning a long association with the corporation. In 1960 he cofounded Art West Associated, an African-American artists' advocacy organization in Los Angeles. In 1970 he published illustrations of subjects from African-American history for Cleveland's New Day Press. Smith's works were displayed in numerous group exhibitions in the Los Angeles area (1960s–80s).

Selected References

Roberson, William C. "Artist Wm. Smith Captures the Humor and Pathos of Negro Life." *Call & Post,* 22 April 1972, A–9.

Smith, William E., and Marjorie Witt Johnson. *The Printmaker, "From Umbrella Stave to Brush and Easel": William E. Smith, the Story of a Man and His Works 1926–1976.* Brochure. Cleveland: privately printed, 1976.

WILLIAM SOMMER

(1867–1949)

Born in Detroit to a family of German immigrants, Sommer first studied drawing at the age of 11 with Julius Gari Melchers. Pursuing a career in commercial lithography, Sommer apprenticed at Calvert Lithography in Detroit, 1881–88, and subse-

CA. 1930

quently worked at various lithography shops in Boston, New York, and England. In 1890 he went abroad for a year of study at the Kunstakademie in Munich. In 1891 he returned to New York and spent the next 16 years working as a commercial lithographer. In 1907 he moved to Cleveland to work for

the Otis Lithograph Company, where he became friendly with William Zorach. Around 1910, and under the influence of Abel Warshawsky, Sommer began to experiment with impressionist colors; subsequently he experimented with a fauvist palette. He exhibited with the Cleveland "secessionists" at the Rorimer-Brooks Studios in early 1911 and cofounded the Kokoon Klub that summer. Around 1914 he moved to Brandywine, a rural valley about 20 miles south of Cleveland, where he converted an abandoned schoolhouse into a studio that became an important meeting place for modern artists, poets, and musicians. In May 1918 Sommer designed stage sets and programs for a production of *Everyman* by the Cleveland Play House. He exhibited in the annual May Shows at the Cleveland Museum of Art (1922–50). In the 1930s and 1940s he exhibited on a regular basis in Cleveland, Chicago, and New York. During the Depression he was employed by various New Deal art programs to paint murals for Cleveland Public Hall (1933), Cleveland Public Library (1934), the post office in Geneva, Ohio (1938), and the Akron Board of Education (1941). After the death of his wife in 1945, he was struck by chronic bouts of depression and alcoholism. Sommer died in Brandywine.

Selected References

Ingalls, Hunter. "The Several Dimensions of William Sommer." Ph.D. diss., Columbia University, 1970.

Kendall-Hess, Wendy. *The Art of William Sommer.* Akron: Akron Art Museum, 1994.

McClelland, Elizabeth. *William Sommer: Cleveland's Early Modern Master.* University Heights, Ohio: John Carroll University, 1992.

Sommer, William. Papers. Archives of American Art. Smithsonian Institution, Washington, D.C.

THOMAS H. STEVENSON

(active about 1840–1869)

Little is known about Stevenson's early years, although information available about his sister (Frances Mary, born in Talehurst, Sussex County, England in 1825) offers a useful

CA. 1860

lead for further

research. In his earliest known advertisement, Stevenson claimed to have studied at London's Royal Academy and at the Louvre, yet the former institution has no record of his enrollment. He is first known to have worked in the United States about 1840, painting portrait miniatures initially in St. Louis and then in Springfield, Illinois. In 1841 he taught art in Chicago and, with James Wilkins, organized that city's first

art exhibit. Later that year, he began a period in Cleveland during which he painted portrait miniatures and watercolors, exhibited watercolors at his studio, and conducted private drawing classes. Leaving the city in 1846, he settled in Toronto, where he and Edward McGregor collaborated on portraits and landscapes. In 1853, Stevenson painted a diorama in Hamilton, Ontario, with Mark R. Harrison. Stevenson moved to Wisconsin in 1855, first briefly to Madison and then to Milwaukee. That year, he collaborated with Samuel M. Brookes on a set of local topographic paintings commissioned by the Fox-Wisconsin River Improvement Company, now at the State Historical Society of Wisconsin, Madison, and the Neville Public Museum of Brown County, Green Bay. In 1856 and 1857 the pair painted several historic battlegrounds, also now at the State Historical Society of Wisconsin. Perhaps to be near his sister, who had married John Wenban in Cleveland in 1842, Stevenson had begun a second Cleveland period by 1863, working in the studio of James F. Ryder as a photograph retoucher and introducing his nephew Sion Wenban to that trade. The last known trace of Stevenson is his listing in the city directory for 1869.

Selected References

Butts, Porter. *Art in Wisconsin.* Madison, Wis.: Democrat Printing, 1936.

Harper, J. Russell. *Early Painters and Engravers in Canada.* Toronto: University of Toronto, 1970.

Madden, Betty. *Art, Crafts, and Architecture in Early Illinois.* Urbana: University of Illinois Press in cooperation with Illinois State Museum, 1974.

ROLF STOLL

(1892–1978)

CA. 1930

A native of Heidelberg, Germany, Rolf Stoll studied at art academies in Karlsruhe and Stuttgart before immigrating to the United States. He briefly attended the Art Students League in New York, then settled in Cleveland in the 1920s. In 1926 he began teaching portrait painting at the Cleveland School of Art, where he had a solo show the following year. In the mid-1930s, Stoll received federal commissions to paint murals for the Board of Education Building in Cleveland and the post office in East Palestine, Ohio. He exhibited in the annual May Shows at the Cleveland Museum of Art (1925–54). From the 1930s through the 1950s his paintings were featured in group exhibitions in Cleveland, at the Butler Art Institute in Youngstown, the Pennsylvania Academy of Fine Arts in Philadelphia, the Art Institute

of Chicago, and the Carnegie Institute of Art in Pittsburgh. Stoll retired from teaching in 1957.

PAUL TRAVIS

(1891–1975)

CA. 1912

Born in Wellsville, Ohio, Paul Bough Travis grew up on his family's farm. After attending high school, he worked for a few years as a teacher in a country schoolhouse. Inspired by a catalogue to attend the Cleveland School of Art, he enrolled at the school in 1913 and graduated in 1917. During his student years he associated with Henry Keller and Charles Burchfield. In 1918 Travis served in the army, stationed in France. He remained overseas for a year after the Armistice, painting watercolors and teaching at American universities in France and Germany. In 1920 he returned to Cleveland and began exhibiting in the annual May Shows at the Cleveland Museum of Art, continuing to do so for more than 50 years. He served on the faculty of the Cleveland School of Art, 1927–57. In 1927 he fulfilled a lifelong dream to paint in Africa, where he also purchased tribal art with funds provided by the Gilpin Players of Karamu House. The works were subsequently divided between the Cleveland Museum of Natural History, the Cleveland Museum of Art, and Karamu House. Exhibitions of his African subjects were held at the Eastman-Bolton Galleries of Cleveland (1929) and the Milwaukee Art Institute (1931). In the 1930s his paintings were featured in group shows at the Carnegie Institute of Art in Pittsburgh and the Art Institute of Chicago. The Butler Art Institute in Youngstown organized a solo exhibition of his paintings (1943). Travis continued to paint after retiring from teaching in 1957 and died in Cleveland.

Selected References

Boger, Ann C. *Paul B. Travis: Africa 1927–1928.* Exh. cat. Cleveland: Cleveland Museum of Art, 1982.

Travis, Paul. Papers. Archives of American Art. Smithsonian Institution, Washington, D.C.

SANDOR VAGO

(1887–1946)

1932

An acclaimed portrait painter, Sandor Vago was born in Hungary and studied at art academies in Budapest and Munich. In the early 1910s he exhibited in Budapest, Vienna, and Venice. Little is known about his art of this period because most of it was destroyed during World War I. In 1921 he immigrated to Cleveland. Soon after his arrival, he joined the Cleveland Society of Artists, opened a studio, and launched a lucrative career as a portrait painter, receiving commissions from individuals as well as private and public institutions, including Western Reserve Academy and the Catholic Diocese of Cleveland. He exhibited in the annual May Shows at the Cleveland Museum of Art (1922–47). His paintings were featured in solo exhibitions at Korner & Wood Galleries (1925), Gunther's Gallery (1927), Gage Gallery (1929), Webb C. Ball Art Galleries (1932, 1934, 1939), and the Cleveland Society of Artists (1940). In 1927 he spent a year traveling in France, Italy, and Hungary, where he painted portraits and genre scenes. From 1929 to 1935 Vago taught at the Cleveland School of Art.

LOUIS VAN OEYEN

(1865–1946)

Cleveland's foremost photojournalist of the early 20th century, Louis Van Oeyen was born in Dayton, Ohio, and came to Cleveland around 1891. Reportedly the first staff photographer hired by a Cleveland newspaper, he worked full-time for the *Cleveland Press,* 1901–37. He developed a distinctive style characterized by carefully selected viewpoints, expert control over stop action, and an eye for the dramatic moment. Although he photographed celebrities, visiting presidents, labor strikes, and catastrophes, his greatest passion was for baseball. Through an early association with the Cleveland Naps (Napoleons), and later the Indians, he became friendly with team owners and received assignments from the American League to photograph the World Series. Living only blocks from Cleveland's League Park, he frequented the games and socialized with future hall-of-famers, including Babe Ruth and Lou Gehrig. Van Oeyen's contemporaries considered him one of the great photographers of the sport.

Selected References

Grabowski, John J. *Sports in Cleveland: An Illustrated History.* Bloomington: Indiana University Press, 1992.

ABEL WARSHAWSKY

(1883–1962)

CA. 1915

Born to a family of Polish immigrants in Sharon, Pennsylvania, Abel Warshawsky moved with his parents to Cleveland in the early 1890s. He studied with Louis Rorimer and Frederick Gottwald at the Cleveland School of Art, 1900–05. After graduating, he attended the Art Students League and the National Academy of Design in New York. In the summer of 1907 he met Winslow Homer while painting in Prout's Neck, Maine. Warshawsky returned to Cleveland that fall and taught night classes at the Jewish Council for Education Alliance, a settlement house, where his students included William Zorach and Max Kalish. The following year, Warshawsky received funds from Rorimer to study at the Académie Julian in Paris. From 1908 to 1910, he painted outdoor, impressionist studies in Paris and Brittany. When Warshawsky returned to Cleveland in the fall of 1910, he exhibited his new paintings at Rorimer's studio, in the Cleveland "secessionists" exhibitions held at the Rowfant Club (1912), and at the Korner & Wood Galleries (1912). He traveled to Paris in the spring of 1911, where he associated with Zorach and Hugo Robus. Warshawsky returned briefly to Cleveland and exhibited at the Gage Galleries in December 1913. He exhibited in the annuals of the Pennsylvania Academy of the Fine Arts (1914–17) and was featured in a solo exhibition at the Cleveland School of Art (1916). He spent 24 years living in France but returned frequently to exhibit and visit his family in Cleveland. The Cleveland Museum of Art organized a solo exhibition of his paintings (1920). In the 1930s he exhibited in Washington, D.C., and New York. In 1939, forced by World War II to leave France, Warshawsky returned to the United States and settled in Monterey, California.

Selected References

Friedman, Stanley S. "And France Takes Off Its Hat." *Cleveland Bystander,* 12 August 1933, 5.

Keny, James M., and Nannette V. Maciejunes. *Triumph of Color and Light: Ohio Impressionists and Post-Impressionists,* 129–30. Exh. cat. Columbus, Ohio: Columbus Museum of Art, 1994.

Warshawsky, Abel G. *The Memories of an American Impressionist.* Ben L. Bassham, ed. Kent, Ohio: Kent State University Press, 1980.

Wilson, Robert Forrest. *The Art of A. G. Warshawsky.* Paris: Editions Dorland, 1927.

FRANK WILCOX

(1887–1964)

CA. 1913

Cleveland-born Frank Wilcox received artistic training with Frederick Gottwald, Henry Keller, and Louis Rorimer while attending the Cleveland School of Art, 1906–10. On a travel scholarship from the school, Wilcox studied at the Académie Callorossi in Paris during the winter of 1910–11 and exhibited at the Paris Salon of 1911. He then returned to Cleveland, where the Taylor Gallery organized his first solo exhibition in the fall of 1911. The Korner & Wood Galleries organized his second solo exhibition in 1913, the same year he began teaching at the Cleveland School of Art. Among his students were Charles Burchfield, Carl Gaertner, and Clarence Carter. The Cleveland School of Art mounted a solo exhibition of his paintings (1916), and he exhibited in the annual May Shows at the Cleveland Museum of Art (1919–60). Wilcox made painting trips to Maine and the eastern seaboard during summers, 1920–25, and studied and painted in Paris, 1926–27. He established a reputation as a book illustrator with the publication of *Ohio Indian Trails* in 1933. In the 1930s his paintings appeared in group exhibitions at the Art Institute of Chicago and in New York at the Museum of Modern Art and the Whitney Museum of American Art. The Cleveland School of Art mounted a solo exhibition of his paintings in 1937. In the 1940s he made several painting trips to the American Southwest and illustrated a historical survey of the Ohio canal system. After retiring from the Cleveland School of Art in 1957, Wilcox continued to paint.

Selected References

The Frank Nelson Wilcox Memorial Exhibition. Exh. cat. Berea, Ohio: Baldwin-Wallace College, 1966.

Frank Wilcox in Retrospect. Exh. cat. Cleveland: Cleveland Institute of Art, 1952.

Sackerlotzky, Rotraud. *Henry Keller's Summer School in Berlin Heights.* Cleveland: Cleveland Artists Foundation, 1991.

Wilcox, Frank. Papers. Archives of American Art. Smithsonian Institution, Washington, D.C.

ARCHIBALD WILLARD

(1836–1918)

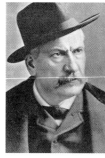

CA. 1895

Archibald Willard was one of the best-known painters working in Cleveland at the turn of the century. Born in Bedford, Ohio, Willard loved to draw and paint at an early age. At the age of 17 he received two weeks of training from an unidentified itinerant portrait artist traveling through Bedford. After moving with his family to Wellington, Ohio, in 1855, he began a career as a carriage painter. In his spare time he created easel work. After serving in the Civil War, he returned to Wellington and resumed painting. In the 1870s he produced a number of comic paintings that were made into chromolithographs published by James F. Ryder. In 1873 royalties from these print sales provided Willard with enough money to study in New York with Joseph Eaton for several weeks, the only formal artistic training Willard ever received. The following year he exhibited in the National Academy of Design in New York. In 1875 he moved to Cleveland, where he began work on *Yankee Doodle* (later known as *The Spirit of '76*), which became his signature image. The enormous success of this conception dominated the remainder of his career, and he was repeatedly called upon to create replicas. His fame established, Willard became an important member of Cleveland's art community, exhibiting in numerous group shows from the 1880s through the 1910s. Willard was a founding member of the Art Club and also involved in the Society of Cleveland Artists and the Cleveland Brush and Palette Club.

Selected References

Archibald M. Willard and "The Spirit of '76": An Ohio Artist and His Work. Columbus, Ohio: Ohio Historical Society, 1992.

Devereux, Henry Kelsey. *"The Spirit of '76": Some Recollections of the Artist and the Painting.* Cleveland: privately printed, 1926.

Gordon, Willard F. *"The Spirit of '76" . . . an American Portrait: America's Best Known Painting, Least Known Artist.* N.p.: Aero Publishers, 1976.

Sackerlotzsky, Rotraud, and Mary Sayre Haverstock. *F. C. Gottwald and the Old Bohemians.* Cleveland: Cleveland Artists Foundation 1993.

THELMA FRAZIER WINTER

(1903–1977)

CA. 1935

Thelma Frazier grew up in New Philadelphia, Ohio, and studied ceramics with Julius Mihalik at the Cleveland School of Art, graduating in 1929. In the late 1920s she and sculptor Waylande Gregory worked at Cowan Pottery as the firm's principal artists. She first exhibited in the 1934 May Show at the Cleveland Museum of Art, and continued to do so until 1949. She showed in the annual National Ceramic Exhibitions in Syracuse, New York (1935–58), where in 1939 she became the first woman to win a first place award. After a postgraduate study in art education at Western Reserve University in Cleveland and Ohio State University, she began teaching in Cleveland public schools. In 1939 the Little Gallery of Cleveland College mounted an exhibition of her works. That year she married the enamelist Edward Winter, whom she had met at Cowan Pottery. She continued to paint and work with clay until the late 1950s, garnering several large-scale ceramic commissions from churches and schools. In 1958, under her husband's influence, Winter took up enameling, and collaborated with him on a number of enamel mural commissions in the 1960s and 1970s.

Selected References

Anderson, Ross, and Barbara Perry. *The Diversions of Keramos: American Clay Sculpture 1925–1950,* 51–62. Exh. cat. Syracuse, N.Y.: Everson Museum of Art, 1983.

Winter, Edward and Thelma. Papers. Archives of American Art. Smithsonian Institution, Washington, D.C.

Zimmerman, Dean M. "H. Edward and Thelma Frazier Winter: Art and Craft in the Cleveland School." In *Cleveland as a Center of Regional American Art,* 84–89. Cleveland: Cleveland Artists Foundation, 1993.

WILLIAM ZORACH

(1889–1966)

1912

William Zorach was born Zorach Samovich in Euberick, Lithuania. At the age of 13 he immigrated with his family to Port Clinton, Ohio. Around 1893 they adopted the name Finkelstein. In 1896 the family moved to Cleveland, where Zorach was given the name "William" by a grade school teacher. After completing the eighth grade, he dropped out of school to apprentice in commercial lithography. He attended evening classes taught by Henry Keller at the Cleveland School of Art, 1903–6. He developed a professional friendship with William Sommer in 1907 and later in the year attended evening art classes taught by Abel Warshawsky at the Jewish Council for Education Alliance. During the winters of 1908–10 he attended the National Academy of Design, New York, but returned to Cleveland each summer to work at the lithography shop. In 1910 he traveled to Paris, where he encountered paintings by Pablo Picasso and Henri Matisse and exhibited his own works at the Salon d'Automne (1911). He returned to Morgan Lithography later that year and in February 1912 showed with the Cleveland "secessionists" at the Taylor Gallery. That April the Taylor Gallery mounted his first solo exhibition. His paintings were also displayed in group exhibitions of the Cleveland "secessionists" at the Rowfant Club and the Korner & Wood Galleries. Late in 1912 he moved to New York and changed his name to William Zorach. His paintings appeared in the Armory Show (1913). From 1914 to 1919 he participated in various Cleveland exhibitions at the Taylor Gallery, the Kokoon Klub, the Play House, and Laukhuff's Bookstore. In 1917 he began working in sculpture and in 1919 returned to live briefly in Cleveland, resuming his association with Sommer and the Cleveland modernists. In 1922 he abandoned oil painting entirely and devoted himself to sculpture. Zorach taught at the Art Students League in New York, 1929–60, and died in Maine.

Selected References

Baur, John I. H. *William Zorach.* Exh. cat. New York: Whitney Museum of American Art, 1959.

Hoopes, Donelson F. *William Zorach: Paintings, Watercolors and Drawings, 1911–1922.* Exh. cat. New York: Brooklyn Museum, 1969.

Tarbell, Roberta. *Catalogue Raisonné of William Zorach's Carved Sculpture.* Ph.D. diss., University of Delaware, 1976.

Zorach, William. *Art Is My Life.* Cleveland: World Publishing, 1967.

BIBLIOGRAPHIC NOTES

General Histories

Any study of Cleveland art must begin with understanding the city and its people. *The Encyclopedia of Cleveland History, 1796–1900* (Bloomington and Indianapolis: Indiana University Press, 1986), edited by David D. Van Tassel and John J. Grabowski, is an invaluable resource that provides both an overview and detailed information about the subject, including a brief history by Robert Wheeler as an introduction. An updated edition of the *Encyclopedia* is being published in 1996. Among the most useful historical studies are: W. Scott Robison, *History of the City of Cleveland* (Cleveland: Robison and Crockett, 1887); Samuel P. Orth, *A History of Cleveland, Ohio, with Numerous Chapters by Special Contributors* (Chicago: S. J. Clarke Publishing, 1910); Gertrude van Rensselaer Wickham, *Pioneer Families of Cleveland, 1796–1840* (Cleveland: Evangelical Printing House, 1914); William R. Coates, *A History of Cuyahoga County and the City of Cleveland* (Chicago: American Historical Society, 1924); Wilfred H. and Miriam Russell Alburn, *This Cleveland of Ours* (Cleveland: S. J. Clarke Publishing, 1933); William Ganson Rose, *Cleveland: The Making of a City* (Cleveland and New York: World Publishing, 1950); and John Grabowski, *Cleveland: A Tradition of Reform* (Kent, Ohio: Kent State University Press, 1986). Examples of the recent trend toward condensed histories include: George E. Condon, *Cleveland: Prodigy of the Western Reserve* (Oklahoma City: Continental Heritage, 1979); Edmund H. Chapman, *Cleveland: Village to Metropolis* (Cleveland: Western Reserve Historical Society, 1981); and Carol Poh Miller and Robert Wheeler, *Cleveland: A Concise History, 1796–1990* (Bloomington: Indiana University Press, 1990). Various opinions about the city's history and future are presented in W. Dennis Keating, Norman Krumholz, and David C. Perry, *Cleveland: A Metropolitan Reader* (Kent, Ohio: Kent State University Press, 1995).

Race and Ethnicity

Cleveland's character as a city of strong immigrant traditions demands that scholars study its ethnic and racial communities. Among the best studies on these topics are: Russell H. Davis, *Memorable Negroes in Cleveland's Past* (Cleveland: Western Reserve Historical Society, 1969); Josef J. Barton, *Peasants and Strangers: Italians, Rumanians, and Slovaks in an American City, 1890–1950* (Cambridge, Mass.: Harvard University Press, 1975); John Grabowski, *Polish Americans and Their Communities of Cleveland* (Cleveland: Cleveland State University Press, 1976); Kenneth L. Kusmer, *A Ghetto Takes Shape: Black Cleveland, 1870–1930* (Urbana: University of Illinois Press, 1976); John F. Cadzow, *Lithuanian Americans and Their Communities of Cleveland* (Cleveland: Cleveland State University Press, 1978); Nelson J. Callahan, *Irish Americans and Their Communities of Cleveland* (Cleveland: Cleveland State University Press, 1978); Lloyd P. Gartner, *History of the Jews of Cleveland* (Cleveland: Western Reserve Historical Society and Jewish Theological Seminary of America, 1978); and Susan M. Papp, *Hungarian Americans and Their Communities of Cleveland* (Cleveland: Cleveland State University, 1981).

Cultural Traditions

Cleveland's cultural traditions have not been studied as thoroughly as its economic, political, and social history. Early attempts include Elbert J. Benton, *Cultural Story of an American City: Cleveland* (Cleveland: Western Reserve Historical Society, 1943), and Matthew F. Browarek, *Cleveland as a Cultural Center* (Cleveland: Cleveland Public Library, 1958). Among the excellent histories of the city's cultural institutions are: Julia McCune Flory, *The Cleveland Play House: How It Began* (Cleveland: Press of the Western Reserve, 1965); Carl Wittke, *The First Fifty Years: The Cleveland Museum of Art, 1916–1966* (Cleveland: Cleveland Museum of Art, 1966); William Milliken, *A Time Remembered: A Cleveland Memoir* (Cleveland: Western Reserve Historical Society, 1975); Edward B. Henning, *The Cleveland Institute of Art: 100 Years* (Cleveland: Cleveland Museum of Art, 1983); Nancy Coe Wixom, *Cleveland Institute of Art: The First Hundred Years 1882–1982* (Cleveland: Cleveland Institute of Art, 1983); and Walter C. Leedy, *Cleveland Builds an Art Museum: Patronage, Politics and Architecture, 1884–1916* (Cleveland: Cleveland Museum of Art, 1991). *Fine Arts in Cleveland* (Bloomington: Indiana University Press, 1994) by Holly Rarick Witchey and John Vacha surveys broad developments in Cleveland art, music, literature, and theater from the city's founding to the 1990s.

Cleveland Art

General surveys of Cleveland art are rare, but sometimes exist as sections in larger books about American and Ohio art. Despite its date, Edna Clark, *Ohio Art and Artists* (Richmond, Va.: Garrett and Massie, 1932), remains a useful study. Significant discussions of Cleveland art are found in: William H. Gerdts, *Art across America: Two Centuries of Regionalist Painting* (New York: Abbeville Press, 1990); Rotraud Sackerlotzky and Mary Sayre Haverstock, *F. C. Gottwald and the Old Bohemians* (Cleveland: Cleveland Artists Foundation, 1993); and James M. Keny and Nannette V. Maciejunes, *Triumph of Color and Light: Ohio Impressionists and Post-Impressionists* (Columbus, Ohio: Columbus Museum of Art, 1994). Special topics concerning Cleveland art are examined in Karal Ann Marling, *Federal Art in Cleveland, 1933–1943* (Cleveland: Cleveland Public Library, 1974), and Jay Hoffman, Dee Driscole, and Mary Clare Zahler, *A Study in Regional Taste: The May Show, 1919–1975* (Cleveland: Cleveland Museum of Art, 1977). The early history of the Women's Art Club of Cleveland is described in *Our First Twenty Years, 1912–1932* (Cleveland: Central Publishing, 1932). Cleveland sculpture is examined by Richard N. Campen, *Outdoor Sculpture in Ohio* (Chagrin Falls, Ohio: West Summit Press, 1980). Eighteen essays, with a foreword by William H. Robinson and an introduction by Karal Ann Marling, are found in *Cleveland as a Center of Regional American Art* (Cleveland: Cleveland Artists Foundation, 1993). The exhibition catalogue *Yet Still We Rise: African American Art in Cleveland 1920–1970* (Cleveland: Cleveland Artists Foundation, 1996) examines a long-neglected facet of the city's artistic tradition. Studies of individual artists are listed in the biography section of this catalogue.

Unpublished Sources

Researchers of Cleveland art must rely on many unpublished sources. An essential tool for locating articles about the city's early artists is *The Annals of Cleveland: Index of Cleveland Periodicals* (Cleveland: Library Service of the Ohio Works Progress Administration, 1939–42). This resource, indexed by such categories as "art," "panoramas," and "photography," quotes excerpts from Cleveland newspapers through 1876. It is not complete, however, and the original publications should be consulted as well. Ingalls Library, Cleveland Museum of Art, maintains clipping files on individual artists and general subjects about Cleveland art, including galleries and cultural institutions. The Cleveland Institute of Art preserves invaluable information about Cleveland art and artists in its *Scrapbooks,* which are available on microfilm in the institute's library and through the Archives of American Art at the Smithsonian Institution in Washington, D.C. The fine arts department of the Cleveland Public Library is another excellent source of information about Cleveland art and artists. Under the direction of Mary Sayre Haverstock, the Ohio Artists Project in Oberlin has collected extensive information about 19th-century Cleveland artists from newspaper and census records. Documents and information about the Cleveland Public Works of Art Project and the Cleveland Works Progress Administration/ Federal Arts Project, gathered by Karal Ann Marling and her students during the 1970s, are preserved in the special collections department of Freiberger Library, Case Western Reserve University, Cleveland. Cleveland newspapers, magazines, obituaries, and census records can be found in the library of the Western Reserve Historical Society in Cleveland. Large photographic archives are located in at the Cleveland Public Library and the Cleveland Press Collection of the Cleveland State University. Researchers of Cleveland art are also advised to consult the extensive collections, often available on microfilm, of the Archives of American Art.

CHECKLIST OF THE EXHIBITION

GEORGE ADOMEIT
(American, b. Germany, 1879–1967)

1. *A Cool Refreshing Drink,* 1931, oil on canvas, 26½ x 31½ in. (67.3 x 80 cm). Miss Ruth E. Adomeit (fig. 127)

2. *Country Lane,* ca. 1900, oil on canvas, 20½ x 13⅞ in. (52 x 35.8 cm). The Cleveland Museum of Art, gift of Ruth E. Adomeit 1983.1065 (fig. 48)

3. *First Snow,* 1930, linoleum cut, printed in color, 6½ x 7⅝ in. (16.5 x 19.3 cm). The Cleveland Museum of Art, gift of Ruth E. Adomeit 1995.112 (not illustrated)

4. *Hillside Farm (Provincetown),* 1941, oil on canvas, 37 x 41 in. (94 x 104 cm). Miss Ruth E. Adomeit (fig. 136)

5. *In Port*, 1926, oil on canvas, 25 x 30¼ in. (63.5 x 76.9 cm). City of Cleveland, the Mary A. Warner Collection (fig. 135)

6. *Where Coal and Iron Meet,* 1933, linoleum cut, printed in color, 12⅜ x 13¹⁵⁄₁₆ in. (31.4 x 35.3 cm). The Cleveland Museum of Art, gift of the Print Club of Cleveland 1933.113 (not illustrated)

7. *WPA Worker,* ca. 1935, oil on canvas mounted to board, 20 x 16 in. (50.8 x 40.7 cm). Miss Ruth E. Adomeit (fig. 149)

RUSSELL AITKEN
(American, b. 1910)

8. *Student Singers*, 1933, glazed ceramic, 12 x 12 x 5½ in. (30.5 x 30.5 x 14 cm). Everson Museum of Art, Syracuse, New York, gift of the artist P.C. 39.317 (fig. 155)

ANONYMOUS

9. *Cleveland Rolling Mills Company,* 1890s, albumen print, 4 x 6 in. (10.1 x 15.2 cm). The Western Reserve Historical Society, Cleveland (fig. 212)

10. *Drawing of the Forest City House,* ca. 1850, daguerreotype, 3¾ x 4 in. (9.5 x 10.1 cm). Peter and Judy Wach Collection (not illustrated)

11. *Unloading Iron Ore,* ca. 1906, gelatin-silver stereoview, 3½ x 6¾ in. (8.9 x 17.2 cm). Peter and Judy Wach Collection (not illustrated)

HENRY T. ANTHONY
(American, 1814–1884)

12. *Commodore Perry's Monument,* 1870, albumen stereoview, 3½ x 6¾ in. (8.9 x 17.1 cm). Peter and Judy Wach Collection (fig. 203)

OTTO BACHER
(American, 1856–1909)

13. *Country Store, Richfield, Ohio,* 1892, oil on canvas, 27 x 34 in. (68.5 x 86.4 cm). Frank P. DiPrima Collection (fig. 45)

14. *Ella's Hotel, Richfield, Ohio,* 1883–85, oil on canvas, 31 x 42½ in. (78.7 x 107.9 cm). Private collection (fig. 44)

15. *Sketch Book: Man Wearing Top Hat,* 1877, graphite, 6½ x 4⅝ in. (16.5 x 11.7 cm). Jean Schenk Collection (fig. 43)

16. *William Eckman,* 1876, graphite, 10 x 5³⁄₁₆ in. (25.4 x 13.2 cm). The Western Reserve Historical Society, Cleveland (fig. 27)

SOL BAUER
(American, 1898–1982)

17. *Seated Woman,* 1941, wood, 13 x 13 x 11 in. (33 x 33 x 27.9 cm). The Cleveland Museum of Art, Dudley P. Allen Fund 1942.202 (fig. 107)

AUGUST BIEHLE
(American, 1885–1979)

18. *The Deposition,* 1913, oil on board, 21¼ x 29½ in. (54 x 75 cm). Stephen F. Biehle Collection (fig. 73)

19. *Farm Near Canal,* 1935, oil on board, 31¾ x 38½ in. (78.8 x 97.8 cm). Frederick C. Biehle Collection (fig. 97)

20. *Fire Tug on the Cuyahoga River,* 1908, oil on board, 14½ x 14 in. (36.8 x 35.6 cm). Nora A. Biehle Collection (fig. 60)

21. *Republic Steel on the Cuyahoga,* 1924, oil on canvas, 26 x 34 in. (66 x 86.7 cm). Courtesy Rachel Davis Fine Arts, Shaker Heights, Ohio (fig. 114)

22. *Study for a Great Lakes Exposition Mural,* 1936, watercolor, 20 x 30 in. (50.8 x 76.2 cm). Joseph M. Erdelac Collection (fig. 96)

ATTRIBUTED TO ALBERT BISBEE
(American, active 1850s)

23. *View of Public Square,* 1859, tinted ambrotype, 5¼ x 7¼ in. (13.3 x 18.5 cm). Ohio Historical Society, Columbus (not illustrated)

LAWRENCE BLAZEY
(American, b. 1902)

24. *Playhouse Square, Cleveland,* 1935, watercolor, gouache, and graphite with collage, 20¼ x 30 in. (51.3 x 76.2 cm). The Cleveland Museum of Art, gift of Joseph M. Erdelac 1992.191 (fig. 134)

ALEXANDER BLAZYS
(American, b. Lithuania, 1894–1963)

25. *Balalaika Player,* 1925, bronze, 12¼ x 7¾ x 3⅝ in. (31.1 x 19.7 x 9.2 cm). The Cleveland Museum of Art, Hinman B. Hurlbut Collection 1548.1926 (fig. 104)

26. *Russian Dancer,* 1925, bronze, 10¼ x 11½ x 5 in. (26 x 29.2 x 12.7 cm). The Cleveland Museum of Art, Hinman B. Hurlbut Collection 1547.1926 (fig. 104)

MAX BOHM
(American, 1868–1923)

27. *Lucy,* 1909, oil on canvas, 49 x 50 in. (124.5 x 127 cm). Mr. and Mrs. Edmund A. Hajim Collection (fig. 57)

ALFRED BOISSEAU
(French, active in Cleveland 1855–1860)

28. *Portrait of a Cleveland Man,* 1855, daguerreotype, 2¾ x 3¼ in. (7 x 8.3 cm). Peter and Judy Wach Collection (not illustrated)

MARGARET BOURKE-WHITE
(American, 1904–1971)

29. *Blast Furnace Operator with "Mud Gun," Otis Steel Co., Cleveland,* ca. 1928, gelatin-silver print, 13 x 10¼ in. (33 x 26 cm). The Cleveland Museum of Art, gift of Mrs. Albert A. Levin 1972.247 (fig. 220)

30. *Garden of Mrs. Homer H. Johnson,* ca. 1929, gelatin-silver print, 12⅞ x 9 in. (32.8 x 22.9 cm). The Cleveland Museum of Art, gift of Mrs. John B. Dempsey 1987.215 (fig. 219)

31. *The High Level Bridge,* ca. 1928, gelatin-silver print, 13 x 10 in. (33 x 25.4 cm). Peter and Judy Wach Collection (fig. 126)

32. *Hot Pigs, Otis Steel Co., Cleveland,* ca. 1928, gelatin-silver print, 13 x 10 in. (33 x 25.4 cm). The Cleveland Museum of Art, gift of Mrs. Albert A. Levin 1972.244 (fig. 115)

33. *Otis Steel, Cleveland,* ca. 1928, gelatin-silver print, 4¾ x 3½ in. (12 x 8.9 cm). Peter and Judy Wach Collection (fig. 117)

34. *Public Square (Terminal Tower) at 5:00, Seen through a Williamson Building Grille,* 1928, gelatin-silver print, 13¾ x 10¼ in. (35 x 26 cm). Joyce Edson Collection (fig. 133)

35. *Rising Cantilevers, Columbus Avenue Bridge,* 1928, gelatin-silver print, 13 x 10 in. (33 x 25.4 cm). Peter and Judy Wach Collection (not illustrated)

36. *Steel Worker at the Furnace, Cleveland,* ca. 1928, gelatin-silver print, 13⅜ x 9½ in. (34 x 24.1 cm). Peter and Judy Wach Collection (fig. 119)

37. *The Terminal Tower and the Cuyahoga River, Cleveland,* 1928, gelatin-silver print, 4⅞ x 3⅝ in. (12.4 x 9.2 cm). Peter and Judy Wach Collection (not illustrated)

38. *Terminal Tower Seen through a Railroad Bridge, Cleveland,* 1928, gelatin-silver print, 14 x 11 in. (35.5 x 28 cm). Herbert and Christine Ascherman Collection (fig. 221)

39. *Terminal Tower with High Level Bridge,* 1928, gelatin-silver print, 13⁷⁄₁₆ x 10¼ in. (34.1 x 26 cm). Peter and Judy Wach Collection (fig. 129)

ELMER BROWN
(American, 1909–1971)

40. *Dorie Miller Manning the Gun at Pearl Harbor,* 1942, oil on canvas, 48 x 61¾ in. (122 x 157 cm). Cleveland Artists Foundation, gift of the Elmer W. Brown Estate (fig. 174)

41. *Wrestlers,* ca. 1936, etching, 6¹⁄₁₆ x 9¹⁄₁₆ in. (15.3 x 23 cm). Ohio Art Program, long-term loan to the Cleveland Museum of Art 4026.1942 (not illustrated)

WALTER BRUNING
(American, active 1920s–1930s)

42. *The Vision,* 1927, bromoil transfer photograph, 8⅞ x 6¾ in. (22.6 x 17.2 cm). Peter and Judy Wach Collection (fig. 128)

CHARLES BURCHFIELD
(American, 1893–1967)

43. *Afternoon in the Grove,* 1916, watercolor and graphite, 14 x 20 in. (35.6 x 51 cm). Burchfield-Penney Art Center, Buffalo State College, Buffalo, New York, gift of Tony Sisti, 1979:27 (fig. 84)

44. *Church Bells Ringing, Rainy Winter Night,* 1917, watercolor, gouache, and graphite on two sheets of paper, 30¼ x 19¾ (77 x 50.2 cm). The Cleveland Museum of Art, gift of Mrs. Louise M. Dunn in memory of Henry G. Keller 1949.544 (fig. 87)

45. *Landscape with Faun,* 1915, watercolor, 14 x 10 in. (35.6 x 25.4 cm). Courtesy Kennedy Galleries, Inc., New York (fig. 82)

46. *Self-Portrait,* 1916, watercolor, graphite, and conté crayon, 19¹³⁄₁₆ x 13⅝ in. (50.3 x 34.6 cm). The Charles Rand Penney Collection of Works by Charles E. Burchfield, Burchfield-Penney Art Center, Buffalo State College, Buffalo, New York, 1994:001.005 (fig. 85)

47. *Summer,* ca. 1915, watercolor, 13⅞ x 9¾ in. (35.2 x 24.8 cm). Private collection (fig. 83)

48. *Untitled* (Clump of Purple Trees), 1915, watercolor, gouache, and graphite, 13½ x 19½ in. (34.3 x 49.5 cm). Burchfield-Penney Art Center, Buffalo State College, Buffalo, New York, gift of Tony Sisti, 1979:9 (fig. 80)

CLARENCE CARTER
(American, b. 1904)

49. *Jesus Wept,* 1936, watercolor, 14⅞ x 22 in. (37.8 x 55.9 cm). Southern Ohio Museum, Portsmouth, Ohio. Purchase: James and Tabitha Pugh Trust, Scioto County Area Foundation, 92.2.1 (fig. 140)

50. *Pennsylvania Station,* 1932, etching and aquatint, printed in color, 6⅞ x 11 in. (17.5 x 28 cm). The Cleveland Museum of Art, the Mary Spedding Milliken Memorial Collection, gift of William Mathewson Milliken 1946.466 (fig. 185)

51. *Study for Barnesville Post Office Mural,* 1935, oil on board, 16½ x 39 in. (42 x 99 cm). Collection of John P. Axelrod, Boston, Massachusetts, courtesy Michael Rosenfeld Gallery, New York (fig. 153)

52. *William Stolte, Ex-Councilman,* 1932, oil on canvas, 50 x 35½ in. (127 x 90.2 cm). Steve Turner, the Steve Turner Gallery, Los Angeles (fig. 141)

LOUIS CHEVALIER
(American, 1823–1889)

53. *Burial of the Officers Slain at the Battle of Lake Erie, September 10, 1813,* 1860, oil on canvas, 35 x 53 in. (88.9 x 134.6 cm). The Western Reserve Historical Society, Cleveland, WRHS 42.20 (fig. 18)

HENRY CHURCH, JR.
(American, 1836–1908)

54. *Angel of Night,* ca. 1885, sandstone and glass taxidermy eyes, 48 x 18 x 18 in. (121.9 x 45.7 x 45.7 cm). Private collection (fig. 55)

55. *The Monkey Picture,* ca. 1888, oil on paper mounted on cloth, 28 x 44 in. (71.1 x 111.8 cm). Abby Aldrich Rockefeller Folk Art Center, Williamsburg, Virginia, 1981.103.1 (fig. 53)

56. *Self Portrait,* ca. 1885, oil on wood, 29¾ x 23½ in. (75.6 x 59.7 cm). Collection of Mr. and Mrs. Samuel Rosenberg, courtesy Joan Washburn Gallery, New York (fig. 54)

57. *Still Life,* ca. 1888, oil on paper mounted on cloth, 26 x 36 in. (66 x 91.4 cm). Private collection (fig. 52)

58. *The Young Lion and the Fatling Together,* 1887, sandstone and glass taxidermy eyes, 54 x 72 x 26 in. (137 x 183 x 66 cm). Private collection (fig. 56)

CLEVELAND NEWS SERVICE PHOTOGRAPH

59. *Louis Van Oeyen, Bob Satterfield, and Doc Rollins,* 1906, gelatin-silver print, 8 x 10 in. (20.3 x 25.4 cm). The Western Reserve Historical Society, Cleveland (not illustrated)

60. *Margaret Bourke-White in the Flats,* 1928, gelatin-silver print, 8 x 7 in. (20.3 x 17.9 cm). Cleveland Public Library (not illustrated)

CLEVELAND NEWS SERVICE PHOTOGRAPH, POSSIBLY BY ARTHUR GRAY

61. *Margaret Bourke-White above Superior Avenue, with the Cleveland Public Library and the Plain Dealer Building in the Background,* 1929, gelatin-silver print, 10 x 8 in. (25.4 x 20.3 cm). Cleveland Public Library (not illustrated)

GEORGE CLOUGH
(American, 1824–1901)

62. *Weighhouse on the Ohio Canal, Cleveland,* ca. 1863, oil on canvas, 19¾ x 29¼ in. (50.2 x 74.3 cm). The Western Reserve Historical Society, Cleveland, WRHS 353 (fig. 20)

ALLEN COLE
(American, 1883–1970)

63. *Beer Store,* 1930s, gelatin-silver print, 8 x 10 in. (20.3 x 25.4 cm). The Western Reserve Historical Society, Cleveland (not illustrated)

64. *Call and Post Newsboys,* 1934 (printed later), gelatin-silver print, 8 x 10 in. (20.3 x 25.4 cm). The Western Reserve Historical Society, Cleveland (not illustrated)

65. *Kyer's Service Station,* ca. 1932, gelatin-silver print, 8 x 10 in. (20.3 x 25.4 cm). The Western Reserve Historical Society, Cleveland (fig. 150)

66. *Lucille's Sandwich Shoppe,* ca. 1940, gelatin-silver print, 8 x 10 in. (20.3 x 25.4 cm). The Western Reserve Historical Society, Cleveland (fig. 152)

67. *Paul Kroukle Company* (Woodland and E. 55th Street), 1930s, gelatin-silver print, 8 x 10 in. (20.3 x 25.4 cm). The Western Reserve Historical Society, Cleveland (not illustrated)

ORA COLTMAN
(American, 1860–1940)

68. *Monuments,* ca. 1928, oil on canvas, 36 x 30 in. (91.4 x 76.2 cm). Cleveland Public Library (fig. 131)

R. GUY COWAN
(American, 1884–1957)

69. *Adam* and *Eve,* 1928, glazed ceramic, each 13¾ x 10½ x 3¼ in. (35 x 26.7 x 8.2 cm). The Cleveland Museum of Art, Educational Purchase Fund 1928.235, 1928.236 (fig. 105)

PHELPS CUNNINGHAM
(American, 1903–1980)

70. *Hinckley,* 1933, woodcut, printed in color, 7¹⁄₁₆ x 8¹⁵⁄₁₆ in. (17.9 x 22.7 cm). The Cleveland Museum of Art, gift of the Print Club of Cleveland 1933.115 (not illustrated)

71. *Sorghum Mill, Tennessee,* ca. 1937, wood engraving, 6¹¹⁄₁₆ x 7⅝ in. (16.9 x 19.4 cm). The Cleveland Museum of Art, gift of the Print Club of Cleveland 1937.74 (fig. 189)

72. *Tri-County Fair,* 1933, wood engraving, 6¾ x 7⅞ in. (17.1 x 20 cm). The Cleveland Museum of Art, gift of the Print Club of Cleveland 1934.315 (not illustrated)

CLARA DEIKE
(American, 1881–1964)

73. *Pineapples,* 1931, oil on canvas, 29⅝ x 31¾ in. (75.2 x 80.6 cm). Hahn Loeser & Parks Collection, Cleveland (fig. 94)

74. *Sunflowers and Chickens,* 1912, gouache on canvas, 14½ x 19¾ in. (36.8 x 50.2 cm). Fawick Art Gallery, Baldwin-Wallace College, Berea, Ohio (fig. 67)

STEVAN DOHANOS
(American, 1907–1994)

75. *Blast Furnaces,* ca. 1933, wood engraving, 8 x 10 in. (20.2 x 25.4 cm). The Cleveland Museum of Art, gift of the Print Club of Cleveland 1933.118 (fig. 116)

76. *Furnace Floor,* 1933, wood engraving, 10 x 7⅞ in. (25.4 x 20 cm). The Cleveland Museum of Art, gift of the Print Club of Cleveland 1933.117 (fig. 199)

77. *Man of the Soil (Connecticut Yankee),* 1934, lithograph, 16⁷⁄₁₆ x 12⁷⁄₁₆ in. (41.8 x 31.6 cm). The Cleveland Museum of Art, gift of the Print Club of Cleveland 1934.69 (fig. 190)

78. *Mourner,* 1934, lithograph, 8½ x 7⅝ in. (21.6 x 19.4 cm). The Cleveland Museum of Art, gift of the Print Club of Cleveland 1934.70 (not illustrated)

WILLIAM EASTMAN
(American, 1888–1950)

79. *The Chalice Flower,* ca. 1920, oil on aluminum leaf on canvas, 31¼ x 27 in. (79.4 x 68.6 cm). Cleveland Public Library (fig. 95)

EDRIS ECKHARDT
(American, b. 1907)

80. *Exodus,* 1945, earthenware, 12½ x 7 x 6½ in. (31.8 x 17.8 x 16.5 cm). Dr. Paul A. Nelson Collection (fig. 154)

WILLIAM ECKMAN
(American, d. 1901)

81. *Seated Boy Reading,* 1876, graphite, 8⁵⁄₁₆ x 10⅞ in. (21.1 x 27.6 cm). The Western Reserve Historical Society, Cleveland (fig. 26)

DE SCOTT EVANS
(American, 1847–1898)

82. *Homage to a Parrot,* ca. 1881, oil on canvas, 20 x 16 in. (50.8 x 40.6 cm). Fresno Metropolitan Museum, FMM 82.24 (fig. 33)

83. *Taxidermist,* 1881, oil on canvas, 36⅛ x 24⅛ in. (91.8 x 61.3 cm). Charles Sterling Collection (fig. 30)

CHARLES FAIRBANKS
(American, d. 1924)

84. *A Less Agreeable Business Engagement,* 1878, ink and watercolor, 5⅜ x 7 in. (13.6 x 17.8 cm). The Western Reserve Historical Society, Cleveland (fig. 28)

LEROY FLINT
(American, 1909–1991)

85. *Amazons,* ca. 1937, etching and aquatint, printed in color, 9⅜ x 7⁵⁄₁₆ in. (23.8 x 18.6 cm). The Cleveland Museum of Art, gift of the Print Club of Cleveland 1937.62 (fig. 198)

86. *Amish,* ca. 1937, engraving, 7 x 6 in. (17.7 x 15.2 cm). Mrs. Leroy W. Flint Collection (fig. 188)

87. *Speaker's Platform,* 1936, aquatint and etching, 9¼ x 7¼ in. (23.5 x 18.4 cm). Ohio Art Program, long-term loan to the Cleveland Museum of Art 4064.1942 (fig. 163)

88. *Strikebreakers,* ca. 1937, etching, 5¹⁵⁄₁₆ x 8¹⁄₁₆ in. (15.1 x 20.4 cm). The Cleveland Museum of Art, gift of Harriet V. Fitchpatrick 1964.318 (fig. 191)

89. *Sun and Dust,* ca. 1936, aquatint, 7 x 8¹⁵⁄₁₆ in. (17.8 x 22.7 cm). Courtesy Rachel Davis Fine Arts, Shaker Heights, Ohio (fig. 193)

90. *Tourist Camp,* ca. 1937, etching, 11 x 8½ in. (27.9 x 21.5 cm). Ohio Art Program, on long-term loan to the Cleveland Museum of Art 4058.1942 (fig. 201)

CARL GAERTNER
(American, 1898–1952)

91. *Christmas Eve,* 1927, oil on canvas, 30 x 35 in. (76.2 x 88.9 cm). Robert H. DuLaurence Collection (fig. 112)

92. *Flying Ponies (Euclid Beach Park),* 1932, oil on canvas, 44½ x 66¾ in. (113 x 169.5 cm). Carol and Michael Sherwin Collection (fig. 113)

93. *The Furnace,* 1924, oil on canvas, 37 x 42 in. (94 x 106.7 cm). Huntington National Bank Collection, Cleveland (fig. 110)

94. *The Ripsaw,* 1923, oil on canvas, 35 x 41¼ in. (89 x 104.8 cm). City of Cleveland, the Mary A. Warner Collection (fig. 109)

95. *Steel Mills on the Cuyahoga,* ca. 1928, oil on canvas, 24½ x 28¾ in. (62.2 x 73 cm). Hahn Loeser & Parks Collection, Cleveland (fig. 111)

RAPHAEL GLEITSMANN
(American, 1910–1995)

96. *The White Dam,* 1939, oil on canvas, 38½ x 43½ in. (97.8 x 110.5 cm). Private collection (fig. 103)

JULIUS GOLLMANN
(German, d. 1898)

97. *An Evening at the Ark,* 1859, oil on canvas, 38 x 54 in. (96.5 x 137.2 cm). The Western Reserve Historical Society, Cleveland, WRHS 91.18.1 (fig. 13)

FREDERICK GOTTWALD
(American, b. Austria, 1858–1941)

98. *The Umbrian Valley, Italy,* 1914, oil on canvas, 28⅞ x 24 in. (73.4 x 61 cm). The Cleveland Museum of Art, gift of Mrs. John Huntington 1915.88 (fig. 51)

WILLIAM GRAUER
(American, 1896–1985)

99. *White Stallion,* ca. 1938, oil on canvas, 30 x 35 in. (76.2 x 89 cm). Hugh J. and Ann Caywood Brown Collection (fig. 102)

ARTHUR GRAY
(American, 1884–1976)

100. *Ore Unloader,* ca. 1940, gelatin-silver print, 13¼ x 10½ in. (33.6 x 26.8 cm). Peter and Judy Wach Collection (not illustrated)

101. *Swing Bridge with Tug and Ore Boat,* ca. 1940, gelatin-silver print, 9 x 7½ in. (22.9 x 19 cm). Cleveland Public Library (not illustrated)

102. *Train on Trestle over the Cuyahoga,* 1940s, gelatin-silver print, 10½ x 13¼ in. (26.8 x 33.6 cm). Cleveland Public Library (fig. 223)

LOUIS GREBENAK
(American, 1913–1971)

103. *Escapist,* ca. 1939, lithograph, printed in color, 18⅞ x 12 in. (47.9 x 30.5 cm). Ohio Art Program, long-term loan to the Cleveland Museum of Art 4114.1942 (not illustrated)

J. M. GREENE
(American, active 1860s)

104. *C.C.C. & I. Railroad Company,* 1869, albumen print, 10 x 15¾ in. (25.4 x 40 cm). Peter and Judy Wach Collection (not illustrated)

JOLÁN GROSS-BETTELHEIM
(American, b. Slovak Republic, 1900–1972)

105. *Beggar,* ca. 1937, drypoint, 7⅛ x 4¾ in. (18.1 x 12 cm). The Cleveland Museum of Art, gift of Harriet V. Fitchpatrick 1964.317 (not illustrated)

106. *Civilization at the Crossroads (Fascism II),* 1936, lithograph, 12¾ x 10 in. (32.4 x 25.4 cm). Reba and Dave Williams Collection (fig. 168)

107. *In the Employment Office,* ca. 1936, lithograph, 10⅞ x 8½ in. (27.7 x 21.6 cm). Ohio Art Program, long-term loan to the Cleveland Museum of Art 4021.1942 (fig. 166)

108. *Industrial Section,* ca. 1936, lithograph, 13⁵⁄₁₆ x 9⅞ in. (33.8 x 25 cm). Ohio Art Program, long-term loan to the Cleveland Museum of Art 4019.1942 (not illustrated)

109. *(Railroad) Gate and Bridges,* ca. 1936, lithograph, 11⁷⁄₁₆ x 8¹¹⁄₁₆ in. (29 x 22 cm). Ohio Art Program, long-term loan to the Cleveland Museum of Art 4015.1942 (not illustrated)

110. *Under the High Level Bridge,* ca. 1932, drypoint, 9⁷⁄₁₆ x 7 in. (24 x 17.7 cm). The Cleveland Museum of Art, gift of the Print Club of Cleveland 1932.138 (fig. 186)

111. *Worker's Meeting (Scottsboro Boys),* ca. 1935, drypoint, 8½ x 6⅞ in. (21.6 x 17.5 cm). The Cleveland Museum of Art, gift of the Print Club of Cleveland 1935.140 (fig. 167)

JARVIS HANKS
(American, 1799–1853)

112. *Abraham Hickox,* 1837, oil on canvas, 28¾ x 24 in. (73 x 61 cm). The Western Reserve Historical Society, Cleveland, WRHS 40.1350 (fig. 4)

ATTRIBUTED TO JARVIS HANKS
(American, 1799–1853)

113. *Death Scene, The Stone Family,* ca. 1840, oil on canvas, 43 x 35¾ in. (109.2 x 90.8 cm). Ohio Historical Society, Columbus (fig. 5)

SEBASTIAN HEINE
(American, b. Germany, 1804–1861)

114. *Cleveland Courthouse on Public Square,* ca. 1845, oil on canvas, 17½ x 25 in. (44.5 x 63.5 cm). The Western Reserve Historical Society, Cleveland, WRHS 42.1394 (fig. 2)

ABRAHAM JACOBS
(American, active 1930s)

115. *The Patriots,* 1936, etching and aquatint, 5⅜ x 8⅜ in. (13.7 x 21.3 cm). Ohio Art Program, long-term loan to the Cleveland Museum of Art 4130.1942 (fig. 164)

SHEFFIELD KAGY
(American, 1907–1989)

116. *American Tragedy,* ca. 1933, linoleum cut, 13¹⁵⁄₁₆ x 9 in. (35.3 x 22.8 cm). Ohio Art Program, long-term loan to the Cleveland Museum of Art 4134.1942 (fig. 195)

117. *Judgment,* 1933, woodcut, 8⅞ x 9 in. (22.5 x 22.9 cm). The Cleveland Museum of Art, gift of the Print Club of Cleveland 1933.436 (not illustrated)

118. *Symphonic Reaction,* ca. 1933, linoleum cut, 9¾ x 8¾ in. (24.8 x 22.2 cm). Ohio Art Program, long-term loan to the Cleveland Museum of Art 4143.1942 (fig. 184)

MAX KALISH
(American, b. Lithuania, 1891–1945)

119. *The Driller,* 1926, bronze, 16 x 9½ x 7¾ in. (40.6 x 24 x 19.7 cm). The Cleveland Museum of Art, gift of friends of the artist 1947.278 (fig. 120)

120. *Road Worker,* 1930, bronze, 19½ x 7 x 8½ in. (47.6 x 17.8 x 21.6 cm). Betty and Kenneth Lay Collection (fig. 122)

121. *Steel Worker (Steel into the Sky),* ca. 1928, bronze, 18¾ x 11 x 4½ in. (47.6 x 27.9 x 11.4 cm). The Cleveland Museum of Art, gift of friends of the artist 1946.435 (fig. 121)

JOHN KAVANAGH
(American, b. Canada, 1857–1898)

122. *Portrait of an Old Man,* ca. 1884, charcoal on tan paper, 19⅜ x 15½ in. (49.2 x 39.4 cm). The Cleveland Museum of Art, gift of Mrs. A. J. Weatherhead 1944.8 (fig. 35)

123. *Washerwomen,* 1889, oil on canvas, 47½ x 39⅝ in. (120.6 x 100.6 cm). The Union Club Company Collection, Cleveland (fig. 38)

HENRY KELLER
(American, 1869–1949)

124. *The Cove at La Jolla, California,* 1935, watercolor and graphite, 14¾ x 20¾ in. (37.5 x 52.7 cm). The Cleveland Museum of Art, gift of Mrs. Edd Ruggles 1972.1112 (fig. 139)

125. *Harvest Time,* ca. 1903, oil on canvas, 12⅛ x 12⅛ in. (30.8 x 30.8 cm). The Cleveland Museum of Art, anonymous gift in memory of Henry G. Keller 1956.357 (fig. 49)

126. *Student at Work,* ca. 1912, oil on canvas, 18 x 12 in. (45.7 x 30.5 cm). Fawick Art Gallery, Baldwin-Wallace College, Berea, Ohio (fig. 66)

127. *Study in Abstraction,* ca. 1912, gouache, 12 x 10 in. (30.5 x 25.4 cm). Fawick Art Gallery, Baldwin-Wallace College, Berea, Ohio (fig. 68)

128. *Wisdom and Destiny,* 1911, oil on canvas, 30⅛ x 40⅛ in. (76.5 x 102 cm). The Cleveland Museum of Art, gift of Mrs. Henry A. Everett for the Dorothy Burnham Everett Memorial Collection 1928.580 (fig. 63)

GRACE KELLY
(American, 1887–1950)

129. *For to Admire, For to See,* ca. 1910, watercolor, 17¼ x 22½ in. (43.8 x 57.2 cm). Mr. and Mrs. William A. Monroe Collection (fig. 59)

KÁLMÁN KUBINYI
(American, 1906–1973)

130. *The Worker,* ca. 1936, offset soft-ground etching, 8¹⁵⁄₁₆ x 7³⁄₁₆ in. (22.7 x 18.2 cm). Ohio Art Program, long-term loan to the Cleveland Museum of Art 4153.1942 (fig. 159)

HUGHIE LEE-SMITH
(American, b. 1915)

131. *The Artist's Life, No. 1,* 1939, lithograph, 11 x 8⅝ in. (27.9 x 21.9 cm). Ohio Art Program, long-term loan to the Cleveland Museum of Art 4230.1942 (fig. 165)

132. *The Artist's Life, No. 3,* 1939, lithograph, 7½ x 10¹³⁄₁₆ in. (19 x 27.4 cm). Ohio Art Program, long-term loan to the Cleveland Museum of Art 4232.1942 (not illustrated)

133. *Landscape No. 1,* ca. 1939, linoleum cut, 9 x 10½ in. (22.9 x 26.8 cm). Cleveland State University (fig. 173)

134. *Portrait of a Boy,* 1938, oil on canvas, 24 x 18 in. (61 x 45.7 cm). Collection of Patricia Lee-Smith, courtesy June Kelley Gallery, New York (fig. 142)

ADAM LEHR
(American, 1853–1924).

135. *Hanging Game,* 1900, oil on composition board, 15¹⁵⁄₁₆ x 19⅞ in. (40.5 x 50.5 cm). Jean Barnett Collection (fig. 34)

STUDIO OF K. A. LIEBICH
(American, active 1860s–1870s)

136. *Public Square with Miniature Boat Advertising E. B. Nock's Photographic Studio,* ca. 1870, albumen stereoview, 3½ x 6¾ in. (8.9 x 17.1 cm). Peter and Judy Wach Collection (fig. 208)

RUSSELL LIMBACH
(American, 1904–1971)

137. *The Excursion Boat,* ca. 1929, lithograph, 8½ x 7¼ in. (21.5 x 18 cm). The Cleveland Museum of Art, gift of William C. Keough 1960.241 (not illustrated)

138. *Laying the Cornice Stone of the Cleveland Post Office,* 1934, lithograph, 17⅝ x 12 in. (44.8 x 30.4 cm). United States Government, Public Works of Art Project, long-term loan to the Cleveland Museum of Art 2536.1934 (fig. 192)

139. *The Reviewing Stand,* 1934, lithograph, 9⅞ x 14¼ in. (25.1 x 36.2 cm). The Cleveland Museum of Art, gift of Mrs. Malcolm L. McBride 1944.335 (fig. 197)

140. *Student and Master,* 1934, lithograph, 8⅞ x 11³⁄₁₆ in. (22.6 x 28.4 cm). The Cleveland Museum of Art, gift of the Print Club of Cleveland 1934.316 (not illustrated)

JAMES MOTT
(American, 1820–1848)

141. *The Throne of God,* 1844, blue, black, and brown ink on fabric, 19½ x 23 in. (49.5 x 58.4 cm). Ohio Historical Society, Columbus (fig. 3)

ELMER NOVOTNY
(American, b. 1910)

142. *The Artist and His Wife* (Virginia Novotny), 1938, oil on canvas, 52 x 44 in. (132 x 112 cm). Karen N. Tischer (daughter of the artist) Collection (fig. 146)

143. *Gathering at the Bar (Les Habitués),* 1941, oil on panel, 42 x 55 in. (107 x 140 cm). Private collection, courtesy D. Wigmore Fine Art, Inc., New York (fig. 151)

144. *John Cherry,* 1929, oil on panel, 18¼ x 14¼ in. (46.4 x 36.2 cm). Cleveland Artists Foundation (fig. 143)

JOSEPH PARKER
(probably American, active 1830s)

145. *The Cleveland Grays on Public Square,* 1839, oil on canvas, 47 x 65 in. (119.4 x 165.1 cm). The Western Reserve Historical Society, Cleveland, WRHS 75.645 (fig. 1)

HORACE POTTER
(American, 1873–1948)

146. *Tea Strainer,* ca. 1910, silver, 5¹⁄₁₆ x 3⁷⁄₁₆ in. (12.7 x 8.6 cm). The Cleveland Museum of Art, John L. Severance Fund 1986.197 (fig. 179)

CAROLINE RANSOM
(American, 1826–1910)

147. *Charles Whittlesey,* 1876, oil on canvas, 29½ x 24½ in. (74.9 x 62.2 cm). The Western Reserve Historical Society, Cleveland, WRHS 40.1345 (fig. 17)

WALTER DUBOIS RICHARDS
(American, b. 1907)

148. *B & O Yards,* ca. 1936, lithograph, 10⁷⁄₁₆ x 16¹³⁄₁₆ in. (26.5 x 41.6 cm). The Cleveland Museum of Art, gift of the Print Club of Cleveland 1936.363 (not illustrated)

149. *Country Church,* ca. 1935, lithograph, 10⁵⁄₁₆ x 6³⁄₁₆ in. (35.1 x 26.2 cm). The Cleveland Museum of Art, Mr. and Mrs. Lewis B. Williams Collection 1958.468 (fig. 200)

150. *Ohio Farmer,* ca. 1938, lithograph, 6³⁄₁₆ x 8⅝ in. (15.7 x 21.8 cm). The Cleveland Museum of Art, gift of the Print Club of Cleveland 1938.274 (not illustrated)

LOUIS RORIMER
(American, 1872–1939) and the
ROKESLEY SHOP

151. *Tea and Coffee Service* (six pieces), 1904–20, silver, ebony, and moonstone; coffee pot: 11 x 9⁹⁄₁₆ in. (28 x 24.2 cm). The Cleveland Museum of Art, gift in memory of Louis Rorimer from his daughter, Louise Rorimer Dushkin, and his granddaughter, Edie Soeiro 1991.314–319 (fig. 178)

**ROSE IRON WORKS, INC.,
DESIGNER PAUL FEHER**
(Hungarian, 1898–1990)

152. *"Art Deco" Screen,* 1930, wrought iron and brass with silver and gold plating, 61½ x 61½ in. (156.2 x 156.2 cm). The Rose Family Collection (fig. 181)

DOROTHY RUTKA
(American, 1907–1985)

153. *Eviction,* ca. 1936, aquatint, 11 x 8½ in. (27.9 x 21.6 cm). Ohio Art Program, long-term loan to the Cleveland Museum of Art 4208.1942 (fig. 161)

154. *Poverty,* ca. 1936, aquatint, 8½ x 10⅞ in. (21.5 x 27.5 cm). Ohio Art Program, long-term loan to the Cleveland Museum of Art 4205.1942 (fig. 194)

155. *Strike Talk,* ca. 1935, aquatint, 6¼ x 8 in. (15.9 x 20.3 cm). Ohio Art Program, long-term loan to the Cleveland Museum of Art 4210.1942 (fig. 160)

156. *Striker's Wife,* ca. 1936, aquatint, 8 x 6¼ in. (20.3 x 15.9 cm). Ohio Art Program, long-term loan to the Cleveland Museum of Art 4209.1942 (fig. 162)

157. *Under Bridges,* ca. 1936, etching, 10⅞ x 8⁷⁄₁₆ in. (27.6 x 21.4 cm). Ohio Art Program, long-term loan to the Cleveland Museum of Art 4198.1942 (fig. 187)

RUDOLPH RUZICKA
(American, b. Czechoslovakia, 1883–1978)

158. *The High Level Bridge,* 1926, wood engraving, printed in color, 7⅛ x 5 in. (17.9 x 12.9 cm). The Cleveland Museum of Art, gift of the Print Club of Cleveland 1926.308 (fig. 125)

STUDIO OF JAMES RYDER
(American, 1826–1904)

159. *Superior Avenue Viaduct, Swing Bridge, and Forest City Ice Wagon,* 1880s, albumen stereoview, 3½ x 7 in. (8.9 x 17.8 cm). Peter and Judy Wach Collection (not illustrated)

CHARLES SALLÉE
(American, b. 1913)

160. *Girl with a Pink Geranium,* 1936, oil on canvas, 22½ x 21¼ in. (57.2 x 54 cm). The Harmon and Harriet Kelley Collection of African-American Art (fig. 169)

161. *Juke Box Jive,* ca. 1937, aquatint, 10¼ x 7⅜ in. (26 x 18.7 cm). Karamu House Collection, Cleveland (fig. 175)

VIKTOR SCHRECKENGOST
(American, b. 1906)

162. *Apocalypse '42,* 1942, glazed ceramic, 16 x 20 x 8 in. (40.6 x 50.8 x 20.3 cm). National Museum of American Art, Smithsonian Institution, Washington, D.C., gift of the artist, 1985.92.1 (fig. 158)

163. *Jazz Bowl,* 1931, glazed ceramic, 11⅜ x 16⅜ in. (28.9 x 41.6 cm). Cowan Pottery Museum, Rocky River (Ohio) Public Library (fig. 106)

LAWRENCE SCHREIBER
(American, 1904–1982)

164. *Casual Meeting,* ca. 1940, bromoil transfer photograph, 9 x 7¼ in. (22.9 x 18.4 cm). William and Mary Kubat Collection (not illustrated)

165. *Churning By,* ca. 1940, bromoil transfer photograph, 9½ x 7½ in. (24.1 x 19 cm). William and Mary Kubat Collection (fig. 124)

166. *Eagle Street Bridge,* 1930s, gelatin-silver print, 9½ x 7½ in. (24.1 x 19 cm). William and Mary Kubat Collection (fig. 222)

167. *Early Traffic,* 1933, gelatin-silver print, 7¼ x 10 in. (18.4 x 25.4 cm). William and Mary Kubat Collection (fig. 130)

168. *Open for Traffic,* 1930s, gelatin-silver print, 7½ x 8 in. (19 x 20.3 cm). William and Mary Kubat Collection (not illustrated)

169. *Passing Tugs,* ca. 1940, bromoil transfer photograph, 7¼ x 9 in. (18.4 x 22.9 cm). William and Mary Kubat Collection (not illustrated)

170. *Ready to Leave,* ca. 1940, bromoil transfer print, 7¼ x 9¼ in. (18.4 x 23.5 cm). William and Mary Kubat Collection (not illustrated)

171. *Tug on the Cuyahoga,* ca. 1940, bromoil transfer photograph, 7½ x 9¼ in. (19 x 23.5 cm). William and Mary Kubat Collection (not illustrated)

MANUEL G. SILBERGER
(American, 1898–1968)

172. *Labor (Composition),* 1936, lithograph, 5⁵⁄₁₆ x 11⁹⁄₁₆ in. (13.5 x 29.4 cm). Ohio Art Program, long-term loan to the Cleveland Museum of Art 4225.1942 (not illustrated)

F. W. SIMMONS
(American, 1859–1926)

173. *A Daughter of Italy,* ca. 1900, oil on canvas, 21½ x 18 in. (55 x 46 cm). The Western Reserve Historical Society, Cleveland, WRHS 64.72.9 (fig. 39)

WALTER SINZ
(American, 1881–1966)

174. *Beautiful Isle of Somewhere,* 1940, glazed ceramic, 13½ x 7¼ x 4¼ in. (34.3 x 18.4 x 10.8 cm). The Cleveland Museum of Art, Dudley P. Allen Fund 1941.50 (fig. 156)

ALLEN SMITH, JR.
(American, 1810–1890)

175. *Cleveland Public Square,* 1869, oil on canvas, 40½ x 63½ in. (102.9 x 161.3 cm). The Western Reserve Historical Society, Cleveland, WRHS 80.0.23 (fig. 21)

176. *Lucy Bidwell,* ca. 1850, oil on canvas, 35¼ x 28¼ in. (89.5 x 71.8 cm). The Western Reserve Historical Society, Cleveland, WRHS 47.535 (fig. 8)

177. *The Young Mechanic,* 1848, oil on canvas, 40¹⁵⁄₁₆ x 32³⁄₁₆ in. (102.2 x 81.7 cm). Los Angeles County Museum of Art, gift of the American Art Council and Mr. and Mrs. J. Douglas Pardee, M.81.179 (fig. 9)

ATTRIBUTED TO ALLEN SMITH, JR.
(American, 1810–1890), and
WILLIAM NORTH
(American, active 1860s)

178. *Franklin Backus,* ca. 1865, oil on canvas, 64 x 54½ in. (162 x 138 cm). Case Western Reserve University School of Law, Cleveland (fig. 10)

R. WAY SMITH
(American, 1840–1900)

179. *Sheep in Landscape,* 1899, oil on canvas mounted to board, 25 x 29 in. (63.5 x 73.2 cm). National City Bank Collection, Cleveland (fig. 47)

WILLIAM E. SMITH
(American, b. 1913)

180. *Maybe Tomorrow,* ca. 1938, linoleum cut, 10 x 7⅜ in. (25.4 x 18.7 cm). Cleveland State University, CSU 33.94 (fig. 176)

181. *My Son! My Son!,* 1941, linoleum cut, 7¹³⁄₁₆ x 5⁷⁄₁₆ in. (19.8 x 13.8 cm). The Cleveland Museum of Art, gift of the Print Club of Cleveland 1941.122 (fig. 170)

182. *Sharecropper,* 1940, linoleum cut, 8¹⁄₁₆ x 6¹⁄₁₆ in. (20.4 x 15.3 cm). The Cleveland Museum of Art, gift of the Print Club of Cleveland 1942.76 (fig. 196)

183. *Siesta,* 1940, linoleum cut, 9 x 8¹⁄₁₆ in. (22.9 x 20.5 cm). The Cleveland Museum of Art, gift of the Print Club of Cleveland 1943.244 (not illustrated)

WILLIAM SOMMER
(American, 1867–1949)

184. *Apples (for Hart Crane),* ca. 1930, watercolor, 8 x 10 in. (20.3 x 25.4 cm). Joseph M. Erdelac Collection (fig. 101)

185. *Bach Chord,* 1923, oil on board, 20 x 23¾ in. (50.8 x 60.8 cm). Akron Art Museum, gift of Russell Munn in memory of Helen G. Munn, 92.45a, b (fig. 91)

186. *Horse Drawn Cart in Thunderstorm,* ca. 1918 , oil on board, 20 x 25½ in. (51 x 64.8 cm). Joseph M. Erdelac Collection (fig. 78)

187. *Psyche,* ca. 1916, oil on board, 21 x 12½ in. (53.3 x 31.8 cm). Joseph M. Erdelac Collection (fig. 77)

188. *The Red Cottage,* ca. 1914, oil on board, 19¾ x 26¼ in. (50.1 x 66.7 cm). Joseph M. Erdelac Collection (fig. 74)

189. *Self-Portrait,* ca. 1917, watercolor, 12 x 9½ in. (30.5 x 24 cm). Joseph M. Erdelac Collection (fig. 86)

190. *Still Life with Palette,* ca. 1925, watercolor and graphite, 6⅞ x 10¼ in. (17.5 x 26.1 cm). Joseph M. Erdelac Collection (fig. 100)

191. *The Three Graces,* ca. 1916, watercolor, 12 x 16 in. (30.5 x 40.6 cm). Cleveland Artists Foundation (fig. 76)

192. *Viaduct at Sunset,* ca. 1914, watercolor and gouache over graphite, 11⅛ x 14⁵⁄₁₆ in. (28.3 x 36.4 cm). The Cleveland Museum of Art, gift of Dr. and Mrs. Theodor W. Braasch 1966.533 (fig. 81)

193. *Yellow Cows,* 1941, watercolor and graphite, 19 x 23½ in. (48.3 x 59.7 cm). Joseph M. Erdelac Collection (fig. 99)

THOMAS STEVENSON
(American, b. England, active 1841–1868)

194. *The Sunny Bank (Kingsbury Run),* ca. 1865, oil on canvas, 28½ x 35½ in. (72.4 x 90.2 cm). The Western Reserve Historical Society, Cleveland, WRHS 42.1898 (fig. 19)

ROLF STOLL
(American, b. Germany, 1892–1978)

195. *Anne Stanger,* 1941, oil and egg tempera on fiberboard, 29 x 22 in. (73.7 x 60 cm). Private collection, courtesy Vixseboxse Art Galleries, Cleveland Heights, Ohio (fig. 147)

THOMAS SWEENY
(American, active 1860s–1870s)

196. *President Lincoln Lying in State, Public Square,* 1865, albumen print, 4 x 6½ in. (10.2 x 16.5 cm). The Western Reserve Historical Society, Cleveland (not illustrated)

STUDIO OF THOMAS SWEENY
(American, active 1860s–1870s)

197. *Old Stone Church, Viewed from the Forest City House,* 1860s, albumen stereoview, 3½ x 6¾ in. (8.9 x 17.1 cm). Peter and Judy Wach Collection (not illustrated)

PAUL TRAVIS
(American, 1891–1975)

198. *The Blue Plate,* 1940s, oil on fiberboard, 24½ x 30¼ in. (62.2 x 76.8 cm). The Wasserman Family Collection (fig. 98)

199. *Campfire Scene, Africa,* 1928, watercolor, 14 x 20 in. (35.6 x 50.8 cm). Dr. and Mrs. Michael Dreyfuss Collection (fig. 138)

STUDIO OF H. D. UDALL
(American, active 1870s)

200. *Music Pavilion, Public Square,* ca. 1870, albumen stereoview, 4 x 7 in. (10.2 x 17.8 cm). Peter and Judy Wach Collection (not illustrated)

SANDOR VAGO
(American, b. Hungary, 1886–1946)

201. *The Artist and His Wife,* ca. 1938, oil on canvas, 38 x 48 in. (96.5 x 122 cm). William R. Joseph and Sarah J. Sager Collection (fig. 145)

202. *The Artist's Wife,* 1930, oil on canvas, 36 x 32 in. (91.4 x 81.3 cm). Renee and Richard Zellner Collection (fig. 144)

LOUIS VAN OEYEN
(American, 1865–1946)

203. *Buckeye Garland (Cleveland Indians),* 1926, gelatin-silver print, 10 x 7¾ in. (25.4 x 19.7 cm). Private collection (not illustrated)

204. *Raising the Flag on Opening Day, League Park, Cleveland,* 1910, gelatin-silver print, 5½ x 8 in. (14 x 20.3 cm). Courtesy Yannigan's Baseball Memories, Westlake, Ohio (not illustrated)

205. *Street Car Day ("Ride Free All Day"),* 1908, gelatin-silver print, 5 x 7 in. (12.8 x 17.9 cm). The Western Reserve Historical Society, Cleveland (not illustrated)

206. *Street Car Strike,* 1908, gelatin-silver print, 5 x 7 in. (12.8 x 17.9 cm). The Western Reserve Historical Society, Cleveland (not illustrated)

ABEL WARSHAWSKY
(American, 1883–1962)

207. *Washerwomen at Goyen,* 1917, oil on canvas, 25½ x 32 in. (64.8 x 81.3 cm). The Cleveland Museum of Art, gift of the Cleveland Art Association 1920.277 (fig. 50)

STUDIO OF WEBSTER & ALBEE
(American, active 1890s)

208. *Interior of the Cleveland Arcade,* ca. 1890, albumen stereoview, 3½ x 6¾ in. (8.3 x 17.2 cm). Peter and Judy Wach Collection (not illustrated)

FRANK WILCOX
(American, 1887–1964)

209. *The Bee Tree,* 1930, oil on canvas, 30 x 40 in. (76.2 x 102 cm). The Wilcox Estate (fig. 137)

210. *The Old Market, Cleveland,* 1920, gouache on board, 28¾ x 22¾ in. (73 x 57.8 cm). The Cleveland Museum of Art, purchased with funds given by Friends of the May Show 1920.279 (fig. 108)

ARCHIBALD WILLARD
(American, 1836–1918)

211. *Kingsbury Run,* ca. 1890, oil on canvas, 30 x 24 in. (76.2 x 61 cm). Private collection (fig. 46)

212. *Minnie Willard,* ca. 1860, oil on canvas, 38³⁄₁₆ x 26⅛ in. (97 x 66.4 cm). The Cleveland Museum of Art, gift of John R. Wherry in memory of John Willard Wherry 1994.285 (fig. 11)

213. *The Spirit of '76,* 1912–13, oil on canvas, 120 x 98 in. (304.8 x 248.9 cm). City of Cleveland (fig. 40)

214. *The Young Tycoon,* ca. 1890s, oil on canvas, 36¼ x 22 in. (92.1 x 55.9 cm). Private collection (fig. 42)

THELMA FRAZIER WINTER
(American, 1908–1976)

215. *The Daring Young Men,* 1940, glazed ceramic, 22 x 13½ x 9¼ in. (55.9 x 34.3 x 23.5 cm). The Western Reserve Historical Society, Cleveland, WRHS 79.75 (fig. 157)

WILLIAM ZORACH
(American, b. Lithuania, 1891–1966)

216. *My Sister Mary,* 1908, oil on canvas, 28½ x 18½ in. (72.3 x 47 cm). The Peter and Julie Jenks Zorach Collection (fig. 58)

217. *Spring,* 1913 (recto), and *Untitled* (Summer), 1914 (verso), double-sided canvas, oil on canvas, 31¾ x 36¾ in. (80.6 x 93.4 cm). The Jamee and Marshall Field Collection (figs. 70, 71)

ACKNOWLEDGMENTS

This exhibition celebrating the first 150 years of Cleveland art could not have been realized without the generous support of many organizations and individuals. To everyone who contributed to turning our ideas and sometimes overly ambitious dreams into reality, we wish to extend our deepest appreciation. We are especially grateful to Robert P. Bergman, director of the Cleveland Museum of Art, for his enthusiastic support. We were constantly inspired by his vision of a museum dedicated to community service and actively engaged in the daily life of this revitalized city.

Transforming ideas and aspirations into reality requires material support. This exhibition and catalogue were made possible by a generous grant from Hahn Loeser & Parks, a distinguished law firm that recently celebrated its seventy-fifth anniversary. Its sponsorship afforded unprecedented opportunities for research, interpretation, and restoration of art works, including some in precarious physical condition. By supporting the documentation and preservation Cleveland's cultural heritage, the firm's generosity will benefit future generations long after the passing of the city's bicentennial year.

Cleveland artists and their families significantly enriched this catalogue by providing interviews and access to unpublished materials. For their assistance and cooperation, we are profoundly grateful to Ruth Adomeit, Frances Babinsky, Blanche Barloon, Frederick and Helen Biehle, Lawrence Blazey, James Brown, Clarence Carter, Frank DePrima, Elisabeth Travis Dreyfuss, Edris Eckhardt, Mort and Marion Epstein, Marjorie Flint, the Carl Gaertner family, Raphael Gleitsmann, Honore Guilbeau, Doris Hall, Kay Hoobler, Jane Babinsky Karlovec, Matthew Kubinyi, Alice Coltman Mayer, William and Alice Monroe, Elmer Novotny, John Puskas, Walter DuBois Richards, Charles Sallée, Viktor Schreckengost, Jean Schenk, Hughie Lee-Smith, Marvin Sommer, Jr., Sue Traut, Gretchen Grauer Vanderhoof, Helen Walraven, David and Lee Warshawsky, and Tessim Zorach. The Burchfield-Penney Art Center at Buffalo State College granted access to Burchfield's private diaries, notebooks, and letters. Unpublished documentary information was also supplied by three offices of the Smithsonian Institution in Washington D.C.: the Archives of American Art, the Inventory of American Paintings, and the Catalogue of American Portraiture.

Clevelanders were remarkably generous in responding to our requests for information and advice. The staff of the Western Reserve Historical Society was an invaluable partner and supplied crucial research assistance. We are especially grateful to Richard L. Ehrlich, director; John Grabowski, director of planning and research; Michael McCormick, head of manuscripts and reprography; Ann Sindelar, reference supervisor; Barbara Billings, reference assistant; Kelly Falcone, library assistant; Bern 1905, assistant registrar; and Samuel Black, associate curator of African-American history. Barbara Bertucio, collections manager, and Leslie Graham, loan coordinator, provided knowledge about objects in their collection.

Scholars and curators throughout the community were equally supportive of our research efforts. Michael Morgenstern, assistant editor for the revised edition of the *Encyclopedia of Cleveland History,* and Richard A. Zellner, curator of the Hahn Loeser & Parks art collection, offered ideas and advice. Peter Wach provided invaluable research and technical expertise to the study of photography. For their constant assistance we are grateful to the staff of the Cleveland Artists Foundation, especially Ann Caywood Brown, director; Nina Freedlander Gibans, president; William Busta, vice-president; and Zita Rahn, coordinator of the African-American art project. Our research was also facilitated by Mary Sayre Haverstock, director of the Ohio Artists Project in Oberlin; N. Sue Hanson, head of special collections at Case Western Reserve University; Cristine C. Rom, director of the Jessica R. Gund Memorial Library at the Cleveland Institute of Art; and Ann Olszewski, preservation librarian at the Cleveland Public Library. We are also appreciative of the cooperation and contributions of Lois Alperin, curator of the Fairmount Temple; Gladys Haddad, professor of American studies at Case Western Reserve University; Rotraud Sackerlotzky; Roger Welchans, former professor of art history and humanities at John Carroll University; Roland Baumann, archivist of Oberlin College; James Edmundson, Allen Memorial Library; Jane Boruff Tesso, art administration consultant for BP America; and Pat Zalba, curator of the Chagrin Falls Historical Society. Research assistance and access to private collections was provided by Eleanor Bonnie, Jean Brodkey, Julie K. Brown, Dean Drahos, Jean Gadde, Willard Gordon, Nan Grossman, Lou Cinda Holt, Hunter Ingalls, Geraldine Wojno Kiefer, Colin S. MacDonald, Janet Marstine, Mr. and Mrs. William McCoy, Elizabeth McClelland, Dr. Miklos Müller, Nancy Persell, Bryan Pierce, Elizabeth Shearer, Melvin M. and Robert B. Rose, Kirk Steehler, Charles Sterling, Nancy Stillwagon, Victor V. Studer and Carol Millsom Studer, Marianne Berger Woods, Richard Wootten, Dean Zimmerman, and Daniel and Lynn Zinko.

We were delighted to discover that not only does Cleveland art have an audience outside the city, but that experts across the state were eager to share their knowledge of the subject. For their assistance, we are grateful to Sara R. Johnson, curator of exhibitions at the Southern Ohio Museum in Portsmouth; Alfred L. Bright, professor of art at Youngstown State University; Lynnda Arrasmith, curator at the Canton Art Institute; Wendy Kendall-Hess, former assistant curator of the Akron Art Museum; Nannette V. Maciejunes, chief curator of the Columbus Museum of Art; Amos Loveday, director of

education at the Ohio Historical Center in Columbus; Melinda Knapp, registrar of the Ohio Historical Center in Columbus; Patricia Lindley, director of the Herrick Memorial Museum in Wellington; Don Schweikert of Auditorium Antiques in Watertown; Richard Squire, director of the Bedford Historical Society; and Evan Turner, former director, Cleveland Museum of Art. We are also grateful to John Vanco, director of the Erie Art Museum; Martin Lerner, curator of Asian art at the Metropolitan Museum of Art; Michael Rosenfeld of the Michael Rosenfeld Art Gallery in New York; Jim Berry Hill of the Berry-Hill Galleries in New York; Charleen Akullian of Alfred J. Walker Fine Art in Boston; Lee Stone of M. Lee Stone Fine Prints in San Jose, California; Steve Turner of the Steve Turner Gallery in Los Angeles; and Laura Miller of Butterfield & Butterfield in San Francisco. Research assistance was provided by Mary Jo Groppe, Shaker Historical Society; Sally Brown, Cleveland Museum of Art Womens Council; JoAnne Houmard, librarian at Mount Union College in Alliance, Ohio; Marjorie Wieseman, curator of Western art at the Allen Memorial Art Museum; John Davis, Smith College, Massachusetts; Michael Conforti, director of the Sterling and Francine Clark Art Institute in Williamstown, Massachusetts; Edward Maeder, director of the Bata Shoe Museum in Don Mills, Ontario, Canada; Walter Leedy, professor of art history, Cleveland State University; Kim McGrew, assistant manager of the Campus Martius Museum in Marietta, Ohio; Mary F. Bell, director of library and archives at the Buffalo and Erie County Historical Society in Buffalo; Douglas Kendall, State Historical Museum of Wisconsin; Rob and Annette Elowitch of Baridoff Gallery, Portland, Maine; Deborah E. Kraak, associate curator and in charge of textiles, Winterthur Museum in Wilmington, Delaware; Thomas H. Pauly, professor of English at the University of Delaware; Sandra Wheeler, archivist of the Hill-Stead Museum in Farmington, Connecticut; and Brucia Whitthoft, professor at Framingham State College, Massachusetts.

Cleveland benefits enormously from its art dealers, many of whom are immensely devoted to Cleveland art. Over the years, these individuals have accumulated a wealth of knowledge about the artists of the city and the surrounding region. We greatly appreciate the advice and assistance of Ellen and Grant Kloppmann of Vixseboxse Art Gallery; Ernestine Brown of the Malcolm Brown Gallery; William Busta of the William Busta Gallery; Carl R. Brainard of Brainard Gallery; Nancy and Jeffrey Cole of the Passionate Collector; William Scheele of Scheele Fine Arts; Laura Sherman of Bonfoey Company; Rachel Davis of Rachel Davis Fine Arts; Michael Wolf, Bridget McWilliams, and Darlene Michitsch of Wolf's Fine Art Auctioneers; James Corcoran of Corcoran Fine Arts; Donald Boncela of the Crimson Gallery; and Judy Gerson of the Blue Phoenix.

Many individuals were involved in the production of this catalogue. Mark Cole served as a research assistant, loan coordinator, and contributor to the biographies and the chronology of Cleveland art. Kerri Ratner provided administrative assistance. Margaret Burgess, Michelle Burkhead, Whitney Conway, Ruth Dancyger, Sabine Kretzschmar, Richard Zellner, and Wesley Zoeller helped write the biographies. Linda Budd, Meredith Harper, Jacob Latham, Alice Lin, Sandra Rueb, and Stanton Thomas gathered information and checked facts. Virginia Krumholz and Dianne O'Malia of the Cleveland Museum of Art Archives made unpublished letters and documents available. Howard Agriesti, Gary Kirchenbauer, and Matthew Kocsis photographed objects. Laurence Channing, Thomas Barnard, and Charles Szabla designed and produced the catalogue. The text was edited by Barbara Bradley and Kathleen Mills, who guided us with enduring patience and skill.

Many colleagues at the Cleveland Museum of Art contributed to the production of the exhibition. For accompanying us on research trips and working tirelessly to restore objects, we are grateful to the following members of the conservation staff: Kenneth Bé, Beth Campano, Bruce Christman, Jim George, Patricia Griffin, Joan Neubecker, Marcia Steele, and Dean Yoder. For their assistance in securing funding, we are grateful to Judith Paska, Kate Sellers, and Michael Weil in the development and external affairs division. We are equally appreciative of the cooperation and assistance of our colleagues Ann Boger, Joan Brickley, Alan Chong, Roger Diederen, Christine Edmonson, Charles Eiben, Karen Ferguson, Jane Glaubinger, Dyane Hanslik, Tom Hinson, Denise Horstman, Patricia Krohn, Nancy McAfee, Hannelore Osborne, William Prenevost, Katherine Solender, Jeffrey Strean, Mary Suzor, William Talbot, Carolyn Thum, Georgina Gy. Toth, and Marjorie Williams.

Above all, we are most grateful to the lenders. It is only through their generosity that we have been able to present such a large display of works representing Cleveland's distinguished visual arts tradition. For their cooperation and support, our deepest appreciation is extended to all the individuals and institutions specified in the lenders list as well as to those lenders who wish to remain anonymous.

William Robinson, Assistant Curator
The Cleveland Museum of Art

David Steinberg, Assistant Curator
The Cleveland Museum of Art
Assistant Professor of Art History and Art
Case Western Reserve University

PHOTO CREDITS

The following list, keyed to figure numbers and depictions of artists in the biography section, applies to photographs for which an acknowledgment is due. Individual works of art appearing in this catalogue may also be protected by copyright in the United States of America or abroad and may not be reproduced in any form or medium without the permission of the copyright holders.

Figs. 1–2, 4–5, 7–8, 10–11, 15, 17–22, 24–25, 30–31, 34–35, 38–39, 42–43, 46–52, 55, 59–61, 63–69, 72–78, 81–83, 87–92, 94–98, 100–105, 107–21, 123–31, 133–40, 143–47, 149, 154, 156–57, 159–68, 170–73, 175–76, 178–80, 182–201, 206–8, 212–13, 216, 218–20, 222–23: Howard Agriesti and the photography studio, Cleveland Museum of Art; fig. 6: Joseph Szaszfai; fig. 56: Henry Church, Jr., Family; fig. 57: Alfred J. Walker Fine Art, Boston; fig. 91: Lydia Dull; fig. 106: Thomas Oakley; fig. 221: © Herbert Ascherman, Jr.

George Adomeit: courtesy Cleveland Museum of Art Archives; Russell Aitken: courtesy Cleveland Press Collection; Otto Bacher: Edgar Decker; Colburn Ball: *Cleveland Town Topics*, courtesy Western Reserve Historical Society; Sol Bauer: H. Hewett, courtesy Cleveland Museum of Art Archives; August Biehle: courtesy Frederick C. Biehle; Lawrence Blazey: courtesy Cleveland Museum of Art Archives; Ora Coltman: courtesy Cleveland Museum of Art Archives; Margaret Bourke-White, detail of *Margaret Bourke-White above Superior Avenue, with the Cleveland Public Library and the Plain Dealer Building in the Background:* Howard Agriesti, after an original possibly by Arthur Gray, courtesy Cleveland Public Library Photography Collection; Charles Burchfield: *Cleveland Town Topics*, courtesy Western Reserve Historical Society; Clarence Carter: Albert Duval, courtesy Cleveland Museum of Art Archives; Henry Church, Jr.: Edgar Decker and Charles E. Wilbur; George Clough: J. M. Greene, courtesy Cleveland Museum of Art Archives; Clara Deike: *Cleveland Town Topics*, courtesy Western Reserve Historical Society; Stevan Dohanos: courtesy Cleveland Museum of Art Archives; William Eastman: *Cleveland Town Topics*, courtesy Western Reserve Historical Society; Edris Eckhardt: courtesy Cleveland Museum of Art Archives; De Scott Evans: courtesy Claire Evans O'Connor; Leroy Flint: courtesy Cleveland Museum of Art Archives; Carl Gaertner: courtesy Cleveland Museum of Art Archives; Frederick Gottwald: courtesy Cleveland Institute of Art Archives; William Grauer: courtesy Gretchen Grauer Vanderhoof; Jolán

Gross-Bettelheim: from the exhibition catalogue *Jolán Gross-Bettelheim retrospktív kiállítása* (Budapest: Kiállítóterem, 1988); Max Kalish: courtesy Cleveland Institute of Art Archives; John Kavanagh: courtesy *Plain Dealer* Archives; Henry Keller: courtesy Cleveland Institute of Art Archives; Grace Kelly: courtesy William and Alice Monroe; Kálmán Kubinyi: Albert Duval, courtesy Cleveland Museum of Art Archives; Hughie Lee-Smith: courtesy Western Reserve Historical Society; Adam Lehr: courtesy private collector; Russell Limbach: Albert Duval, courtesy Cleveland Museum of Art Archives; Elmer Novotny: Robert Phillips; Caroline Ransom: unknown painter, courtesy Architect of the Capitol, Washington, D.C.; Louis Rorimer: courtesy Cleveland Institute of Art Archives; Dorothy Rutka: courtesy Cleveland Museum of Art Archives; Charles Sallée: courtesy Western Reserve Historical Society; Victor Schreckengost: *Cleveland Town Topics*, courtesy Western Reserve Historical Society; F. W. Simmons: George C. Groll, from *A Cleveland Scrapbook*, courtesy Ingalls Library, Cleveland Museum of Art; Walter Sinz: courtesy Cleveland Institute of Art Archives; Allen Smith, Jr.: courtesy Cleveland Museum of Art Archives; William E. Smith: courtesy Western Reserve Historical Society; William Sommer: courtesy Cleveland Press Collection; Thomas H. Stevenson (oil painting, ca. 1860, by Mark R. Harrison): courtesy State Historical Society of Wisconsin; Rolf Stoll: courtesy Cleveland Press Collection; Paul Travis: courtesy Cleveland Institute of Art Archives; Sandor Vago: Albert Duval, courtesy Cleveland Museum of Art Archives; Abel Warshawsky: courtesy Cleveland Press Collection; Archibald Willard: from James F. Ryder, *Voigtländer and I: In Pursuit of Shadow Catching* (Cleveland: Imperial Press, 1902); Thelma Frazier Winter: courtesy Cleveland Institute of Art Archives; Frank Wilcox: *Cleveland Town Topics*, courtesy Western Reserve Historical Society; William Zorach: courtesy Western Reserve Historical Society.